F V

WITHDRAWN

Art Nouveau

CRITICAL INTRODUCTIONS TO ART

This major new series aims to provide critically-informed textbooks which utilise the latest research and a wide range of approaches, to survey and analyse subjects studied widely on art history courses.

Using a thematic structure to cover individual artists, specific periods and genres, authors will highlight issues of contemporary concern such as gender, race, art practice and institutions to expand debates around mainstream subject areas for students. Each of these well-illustrated books will include a full bibliography and a detailed index.

ART NOUVEAU

International and national styles in Europe

JEREMY HOWARD

Manchester University Press

MANCHESTER AND NEW YORK distributed exclusively in the USA by St. Martin's Press

Published by Manchester University Press
Oxford Road, Manchester M13 9NR, UK
and Room 400, 175 Fifth Avenue, New York NY 10010, USA

Distributed exclusively in the USA
by St. Martin's Press, Inc.,
175 Fifth Avenue, New York, NY 10010, USA

British Library Cataloguing-in-Publication Data
A catalogue record is available from the British Library

Library of Congress Cataloging-in-Publication Data
Howard, Jeremy
 Art nouveau : international and national styles in Europe / Jeremy Howard.
 p. cm. — (Critical introductions to art)
 Includes bibliographical references and index
 ISBN 0-7190-4160-0 — ISBN 0-7190-4161-9 (pbk.)
 1. Art nouveau—Europe. 2 Art, European. 3. Art, Modern—19th century—Europe.
 4. Art, Modern—20th century—Europe. I. Title. II. Series.
 N6757.5.A78H68 1996
 709'03'49—dc20 95-47946

ISBN 0-7190-4160-0 *hardback*
ISBN 0 7190 4161-9 *paperback*

First published in 1996

00 99 98 97 96 10 9 8 7 6 5 4 3 2 1

Typeset in Scala
by Koinonia, Manchester
Printed in Great Britain
by Bell & Bain Limited, Glasgow

Contents

List of plates

Acknowledgements

In the process of researching and writing this book I have benefited immensely from the help and advice of many individuals and institutions. First and foremost was the British Academy, which funded a three-year Postdoctoral Fellowship at the University of St Andrews, during which time a large proportion of the material presented here was gathered. The Academy's new exchange agreement with the Latvian Academy of Sciences was instrumental in assisting my fieldwork in Riga where I was able to draw on the expertise and generosity of numerous scholars, most notably Professor Eduards Kļaviņš, Professor Jānis Krastiņš, Dr Ruta Čaupova, Maris Brancis, Ingrida Burane, Genoveva Tidomane. I am extremely grateful for the time they spared and the warmth with which they received me. In addition, the Latvian Museum of Art and the Misina Library provided much assistance. The British Academy has been very generous in providing a substantial grant for the reproduction of the colour plates. For the course of the fellowship the School of Art History at the University of St Andrews, together with the University Library and Photographic Unit, provided essential practical support, this combined with invaluable encouragement from my colleagues, especially Dr John Frew, then Head of School. I am also indebted to the School of Fine Art, Duncan of Jordanstone College of Art, Dundee for providing financial assistance for my research in Prague, where the staff of the Museum of Applied Arts, Professor Petr Wittlich and Malcolm Griffiths were particularly helpful. In Russia Dr Sergey Kuznetzov proved an invaluable fount of information as did Dr Wojciech Bałus in Cracow. I owe a special debt of gratitude to Mrs Irma Ozols for the time and energy she devoted to conveying to me her profound understanding of her culture.

Finally, I am immeasurably indebted to my family, not least my mother for the checking of drafts and my unfailingly supportive wife Albina and our children, who put up with my long-term early morning disappearances with remarkable fortitude. Without them this book would not have been.

FOR MADINA AND DUNCAN

Preface

The intention of this book is to supply a new appraisal of the arts movement that has become known as Art Nouveau. To this end it addresses the development of the movement's art through a regional survey. This is given wider scope than has been usual to date and includes several areas that have hitherto been neglected despite the wealth of their contribution, e.g. Latvia and Hungary. Given this scope, which in no way aims at being comprehensive, it has proved necessary to limit the selection of material for analysis within the individual regions. First, this has meant focusing on certain centres of production. Second, an overview of the art produced in those centres is offered with the work of a restricted number of artists being expanded upon. This is backed up by relevant background to the appearance of Art Nouveau, including mention of political and cultural context and the artistic preliminaries to the style.

Inherent in the book's structure is a fresh assessment that breaks with a number of conventions which have gained currency. This particularly concerns the notions that Art Nouveau was essentially a west European, and particularly French and Belgian phenomenon; that it sprang from eclecticism and preceded modernism; that it was a curvilinear decorative style created for the decadent rich. The result has been numerous studies devoted to these and few that seek for a more holistic treatment, in tune with the shape of Europe at the time. For this reason, the crucial developments in France, Belgium, Germany, Britain, Spain and Vienna are outlined and discussed, but the chapters dedicated to them are kept brief. More space is taken by analysis of the art created in others areas, specifically six regions in the huge European holdings of the Habsburg and Romanov empires: Bohemia (Czech), Hungary, Poland, Russia, Finland and Latvia. The emphasis is justified not only by the uniqueness of contribution from each of these areas, but also by the weight of Art Nouveau created therein. Riga and St Petersburg, for example, vie with one another for the title of the European city with most Art Nouveau buildings.

The approach taken here concerns the style's varied appearance in relationship to its patronage, response to the modern, machine age and national identity. The aim has not been to show that Art Nouveau was bound to happen, that the circumstances pertaining in the 1890s and 1900s were entirely propitious, but rather that there were certain imperatives that contrived to provoke it into existence. And in so doing established the direction of modern art and design for the new century. The nature of the movement meant abandonment of, or at least challenge to, the hierarchies that divided the fine arts, architecture and the applied arts. The result was a quest for a synthetic style based on new values. This form of art-design integration suggests that a study

which seeks to divorce the realms can be accused of not being in keeping with the movement's spirit. While the same charge can be levelled at a regional survey, the attempt here has been to provide as much comparative analysis as possible. In this way it is hoped that the book will provide readers with a new sense of the place and role of many associated artists, and a new insight into the variety of manifestations, achievements and influence of Art Nouveau.

A note on translation: The titles of periodicals, groups, societies etc. are generally given in English. They may, however, be given in the original language, an English translation being provided with the first mention in the regional section to which they belong. The decision for this is based on the perceived ease or difficulty for English readers of the titles, the frequency of reference and significance. Also, where they differ very little from English (e.g. *L'Art Moderne*) or are particularly well known (e.g. *Jugend*) they are kept in the original.

Map: Europe 1890–1910

Colour plates

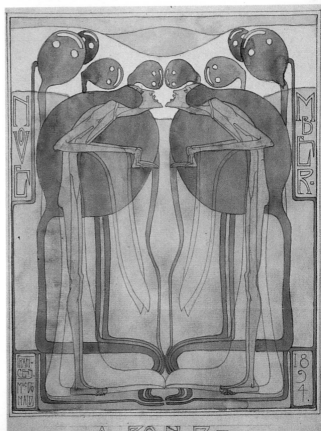

[2] Gaudí, Park Güell entrance lodge, Barcelona, 1900–14

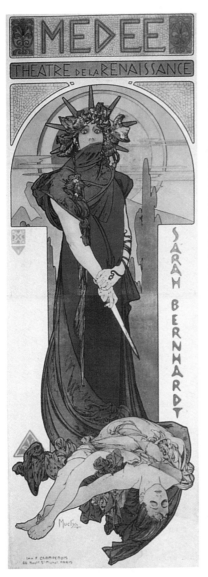

[1] Mucha, *Médée*, poster, 1898, colour lithograph

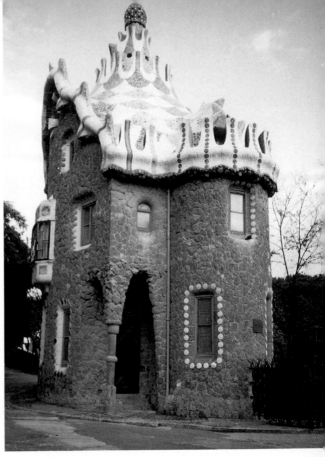

[3] Frances Macdonald, *A Pond*, frontispiece to *The Magazine*, 1894

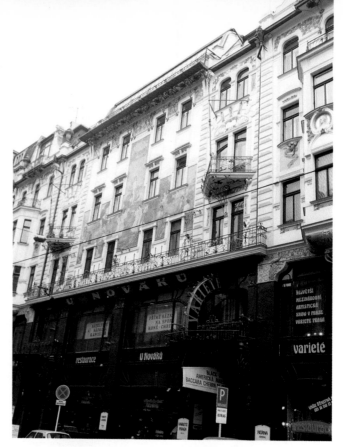

[4] Polívka, Novák
Department Store,
30 Vlodickova,
Prague, 1902–3

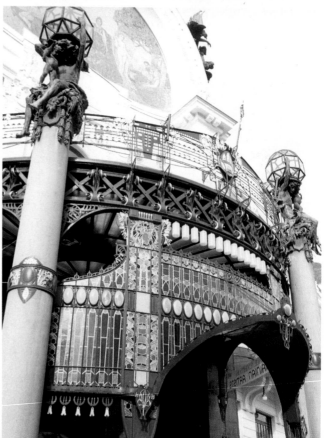

[5] Polívka,
Municipal Building,
2 Republic Square,
Prague, 1905–12

[6] Rippl-Rónai,
The Virgins, 1895

[7] Okuń, *Chimera*,
cover, 1903

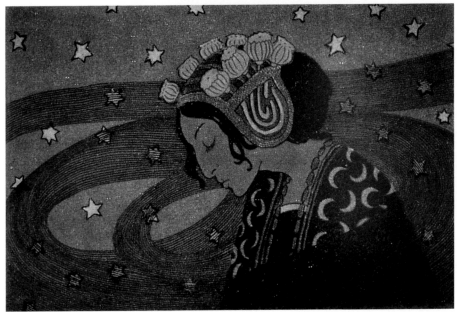

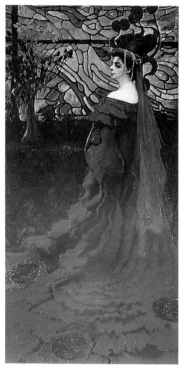

[8] Wyspiański, *Polonia*, 1894, detail,
design for stained glass, Lemberg Cathedral,
pastel, 298 x 153

[9] Stabrowski, *Stained glass background:
A Peacock (Portrait of Zofia Borucińska)*,
1908, oil on canvas, 277 x 115

[10] Vrubel, *Princess of Dreams*, ceramic frieze, Metropole Hotel, Moscow, 1899–1904

[11] Shekhtel, ceramic frieze, Northern Railway Station, Kalanchevskaya Square, Moscow, 1901

[12] Shekhtel, Ryabushinsky house, Malaya Nikitskaya 6/2, Moscow, 1900–3

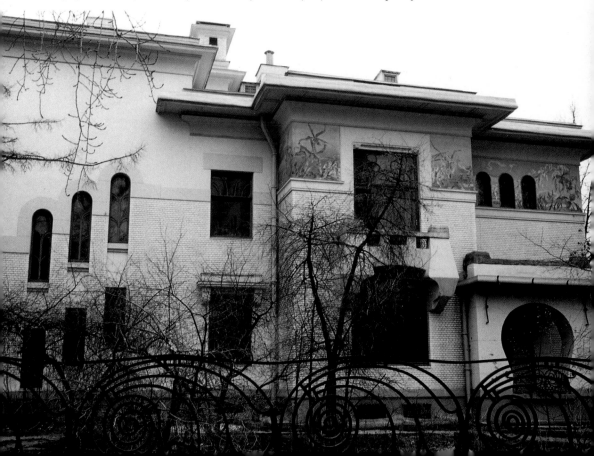

[13] Baranovsky, Eliseyev shopping hall, Tverskaya 14, Moscow, 1901–3

[14] Gallén, *Defence of the Sampo*, 1896, tempera on canvas, 122 x 125

[15] Gallén, *Lemminkäinen's Mother*, 1897, tempera on canvas, 85 x 118

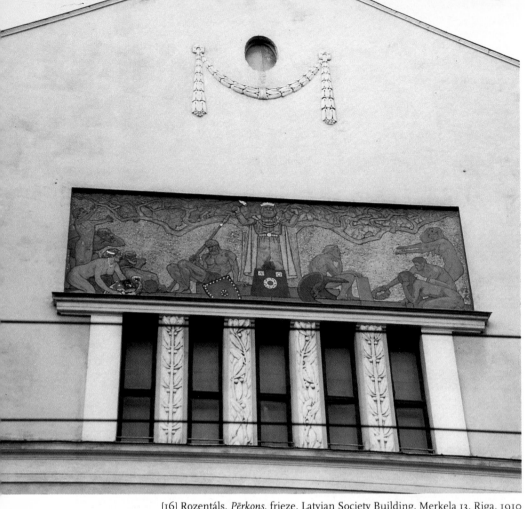

[16] Rozentáls, *Pērkons*, frieze, Latvian Society Building, Merkela 13, Riga, 1910

[17] Tillbergs, *Tourists in Riga, Svari*, 1907

[18] Baranowsky, *Autumn*, 1902

Introduction

Art Nouveau: the myth, the modern and the national

THE MYTH

In 1904 the London periodical *The Magazine of Art* published a collection of views by professional artists, craftsmen and architects under the title '*L'Art Nouveau*: What it is and what is thought of it'. Among those who contributed were several leading academicians; Walter Crane, president of the Arts and Crafts Society; Alfred Gilbert the sculptor; the designers George Frampton and Gerald Moira; and the architects Richard Norman Shaw and Charles Voysey. At some point or other all of these were themselves regarded as precursors of, or participants in, the movement generically known as Art Nouveau. And yet the drift of the opinions offered was haughty and sometimes dismissive:

I believe it is made on the Continent and used by parents and others to frighten naughty children – a very bad practice and far worse than the old English bogeyman ... It is the resort of the uncultivated and duffer ... a disease ... I fail to see in it more than a fungoid growth ... the furniture seems indebted very much to the torture chambers of the middle ages ... a morbid craving for originality at any price ... The less refined forms are ridiculously easy, and the wild extravagances of Berlin and Vienna, which are re-reflected in this country are the result. It is not art at all, but an evil dream – a nightmare, which only weakens the tired seeker after rest and refreshment[i]

Only some were more circumspect, serious and positive:

To pass an opinion is not easy at it covers such a wide field, and it is very difficult to say where it begins and ends ... it is a convention of conventions ... extracted from many essences and compounded of many simples. Traces of decadence, primitive motives, attenuated Pre-Raphaelitism, Japanese influence – all are summarised. One sees even the electric wire and insulator motive as decorative units. Modern, certainly, and modern in its rapid development ... *L'Art Nouveau* is replete with beauty of line, grace of form, and freedom. It is a sympathetic style and in its best rendering is full of repose and quiet unobtrusive beauty. It is Art pure and simple, untrammeled by convention and therefore, in a sense, original. Its proper expression must result rather from what is within a man, his sympathies, nobler qualities and aspirations, than from studious effort; he must feel rather than know, sympathise rather than study.

For one hundred years Art Nouveau has been a source of controversy and an enigma. Ambiguous, hard to pin down, hard to define, easy to deride. It is not a

singular style but a movement in which certain formal characteristics recur and certain ideologies are expressed. It is a response to the age, a response that was to encapsulate the rapidity of change, of new worldviews and scientific advances. As such it contains elements of the past as well as the present.

The contradictory nature of Art Nouveau and its interpretation has led to misapplication of the term. Supposed synonyms most frequently refer to stylistic branches within the wider movement, e.g. the Secession Style, Modern Style, New Style, National Romanticism, Jugendstil, Free Style, Arts and Crafts. They overlap. Further, confusion has reigned because of its breadth: it is to be found in architecture and design, the graphic and fine arts, theatre and dance. It can be perfectly manifested in one object, be that a vase, a tapestry, a poster or bed. Or, broaching artistic borders and hierarchies, it can be a cohesive, integrated ensemble of construction and decoration.

The vagueness of application has led to its identification with a period more than a style, approximately 1890 to 1910. This crossing of centuries is symbolic of its transcendentalism – it is both *fin-de-siècle* and *debut-de-siècle*. It also partly accounts for the unease with which it has been handled. It can be seen as the commercialisation of art, a debasement of symbolist aestheticism into the realms of mass culture and popular appeal. Or as elitist and aristocratic, clinging to vanishing values. It is at once anti-rationalist, expressing the wildest of fantasies, and functionalist, giving material form to socialist aspirations and technological advances.

Generalised simplifications of definition have tended to arise where an overly narrow selection of media or artists devoid of comparative analysis has been exercised. The views which have gained most credence are those which have interpreted Art Nouveau as *a* style, a play of surface decoration and narcissistic art for art's sake. They have seen it devoid of socio-political message or consequence. Hence its demise when challenged by the more profound, rational and intellectual art of Modernism born in the decade before the First World War. Added to this, currency has been given to the idea that only western Europe produced noteworthy, true Art Nouveau and that the centre, north, south and east were all derivative, impure or crude. Confinement has been seductive. For a long time it was considered the Pevsnerian bridge between historicism and modernism,[2] a feminised world of ephemeral, emotional forms,[3] a movement whose originality was restricted to a few western centres such as Paris, Brussels, London, Glasgow, Munich and Berlin.[4]

In fact, Art Nouveau's strength and vitality derived from its diversity, complexity, ambiguity and pan-European manifestation. The struggle of forms it represented was a struggle of worldviews. It is chauvinism mixing with universalism, science co-mingling with art, the pagan with Christian. It can be both decadent and progressive, national and liberal, eastern and western, vernacular and international, urban and rural, imperial and social, natural and artificial, material and spiritual.

So who has encouraged the myth of its exclusivity? The critics, as we have seen, but also the dealers, politicians, historians and some, self-aggrandising, artists. Dealers find Art Nouveau wares are eminently marketable as objects of luxury and style, mementoes of a lost age of self-embellishment and optimism. Lalique's brooches, Gallé's glass and the Wiener Werkstätte's furniture, all objects deliberately imbued with quality, refinement and care, perfectly accord with this vision.

Concurrent with this, politicians on the left have been able to dismiss Art Nouveau as an example of the worst excesses of bourgeois capitalism; those on the right have seen its stance against traditional hierarchies, treatment and motifs as dangerous signs of decay; while nationalists, particularly in the west, have found fit to ignore the richness of work created in the east. There has also been a reluctance to explore both the eastern patronage of western Art Nouveau and the 'eastern' identity of many of its artists.

Art historians have tended not to probe too far into the actual European-wide phenomenon that was the movement. The integration and conflict of cultures at the time has been largely overlooked. For instance, despite the numerous studies of Art Nouveau and its artists, the following have been virtually forgotten: that the English architects Ashbee and Baillie Scott were popular and had prominent clients in Hungary and Poland; that the outstanding exponent of Art Nouveau in Paris, Alfons Mucha, was a Moravian who also worked in Prague; that Mackintosh exhibited in Moscow; that Romanians were amongst the most important patrons of Falize, the leading Parisian enamelware makers; and that the Finns Gallén and Vallgren were among the most famous and influential New Style artists. Further, while the focus has been on certain western centres, the contemporary coverage of developments across the continent, in journals like *The Studio*, has been ignored.

Here the attempt is to redress the balance, at least slightly. Still, room does not permit examination of all the forceful regional and individual contributions to Art Nouveau. It is not possible, for instance, to discuss the architecture of Fernando Navarro Navarro on Gran Canaria, or that of Pierro Arrigoni in Thessaloniki, Johann Osness in Trondheim, Vasyl Krychevsky in the Ukraine, Georgi Phingov in Sofia. Nor can the designs of Carlo Bugatti, the Sicilian Ducrot furniture work-shop, or Uiterwyk's metalwork in The Hague be covered. Yet a wider selection than usual is offered. This, together with an analysis that integrates the arts with their socio-political context.

THE MODERN STYLE FOR A CHANGING WORLD

The Art Nouveau age was an epoch of unprecedented diversity in material and spiritual culture. Responding to the advances of the modern age and its spirit of change, the movement rejected the slavish copying of past styles, and preferred the selection and manipulation of that relevant to the present. Its artists and designers, sharing in the climate of new ideas, hopes and modes of life, also revealed an ability to incorporate innovation and discovery. Hence Art Nouveau's synthetic appearance (Fig. 1).

This was an age of new ways of looking: at the world, the self and the human relationship to the natural environment. All spheres of human activity and thought were examined afresh. Inevitably there were those who were invigorated by change and those who retreated from it. This was encouraged by innumerable new organisations and institutions, whether educational, social, religious, political or industrial, as well as the changes to the European map. It could be justifiably argued that there was a shift towards a *zeitgeist* that was dominated by an un-precedented feeling of understanding and confidence with regard to the human condition and environment. There was a strong sense that mankind was coming to terms with life, that the Gothic notion that we live in a world surrounded by the fantastic, unknowable, incomprehensible and mysterious was being chipped

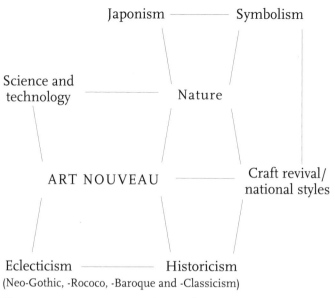

Fig. 1 *Art Nouveau*: sources and interrelations

away. Yet, as a counterpoint, there was also a reaction against positivism, against empirical knowledge and the signs of western materialist progress. A sense of antipathy led to reversion to lost traditions and forgotten cultures, an aversion to the Europeanisation of the world and its emphasis on mercantilist capitalism. Despite such duality, the new worldviews shared a sense of discovery, a new identity for the self and a love of some kind of movement. The first would envisage the supreme, Darwinian *Homo sapiens*, in control of nature and able to exploit it in order to attain a more comfortable and longer life. The second preferred man in harmony with nature, comprised of the same stuff.

The burgeoning of the numerous developments in material and intellectual culture meant that European man and woman suddenly had a startling array of spiritual, political and social choice in front of them. This stimulated a variety of reactions, that could waver between conflict, confidence, comprehension and confusion. But this array also meant that it appeared that mankind was on the verge of becoming superhuman – not only capable of understanding the elements of nature, but also of conquering and manipulating them in order to transcend them in some way. Hence, the rush to climb mountains and reach the poles; the urge to flight – to leave the earth; the urge to travel at speed; and the urge to further scientific discovery.

Art Nouveau encapsulated almost all the facets of newness that abounded in the Europeanised world in the 1890s and 1900s. This helps explain its contradictions and ambiguities as well as its stylistic and regional variations. With its artists aware that the old worldviews were being revoked, discredited, or at least challenged, the movement took sustenance from the current theories of physical, political and social science; the spate of application of these theories in practice – inventions; and the dissemination of literature on 'other' cultures and religions. They were informed by the immense popularisation of science, ideas and alternative worlds that was channelled through a greatly extended variety of newspapers, magazines and books and a greatly expanded network of museums

and intellectual associations. And so in many respects their art was a response to the variety of products of the late nineteenth-century European mind and culture that significantly affected existing models of the way the world works (see Chronology).

The era was the first in which the advantages and dangers of modern materialist capitalism were being consistently revealed and addressed. For Art Nouveau artists this could mean an absorption into the material world, expressed through the creation of beautiful decorative art and luxury items, with rare or exotic materials, expressing high craftsmanship, ingenuity and uniqueness. Or, aided by the new technologies, it could mean the suppression of such qualities, as well as the subjugation of the material and its decoration, in favour of new forms of unified art and architecture. It could also mean the rejection of visual appearances in favour of an art of spiritual or material essences. And it could be a combination of skilful exploitation of the material, imbued with a sense of mysticism, and placed within the internal space of an Art Nouveau *gesamtkunstwerk*. Further, the different trends of Art Nouveau were frequently united by the formal evocation of motion, as if in accordance with the increasing awareness of the state of flux that comprised the world. This as opposed to the earlier concentration on producing something that solely purported to stability and solidity.

Nature and science

With such varied responses to the world it is possible to include under the Art Nouveau umbrella extremely diverse artists. A unifying characteristic was simplification of forms for the sake of a more organic art. Occasionally, for some, like the Pont Aven group, Gallén and Bílek this could mean primitivisation. Or, as shown by the work of the Nabis, Wyspiański or Shekhtel, it could mean the rendition of natural rhythms. For others it could be combined with the use of the latest technology in order to create objects of new refinement. Among these can be included Toulouse-Lautrec and Mucha, with their mastery of colour lithography, or Horta and Guimard with their extravagant use of curved iron.

With so many current theories about the synthetic nature of reality and the world beyond our vision, it was not surprising to find artists creating hybrid forms representative of no particular organism. This helps explain why Art Nouveau often delved into the grotesque, producing fantastic Chimeras, as Endell did on the facade of the Elvira Studio in Munich. Such fabulous, hybrid forms were also to be created by Gaudí for the Gate of the Finca Güell, and by Lalique in his dragonfly brooch for Sarah Bernhardt.

Endell substantiated the abstractions seen in his art, and so in much Art Nouveau, through theoretical publications. He wrote not only of creating art forms that represent nothing, but also of the immense power natural forms may have if the perception is opened to them:

... he who has never been delighted by the exquisite bendings of the blade of grass, by the wonderful inflexibility of the thistle, the austere youthfulness of the sprouting leafbuds – who has never been gripped by the powerful form of a tree root, the stolid power of the cracked bark, the slender flexibility of the birch trunk, the great calm of broad masses of leaves, and stirred to the depths of his soul, he still knows nothing about the beauty of forms.[5]

So, although true art for many Art Nouveau artists was the creation of forms united

in ways distinct from those of nature, it nevertheless was to be dependent on a feeling for nature, an understanding of its rhythms, its organic potential and means.

The new knowledge that Endell required for art could be acquired not only from direct observation but also from popular scientific books like those of Ernst Haeckel and Wilhelm Bölsche, as well as from the new circulation of plant microphotography. Informed by such sources the artist could more assuredly incorporate the laws of nature into his products. Hence a pedestal stand by Serrurier-Bovy reflected and used the tensile elasticity of plant forms. Artists like Van de Velde and Pankok studied the ideas being propagated about the limits of elasticity, the breaking point of plant stems, their mechanical efficiency, their stress and load-bearing qualities and transferred this to their objects. They also studied, indirectly, the marine life, a realm which was bountifully reproduced in the popular science literature. This included many asexual organisms, halfway between plant and animal that often had qualities of phosphorence; Gallé's vases can seem to phosphoresce, hence perhaps his use of marine forms – fish scales, shells, molluscs.

Motion and the machine
The sense of infinite variation, infinite movement and the lack of solidity and opaqueness of the sea made it an inevitable source for the modern artist. But the sensation of growth and the understanding that the plant state is never rigid but one where touching, shaking and changing are fundamental to growth, also meant that many were also drawn to life below, on and above the ground. Motion, whether that of the sea, the earth, or the air, was to absorb Art Nouveau artists. Spurred on by the 'soaring grace' and modernity of the Eiffel Tower and Gallery of Machines at the 1889 Paris exhibition, many took a constructive approach based on the new scientific discoveries. Suddenly aesthetic design was to be unified with the science of flight. Eiffel promoted this as much through his iron embodiment of the modern urge to leave the world as his contribution to aeronautics, that is his experiments in air resistance, velocity, aerodynamic balance and streamlining. His research was part of the race to heavier-than-air flight which was to see the establishment of aviation societies, aeronautical exhibitions, patents for wings, Lilienthal's study of thrust, and piloted aircraft finally taking off from the ground, all in the space of forty years (1863–1903).

The implications this held for art were immense. The traditional horizontal viewpoint taken from just above the ground was now open to challenge: increasingly birdseye viewpoints began to appear, as in Somov's and Bonnard's paintings, this in turn encouraging, or coinciding with, a flattening and generalisation of forms and colour blocks. Wings of flying creatures or their effect began to abound as motifs – as in Guimard's Paris Metro stations.

The expression of directional lines of force was to become popular, this in part explaining the frequency with which the spiky iris appeared as a symbol for the new art movement. Often, however, the lines could be abstracted from organic nature, more evocative of the vital state of dynamic tension, of ascension and descension, lift and gravity, this having been suggested by Christopher Dresser in his early studies of ornament. Such forms were to be found in the designs of Horta, Behrens, Klimt and Moser. A similar abstract dynamism was also to be used to convey, not just a sensation of force but also of speed, this in accordance with research into solids of least resistance – hence Art Nouveau was to be nicknamed the Yachting Style by Goncourt after he had experienced the flowing forms of Van

de Velde on display at Bing's gallery. Hence also the abstract evocation of fluid movement in the work of numerous Art Nouveau artists from Barcelona to Moscow.

National identity

The forms of Art Nouveau apparently pertain to universalities: to the laws and varieties of nature, to the underlying rhythmic forces of life, to abstract geometricism or curvilinearity – the interplays of line and colour, colour and void. Yet these could also be manipulated so as to represent individual responses to the perception of the realities of nature. These, while focusing on the perceived qualities of unity and synthesis which can often give an impression of internationalism, also contain shades of subjectivism, the denial of absolutes and varying degrees of egotism, exhibitionism, nationalism, patriotism and racism.

So although Art Nouveau can be viewed as the scientification and de-personalisation of art, as being concerned with the suppression of the artist's identity in favour of archetypal stylisation, it is more complex than this. Much depended not just on the artistic temperament of the designer but also on the cultural and physical environment in which he or she worked. Few worked in isolated conditions of stability and wealth, impervious to the changes transforming the society or community to which they belonged. Art Nouveau production created a visual counterpart to the social dialectics of the period. It arose out of the desire for renewal, for an art that would correspond to the movements of the times; and essentially for a new art, burgeoning with the visions of vernacular revivalism or romanticism, that could be instilled with the spirit of modernity and relevance.

The respect paid to medieval values, to honest craftsmanship, truth to nature, and the call to reinvest the material environment with beauty and quality, particularly by artists of the English Aesthetic and Arts and Crafts Movements in the 1870s and 1880s, encouraged artists throughout Europe to plumb their local traditions and surroundings. As a consequence overtones of nationalism, or at least of an attempt to construct something of a National Style, are frequently present in Art Nouveau. On the continent this aspect was given extra impetus by the volatile political situation in many of the regions, and the increasingly competitive tinge of European capitalism and imperialism as a whole. Hence the national traits to be found in the work of such artist-designers as Doménech, Vrubel, Saarinen, Kriesch and Majorelle. In all of these any sense of truth to nature or medieval traditions, whether for the sake of political goals or not, contained an element of falsification. For the artists connected with Art Nouveau, the means and aims of such manufacture were investigated anew. Thus their manipulation of inanimate or dead matter in order that it take on the form of organic nature saw a freeing up from the constraints of convention: be that iron twisted into the shape of a plant tendril; colour dyes applied to paper to give the effect of flight or running water; or steel, glass, masonry, concrete, ceramics and wood combined to create a building whose contours defy the stable ground on which it is built and whose affectation of a co-ordinated organicism need not correspond with the actual organic activity within it. Likewise, the simulation of medieval values within a mercantilist-dominated society far removed from the cultures-of-yore constituted a sham, often romantic, which extracted from tradition those elements which suited the limited, contemporary goals of the artists and their clients, while only being possible due to the wealth-making organisation of late nineteenth-century European society.

Nationalism or, indeed, racism, could be less explicit, more a subtext. Those countries, regions or artists vying to show themselves at the forefront of the modern machine age, could strive to show their embrace of modernity in an original way, deliberately avoiding recourse to tradition. Alternatively, they could seek to express the intellectual superiority of their ethnic group, or themselves, through the highly skilled manipulation of rare, exotic and expensive materials or through images of men and women in touch with higher orders of reality. Belgium stands out as an example, Art Nouveau becoming the favoured face of a new nation for which a distinctive architecture was a nationalistic imperative. As Brussels' special style, it expressed energy and verve. Its patriotism conjoined with individualism and supranationalism, as seen in Hoffmann's Palais Stoclet and Hankar's Hôtel Veuve Ciamberlani, their disparate combination a defining characteristic of the new movement.

Politics and culture

In the years 1890–1910 the political map of Europe was as much in a state of flux as the ways and views of life contained therein (see map). Wars and treaties between nations coupled with centralised, autocratic empires and increasing political awareness meant states of unrest. Ruled from Berlin, the German Reich covered northern central Europe as far east as Königsberg, as far west as Alsace-Lorraine. Poland had disappeared. Sweden controlled Norway. Italy, a collection of mini-states, had just become a united kingdom; as had Belgium. Russia governed Estonia, Latvia, Lithuania, Finland and much of old Poland; and the Austrian empire of the Habsburgs covered Hungary, Transylvania, Bohemia, Galicia, Slavonia and Bosnia. Much of the Balkans was under the Turks.

The ferment was furthered by access to new colonial wealth, particularly that derived from Africa, not being shared equally around. The provinces and the workers of the metropolises were often deprived. And could understand they were so. Signs of the luxury and comfort of society's upper echelons were on display – in glamorous, expensive shops, and in the suburban and country homes, with their rare, opulent, handcrafted objects made from all kinds of hitherto unseen materials. The display was made all the more emphatic by the new possibilities, brought by the expansion of railways, to see it. And envy, admire or purchase it.

Rivalries arose. Between empires, their provinces, ethnic groups and layers of society. They were fed by the new range of political ideologies, this including conservatism, liberalism, socialism, anarchism and nationalism. Nurtured by a wave of self-assertion among the repressed and the repressors, these ideologies could be the outcome of new values being applied to threatened indigenous cultures. In some instances these derived from policies of appeasement, in others from genuine interests in the survival of traditions. One result was folk revivalism or romanticism: a pan-European promotion of the distinctly local. Another was supranationalism, fanned by the new mesh of human interaction as well as new views of equality and biological identity. Both found their way into Art Nouveau, this being a form of primal exegesis of the complicated moment.

The situation can be briefly elucidated by focusing on developments in the largest European empires and their integration with the rest of the continent. The diversity of Art Nouveau production in the regions under Austrian control is indicative of the stop-gap flexibility of the Habsburg system and the vicissitudes of its government. It is also derived from the ethnic and cultural variety within the Habsburg lands. Assertion of this variety occurred in response to the diminishment of the German majority in the central European Habsburg holdings, a result of earlier losses of territory (notably Silesia) to Prussia; the subsequent imposition of German as the official language across the remaining provinces; the centralisation of the bureaucracy; and the growth of liberalism and nationalism. While liberalism was to be particularly attractive to the German-speaking Austrian bourgeoisie, the national minorities, in particular the Hungarians, Czechs and Jews, and after their annexation, the Ruthenians (Ukrainians) and Poles, were to become increasingly vociferous in their quest for recognition. In the forefront of the politically conscious non-Germans, were Hungarians, though a significant proportion of these were also committed to the Magyarisation of the ethnic minorities within their kingdom. As an alternative, the Czech national awakening led to the idea of Austro-slavism, which envisaged the autonomous organisation of the Slavs within a multinational Habsburg empire, much as the Catalan regionalists' emerging concept of national recognition within Spain.

When faced with increasing strains within the empire that threatened its very survival, the absolutist Emperor Franz Josef undertook constitutional reorganisation which showed sensitivity to both liberal and national standpoints. A parliament, the *Reichsrat*, was established with limited powers and less accountability to the people; political parties and workers' associations were allowed. Yet he could not prevent the Prussian assumption of German leadership in 1866 and the subsequent unification of German states (following that of Italy), with Austria excluded, under a nationalist regime. Nor could he sustain central control over Hungary, which, through the *Ausgleich* (Compromise) Agreement of 1867 became a separate unit within a dual Habsburg monarchy. Such developments led to further tensions, not least because they raised the level of national awareness among the numerous other peoples of the empire, the non-Germans and non-Hungarians, who actually represented over half the total population. Towards the end of the century the picture was further complicated by increasing German national awareness in Austria. This was coaxed into life by both loss of status and privilege at home and the exclusion from the consolidating greater German state, which from 1888 had its own emperor, Kaiser Wilhelm, the Hohenzollern king of Prussia. National conflict proved harshest in the Bohemian lands where the Czechs, who were the second largest national group in Austria, were actually in the majority. Their quest for new political rights therefore had the potential to cause the German power-holders most harm.

The Habsburg economy remained agriculture-based, the more so in Hungary and the east. Still the industries of the west, and most notably of Bohemia and Moravia, grew steadily. From 1850 until a crash in 1873 and subsequent depression that was to linger into the 1890s, Austria underwent something of a boom. The early period became known as the *Gründerzeit*, the Founders' age, though it was not only iron-based industries that grew – textiles, chemicals, coal and glass manufacture all saw substantial progress in the Czech regions, while Vienna became the

financial and banking centre of the empire. Development was encouraged by new transportation links such as the Vienna–Trieste railway which gave access to the sea. Industrialisation meant urbanisation, which, in the case of Prague meant its transition from a German city to a Czech one as Czech peasants poured in from the countryside.

The crafts schools

Uniquely for Europe in the late nineteenth century, education in the applied arts was organised by the state in Austria. Established by the Ministry of Commerce and Trade in the 1860s, following the 1873 crash the system was taken over by the Ministry for Culture and Education. By 1900 it consisted of a network of two hundred technical and crafts schools (*Fachschulen*), stretched throughout the Dual Monarchy. The aim was multifold: to raise the level of the industrial arts; assist manufacturers in the training of craftsmen; broaden knowledge of modern techniques and awareness of worldwide traditions; and give workers a useful occupation and a valuable income when working on the land, or indeed in the factory, was no alternative.

The network of *Fachschulen* was set up under the aegis of the Museum of Art and Industry and its school in Vienna, with kindred museums and Applied Arts (*Kunstgewerbe*) schools in Prague, Brünn (Brno) and Lemberg (Lviv). These schools were responsible for teacher training, an annual collective exhibition of the schools' work and the design and distribution of new patterns. This state system of arts education proved to be of prime significance for the development of regions' versions of Art Nouveau. Taking into consideration local traditions and using the local tongue as the language of education, the schools included those which specialised in ceramics, embroidery, basket weaving, carpet-making, glass manufacture, jewellery, cabinet-making and all kinds of smithery. The most successful proved to be in Bohemia, such as the cabinetmaking schools at Königsberg and Chrudim; the ceramics schools at Teplitz (Bechyne) and Steinschönau; the Warnsdorf weaving school; the jewellery schools at Gablonz and Turnau; the metalwork school at Königgrätz (Hradec Králové); the stone-cutting school at Horic; and the lace-making school at Graslitz. Not that the other regions missed out, for there was an important woodcarving and sculpture school at Zakopane (Poland), a ceramics school at Znaim (Moravia), and in Austria a leading cabinet-making school at Bozen as well as several important lace-making schools.

Extraordinarily pragmatic, the *Fachschule* curriculums promoted technical mastery coincidentally with theoretical and commercial understanding, the direct observation of local nature and a Ruskinian joy in, and ennoblement through, work. Such a system ensured a revival of the arts of the regions, the more so since von Scala, the state inspector, also introduced the '*Wandercurse*' whereby *Fachschule* teachers were sent to isolated villages, together with travelling libraries and exhibitions, and new technology, to help revitalise their local crafts. But it also served to modernise urban art production. For through its acceptance of foreign and female students, its dissemination of the latest literature and art journals from around the continent, its encouragement of trade in local products in the larger centres, and its sending of the best students to those urban centres to complete their education or to work, it was to have a marked, and not necessarily provincialising, effect on the character of modern Austrian art.[6]

The peculiar political circumstance of Hungary within the Austrian empire, that is the authority it had over its own affairs, is most akin to that of Finland within the Russian empire. The degree of autonomy attained by these two regions hints at a common bond between them and a cultural identity clearly distinct from that of their governors. This bond was to be most vitally expressed in the vocabulary and forms of the national style in the plastic arts of both peoples in the 1890s and 1900s. Indeed, of all the regions of eastern Europe it was Hungary and Finland which were to produce the strongest variants of vernacularist Art Nouveau. The striving for cultural expression was encouraged by the variety of ethnic groups within their borders; the strength of their pagan culture, the longevity of their peasant economies, feudal systems and small handicrafts industries; central government policy; and the deeply imbedded insecurity they felt in relation to their neighbours, whether rulers or ex-rulers.

In fact, both the Magyars and the Suomi people originated from the northern Urals, and being pastoral folk had gradually migrated west. Their languages, akin to that of the Samoyeds on the Arctic coast where Europe joins Asia, belonged to different branches of the same family – Finno-Ugric, within the Uralic. In the late nineteenth century, in both the new capitals, Budapest and Helsingfors (Helsinki), numerous organisations were established to research into the etymology of the languages and the ethnography of the peoples, related journals were published, and scholars and artists travelled between the countries eager to rejuvenate their ancient roots.[7]

THE ROMANOV EMPIRE

At the end of the nineteenth century the Russian Romanov empire stretched west along both shores of the Baltic, south to Transcaucasia to borders with Turkey, and east across Asia to the Pacific. It was the largest multinational European state. Besides Russians, its ethnic European peoples including the Suomi, Karelians, Estonians, Latvians, Lithuanians, White Russians, Ukrainians, Georgians, Armenians, Moldovans, Poles, Germans, Jews and many other smaller nations. This mixture, combined with the vast scale of the country and the size of its population, held great implications for the development of modern art, not least its widespread proliferation, variegated appearance and peculiarities of function.

The capital of the centralised Tsarist autocracy, St Petersburg, was on the Baltic coast. It was a relatively new metropolis and a vital symbol of the Russian search for a modern identity. The emergence of Russian Art Nouveau, the New Style (*novyy stil'*) or Modern Style (*Stil' Modern*) as it became known, was to be characterised by both the desire for integration with the cultures to the west and the readiness to assert a unique, distinctly Russian, identity. The two sides frequently clashed, not just in the artistic arena, but generally in the intellectual and with it the political. In many respects this was the same liberalism versus nationalism argument that was raging across Europe. The New Style was to be a lively forum for the airing of shades of the debate. It was to provide evidence that most activity actually lay between the three extremes of out-and-out westernisers, pan-Slavists and Russophiles.

Social change in contemporary Russia was phenomenal. Capital flooded in to the major cities through the exploitation of the expanding empire's vast mineral wealth, the development of the railway system (it reached Tashkent in 1898), rapid industrialisation, export trade and the growth of banking and other credit institu-

tions. Alliances with France and Austria meant that Russian business thrived. Urbanisation followed suit. Both St Petersburg and Moscow were among the six largest European cities by 1900, with their populations more than doubling over the previous forty years to reach around one million.

Ideas, science and the arts also thrived in this hotbed of frantic development. As did mass poverty, atrocious living and educational standards, brutal autocratism, anti-semitism and the degradation of rural traditions. Anarchism, nationalism, mysticism, behaviourism, medicine, biology, electro-technology, physics – including aerodynamics and heavier-than-air flight, chemistry, sociology, orientalism, music, literature and folklore studies, were but a few of the fields in which Russia began to excel. The country possessed an unparalleled wealth of material to draw on, huge amounts of money to fund the intellectual pursuits, and a glut of original minds and enthusiasts whose list of contributions to the pursuits was second to none.

New institutions and societies ensured the flow of ideas, although the persuasions of the governing classes often meant a slant of their activities towards a unified 'all-Russian' identity. Such a slant was to be felt, for instance, in societies concerned with ethnography, preservation of antiquities or archaeology, some of which were associated with the arts institutions. Dominating the latter were the Academy of Arts, the Stroganov Art and Industrial Institute (Moscow), the Stieglitz School of Technical Drawing, the Civil Engineers' Institute and the Drawing School of the Imperial Society for the Encouragement of the Arts (St Petersburg).[8] Under the aegis of the Imperial Society, Russia's first Applied Arts Museum was established in 1870, design competitions were held annually and numerous exhibitions and lectures were organised.[9] The privately funded Stroganov Institute and Stieglitz School complemented this work with similar activities and museums, their artists producing many New Style products in fields as diverse as majolica, woodcarving, graphic art, textile design, stained glass, metalwork, theatre decoration, ceramics and leatherwork. These institutions were to attract students from across the Russian empire and send forth to the provinces graduates as teachers and practitioners proficient in the New Style.

CULTURAL TRANSFERENCE

The wealth of the Russian elite – the entrepreneurs, the aristocracy and the royal family, brought about a new, symbiotic cultural transference in Europe. Each group funded arts education and acted as patrons to the new generation of artists, often sending them abroad for further studies. Each also collected avidly, stretching their clutching tentacles deep into western Europe, particularly in France, where their patronage was to be of high significance to the development of the contemporary arts, as well as to Persia, Mongolia, Siberia, Egypt and China. Many, like Pavel Tretyakov, Count Kushelev-Bezborodko and Tsar Alexander III, made their collections available to artists, scholars and the public. In addition, aided by the comprehensive railway network linking the European cultural centres, artists, musicians, dramatists and dancers moved between states with increasing frequency and effect. The art they brought with them inevitably spilled over into that of the centre they visited, as well as those centres serving to influence the art of the visitors. The trend was towards internationalism, to the expression of universal truths comprehensible to all, but coloured with romantic and individual tinges of the vernacular or the exotic.

The artistic interchange was marked by the participation of Russians in the Paris salons, the Munich and Viennese Secessions, the tours of the *Ballet Russe*, the arrival of Isadora Duncan, Jaques-Dalcroze, Strindberg, Saint-Saëns, Denis, *Theatre Libre*, Gustav Mahler, Edward Gordon Craig and many others in Russia. Translators were busier than ever – Zola, Baudelaire, Maeterlinck, Wilde, Verlaine rapidly appeared in Russian; Dostoevsky, Solovyov and Tolstoy in French and English. In the visual arts, many Russian, Czech and Hungarian artists settled or studied in Paris; others travelled to the Slovenian Anton Azbè's school in Munich, or to Vienna.

In many respects the movement of artists and development of the art to which they contributed reflected the international pedigree of the European monarchs, not least the Romanov kinship with the Hesse-Darmstadt dynasty and the British royal family. Their desire for trans-European influence undoubtedly contributed to the symbiotic character of the arts.[10] An illustration of this was to be found in the Darmstadt Mathildenhöhe artists' colony of Grand Duke Ernst Ludwig, brother of Alexandra, the Russian Tsarina. While the modernist colony included a Russian Orthodox Cathedral, following its creation the Russian New Style went through a phase of response to the austere, simplified styles of Voysey, Mackintosh and Olbrich, as well as to the more decorative, rustic style of Baillie Scott to be found in Darmstadt. In fact the process had started even earlier, for in 1896 Grand Duke Boris Vladimirovich's mansion at Tsarskoye Selo near St Petersburg was designed in the half-timbered English style reminiscent of Baillie Scott and furnished by the London retailers Maples.[11]

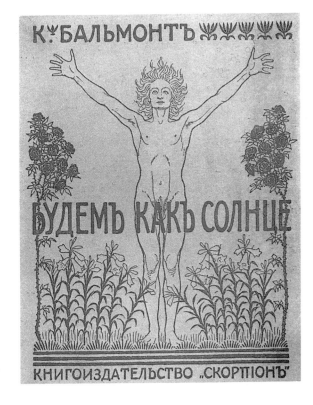

1 Fidus, *We'll be like the sun*, Moscow, 1903

Royal influence in Russia went further. The Tsar's brother Grand Duke Vladimir Aleksandrovich, president of the Academy of Arts and a sponsor for Diaghilev's ventures, was married to Princess Maria of Mecklenburg-Schwerin, the leading Petersburg hostess for artistic circles. In the 1890s Grand Duchess Elizaveta Fyodorovna of Hesse-Darmstadt, Ernst Ludwig's elder sister and the Tsar Nikolay's sister-in-law, was patron of the Moscow *Kustar* (Craft) Industries Museum.[12] She was also to be patron of the seminal Moscow exhibition of 'Architecture and applied arts of the New Style' organised in 1902, which brought together leading European designers such as Kotěra, Olbrich, Mackintosh, Margaret Macdonald and Korovin. Thus, directed from on high, prevailed the synthesis of ancient and modern and the desire for material and spiritual beautification.

The movements in the arts had their counterparts in industry, science, political thought, commerce and the other components of mass culture.[13] The large Russian diaspora and the west Europeans in Russia, ensured the dissemination of ideas in both directions. As did the mass circulation of newspapers, new magazines, international scientific conferences and congresses, joint enterprises and exhibitions of industry and art. Quite simply, the age was characterised by this new trans-continental flow. So, while the Petersburg electrical technologist Pavel Yablochkov was lighting up the streets of London, western firms were altering the face of Russia. Those with huge interests, factories and influence there included the American rubber company Triangle (co-owned by the Russians), the sewing machine manufacturer Singer, the Nobel brothers oil company, Kodak, Daimler, and the House of Cartier. Starley, the Coventry bicycle manufacturers had branches stretching across Russia and Poland, from St Petersburg to Kharkov, and from Warsaw to Irkutsk. Jakob and Joseph Kohn, the Viennese furniture manufacturers of *Wiener Werkstätte* designs had sales outlets in Moscow, St. Petersburg, Kiev, Warsaw, and Rostov on Don. And the leading Parisian Art Nouveau jewellers Boucheron opened a branch in Moscow, patronised by the Romanovs.

Elsewhere, science and literature were popularised by such publishers as 'Enlightenment' (*Prosveshcheniye*), a joint Russian–German enterprise, founded in St Petersburg in 1896. Besides encyclopaedias and the standard classic and contemporary authors, they also published Ernst Haeckel's *Kunstformen der Natur* in Russian translation, shortly after its appearance in Leipzig. Further, the Moscow symbolist publishing house *Skorpion* (Scorpio), was to publish Konstantin Balmont's most ecstaticist, narcissistic collection of poetry *We'll be like the Sun* (*Budem kak solntsem*) (1903) (Plate 1) with a cover by Fidus (Hugo Höppener), the *Jugend* illustrator and follower of the racist, anti-progressive 'back-to-nature' life reformer Julius Langbehn. It depicts a naked, youthful Aryan superhuman, his head framed by sun-like hair and his arms stretched aloft in equanimous transcendence of the earth's materiality.

Notes

1 *The Magazine of Art*, 1904 vol. 2, pp. 209ff.
2 A typical source of this was N. Pevsner, *The Pioneers of Modern Fesign*, London, 1972.
3 See D. Silverman, *Art Nouveau in Fin-de-siècle France*, Berkeley, 1992.
4 See S. Tschudi Madsen, *The Sources of Art Nouveau*, New York, 1976; S. Wichmann, *Jugendstil Art Nouveau. Floral and Functional forms*, Boston, 1984; M. Amaya, *Art Nouveau*, 1985; K.-J. Sembach, *Art Nouveau*, Cologne, 1991; A. Duncan, *Art Nouveau*,

London, 1994. One of the more valuable attempts at definition is R. Schmutzler, *Art Nouveau*, London, 1977.

5 A. Endell, *Um die Schönheit*, Munich, 1896.

6 For a contemporary examination of the *Fachschule* system, see A. S. Levetus, 'The Craft Schools of Austria', *The Studio*, 1905, vol. 35, pp. 201-19.

7 Among those who travelled to Hungary from Finland were the artist Gallén and architect Saarinen. Gallén visited Gödöllő and Budapest in 1907, at the time of an exhibition of modern Finnish art in the Hungarian capital. Among those who went to Finland, was the Neo-Magyar architect, sculptor and designer Géza Maróti, who maintained close contact with Saarinen, visiting him at Hvitträsk during from the mid-1900s. Finno-Ugric studies were commenced at Pest University in 1872 and a Finno-Ugric Society established in Helsingfors in 1883.

8 Teachers at the latter, whose curriculum was similar to that of other European design schools, included the Latvian Jēkabs Belzēns and Nikolay Roerich, both prominent New Style artists.

9 In 1900 the architect Aleksandr Uspensky lectured on the architecture of Voysey and Baillie Scott at the Society.

10 The tremendously influential Russian Finance Minister (1892–1903) Sergey Witte, himself of Dutch origins, also played a vital role in this – not least through his sponsorship of Russian celebrations of industrial achievement – e.g. the exhibitions at Nizhny Novgorod in 1896 and Glasgow 1901.

11 Enigmatically the English architects are only known as 'Scott and Sherborne'. Baillie Scott designed a house for 'Russian clients' in Poland, 1903–4.

12 The Grand Duchess was wife of the Tsar's brother, the anti-semitic Grand Duke Sergey Aleksandrovich, Governor-General of Moscow.

13 For instance, the Lumières' *cinématographe* was shown in St Petersburg, Moscow and Nizhny Novgorod in 1896.

I

FRANCE

Paris and Nancy

Background

The initiatior of the term 'Art Nouveau', the proprietor of the Parisian gallery *L'Art Nouveau*, Samuel Bing, as well as the leading proponent of the movement in the French capital, Hector Guimard, both provided important indicators for its definition. Bing, who opened *L'Art Nouveau* in 1895, said of his use of the term that it was conceived with no generic intentions but was simply the name of an enterprise

opened as a meeting ground for all ardent young spirits anxious to manifest the modernness of their tendencies, and open also to all lovers of art who desired to see the working of the hitherto unrevealed forces of our day ... this aim ... to which it tended ... would be indicated more clearly – if the name of an establishment could extend to the length of a phrase – by the denomination: *Le Renouveau dans l'art* – the Revival of Art.[1]

This vague assertion of appropriateness to the modern age and revivalist spirit was in practice to evolve into a more sharply focused design aesthetic, encouraged by Bing's establishment of his own workshop. For this he advocated the following of three simple principles: a level of sobriety, the primacy of function, and harmonies of colour and line. He also tried to place his initiative in an historical context and through so doing invoked some of the sources of French Art Nouveau – namely, the 'grace, elegance, sound logic and purity' of French eighteenth-century art – the Rococo.

Such picking up of the threads of a lost national tradition was of prime importance for Guimard, whose guiding principles showed remarkable similarity to Bing's:

1. Logic – the suiting of the object to its purpose. 2. Harmony – the suiting of the object to its place. 3. Sentiment – the emotional complement to logic and harmony which sets the object apart as a work of art.[2]

In 1902 Guimard placed himself, together with the Belgian innovators Horta and Van de Velde, in the vanguard of the movement that followed these precepts. At the same time he acknowledged that there were many imitators, particularly in Germany, Austria and France, who lacked both taste and soul, and who were erroneously labelled as Art Nouveau producers. Again he stressed recourse to national tradition and response to the age as vital requirements for the new style:

A style of architecture, in order to be true, must be the product of the soil where it exists and of the period which needs it. The principles of the middle ages and those of the

nineteenth century, added to my doctrine, should supply us with a foundation for a French Renaissance and an entirely new style. [3]

The national content in French Art Nouveau was encouraged by defeat in the Franco-Prussian war in 1870–71; a long recession triggered by liberal, free market economic policies; and then in the late 1880s and 1890s a recovery, urged on by a new patriotic striving, that saw the rebuilding and development of the cities, the economy and the local pride. And so just as the introduction of tariffs as protection for French industry meant an abandonment of international free trade, so the search for a modern style in art entered a new nationalistic phase. This had many faces and determinants, among which were three primary factors: the desire for a new art, freed from historical restraints and conventions; an expression of unrivalled cosmopolitanism; and the overtly national exploitation of Neo-Rococo, local flora, fauna and anti-Prussian epithets.

These forms of nationalism in French Art Nouveau can be highly distinct from one another or they can be merged. In any case they constitute a single movement that, despite its disparateness, was united in its attempt to move art, and in particular French art, forward, to raise the level of the arts and to draw attention to them. The same applies in the other countries and in many respects it accounts for the apparently contradictory, eclectic use of historicist styles, as well as the rejection of historicism. In addition, it helps explain the multifarious elements of extravagance and simplification; symbolism and formalism; the erotic and the depersonalised; the automated and the individual; the vernacular and the oriental; truth to nature and stylisation. The presence of these dichotomies of content within one movement has meant that Art Nouveau can be perceived as both a decorative art movement and an intellectual one. However, since it often reverts to the sensual in order to effect an emotional response its philosophical side is frequently overlooked.

Nevertheless such varieties mean that consideration of French Art Nouveau can include creations as diverse as the Nabis' decorative work where the emphasis appeared to be on new formal *and* symbolist concerns, the metropolitan art of Toulouse-Lautrec, the cosmopolitan 'Style Mucha', the distinctly international Bing's *L'Art Nouveau*, the organic, sometimes Neo-Rococo, creations of Guimard, Lalique and de Feure and the sculptural depictions of the sensational American dancer Loïe Fuller in full flight.

Appearance

The Nabis, while predominantly French, were a loose affiliation of artists of various nationalities. They came together in 1889, most having been students at the Académie Julian in Paris. In 1894 they were among the first artists commissioned by Bing to establish the universalist image of his soon-to-be-opened *L'Art Nouveau* gallery. Searching for a new aestheticisation of art they employed various formal principles, including flattened space, birdseye viewpoints, large blocks of colour, heavy contours, Japonist division of the surface and depersonalised figures. This indicated their rejection of academic styles and their promotion of something distinctly modern. Their art would beautify the material environment without recourse to trivial representation of visual nature or anecdotal narrative. The approach implied an anti-bourgeois establishment stance, although their art was

generally unpoliticised.

Of primary significance to Denis, Bonnard, Lacombe, Ranson, Maillol and their associates was the abolition of the hierarchy of the arts, the rejection of the pre-eminence of painting and the establishment of unity whereby a painting could be primarily decorative, a tapestry could be sensual and a woodcarving or vase could be symbolist or spiritual. Thus they worked as painters, graphic artists, sculptors, tapestry designers, ceramicists, stage designers (for the radical Théâtre de l'Oeuvre and Théâtre Libre) and interior decorators. Their universalism was undoubtedly inspired by Gauguin and Bernard, who, from the late 1880s, started to create furniture and ceramics with simple motifs abstracted from nature or the human figure, often with a Japonist sense of refinement and a Breton subject matter. This combination of internationalism and regionalism was to be present in the Nabis, notably through Maurice Denis' recourse to Breton subjects with their lyrical colourism and cloisonnism. But Denis' work almost always held a note of spirituality; a sense of the transience of life and the rhythmic cycles of nature being conveyed in his wan, weightless females figures set within stylised landscapes. Such spirituality and provincialism is less apparent in Paul Ranson, who tended to fuse his figures with their surroundings to a greater extent. In his perpetually flowing, serpentine lines, nothing rests, everything is synthesised in process, suggesting a more pantheistic conception of the unity of matter. Such features characterised much of his mid-1890s work, be that a tapestry design (Plate 2), an ink drawing, a wall panel or a fabric design for Bing's *L'Art Nouveau*.

The rhythmic, metamorphic movement found in Denis' and Ranson's work was a distinguishing feature of other Nabis, several of whom revealed it through a penchant for images of the sea and waves. These included Georges Lacombe who in 1893 painted the cliffs near Camaret as if they had human features, and the Catalan Aristide Maillol, whose contemporary *The Wave* depicted a colour-reso-nant swirl of organic nature in the midst of which was a recumbent female nude.

Rhythmic movement was also to be a recurrent feature of Toulouse-Lautrec's more urban art. It was to be found, for instance, in his lithographs of Loïe Fuller (1893), where the dancer was transformed into an organic ethereal swirl in mid-air, an appearance that suggested, like William Nicholson's contemporary print, flight, iridescent butterflies, orchids and spiritual apparitions. However, his preference for images of well-known figures in the new Parisian entertainment industry, such as the cabaret singer Aristide Bruant and the dancer Jane Avril (Plate 3), was usu-ally expressed with greater concern for their personal features. As such he was responding more directly to the bourgeois marketing of the working class and implicitly supporting the changes being wrought on French social life by the middle-class establishment. Still he employed similar formal principles to the Nabis, such as Japonist effects, flattened figures, silhouettes, and bold colour blocks combined to create a musical composition. These he made deliberately eye-catching, and by so doing indicated the French leadership of the field of modern graphic design. Through Toulouse-Lautrec's aestheticisation of the poster such commercial, momentary art was raised to the level of fine art – a fact which was to find resonance throughout the continent.

MUCHA

The leading exponent of Art Nouveau poster work was the Moravian Alfons Mucha, who had arrived in Paris in 1887. After studying at the Académies Julian

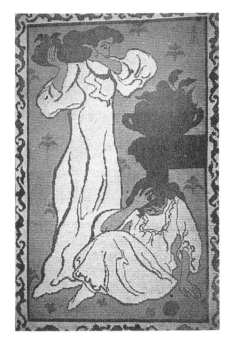
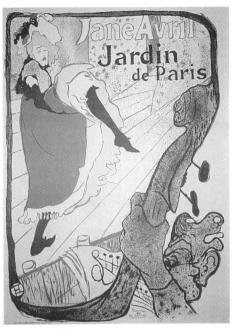

2 Ranson, *Women combing their hair*, design for a tapestry, 1892
3 *right*] Toulouse-Lautrec, *Jane Avril*, poster, 1893, colour lithograph

and Colarossi, where he became friendly with Gauguin, the Nabis, Ślewiński and Wyspiański, his career in Paris was to see him establish the 'Style Mucha' as something of a synonym for French Art Nouveau. He was the embodiment of the Art Nouveau synthetist – practising almost all the arts, including architectural design and photography, fusing the spiritual with the material, fine with commercial art, socialism with elitism, the ideal with the real, the universal with the national, the eastern with the western, the Christian with the pagan, the ancient with the modern. All in a quest for the beautiful.

Such many-sided aestheticism was to be particularly felt in Mucha's contributions to architectural projects, not least those concerned with the Paris 1900 exhibition. These included the decoration of the vernacularist Bosnia-Herzegovina pavilion,[4] a poster and carpet for the Austrian pavilion (the latter with his familiar wheels of life and vivacious Indo-Celtic-Japanese filigree patterns), and the design of a projected Pavilion for Mankind for the Paris 1900 exhibition. At the same time he also designed a new shop for the leading Parisian jeweller Georges Fouquet, for whom, at the 1900 show, he created numerous winning jewellery designs, as well as display cases.

For the Bosnia pavilion Mucha toured the Balkans in 1899 studying the folk art, traditions, costumes and people. The result was his first major Slavist composition, with allegorical frescos depicting Ottoman oppression, Sarajevo and the wealth of Bosnia, as well as embroidery and sculpture.[5] On the other hand his Pavilion for Mankind, though similarly idealised, was more fanciful and universalist: a manifestation of his belief in cosmic harmony and integration, of the need for man to feel the primal forces active in the world and thereby raise his consciousness to higher, more enlightened levels. Sketches reveal a massive global

19

structure with large concave circular entrances adorned with extended crescent-shaped architraves covered in murals symbolising life. Straight lines are all but banished, creating a feeling of eternal flux and dynamism. This was heightened by the exaggerated proportions of the architraves (cf. Shekhtel's Mining pavilion at Glasgow the following year) and the integral sculptures which reflect man's evolution from lowly matter to supplicating creature and finally to a winged, heavenly spirit fleeing the earth's bounds (cf. Obrist's *Design for a Monument*).

Although the Pavilion for Mankind remained unrealised, some of its features were to be found in Mucha's design of the Fouquet jewellery shop. For the front he created a bronze central panel depicting, in relief, a nine-foot semi-naked maiden enveloped by tresses of hair and drapery that flow in S-shaped curves and which are combined with looped pieces of jewellery. Another touch was a frieze of ten stained glass panels, nine of which were square, depicting fashionable female beauties. Inside, the salesroom was fitted out in a menagerie of Art Nouveau organic motifs that blended the Rococo with the Byzantine – turquoise tendril mouldings on the ceiling, peacocks, snakes, floral stained glass, budding forms, shells, reptiles, nymphs aspiring to the heavens, off-centre circle-within-circle designs and a swirling crescent-shaped fireplace reminiscent of the Mankind Pavilion's entrances.[6]

Mucha only worked for Fouquet from 1899 to 1901, but during that time he made a serious impact on the image of the jeweller's work. Simultaneously employed was the designer Charles Desrosiers who excelled in natural motifs such as orchids, butterflies and other delicate flowers and insects. Fouquet himself preferred marine life for the forms of his ornaments: algae, shells, seaweed, coral. However, Mucha was not afraid to combine and stylise fantastic and natural motifs, nor to transcend current conventions concerning jewellery attire. Thus his designs included elaborate corsage and shoulder ornaments, pendants and brooches, many with his favoured series of mystical crescents and circles, wings unattached to bodies and alluring images of young women.[7] One of the most striking examples of his work was the combined gold serpent bracelet and ring he designed for Sarah Bernhardt and which Fouquet made in 1899. Here the snake coiled around the wrist, its tail extending up the arm, its winged head, set with a mosaic of enamel, opals, rubies and diamonds, resting on the back of the hand. It was linked by a series of chains to another 'snake', this a finger ring, its head turned to face that of the bracelet. The piece was given extra flexibility by a discrete system of hinges which allowed movement of the hand.

The overall effect of the serpent bracelet was one of ominous Oriental antiquity. Indeed, a bracelet of similar form, and which almost certainly inspired the commission, was to appear in Mucha's poster for Sarah Bernhardt's 1898 performance of 'Médée' at the *Théâtre de la Renaissance* (Colour plate 1). This was his fifth poster for the actress and it showed her in the title role of the new verse drama by Catulle Mendès based on Euripides' 'Medea'. Medea is a princess from Colchis at the eastern end of the Black Sea, a land of fabulous wealth and sorcery to which Jason had sailed in search of the Golden Fleece. However, it was also a land of passion and barbarism and so when Jason leaves Medea for a Corinthian princess, she poisons her rival and murders the sons she herself has had by Jason. Mucha depicts Bernhardt as the veiled princess with blood-stained knife and sorceric bracelet, standing above one of the boys she has just slain. The moment of tragedy is conveyed by the mute gaze with inflamed eyes and the body enswathed in

crumpled drapery like a withered leaf. Medea stands before a simplified ochre landscape, her head enhaloed by the rings of the sun. Although the format is elongated vertically, many of the stylistic features, including the lettering enveloped by Byzantine mosaic patterns, recall von Stück.

While the Médée poster was the most effective of the posters Mucha designed for Bernhardt, the others utilised similar stylisations and format, starting from 'Gismonda' in 1895, through 'La Dame aux Camélias', 'Lorenzaccio' (both 1896), 'La Samaritaine' (1897), 'Hamlet' and 'La Tosca' (both 1899).[8] These kept to the elongated vertical format with central Sarah Bernhardt as *femme* (or *homme*) *fatale* surrounded by stylised decorative motifs that mostly derived from the ambience of the drama – be that Byzantine, Rococo, Gothic or Judaic. Often the actress, now over fifty, was recognisable despite her youthful looks. She was depicted standing above small figures, or symbols, of those loved ones who had been their victims of torment, jealousy or murder. Though usually contained in separate panels the two would be connected by a foot or a robe extended over the frame.

Despite the simplifications and stylisations of form in Mucha's theatre posters, they remained intricately detailed and softly coloured with numerous small broken masses of gold and silver – the obverse of the minimalist tendencies of the Beggarstaff brothers' posters with their huge blocks of colour screaming the message. Further, Mucha retained elements of naturalism, most notably in the illusion of volume and shading of the figures. Such a combination of the idealised and real was to characterise much of his other work of the late 1890s, this extending

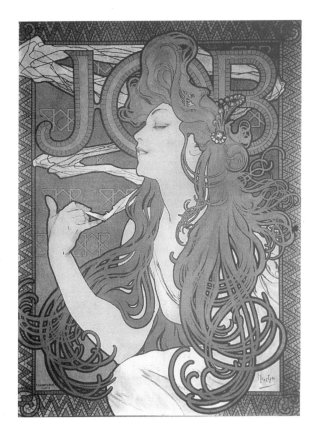

4 Mucha, *Job cigarette papers*, poster, 1896, colour lithograph

from posters and other graphic art to the design of *objets d'art*. In this he employed virtually the whole arsenal of Art Nouveau motifs and methods. In addition, for the production of his graphic work he most frequently used the Parisian printers Champenois who were renowned for their use of the latest and most refined lithographic techniques. And he designed for a spectrum of typical new patrons and their products – Nestlé's baby foods, Waverley cycles, Carmichael's Luxuria bath tablets, Job cigarette papers, the Monaco-Monte Carlo railway company, Cassan Fils printers, La Trappistine liqueurs, Moët and Chandon champagne, Lefèvre-Utile biscuits, new magazines, exhibiting societies, art schools, calendar and book publishers. Such commercial art engendered a formulaic response – his personal signature was to be instantly recognisable in the lyrical evocation of femininity; the delicate eroticism of the heavy eyelids; the gentle, subdued colouring; the cloisonnist outlining; the sensual and contemplative poses; the flat trusses of hair; the secular haloes; the air of mysticism and spirituality in the wafting arabesques of stars or the geometricised background letterings, as in the Job advertisement (Plate 4). Sometimes there could be multiple evocations of the product without it actually being present – as in the Monaco-Monte Carlo raliway poster with its dreamy young woman set amidst a swirl of botanic wheels. Here, the floral spoked wheel which acts as her halo is complete with birds. This is the closest Mucha gets to suggestion of industry with its correspondence to the convention of winged wheels as symbols of the railway. Further, the location is also suggested – this through the wave and algae-like forms of some of the plants superimposed on the picture surface and the curving coastal scene of the background.

Often Mucha would subtly vary the degree of his sensualism and mysticism commensurate with the type of product or patron being objectified. Thus his poster for the socialist *Société Populaire des Beaux-Arts* (1897) showed a sweet, almost shy, nymph leaning on a camera and being gazed upon by the realistically portrayed photographer, while that for the more esoteric symbolist group, the *Salon des Cent* (1896), portrays a figure in a greater state of undress with eyes closed and holding a brush, quill and ceramic object. From these emanate a meandering flow of stars and vapour that end up encircling the maiden's head like some kind of immaterial headdress. Perhaps surprisingly the effect of the latter is strikingly similar to that of his first poster for Job cigarette papers, both betraying a feeling for altered states of consciousness that can be induced through the medium of the wares being offered.

Release from the material into the spiritual were constant concerns of Mucha. This was frequently expressed by a relapse into lyricism, inspired no doubt by the lyre music that, through some kind of mechanical system attached to the door, began to play when the artist entered his studio. This could be sentimental, as revealed in his designs of lithographic sets – on subjects such as the arts, flowers, times of the day, seasons, months, precious stones, hairstyles, the stars. Some of which would be turned into screen decorations, wall panels, postcards or quickly reproduced and widely disseminated in magazines. Without exception Mucha stuck to his formula of scantily dressed young females in stylised natural settings for these cycles. Aided by the technological advances being made in French lithographic printing he was able to imbue individual works with distinctive tonal qualities appropriate to their themes. Frequently employing Japonist techniques in the evocation of nature this art was virtually an archetypal response to the association of woman with nature and the emotions.

If anything there was a greater sense of deconstruction of convention in Mucha's more overtly spiritualist work. This was evident in his design for the Pavilion for Mankind, but it was also to be evinced in several designs which purported to occult and esoteric traditions. Soon after his arrival in Paris he had become involved in experiments with hypnosis, extra-sensory perception and auto-suggestion, and acquainted himself with theosophy and Rosicrucianism. As a consequence he was not content to restrict his art to superficial commercialism that through its euphoric portrayal of arcadian purity and innocence lacked spiritual depth or the application of critical motifs. Indeed he imbued whole sections of his work with symbolist undercurrents that suggested paths to enlightenment and transcendence of the material through the raising of human consciousness to higher, cosmic levels. Sometimes he hinted at this by his inclusion of religious symbols in his posters, as in his zodiac calendar which ended up as a poster for 'Cachou de Luxe New Breath Perfume – Healthful, Agreeable and Portable'.

But in some instances his imagery was a direct response to religious feeling, as in his edition of *The Lord's Prayer* (*Le Pater*) (1899) with its variety of anthropo-morphised and effervescent, elemental images of cosmic forces. The cover of the book adopted the stylisations of most of the illustrations within: geometric motifs based on eight-pointed stars interlaced with circles. The dominant image was that of a cosmic naked maiden enveloped in a swirl of tresses, head held aloft and right arm holding a humble, miniature female human being. The figure is crossed by the title, the script of which, like much of Mucha's lettering, being stylised in such a way as to suggest a Romanicised version of Kufic writing. The seven smaller stars contained symbols such as the knowing eye, a garland of thorns and a serpent. Seven appears as a crucial number in the work, relating to the seven petitions of the prayer and the sevenfold path to enlightenment of Buddhism and other religions. Indeed, the absence of images of Christ from the book, together with the use of crescent moon symbols, progressive circles and eastern-type script, suggests an altogether Gnostic or Cabbalistic approach to the Christian prayer, this in keeping with many of the spiritual movements of the day.

Ultimately Mucha realised a more profound expression of his convictions than his commercial art suggested. And this was to be effectively commuted from religious symbolism to national romanticism and criticism. Indeed, the latter made its appearance in the cycle 'The Seven Cardinal Sins' (1897–99, lost), sketches for which were shown at the *Salon des Cents* in 1897. Contemporary critics found it 'a highly philosophical and social work ... (that shows) the deplorable con-dition of mankind, uncovers its secrets, its crimes, its physical and moral pain and the fateful consequences of passion'.[9] Thus Mucha's work proved more than the debasement of symbolist art which it could so easily have been considered. Rather, its syncretism, like that of so much Art Nouveau, moved symbolism on, brought it into contact with the machine age and provided a bridge between elitest trends and art for mass consumption.

THE OTHERS

French Art Nouveau consistently strove to express universals, this in keeping with its cosmopolitan 'nationalism' and its favouring of the feminised world of Rococo. In many respects the diverse work of the Dutchman Georges de Feure encapsu-lated this. For it included symbolist paintings and prints with stylised, misogynistic images of grotesque *femme fatale* figures set in a medley of brightly

coloured flowers, devil figures, burdened men and Gothic architecture. Many of these elements were found in *The gardens of Armida*, with its updated rendition of the Renaissance epic study of irresistibly voluptuous witchery.[10] Here, instead of a Saracen girl enchanting crusaders in her luxurious pleasure grounds, de Feure depicts in exaggerated profile four young women in modern dress, accompanied by symbolic hunting dog, roses and a freed bird as they amble through their park amidst numerous signs of ill-omen – threatening clouds, thorns, cut saplings and a statue of a cross-bearing male figure cut off by the picture edge. Thus feminine beauty is identified with the maleficent, all-consuming power of transmutating nature. On the other hand, the delicate, sensual gilded Neo-Rococo furniture and fittings in his various installations designed for Samuel Bing around the turn of the century (Plate 5) revealed a more soothing femininity. Produced in accordance with Bing's ideals of reflecting the spirit of French elegance and refinement while being essentially modern, the pleasing curves of abstract organic nature and the subtly harmonised colour schemes that dominated the boudoirs and dressing rooms, echoed those of fellow Bing designers Eugène Gaillard and the Italian Edouard Colonna.

The jeweller and glassmaker René Lalique also catered for an international market and employed a Rococo sensitivity to refined feminine nature.[11] By imbuing his dragonfly brooches, peacock clasps, wasps pins, fish buckles, grasshopper diadems and serpent handbags with unprecedented realism and attention to detail Lalique denied various 'Art Nouveau' conventions (Plate 6). However, his refined, Japonist sense of nature, his recurrent use of female motifs, including Medusas, nudes, nymphs, fairies, dancers, many with stylised arabesques of hair, as well as kisses, swans, flight, sea organisms, androgynous and hybrid figures align him with the movement. As does his evocation of atmosphere through the use of iridescence, translucence and milky moonlight. Such characteristics indicate the appropriateness of his participation in Bing's opening *L'Art Nouveau* exhibition in 1895. Further, the craftsmanship of his works, together with his use of unconventional materials and experimental enamelling techniques, was to signify new French preeminence in jewellery design, just as Gallé's manipulation of glass and Louis Majorelle's of wood and metal, were to indicate the resurgence of French design in those fields.

During his Paris period (1877–1913), the Finn Villé Vallgren established himself as one of the leading sculptors active in France. One critic assessed his significance thus:

In all probability Vallgren could be considered the creator of the decorative *objet d'art* in France and abroad. He has established a school at the annual Salons of the *Société nationale des Beaux-Arts* of Paris, just as at the ones of the Viennese Secession. But few of the sculptors can aspire to his originality or talent.[12]

Sensing the persuasions of the day, both locally and across Europe, Vallgren both appealed to international taste and helped to define it. His sculpture was a product and reflection of the vicissitudes of the *fin-de-siècle*: it could possess a classical serenity and refinement of form, a Neo-Rococo stylisation of nature, a primitivist treatment of provincial subject matter, a symbolist evocation of the mysterious, or an Art Nouveau love of female beauty and its synthesis with flowing, organic movement. He also occasionally expressed his roots through Finnish subjects: such as the tragic maiden *Aino* (1889) and portraits of his famous compatriots, e.g. the

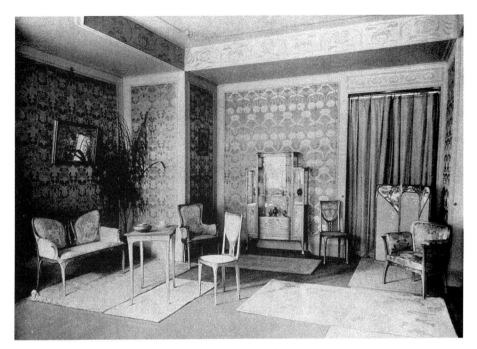

5 De Feure, Drawing room installation, *L'Art Nouveau*, Paris, 1900

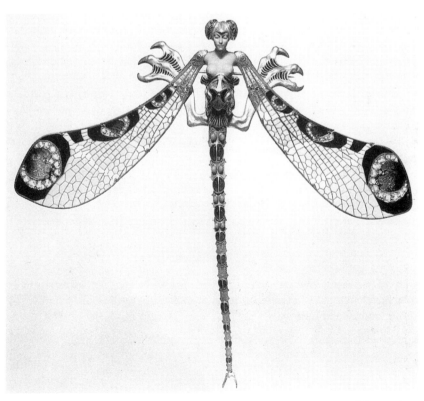

6 Lalique, *Dragonfly* brooch, *c.* 1898, gold, enamel, chrysoprase, moonstones and diamonds, 27 x 26.5

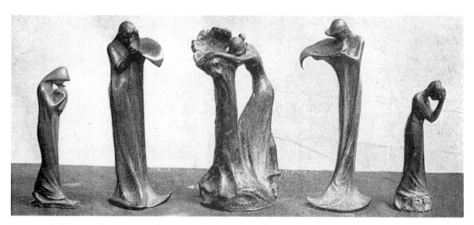

7 Vallgren, *The Widow, Girl Flowers, The Weeper*, five statuettes, c. 1897, bronze

painter Albert Edelfelt or Mikael Agricola, the head of the Reformation in Finland and father of Finnish literature.

Vallgren was recognised primarily for his statuettes and small metal vessels and fittings (Plate 7). His search for beauty and essential truth meant that he could exhibit these at the *Rose et Croix* salons, *L'Art Nouveau*, the *Salons du Champs de Mars*, as well as the Exhibitions of Finnish Artists in Helsingfors and international shows across the continent (from the World of Art to the Viennese Secession). Often he strove to express inner human feelings and the affinity of mankind and nature. With conventional gender casting, the female and the feminine form were used to symbolise all kinds of emotions, the link with 'mother Earth', regeneration and beauty. Thus we find 'grief', 'youth', 'despair', 'contemplation', 'curiosity', 'pride', 'luxury', 'misery', 'consolation' and 'blindness' all expressed through simple, slender, beautiful young female figures given evocative poses and gestures. Frequently the figures, nude or clad in flowing drapery given diaphanous effect, blend with the ground from which they spring or with flowers, shells or flames. Sometimes the fusion is such that the figure appears hybrid, neither flower nor nymph, but both.

Vallgren belongs fully to the sensual tradition of Art Nouveau, his use of arabesques extending to Neo-Rococo inspired electric chandeliers and light fittings for Bing's salon. While these show clear similarities with Joseph Chéret's lighting designs, his sculpture indicates an affinity with Alexandre Charpentier's use of the feminine beauty, but develops it towards a more intimist, generalised form in which detail is omitted in favour of suggestive gesture, this anticipating that seen in Lalique and Mucha. As such he was one of the main instigators of the French Art Nouveau style in the fields of sculpture and metalwork, his works, as was noted by his contemporaries, expressing great sensitivity, as well as an inventiveness with regard to technique:

he moulds flowers into fruit-dishes, twists leafy tendrils round the handles of spoons and adapts poppies to the bolts and handles of a glass case ... A door knocker represents the figure of a suppliant, with hands uplifted to the barred glass panel, behind which a drama may be imagined; she strikes with all the weight of her supple body, which ends, siren-like, in drapery that clings to her feet and finishes in a flower, the whole admirably proportioned. *Consolation* is a group of two figures closely clasped in an eternal

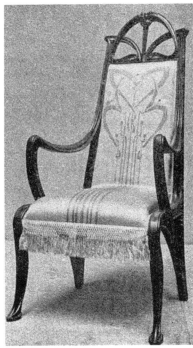

8 Guimard, Castel Henriette, Sèvres (destroyed), 1899–1900
9 *right*] Majorelle, Armchair, 1900, walnut and textile

embrace – an almost painful grip; in spite of their nudity exquisitely chaste, a pure kiss of souls ... a chimney place where women-flowers spread their skirts like fragrant petals, and their tiny feet, like pistils, scarcely touch the ground. Vallgren gets a patina on his bronzes of amazing brilliancy and vivid richness, shaded off by some process, from verdigris green to a rosy tint, through all the tones of gold.[13]

None of the above designers, like their counterparts in architecture, sought the recreation of French national traditions, but rather their appropriate and selective incorporation into what was to be a fundamentally modern, French idiom. Hence, the touches of Baroque and Rococo in Guimard's Castel Béranger, the Paris Métros and the Humbert de Romans building, mixing with something that is at once original, Japonist, evocative of flight, of bones, of plant tendrils, of abstract dynamism – without adherence to any convention or style. Hence also Guimard's modern interpretation of the medieval and vernacular in his suburban villas, such as Castel Henriette in Sèvres (Plate 8) and Castel Orgeval at Villemoisson. It is not by chance that Lalique's hybrid dragonfly brooch with green female head and great griffin claws designed for Sarah Bernhardt in 1897–98 has large diaphanous, veined wings that evoke a similar sense of flight to the iron and glass canopies of Guimard's Métro entrances. Nor does it appear coincidence that the brooch resembled a study in fluid dynamics through its evocation of lift and drag tension created by the oppositional V-shaped direction of the wings and claws. For increasing revelation of the laws of physics, not least by Gustave Eiffel and his tower built for the 1889 Paris exhibition, was increasingly leading artists, designers and architects to simulate the abstract forces and motions that constituted the world.

The sensation of flow and energy was to be expressed, for example, in numerous glass vases by the Lorrainian Gallé. But there were more parallels between Parisian and Nancy products of Art Nouveau than the refined presentation of nature as an inevitably transformatory process. These included the use of the Rococo, and in particular the association of seductive feminine beauty with that of flowers witnessed in the Baudelairian paintings of de Feure and vases of Emile Gallé. However, in the work of Gallé, who had studied botany from an early age, this combined with unprecedented freedom from formal and functional constraint. Vases need no longer hold flowers, bowls need not contain fruit, for they were complete in themselves as objects for contemplation and the beautification of the home, this through the introduction of aspects of organic nature metamorphised into the static objects.[14] Such a concept was taken up by the Daum brothers in their totally decorative glass flowers (*fleurs-corolles*). The Daums, like Majorelle in his furniture designs (Plate 9), remained more concerned with the creation of beautiful objects than imparting any latent meaning to those objects. So although they did use local flora and fauna for their art, they did so less consistently than Gallé whose patriotism was overtly stated, together, as he delved deep into the workings of the psyche and his own mortality, with his individual form of symbolism.

Gallé, Majorelle, the Daums, along with Victor Prouvé, Jacques Gruber and others, formed the core of the Nancy school, representatives of the Lorrainian movement in the visual arts that appeared as a result of the anti-Gallophile policies of the Germans in the occupied parts of Lorraine. Seeking to excel in all fields, the artists developed from a primarily eighteenth-century Rococo-revivalist spirit, to a deliberately indigenous vocabulary and on to an overtly modern one – experimenting with Japonism; pantheistic, sexual and morbid symbolism; scientific discoveries; and with rare or new materials and techniques. Gallé's delving into these new realms was to result in, for example, a glass bowl of iridescent swirling colours and amorphous forms created with his own hot-pressing technique *marqueterie de verre*; an iron and blown glass table lamp in the shape of ink cap mushrooms in three stages of growth; and a fruitwood bed with veneered and mosaic apparitions of moths. These and the rest of his mature work suggested his concern with mysterious, inner experiences as well as a sensitive appreciation of the fragility and synthetic character of the multi-faceted eco-system which sustains life.

Largely as a result of Gallé's approach the applied arts in France were imbued with new psychological effect, and this was to correspond to developments in architecture, primarily in the buildings of Guimard, but also Henri Sauvage who designed Majorelle's villa in Nancy (1901–2), Plumet and Selmersheim, Lavirotte and Jourdain. The Villa Majorelle was given an asymmetrical plan, with interior function and spatial arrangement reflected on the exterior – through projections, balconies, bays and recesses; articulation of masses; and distribution of windows of varying shapes and sizes. The effect was organic, this being complemented by the plastic treatment accorded the chimney stacks, canopies, railings and the curvilinear window traverses. Most importantly, the villa was a collaborative *gesamtkunstwerk*, with every detail closely co-ordinated according to a rationalised design system. Without recourse to any historicist style, the vibrant-life effect created by the ensemble of Gruber stained glass, Prouvé murals, Alexandre Bigot ceramics and Majorelle metal- and woodwork, was at once medievalist and and ultra-modern. It was a short, but ostensibly contradictory, step from this form of

elitest functionalism to Sauvage's other major commissions – rationalist tenements for Parisian workers and bourgeoisie. These, such as that built for the Société Anonyme des Logements Hygiéniques à Bon Marché (1904), most emphatically revealed the Art Nouveau architect's sensibility to new construction techniques and materials (particularly reinforced concrete), social activities, hygiene, finish, as well as 'style'.

While 'style' in Sauvage's work was characterised by structural and decorative harmony and restraint, such integration and lack of excess was often neglected in the more exuberant Paris tenements created by Jules Lavirotte. The most shocking of these was the openly sexual block on Avenue Rapp, though here the erotic symbolism of the facade was echoed in the ground floor plan with its phallic distribution of the court, entrance hall and stairwells. Bravura of a more socially acceptable kind was provided by Frantz Jourdain in his La Samaritaine department store (1905–8), and even by the extravagant Guimard. Still, Guimard's indulgence in multifarious whiplash curves, did see him treat wood, for instance, as if it was iron, bending it beyond the logic of construction purely for the sake of continuity and show of plasticity. While appearing to deny his principles of logic such incidences of exhibitionism were usually integral to an overall scheme that sought, through the careful selection of materials and flowing, linear motifs, to evoke a feeling of unified, organic rhythm. In the case of the seminal Castel Béranger (1894–98), a low-cost speculative tenement block, this enabled it to become a highly effective 'shanty de luxe '.[15]

Notes

1 *The Architectural Record*, vol. 12, 1902, reproduced in I. Latham (ed.), *New Free Style*, special issue of *Architectural Design*, 1/2, 1980.
2 *Ibid.*
3 *Ibid.*
4 Bosnia-Herzegovina had come under Austrian suzerainty in 1879, although it remained nominally part of the Turkish empire until being annexed by the Habsburgs until 1908.
5 Mucha's post-1900 enthusiasm for Slavic themes stemmed from this Balkan project, during the creation of which he appears to have become intensely anti-Turk. He was subsequently to work on a massive *Slav Epic* painting cycle and to create several posters for Bohemian and Moravian events, using a medley of local archetypal motifs, e.g. for the exhibitions of industry, trade, art and ethnography in Hořice and Vyškov (1902-3), and Ivancice (1912); and the Moravian Teachers' Choir (1911).
6 The interior has been recreated in the Musée Carnavalet, Paris.
7 In 1902 Mucha published many of his designs in an album *Documents décoratifs*, Paris. This contained 72 plates giving examples of his style, not only in jewellery, but also graphic art and household items. It was followed in 1905 by an album *Figures décoratifs* which detailed his approach to the female figure.
8 Mucha also made a sketch for a 'Princess lointaine' poster (1895).
9 Cited from T. Vlček, 'National Sensualism: Czech Fin-de-siècle Art', in Pynsent (ed.), *Intellectuals and the Future in the Habsburg Monarchy*, London, 1988, p. 113.
10 The late Renaissance poet Torquato Tasso had provided the image, subsequently taken up by Rossini and Gluck in their operas, in his *Gerusalemme liberata* (1581). De Feure produced at least one more pictorial equivalent of Armida and her ability to rise up in the face of Christian opposition – *Woman Damned* (1897), reproduced in I. Millman, *Georges de Feure 1868–1943*, Amsterdam, 1993, p. 52.
11 Lalique's clients included the French actress Sarah Bernhardt, the Armenian oil-leasing millionaire Calouste Gulbenkian and Baron Stieglitz, owner of the most important Rus-

sian training ground for decorative artists, the Stieglitz School of Technical Drawing in St Petersburg. Concerning Lalique, see V. Becker, *The Jewellery of René Lalique*, London, 1987.

12 Cited in L. Forrer, *Biographical Dictionary of Medallists*, vol. 6, London, 1916, p. 189.
13 B. Karageorgevitch, 'Vallgren; Artificer and Sculptor', The Magazine of Art, 1898, pp. 219–20.
14 Concerning Gallé, see P. Garner, *Emile Gallé*, London, 1990.
15 Concerning Guimard, see G. Naylor and Y. Brunhammer, *Hector Guimard*, London, 1978 and *Guimard*, Musée d'Orsay exhibition catalogue, Paris, 1992.

2

BELGIUM
Brussels and Liège

Background

In 1901 the leading promoter of modern art in Belgium, Octave Maus, declared that the new Belgian movement was morally-inspired, national and seminal for the continent as a whole:

In the last few years the decorative and industrial arts have undergone a change in Belgium – an evolution rapid and radical that bears witness to the advance of culture in the nation. They spring from the soul of the people, their roots are planted in its daily life, they respond to its aspirations. The principal aim is the beautifying of the objects of daily and practical use and the tasteful decoration of the home. One thing is indisput-able, and that is that within ten years Belgium has revealed such originality in the industrial arts that France and Germany alike have borrowed from her largely. The movement had its origin at Brussels, and expanded throughout Belgium; nor was it long before it crossed the frontiers and impressed foreigners with what has very deserv-edly been called 'the Belgian Style'.[1]

It was undoubtedly the case that in the last two decades of the nineteenth century France's greatest rival for the leadership of modern art in Europe was Belgium, and in particular the city of Brussels. The Belgian role in the development of Art Nouveau was crucial. Further, the development of Art Nouveau was regarded as a nationalistic imperative for the country – which sought a new face for a newly created nation. As Brussels' special style it was the sign of the new capital. Express-ing energy, verve and leadership, the movement was far from a manifestation of decadence. Still nationalism conjoined with individualism, the union being expressed through patronage of leaders of the new international movement be they Belgian or otherwise. This was witnessed in Paul Hankar's Hôtel Ciamberlani (1897) and Josef Hoffmann's and the Wiener Werkstätte's Palais Stoclet (1905–11).[2]

Representing Belgium's prominence as an industrial and imperial power, the advance of Art Nouveau had much in common with that of France and so it is unsurprising to find many principles being shared: cosmopolitanism, modern-ism, symbolism, recourse to underlying natural laws and their evocation through a variety of arts. Many also saw in it a practical, middle way forward in the face of political extremes, although in distinction to France there was more widespread backing from the industrial sector. A central concern was the abandonment of the particular in favour of a new search for universals. Hence the new literature by Maeterlinck and Verhaeren with its emphasis on mood and suggestion; the intro-

spective and morbid painting of Khnopff, Frédéric and Delville; the decorative arts of Lemmen and Finch, with their reflection of abstract organic nature; and the syncretic architecture of Van de Velde and Hankar.

The response to industrial progress, particularly the flair of the Belgian metallurgical industry and its accompanying disregard for workers and the environment, was to be particularly powerfully felt. The expanse of the railway network and the small size of the country kept rural depopulation at bay and served the revival of handcraftsmanship. The population split between Walloons and Flems, that is Dutch and French, together with the international populace of contemporary Brussels, also contributed to the cosmopolitan nature of Belgian Art Nouveau.[3] As did the masonic tendencies of many of the *nouveau riche* patrons and such ideas as 'social energetics', advocated by the millionaire chemical industrialist Ernest Solvay. Based on the notion that the only reality in the world is energy, which unifies matter and spirit, Solvay proposed a state-regulated system of Productivism, whereby those who understand the most efficient and purposeful conversion of energy would be able to reform society for the better, since society comprised only a community of biological beings involved in the transformation of energy. This halfway house between socialism and capitalism, with its rejection of religion and call for social reform, was, despite its dangerous implications for totalitarian dictatorship, to appeal to many intellectuals, not least Belgium's leading architects and artists.

The development of Brussels was rapid and emphatic. It became an increasingly confident city, its middle classes expressing a new feeling of independence, security and wealth. Bourgeois vulgarity flourished. At the same time artistic experiment was encouraged, this hand-in-hand with rebellion against historicism and the conformist approaches of older generations. Literary and arts magazines were founded, among them *L'Art Moderne* and *Van Nu en Straks* (Of Present and Future). The new artistic dialectics proposed a useful form of art to improve social conditions, a lyrical transcendence of material reality, or a truth to Flemish and Walloon origins, nature, life and the spirit of their localities.

The ferment and lack of readily identifiable, integral national culture encouraged Belgian Art Nouveau to take on many forms and features. Its exuberance was felt well beyond the country's borders: artists, poets and writers descended on Brussels from all over the continent, joined its art groups, appeared in its periodicals and exhibitions. The most international of the new art organisations were those established by the lawyer Octave Maus – the *Société des Vingt* (*Les XX*) and *La Libre Esthétique*, with their mutual mouthpiece, *L'Art Moderne*.[4] From the first of these emerged a preference for Neo-Impressionist and Symbolist styles, as well as an early promotion of the applied arts. Between 1891 and 1893 *Les XX*'s exhibitions included ceramics by Gauguin and Finch, posters by Toulouse-Lautrec, screens by Anna Boch and Emile Bernard and a tapestry design by Van de Velde.

Such a freeing of art from established constraints and hierarchies comprised a radical attempt to create a new art responsive to, and representative of, the times. It was *La Libre Esthétique* that proclaimed with particular intensity the social imperative of art, its significance in the raising of both moral and living standards. Hence the new emphasis on the applied arts and synthesis. Its first exhibition, in early 1894, included an international *mélange* with silverware by C. R. Ashbee, tapestries by Maillol, books from William Morris' Kelmscott Press, glass by Gallé, and numerous posters, rugs, bookbindings and ceramics. In addition, there was the installation *Cabinet de travail*, an integrated domestic interior with sober, sim-

ple rustic-inspired oak furniture and fittings by Gustave Serrurier [-Bovy], a designer from Liège. This spawned new ventures, not least other installations by the architects Van de Velde and Horta in the succeeding years. Further, the co-founder of *L'Art Moderne*, Edmond Picard, opened 'La Maison d'art' in his own mansion on Avenue de la Toison d'or in Brussels later in 1894.[5] This was a gallery, given a domestic environment perfectly suited to the new art, where exhibitions, plays, lectures and concerts were put on. Visited by Bing it undoubtedly influenced his plans for *L'Art Nouveau* in Paris. In May 1895 Serrurier followed suit with his organisation of a modern art extravaganza, 'L'Oeuvre artistique', in Liège. This composite, international occasion gave the Glasgow School the chance to make its first impact on the continent.

Appearance

Such activities led many to realise the Belgian leadership in modern design, with artists such as Van de Velde, Lemmen and Finch, being singled out as the 'Argonauts', the direction of their 'adventurous expedition' quickly emancipating architects as well, not least Horta.[6] Examples of Lemmen's graphic art, such as his covers for *Les XX* exhibitions catalogues and *L'Art Moderne*, encapsulated the new approach. As if visualising Solvay's monistic theories, they emphasised the unity

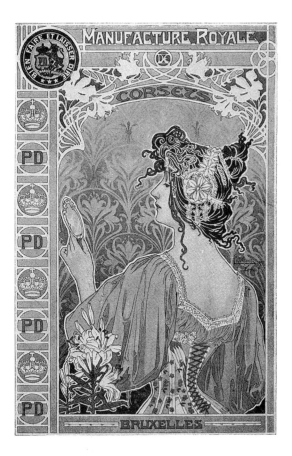

10 Privat-Livemont, *PD corsets*, poster, 1897

of all life, fusing curvilinear vegetal or aquatic forms with their surroundings in an unstable flow of energy. For the 1891 exhibition catalogue Lemmen created an image of Les XX's sun and its rays rising from bold Japonist waves of the earth, its force capable of enlivening and transforming the environment. Likewise, the following year's catalogue saw curling, tentacle-like roots of Les XX's fruit-laden tree spreading out over both the radiating earth and sky, suggesting the universal productivism of the group.

The vitalisation of Belgian graphic art inspired by Lemmen and Les XX produced a strong new wave of poster designers. Prominent among these was Gisbert Combaz who in 1895 designed posters for the Maison d'art featuring flat, simplified images of the red sailboat Argo riding Japonist-styled crests of waves. It was not uncoincidental that the same year Edmond de Goncourt adopted the name the Yachting Style for the new art upon viewing Van de Velde's designs at L'Art Nouveau in 1896. The appropriateness of fluid dynamics to the ideals of the new art and the emphasis the new world was now placing on movement as the basis of life further encouraged this.

With printers in Brussels and Liège, such as O. de Rycker and August Bénard, excelling in their manipulation of the new techniques of colour lithography, Belgian commercial poster design attained unique heights. This was to be seen in the exquisitely refined, alluring images by Privat-Livemont (Plate 10), Fernand Toussaint, Adolphe Crespin and Armand Rassenfosse. Whether for a railway, absinthe, corsets, coffee, electric lighting, a chemical laboratory, exhibitions of art or even Russian shoe oil, the artists exploited the image of the sensuous, beautiful young woman in fashionable dress and with exotic hairstyle. She was shown in a serenely dreamy state amidst swirling plumes of vapour, waves or flowers: the stylised embodiment of temptation by the products of the modern world. While she might be a modern woman revealing new emancipations in fashion or café life, clearly neither patron nor artist saw the function of poster art as lending itself to the depiction of certain positive changes in social status and role for the female sex.

VAN DE VELDE

Perhaps it was partly for this reason that the socialist Henry Van de Velde abandoned reliance on the female figure in his 1897 poster for the Tropon chocolate factory. For here, as elsewhere in his work, he concentrated on abstract curvilinearity, with only a hint that the flowing forms could comprise a pattern of eggs breaking. Such serpentine lines, in repetitive design, were also to be found in his wallpapers, not least that created for the study of his own house, Bloemenwerf, on the outskirts of Brussels. Here, however, they can be read as stamens and leaves topped by buds. It was no coincidence that such musically rhythmic forms should have been made a backdrop to Toulouse-Lautrec's Divan Japonaise poster.[7]

Van de Velde's turn from painting to applied art and architecture symptomised the new attempts to democratise art. However, in seeking to make his own art more relevant to daily life he placed no limits on the world of design – it was to infiltrate all spheres of human life bringing to them an inner logic, harmony, balance and sensation of universal laws. The conception allowed no room for historicism and little scope for decoration based on visual representation. Rather it encouraged an orientation towards the linear – the vital force-line capable of expressing the forms of energy which comprised the world. Everything, from the twisted forms of a candelabrum to the patterns on a Meissen dinner service or a

Reform dress, or from the bentwood forms of his chairs to the billowing designs of his and Georges Lemmen's Smoking Room at *L'Art Nouveau* (Plate 11), expresses motion, is restless, tensile, unstable and lacking in volume.

A simplified, constructive quality indicative of an aspiration towards organic functionalism capable of vivifying the environment characterised Van de Velde's approach. Indeed his organic perception of art meant logical integration – he viewed furniture and fittings as living organs, and rooms as parts of skeletal bodies that when rationally harmonised comprise a vital organism. This was his notion of *gesamtkunstwerk* which allowed the insertion of others' work and machine-made components as long as they contributed to the cohesive effect. Such a scientific notion of art stemmed from his, and other Belgian Art Nouveau artists', late 1880s experimentation with Pointillism. It was to be embodied in many of his installations and interiors for German exhibitions and patrons from 1897 on, not least that for the Dresden exhibition (1897), the Havana Tobacco Company Shop in Berlin (1899), the Folkwang Museum in Hagen (1901) and the Nietzsche Archive in Weimar (1903).[8] All of these united an expression of supple, flowing movement in graceful linear forms with a central concern for convenience and comfort. In none was there any room for extraneous or uncoordinated detail.

Van de Velde's turn to design and the pliant functionalist aesthetic he adopted had much in common with that of Gustave Serrurier. For the Liège architect and craftsman also preferred to emphasise the structural, linear qualities of furniture and metalwork, without the effusion of complex, interlacing patterns or extravagant floral motifs elsewhere associated with Art Nouveau. This meant simplicity, or at least restraint, in order to imbue the work with elemental force. As with Van de Velde, with whom he was on intimate terms from 1893, such an approach overrode national concerns. The result was that, having established a large manufacturing workshop with retail outlets in Liège and Brussels, in 1899 Serrurier opened a shop in Paris; in 1900 he designed the Blue Pavilion, a restaurant and eye-catching exploration of curvilinearity, at the Paris exhibition; and in 1907 opened a branch in Nice. Always marked by superb craftsmanship and clear expression of structure, in the late 1890s his furniture was characterised by a lyrical indulgence in the continuity of line. This allowed taut, 'vegetal' curves to dominate – be it a mahogany bed with splayed headrest or a padouk dresser whose play of convex and concave wooden surfaces was complemented by the curling forms of the metal fittings. While this phase in Serrurier's work can be associated with the attentuated, flowing lines of Mackintosh, other pieces, like his 'Artisan' dining room suite (1898) (Plate 12) expressed a rustic, geometric solidity and practicality akin to that of Voysey and Baillie Scott. In the second half of the 1900s he went further, introducing his so-called 'Silex' furniture for workers with its light but rugged forms and stencil decoration. Here, however, the simplicity and clarity of design was encouraged by a construction-kit approach which allowed the pre-fabrication of certain parts.[9]

HORTA

Victor Horta, the artist most commonly identified with the spirit of Belgian Art Nouveau, also revealed a striking ability to move from ostensibly individualist designs to new symbols of mass culture, as witnessed in his major commissions, from the Hôtel Tassel (1892–93), designed for an engineer who was also a freemason, to the L'Innovation Department Store (1901) and the Maison du Peuple (1896–99), for the Belgian Socialist Party. Influencing his progressive

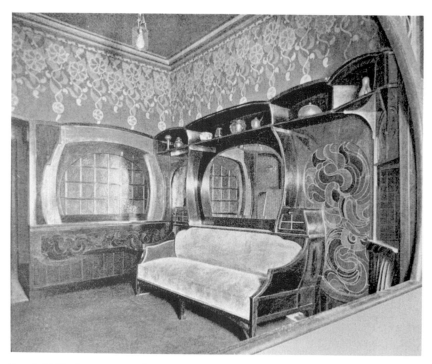

11 Van de Velde, Lemmen, Smoking Room installation, *L'Art Nouveau*, 1895

compatriots, as well as others further afield, his penchant for the linear organic was manifested through the frequent exposure of the tensile qualities of iron. This, combined with extensive use of plate glass, allowed a new freedom in spatial organisation that saw the opening up of many of his interiors.

Horta's seminal Brussels mansions, including the Hôtels Solvay (1894), van Eetvelde (1895–98) and his own house and studio (1898–1900), all relied on the iron-glass combination. Their plans and finish were created to suit the life-style and personality of the occupants, be they geometry professors who worked for Solvay and were avid photographers, as in the case of Tassel, or the Belgian secretary of the Congo Free State, as in the case of van Eetvelde. The stress was always on efficiency and comfort as the means of realising one's potential in accordance with individual rhythms and through appropriate exploitation of resources. The masonic and Solvayian stimulus for this was not chance – both Horta and many of his clients were masons and members of Solvay's circle. The symmetrical plan of the Tassel house was simple, that of the grandiose van Eetvelde, more elaborate, in keeping with its owner's entertaining requirements. All the materials, furnishings and details, including those of the modern heating and ventilation systems, were harmonised. Rooms could interpenetrate one another through the use of movable screens. Aestheticised organic effect was achieved through the combination of glass ceilings, warm apricot hues, light green iron pillars, and a plethora of mosaic, painted and stained glass arabesques suggesting writhing movement. Further, in the van Eetvelde house these were used in unison with stylised motifs based on the flora and fauna of the Congo and with Congolese hardwoods such as mahogany, bilinga and okoume (Plate 13).[10]

12 Serrurier, installation,
Liège, 1898

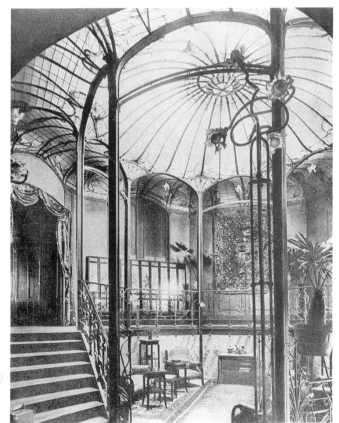

13 Horta, Hôtel van Eetvelde,
4 avenue Palmerston,
Brussels, octagonal hall,
1897–1900

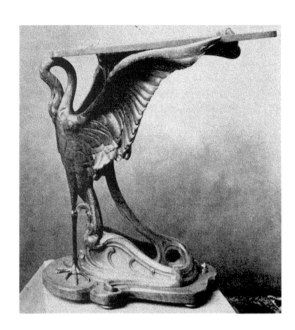

14 Wolfers, Congo album stand,
c. 1899, bronze and oak,
100 x 65 approx.

Endorsement of the Belgian exploitation of the Congo could also be read into
the commission of Hankar, Van de Velde and Serrurier for designs for the Congo
display co-ordinated by van Eetvelde at the Brussels International Exhibition of
1897. Horta's proposal for the pavilion was rejected, as, ultimately, was his plan for
a Congo pavilion at the Paris 1900 exhibition. Symptomatic of a cooling in his
relationship with his influential client, the failure to realise these projects could
also be attributed to his acceptance of the socialist flagship commission – the
Maison du Peuple. This 'People's House' was a symbol of proletarian solidarity:
built, decorated and furnished by co-operatives, it was to be the headquarters of the
worker's party, a place for education, culture, the arts, relaxation and shopping. It
was a huge, light-filled building constructed on a sloping corner site. Horta made
the facade extremely plastic – a long sweeping curve of iron, glass and masonry.
On the ground floor were co-operative shops, ticket offices, a games room and a
large central café. Above came the party offices and conference rooms, and on the
top floor a vast meeting hall whose finely worked out acoustics were to be exploited
for political events, concerts and dramatic productions. The steel framework was
deliberately exposed, in compliance with Horta's desire for structural honesty and
suitability to the client. This was not a suburban 'palace' for a bourgeois family
with pretensions of grandeur, but an urban 'house' where 'light and air would be
the luxury long denied to workers in their slums'.[11] Imbued with his rationalist
aesthetic, while retaining a feeling of the organic in its bold iron curvilinearity, the
simplicity, vigour and dynamism that distinguished Horta's Maison du Peuple
made it a paradigmatic expression of the new age.

Despite his social concerns Horta's collaboration with the political left was
rare. Indeed, rather than building for the underprivileged most of his commis-
sions came from those who benefited from the capitalist state of things, not least
designers and purveyors of luxury goods: he created houses for the ceramicist
Anna Boch and the silversmith and medallist Fernand Dubois, and a shop for the
38 jeweller Philippe Wolfers (Plate 14). These, together with the Val Saint-Lambert

glassware factory, represented the cream of Belgian Art Nouveau in the applied arts. Experimenting with the latest techniques in their various fields, their output was to be singled out by the quality of its craftsmanship and its exquisite, often Japonist, evocation of fragile nature – be that real – as an iris on a Val Saint-Lambert vase, imagined – as a Niké brooch by Wolfers, or abstract – as a candelabrum of writhing entangled lines by Dubois.

Notes

1 O . Maus, 'Decorative Art in Belgium', *The Magazine of Art*, 1901, p. 271–3.
2 Concerning Hankar, see F. Loyer, *Ten Years of Art Nouveau: Paul Hankar. Architect*, Brussels, 1991. Concerning Hoffmann and the Wiener Werkstätte, see below, Chapter 6.
3 The great master of the movement, Victor Horta, was himself the son of a Spanish father and Flemish mother.
4 For an informative study of the groups, see J. Block, 'Les XX and La Libre Esthétique', in *Impressionism to Symbolism: The Belgian Avant-Garde 1880–1900*, exhibition catalogue, Royal Academy of Arts, London, 1994.
5 The siting of the gallery on 'Golden Fleece Avenue', appears to have inspired the use of the Argo as its emblem (see below). While the sailing boat was a pertinent symbol for the new movement, the recourse to Greek mythology, and in particular its association with Pallas Athena who helped build the Argo, was to be most emphatically expressed in the art of the Vienna Secession.
6 See Maus, 'Decorative Art', p. 274. Concerning Finch, see Chapter 11.
7 Contemporary photographs also reveal that Guimard hung the poster against his abstract curvilinear patterned wallpaper in Castel Béranger.
8 Concerning Van de Velde's output, see K.-J. Sembach, *Henry Van de Velde*, London, 1989.
9 Concerning Serrurier, see J.-G. Watelet, *Serrurier-Bovy. From Art Nouveau to Art Déco*, London, 1987.
10 For an informative survey of Horta's work and ideas, see F. Borsi and P. Portoghesi, *Victor Horta*, London, 1991.
11 *Ibid*, p. 68.

3

GERMANY

Munich

Background

When the Munich designer Hermann Obrist showed his embroideries at the second Arts and Crafts Society Exhibition in London in October 1896 their appearance was so striking that *The Studio* critic lapsed into superlatives:

There are few people to whom the embroideries of Obrist will not come as a surprise, for they reveal unsuspected possibilities in an art hitherto accounted trivial, and startle us into taking needlework as serious decoration. Here are great embroideries, greater perhaps than any that have ever been made in Europe.[1]

In fact by the time of the show the German Reich was on the brink of becoming a melting pot of the so-called Jugendstil movement in the arts, a movement of which Obrist's embroidery designs were to be a leading, and highly revealing, manifestation.

Further, Germany was on the verge of following Belgium and France in becoming a magnet for many foreign leaders of the new movement. Among those who were to work there in the next years were Van de Velde, Munch, Gallén, Kandinsky and Baillie Scott. In addition, Germans were to provide patronage for the progressive international art community, not least through such enterprises as Bing's *L'Art Nouveau* and Julius Meier-Graefe's rival gallery *La Maison Moderne* in Paris, as well as their Berlin equivalent the Keller and Reiner Kunstsalon.[2] Indeed, Munich, in which the Swiss-born Obrist was based, was just one of several centres to successfully assert the modernity of their art and intellectual culture at the turn of the century, others being Berlin, Dresden, Hamburg, Darmstadt, Leipzig, Weimar and the northern village of Worpswede.[3]

With a more relaxed approach to censorship laws than elsewhere in Germany, Munich was to attract artists from near and far, this despite the small size of its art market and lack of industrial capital.[4] The Academy and museums had established good reputations from mid-century, encouraged by the patronage of King Ludwig II. However, upon his death in 1886 public money for the arts dwindled and it was the modernisers who were to feel the shortage of patrons and funds most. The 1892 opening of the Munich Secession as a rival to the established Artists' Guild (*Kunstlergenossenschaft*) was symptomatic of the depression and the new tensions it wrought. In addition, it was a reaction to increased competition from other German cities and abroad.

The patronage shortfall proved beneficial for the arts, if primar'' through strengthening artists' resolve to develop new paths. This was seen ´ Munich Secession, which despite a preponderance of weak naturalisr genre painting, promoted the latest European tendencies – ´ ism, Pointillism and the applied arts. Such an approach enc´ ´ssion of previous taboos – be they pent-up sexuality, man's ´ ´ı with the natural world or the promotion of the applied arts i´ ___ ´ setting. Besides its synthesis of styles and media it also concentrated on smaller, more selective and international exhibitions than the Artists' Guild. The international applied arts representation meant, in the years around 1900, the display of installations by Mackintosh and the Macdonalds, a study by Van de Velde, metalwork by Vallgren, jewellery by Lalique and Wolfers, rugs by Lemmen and glassware from Gallé and Tiffany. These were joined by local designers, many of whom had first worked as painters or sculptors, such as Obrist, Endell, Pankok, Riemerschmid, Behrens and Eckmann. Overall there was to be an anti-historicist emphasis on the organic and linear. Through this the Secession broke the stranglehold of conservatism, though the effect was to be mostly felt in the work of other groups, such as the United Workshops for Art in the Handicrafts (*Vereinigte Werkstätten für Kunst im Handwerk*) and Kandinsky's Phalanx Society.

Appearance

The way forward was initially signalled by Franz von Stück, lover of human sensuousness, with full-frontal eroticism in his paintings bawling 'there is no morality in Paradise and art is paradise regained'; designer of his own villa (1897–98), with its homage to the classical vision; and founder of a school whose students were to include Kandinsky, Paul Klee and Fritz Erler. It was Stück who was to select Pallas Athena, the goddess of wisdom, war and patroness of the arts and crafts, as the symbol of the Munich Secession: his poster for the first exhibition (1893) depicted her noble head in profile, crowned by a plumed helmet and set within an octagonal mosaic pattern.

OBRIST
Stück's start was followed by Obrist. In April 1896 he opened an embroidery exhibition at the prestigious Littauer art salon. The advocacy of weaving as fine art and his modern themes caused a sensation. His approach was informed by his earlier study of morphology and monist theories of existence. It established him alongside Gallé as one of the first Art Nouveau artists to conceive the relevance of plant states, and with them the potential of growth and universal flow, for art. He constantly sought to express their tremulous, invisible, vital qualities – be that in a table with four splayed stems rising from root-like forms in a display of tensile strength; a drawing of a starfish, shell or human figure metamorphosing into a flower; a sketch of smouldering fire-flowers; or the writhing, convoluted linear forms of the metalwork on an ottoman or silk stitches on a wall hanging.

Obrist's selection of motifs for the evocation of natural processes and conditions was extremely widespread. He saw the artist's relationship with nature as symbiotic – one in which each side was capable of reflecting the other's characteristics. Further, he did not confine his ideas to visual expression but also conveyed

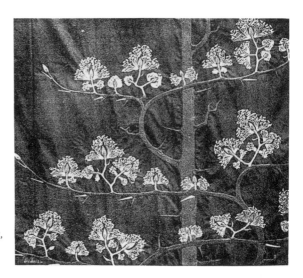

15 Obrist, *Blossoming Tree*,
embroidered wall hanging,
1896, silk on silk rep,
321 x 210

them through his establishment of the Munich Teaching and Experimental
Studios for Applied and Free Art, as well as his writings. In the note 'Ecstatic
Vortex', for example, he synthesised numerous Art Nouveau concerns, such as
movement, flight and essential nature, into an homogeneous set of restless, turbu-
lent and intensely vitalised images:

Dynamic: energies, forces to make visible through strength or weakness of the means.
— Curve intensity/ ... the intensity of convexity, through strengthening of the line,
through/multiplication ... battle, wrestling, encircling maestoso: tornado. Whirlwind.
Cigar glow, cookstove, Andromeda/fog. Spiral funnel of the rudder in water/water
vortex in the washbasin, bat spiral, crater vortex/machineatomic, sculpted cigarette
smoke. Rococo chapel volute, torrent, Zermatt, vortex around cliffs, play of ecstasy
around vortex, seagull's flight, butterfly vortex, humming birds.[5]

Such an agglomeration of amorphous, energised and ephemeral natural forms
was to be reflected in Obrist's tapestry designs. While these could retain a stylised
Japonist truth to the appearance of dragonflies, reeds, lilies, cyclamen, sea-organisms
or trees, the most remarkable distorted this by presenting a composite of different
life-forms or of an ideal, root-to-tip plant. Such distortions characterised his
Blossoming Tree (1896) (Plate 15) which fused blooms based on amoeboid forms
and a flattened image of a thorny tree with spiralling branches. Here, as in his
better known *Cyclamen* (1895) which earned the nickname 'The Whiplash', the
composition, aided by the attention given to each stitch, was to evoke the sensation
of life-force, of essential becoming rather than being.

Obrist's art and ideas reflected a monistic worldview, in keeping with that
being promoted by the zoologist Ernst Haeckel, founder of the German life-reform
movement, the Monist League, a proto-Nazi organisation whose transcendentalist
tendencies took Solvay's Productivism a step further towards racism.[6] Haeckel's
monism called for racist social reforms based on his study of the active material
substrate – the stuff of life, present in all organic bodies. Through this he had come
to realise, akin to Solvay, that life was essentially the conversion of energy, and that
it was only the vital combination of internal and external factors that leads to life.
Obrist's sculptural work, such as his plaster model for a *Monument to the Pillar*
(1898), suggests the relationship. From a base of unhewn rock rises a smooth

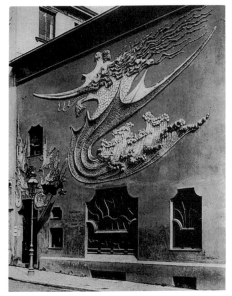
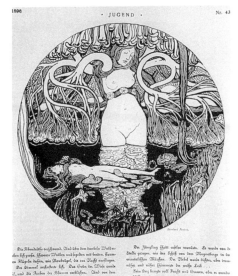

16 Endell, Elvira Studio, Munich, destroyed, 1897
17 *right*] Pankok, *Tree of Life, Jugend,* 1896

column crowned by a capital of geometric forms that culminate in the square slab of the abacus. The pillar, not a human figure, is now the subject. It becomes a symbol of the transformation of matter, or energy, from its chaotic natural state into one perfectly shaped by man.

OTHERS

Obrist was not alone in this association. For the leading Munich arts periodical, *Jugend* (The Youth), was edited by Georg Hirth, a co-founder of the Monist League, who dedicated much of the magazine to romanticised celebrations of Aryan youth and nature.[7] Inevitably contributors to *Jugend* also came under the same sway. These included illustrator Fidus (Hugo Höppener), who was simultaneously living in a rural 'Volkish' commune, practising 'free love, vegetarianism and nudity', trying to be self-sufficient, wearing reform-dress made from natural fibres, letting his hair grow long, indulging in occult religions and painting 'young men and women, who are always blond and fairskinned, tall and slender, even to the point of emaciation, usually naked (if clad at all, then only in Germanic costumes), frolicking in virgin landscapes'.[8] Certainly his graphic art appears as a promotion of anti-Christian paganism and the cult of heroic nudity, of a super-race in touch with the rhythms of the cosmos (Plate 1).

 The relationship between Obrist and August Endell was like that of master and pupil. Endell also came to art after studying in another field – in his case philosophy and psychology. He lived in Munich from 1892 to 1901 and there devoted himself to design and theory. His main precept was to 'stop thinking and start feeling'. To provoke this he championed the direct power of form on the empathetic observer and considered that appropriate focus on structural organic details, stripped of reference to the particular, should be capable of arousing a powerful new and pure sensation in the spectator's soul. Hence his creation of a

43

sensual feast – the Elvira Studio for the photographers Sophia and Mathilde Goudstikker (1896–97) (Plate 16). Renovating an existing building, he invented a gigantic decorative form in plaster relief to fill the windowless space of the upper facade. In this he fully, if grotesquely, embodied Obrist's ideas concerning the expression of the underlying forces of nature. The disparate formal qualities suggested a bizarre abstract agglomeration, some kind of 'horned, cellular Rococo bat-winged Venus or Chinese dragon with comet's tail on a Japanese wave from a Germanic fairy tale'. It was nothing and everything: organic and fantastic dynamism; a swerve in grating tones of turquoise and crimson; abstract and real; vital, indeed almost aggressive, in its liveliness.

Hybrid, non-representational forms, often grotesque, always dynamic, dominate Endell's work – be that an embroidered wall hanging, a desk, a piece of jewellery or a book cover. Yet while they cannot be identified with specific nature many of his decorations borrowed elements from marine organisms, including feather coral, octopus tentacles, or spiny Acanthus shells, as they were being popularised in the books of Haeckel and his follower Wilhelm Bölsche. Similar sources inspired other leading Munich designers, not least Bernhard Pankok and Friedrich Adler.

Pankok was an early contributor to *Jugend* and, like Obrist, a founder of the United Workshops in 1897, an enterprise set up to establish a sound, commercial basis for the new applied art and a co-operative relationship between the designer, craftsman, manufacturer and consumer, without aesthetic or technical parameters. A black and white illustration to an extract of Johannes Jørgensen's symbolist novel The Tree of Life published in *Jugend* (Plate 17) indicates that in 1896 his art remained figurative. Still, the closed-eyed images of a part-submerged, beautiful young woman-plant and a naked female body with flowing tresses of hair floating in water, are fantastic hybrids and convey a sense of the unity of nature. This organic monism was to become more abstract with Pankok's post-1897 concentration on furniture and interior design, particularly in the work commissioned by Obrist for his new villa in 1899 and made by the United Workshops. This included a cabinet with knotty, gnarled joints in the bent leg-supports and spreading, webbed decorative forms at the top. In other works, such as a later vitrine and lady's desk (1901–2), he utilised broad, taut and arrow-shaped forms suggestive of stretched skins or wings as rear supports, these acting as a counterpart to the slender front legs and imbuing the pieces with an unmistakable feeling of insect-like ascension. In much of Pankok's work there is a sensation, akin to that of Endell, of grotesque organicism. This was to be given a sexual interpretation in a wardrobe designed in 1902. Here the inlaid decoration of the door appeared ostensibly as two pheasants sitting upon some luxurious vegetation but also clearly suggested a penis entering a vagina.

Pankok proved to be an immensely versatile artist, his oeuvre including the design of passenger compartments for zeppelins, theatre sets, installations for the German displays at international exhibitions around the turn of the century, and a house in Tübingen (1900–2) for art historian Konrad Lange which fused a new functionalism with streamlined organic grace and elements of rustic romanticism. Such successful diversity was to be a trait of several other members of the United Workshops, foremost among them Paul, Riemerschmid and Behrens. Bruno Paul was a frequent contributor to *Jugend* and the satirical magazine *Simplicissimus*. His social and political caricature lampooned corruption and immorality without quarter – be it of the state, aristocracy, military, church and bourgeoisie or workers,

women, nationalists and foreigners. Although stylistically varied, Paul's cartoons were readily identifiable and became a hallmark of *Simplicissimus*. Characteristic was his use of flattened, sinuous forms, exaggerated facial expressions and distorted anatomies, large blocks of monochromatic colour and empty space, few linear details, and stark constrasts of light and dark.

Some of the features of Paul's cartoons were to be carried over into his other work. His posters, chairs and candelabra, for instance, were also heavily reductionist, conveying a bold purity of organic form, colour and material that was enabled by a highly precise use of curvaceous contour stripped of any superfluous movement or decoration. Similar tendencies were characteristic of the work of Richard Riemerschmid, the only Bavarian among the founders of the United Workshops. However, having experimented with delicately linear floral designs in his early metalwork, furniture and *Jugend* illustrations, Riemerschmid was to develop a striking functionalist aesthetic. The transition was seen in a musician's chair designed in 1898 for J. Mayer, the court piano makers. Here, replacing stretchers were two braces sweeping from the front feet to join the curved back and slanted rear legs in an exquisitely serene diagonal wave that allowed the musician ample room for movement while providing appropriate support.

The laconic linearity and constructive grace of Riemerschmid's chair caused a sensation and led to many more commissions, not least austerely organic furniture for Obrist's villa, and the more dynamic German 'Room for an Art Lover' at the Paris exhibition in 1900. Expressing increasing confidence he diversified into glass, ceramic, fabric and wicker furniture design, created a sensual masterpiece in his interior of Munich's New Playhouse (1900–1), and moved into mass production. Motivated by an imaginative pragmatism and concern for quality at affordable prices Riemerschmid began to work with the Dresden Workshops for Applied Art (*Dresdner Werkstätten für Handwerkskunst*) in the mid-1900s. There he designed model apartments and their furnishings, these including *Maschinenmöbel* (machine-made furniture), akin to Serrurier's Silex furniture in Liège. Created for modest middle-class homes, the furniture was extremely simple and practical, was built from machine-made parts, and openly exposed bolts and joints. Its success was to inspire the 1907 foundation in Munich of a new champion of mechanistic modernism, the Deutscher Werkbund.

The rapid development of Riemerschmid and other Munich-based artists away from a floral, pictorial form of Art Nouveau to a rationalist aesthetic was not universal. For the work of Otto Eckmann, one of *Jugend*'s principal illustrators and an early designer of tapestries made at the new Scherrebek weaving school in Schleswig, never strayed far from the lyrical rendition of botanic nature, swans and lovely young maidens. Yet such reticence was mostly confined to those who did not diversify into the applied arts. Among those who did make the transition was Riemerschmid's colleague at the United Workshops, Peter Behrens. Despite a formal similarity to Eckmann's Japonist curvilinear style in his woodcuts of idealised lilies, butterflies, flowing streams and androgynous kissers created in the late 1890s, Behrens simultaneously moved to more abstract organic forms in his designs for glass and ceramics. This bore witness to his experience of Van de Velde's approach, a source also apparent in the house he built, decorated and furnished for himself at the Darmstadt artists' colony (1901), as well as his Hamburg vestibule at the Turin international exhibition in 1902. From this he developed a new language reflecting the machine age that was based on classical

severity sometimes with conjoined elements of rustic tradition, as evinced in his turbine factory for the electrical conglomerate AEG (1910–12).

In distinction to Behrens, the artists associated with the shortlived Phalanx society (1901–4), appeared more committed romanticists. Indeed it would have been hard to visualise a greater contrast between the regulated, geometricised, symmetrical, black and white company image that Behrens created for AEG and the liquid, sensual, intuitive, Russian medievalist, brightly coloured and free forms of Kandinsky's work. Yet in both there was a striving for idealisation through recourse to essential nature; a keen transcendentalism expressed through reductionism. This empathy was suggested in Behrens' early recognition of Kandinsky's approach as well as his and the United Workshops' participation in several Phalanx exhibitions from January 1902. Indeed, Kandinsky's removal from descriptive or narrative painting to decorative forms of art was evidenced in his sketches for murals depicting generalised scenes of knights on horses shown in the early Phalanx shows. This coincided with a synthesis of art forms and nationalities which betrayed the group's universalist concerns – exhibits included a Monet show, and works by Gallén, the Russian designer Natalya Davidova, Scherrebek carpets, Lemmen, Ludwig von Hofmann, Jan Toorop, Toulouse-Lautrec and a Meier-Graefe portfolio of prints by numerous modern artists.

Notes

1 M. Logan, 'Hermann Obrist's Embroidered Decorations', *The Studio*, 1897, vol. 9, p. 98.
2 The arts entrepreneur Meier-Graefe was also editor of the leading French periodical promoting Art Nouveau, *L'Art Décoratif*. In Germany, he founded the Berlin quarterly *Pan* in 1895. The Keller and Reiner salon was designed by Van de Velde (1899).
3 The Darmstadt promotion of the modern movement was particularly remarkable given the city's small size. Patrons included Grand Duke Ernst Ludwig of Hesse who from 1900 funded the creation of an artists' colony, to which Olbrich and Behrens were to be primary contributors; and Alexander Koch, publisher of the periodical *Deutsche Kunst und Dekoration*. Remarkable among the artists' colony in Worpswede was Heinrich Vogeler, a versatile Art Nouveau artist, who excelled in black and white illustrations, notably for the periodical *Die Insel*, as well interior design.
4 In 1887 the population was 268,000, quarter that of Vienna or Berlin. The number of artists registered as living in Munich was about a third greater than that of Berlin. Though expansion was rapid (415,000 by 1896, 600,000 by 1914), Nuremburg and Augsberg remained the main Bavarian manufacturing centres.
5 Cited from K. Bloom Heisinger, *Art Nouveau in Munich*, Munich, 1988, p. 81.
6 See Chapter 2. The Monist League was eventually founded in 1904. Obrist was to give lectures at its meetings.
7 Hirth was also the owner of Munich's largest daily newspaper the *Munchener Neuesten Nachrichten*. Henry Van de Velde was also to be associated with the Monist League.
8 A. Pagel, 'Jugendstil and Racism: An Unexpected Alliance', *Canadian Art Review*, 1992, vol. 19, pp. 99–100. Pagel goes on to identify Fidus's work with proto-Nazism, e.g. 'Comparisons with propaganda photography of the National Socialists or even the films by Leni Riefenstahl, promoting the ideal Aryan, reveal the influence of Fidus-figures: streamlined Aryans, in the prime of their youth, display their often naked, always idealised and sculpturesque bodies in splendid natural or artficial light conditions.'

4

SPAIN

Barcelona

Background

In 1899 the London periodical *The Poster* devoted much space on its pages to discussion and reproduction of the most modern art posters coming out of Spain. Without exception, all were taken from the eastern region of Catalonia, and in particular Barcelona. The artists featured included Alejandro de Riquer, Ramón Casas, Miquel Utrillo, Santiago Rusiñol and Adria Gual.[1] Their work varied from de Riquer's versatile fusion of Mucha, Grasset and the Pre-Raphaelites in his posters, whether for the Catholic society *Circol de Sant Lluch* (St Luke's Circle) or for Juan Torra's sausage factory (Plate 18), to Rusiñol's moody, decadent advertisement for a performance of Maeterlinck's 'Interior', Gual's interpretation of Privat-Livemont's feminine stylisations, and the more caricatural style of Casas and Utrillo in their posters for the Els Quatre Gats cabaret and the *Pèl & Ploma* (Pen and Pencil) magazine. The reason for the focus on these artists and the new Catalan movement in general was explained as follows:

Barcelona, the industrial and publishing centre of Spain, Barcelona, which long ago recognised advertisement in all its forms as the biggest factor in modern business, is the cradle of this artistic and literary movement, and it must be admitted that the above-named city has courageously persevered in this line, which has today attained its apogee. Leaving far behind the routine prevailing in other Spanish towns, Catalonian art was for a long time inspired by the French school of painting, as well as by the beauty and grandeur of native rural scenery, until at length it was given an entirely fresh impetus by the works of English and Belgian artists. A new field of decoration was opened up to Barcelona's painters and designers ... many have succeeded in it to admiration, showing both taste and originality.[2]

In fact the innovations being expressed by the Catalan artists were fired by a complex of factors, among them: proximity to France and access through excellent communication networks to international developments; trade and industrial expansion; increasing wealth and confidence of the local bourgeoisie; disaffection among the impoverished, propertyless and unenfranchised labour force; opposition to Castilian rule; secularisation of society and the Catholic Revival in Spain.

 Swallowed up by the Bourbon dynasty in the early eighteenth century, previously proudly independent Catalonia was to undergo a process of gradual de-Catalanisation and Espanyolisation over the next century and a half. The attack on national identity which most inflamed the Catalans was the prohibition of their

language. It stimulated the Catalan revival movement known as the *Renaixença*. Around the mid-nineteenth century national romanticist poets began to appear, followed by the revival of Catalan music and festivals, Catalan language newspapers and various Catalanist organisations. The latter, whose membership tended to be drawn from the conservative bourgeoisie, was federalist rather than republican, preferring 'autonomy within the Spanish state'. Leading representatives included Josep Puig i Cadafalch and Eusebio Güell, designer and patron of the new Catalan architecture.

As Barcelona began to flourish in the nineteenth century so its intellectual and cultural development was encouraged. A gridiron plan of broad boulevards and regularly spaced community services, the so-called Eixample, was adopted for the expanding city in 1859. In 1869 the Higher School of Architecture was founded, this being followed two years later by the reopening of the university, with which it was to merge. Archaeological associations were formed, a museum of natural sciences created, scientific periodicals published and the Catalan Atheneum, a club and archive for the local intelligentsia was founded.[3]

Inevitably this vitalised complex of political, economic, intellectual and cultural factors stimulated the arts. Dealers began to open private galleries trading in local modern art, the first and most prestigious being the Sala Parés established in the mid-century. Contact with developments abroad increased, many young artists being attracted to Paris.[4] Among these were several, like the Nabi Aristide Maillol and Herman Anglada, a painter of sensual dancers and decorative café scenes, who left their native Catalonia to become leading figures of the burgeoning international art movement in the French capital. Within the province the Circol de Sant Lluch was founded by the realist and religious painter Juan Llimona in 1893. It was a society of Catholic artists, architects, critics and other intellectuals who promoted moral and religious ideology in art in order to effect a renovation of urban life based on personal charity and integrity. A sort of craft guild, with the motto 'Artisans of Beauty', one of its leaders was the rich aristocrat and supranationalist de Riquer whose art was fully derivative of its French and English models. Another member was Antoni Gaudí whose architecture was to be the epitome of the wealth of the Catalanist imagination.

Catalan romanticist, symbolist, radical socialist and anarchist writers and visual artists emerged. In 1898 Gual opened his Teatre Intim, advertising it with fluent Lautrecian posters, and staging his own symbolist dramas, such as 'Blancaflor' which was inspired by a Catalan folk tale, 'Nocturne. Andant morat' and 'Silence'. The last two were sombre evocations of mood and emotion, with radically simplified set and costume designs in one or two dark colours. Also remarkable was the rapid expansion of publishing and with it the graphic arts, this aided by the import of the latest German printing equipment. Numerous Catalan arts magazines featuring the latest work of the young generation of literati and artists, as well as international developments, began to appear. In the 1890s and 1900s they included the symbolist-oriented *Luz* (Light) and its successor *Pèl & Ploma*; *Joventut* (Youth), the politicised sister to *Pèl & Ploma*, fashioned after the German *Jugend*; *L'Avenç* (Progress) which promoted free aesthetics and diverse political opinion; *Hispania* which advanced new decorative art and architecture; and the satirical *Cu-Cut*.

The boom in art journals coincided with the municipality's establishment of regular combined exhibitions of fine and applied arts that followed the 1888 Barcelona World Exhibition. These in turn encouraged the new prestige and rapid

development of the decorative arts. Workshops were set up, foremost among them the *Castell dels Tres Dragons*, with its ceramics, stained glass, metalwork, woodwork and embossing studios, in the seminal café-restaurant building designed by Luis Domènech in a mixture of modernised Catalan Gothic, Moorish and Aragon styles, for the 1888 show. Organised by Domènech, one of the technical innovations to come out of these studios was Jaime Pujol's opalescent glazes for ceramic tiles (*ceramica dorada*), these providing the iridescent surfaces of many of Barcelona's Modern Style (*Modernista*) buildings.

With an emphasis on quality of craftsmanship and opulence there appeared, despite Domènech's acknowledgment of the place of modern technology, little room for mass production or pre-fabrication in the Catalan applied arts and architecture. Instead the Barcelona craft revival, led by the local desire to reassert the strongly felt national identity as well as integration into the general European cultural hegemony, tended to emphasise past traditions of technique and style, while dabbling with recent developments in France, Belgium, Germany and Italy.

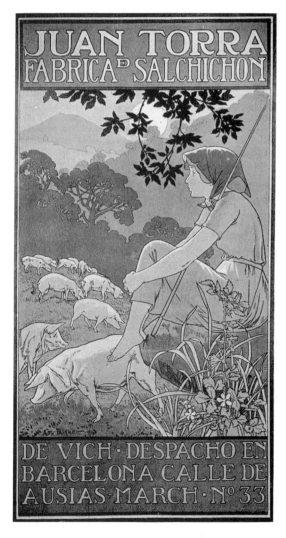

18 De Riquer, *Juan Torra Sausage Factory*, poster, 1899

A form of Catalan eclecticism emerged, as witnessed in the work of the Gaspar Homar, one of the region's most talented interior and furniture designers, who moved from a fusion of Gothic and Moorish motifs in the early 1890s to a more delicate, curvilinear floral style with hints of Neo-Rococo later in the next decade. The latter, evident in his designs for the Casa Oller (1901) and Domènech's master-piece of domestic Modernista architecture, the Casa Lleó Morera (1904–6), bore witness to his assimilation of trends emanating from Paris, and in particular Bing's *L'Art Nouveau*.

Appearance

Such an international synthetic approach typified much of the Modernista produc-tion. It was to be evident in the metal and stained glass designs by de Riquer, the furniture and interiors of Juan Busquets,[5] and the plastic treatment of new cafés and chemist shops, such as the Cafés Torino (1902) and de la Luna (1909) and the Farmacia Grau Inglada (1900). It was also to be found in the work of the artists associated with Pere Romeu's café-concert Els Quatre Gats (The Four Cats). Based on the Parisian Le Chat Noir, Els Quatre Gats was founded in 1897, after the wealthy Bohemian painters Casas, Rusiñol and Utrillo settled back in Barcelona following periods of study in the French capital. It was designed by Puig i Cadalfalch in a modern Neo-Gothic style and adorned with a two-metre long mural by Casas depicting the artist and proprietor on a tandem. In cloisonnist outline the figures and bicycle are flattened against a monochromatic background with Japonist sprigs of leaves entering top left. Dominant, they form a symbolic, newly mobile, link between natural and constructed environment – the singular lines of the hills and the city behind them.

Els Quatre Gats proved to be a fount of much Modernista art during the six years it functioned. It became a regular meeting place for artists, architects, anar-chists and socialists. Exhibitions were organised there, as were concerts, cabarets and a puppet theatre. Further, in 1899 Romeu published fifteen issues of his own arts magazine, *Quatre Gats*, dedicated to the café's happenings and the activities of its frequenters. Its motto was 'Art without political colour'. Yet its association with 'free aesthetics', bohemian lifestyles, *épater le bourgeois* ideas and art for art's sake, meant a political colouring was unavoidable, and more than that it was to vacillate to extremes beyond conservative blue and socialist red. Such variegation was hinted at in the work of Casas, who in 1899 held a large one-man graphic exhibi-tion in the café and edited its magazine. This indicates that he had fully absorbed the progressive and decadent movements during his prolonged stays in Paris from 1882. Veering between Whistlerian tonal suggestion, Degas' Japonism and Manet's realism in his painting, Casas' subjects included fashionable ladies at fiestas, the execution of an anarchist and a commissioned portrait of King Alfonso XIII. He also created commercial posters using alluring images of youthful feminine beauty, that for a Barcelona syphilis clinic (1900) being an appropriate, though obvious, *femme fatale*, complete with loose mantilla, delicate budding flower and black snake.

In comparison with Casas, Utrillo and Rusiñol, who showed their commit-ment to artistic reform through symbolist, Pre-Raphaelite and Impressionist tendencies, other Els Quatre Gats habitués, such as Pablo Picasso, and Isidro

Nonell, were more radical. Still, Picasso did respond to similar sources, particularly during his Barcelona period of 1899–1900, and did produce paintings, posters and menus for the café, and illustrations for the local magazines, with sympathetic images of fashionable society, be they well-attired drinkers or beautiful young women. For these he employed the sinuous line and colour blocks of Art Nouveau, the charcoal sketchiness of Casas and the vaporising forms of the symbolist Eugene Carrière. The latter were suggested in works such as *Sabartés as a 'decadent poet'* (1900) and *The Cry of the Virgin*, an illustration to a sensual symbolist poem published in *Joventut* (1900). Both comprised dissolving images of human figures in touch with the rhythms of their worlds.

In addition, Picasso and Nonell were drawn to Parisian developments, though in their case it was to non-picturesque expressions of decadence, low-life and anarchism, not least Steinlen's documentary visions of the urban underworld, that they turned. While undoubtedly associated with their own modest social origins and lack of security, their subject matter also had as a source the depiction of Barcelona's social derelicts by their predecessor Luis Graner. Encouraged by the new vehemence of the calls for social revolution in the 1890s, the popularity of Bakunin's anarchism, the severity of its repression and the abysmal living and working conditions of the workers, Nonell toured the ghettoes. With Goya-like brutality he drew and painted the cripples, gypsies, unemployed, prostitutes, the aged and mentally ill, their heads bowed, huddled against walls or in dark, undefined hovels. In keeping with the Modern Style's striving for depersonalisation, if for reasons at variance with those, say, of the Nabis (who used it to express a lyrical, often pantheistic conception of reality), he used fluid dark outline, and faceless, simplified and generalised blocks of form. Likewise, Picasso's decadence entailed a similar treatment for his archetypal depictions of tragedy, suffering and injustice, as well as an overt opposition to the idealised identification of young womanhood with natural beauty. This was apparent in the drawing of *The Madwoman* (1900) and the works of his Blue Period (1901–3), such as the poignant reworking of a Madonna and infant pose in *Mendicant* (1902), with its huddled bundle of a childless female figure set against a monochrome background, and the analogous *Drunk Woman Drowsing* (1902).

The Quatre Gats artists showed no desire to be ensnared into narrow regionalism; their work abroad, their flirtation with symbolism and their broad choice of subject matter and treatment, extending beyond the Catalanist motivations of Sant Lluch artists such as Juan Llimona, and even de Riquer. In fact the manifold appearance of the Modernista movement and the schism between the liberal universalist and conservative Catholic nationalist wings is most apparent when the work of the liberals and left-wing socialists is contrasted with the architecture of Llimona's Sant Lluch colleague Antoni Gaudí.

As early as 1878 Luis Domènech had proposed in the first Catalan revival periodical, *La Renaixença*, that the search for a national architecture should comprise a synthesis of selective interpretation of past styles and appropriate response to both the present and the particular. At that time both he and Gaudí, recent graduates from the new School of Architecture, were assisting the medievalist architect Juan Martorell in his creation of a Neo-Gothic complex in the Basque town of Comillas. This was for Antoni López, an entrepreneur who had made a fortune in the Spanish West Indies and in 1878 been made the new Marqués de Comillas. Within two years the young assistants were creating independent buildings which

marked the beginning of the Modernista movement in architecture: Domènech's Montaner y Simón publishing offices and Gaudí's Casa Vicens. Both set precedents through the use of unadorned red brick in newly expressive fashion. Particularly marked were the Islamic-style patterns and their evocation of the eighth-century Moorish settlement of Catalonia. Gaudí took this furthest, both in the Vicens house, built for a Barcelona brick and tile manufacturer, and his next domestic commission, the Casa El Capricho (1883–85) up in Comillas. There is no slavish or comprehensive copying of Moorish elements in this so-called Mudéjar style, but rather, in accordance with Domènech's first tenet, their select interpretation: a minaret-like tower, stepped arches and supports, and geometricised tile patterns. Fused with some Iberian details these are incorporated into works of exotic fantasy that are *gesamtkunstwerken* in which every surface, every material, every motif and their treatment is attentively co-ordinated.

GAUDÍ

Gaudí's early contact with the Marqués de Comillas was to be furthered in 1881 by his contribution to the López's lavish leisure garden at Comillas, this including a fanciful gazebo with an exaggerated, bulbous-shaped roof complete with speckle finish, floral motifs, and quasi-religious metal finials. In addition, the relationship coincided with his first meeting with the new aristocrat's son-in-law, the textile magnate Eusebio Güell. And it was Güell who was to be his most important patron. One of his first commissions was the entrance to his estate in the Barcelona environs (1884–87). Gaudí built a stable, lodge and gate. Again the Mudéjar style is present in decorative brickwork and polychrome tiling of the turrets. But here it is combined with elements taken from local nature and mythology: the elongated gatepost has sunflower and orange tree motifs, while the gate itself features a grotesque dragon with stretched wing and curvilinear body that anticipates the Art Nouveau obsession with fantastic creatures, flight and swirling lines.

In the course of the next two decades Gaudí was to design extensively for Güell, this patronage allowing the development of a unique personal style which showed many affinities with the international Modern Style movement. The idea of the grand Güell Palace (1886–89) was to create an integrated luxurious home and cultural centre. In it he synthesises Gothic, Renaissance and Mudéjar styles, now fusing these with a more modern expression of dynamism. The latter is seen in the upward thrusting movement of the parabolic arches and tapering pillars in the dining room as well as the ventilation ducts and chimneys, the writhing lines of the ironwork on the entrance, and the curvaceous, asymmetrical forms of some of the furniture. In addition, Gaudí provided a large central hall rising through two storeys for concerts, dances, dramatic perfomances and a salon for literary gatherings.

Güell's subsequent employment of Gaudí was to make manifest his ideas concerning the use of modern design as an instrument of reactionism. In the 1890s, faced with increasing political unrest, social gulfs and economic instability, and in keeping with the approach of the Circol de Sant Lluch, Güell sought to disassociate himself from the wings by playing the role of paternal benefactor. Indeed, despite Gaudí's imaginative and individual conceptions, his work derived from the self-righteous and religious bearing of both client and artist, with its romantic utopianism, its reconciliation of the ancient and modern, professed organic and ergonomic basis, and regionalism. While differing in details and resolution this showed marked correspondence to the social engineering programmes of

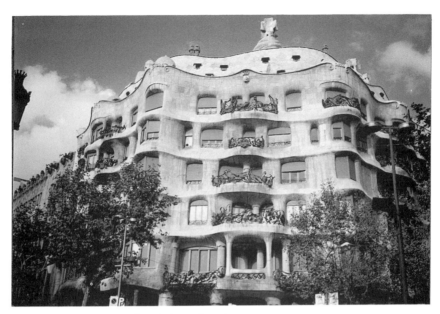

19 Gaudí, Casa Milà, Passeig de Gràcia 92, Barcelona, 1905–10

Solvay, Haeckel and Ruskin. It is therefore unsurprising to find numerous formal similarities between Gaudí, Horta, Van de Velde, Endell, Pankok, Ashbee and Baillie Scott, nor that there should have been a coincidence with the medievalist modern styles being created elsewhere, for instance by Guimard in France, Mackintosh in Scotland, Lechner in Hungary, Sonck in Finland and Shekhtel in Russia. Indeed, the Old Believer industrialist patronage of the latter, with its emphasis on paternalist, communitarian and meritocratic values, as witnessed in his work for the Morozov and Ryabushinsky families, shows remarkable parallels to the Catholic revivalist clientele of Gaudí.

In the late 1890s Güell founded the Colònia Güell near his textile factory at Santa Coloma de Cervelló, south of Barcelona. It was to be a Christian community for workers, with housing, a workers' co-operative and school. Gaudí was commissioned to design the church. The ultimate in organic design only the crypt could be built (1898–1917). With irregularly sloping, rough hewn basalt and brick pillars, most echoing the forms of the pine trees outside, and using waste material from brick and ceramic factories as well as sewing machine parts from the textile mills in the windows, the effect is a picturesque marriage of the primal, archaic and modern. In addition, Gaudí exploited hyperbolic paraboloid arches, the eccentric lines of which were to symbolise the Holy Trinity.

Religious symbolism was an abiding feature of Gaudí's mature work. For him the Roman Catholic church itself was a symbol of the ultimate cosmic order, and this he sought to express, not only in his uncompleted Gothic extravaganza, the Sagrada Família (Holy Trinity) Church (1888–1926), a grandiose experiment in timelessness built in an impoverished workers' quarter of the Eixample, but also in the sacred allusions of his Park Güell (1900–14).[6] Conceived (though not realised) as a garden city for sixty families of the *haute bourgeoisie*, a walled retreat from the grim realities of the metropolis, the park was designed beyond the industrial belt on the barren slopes of Bald Mountain. Integration – of the pleasurable and the

53

pious, the traditional and the contemporary – was a primary concern for both artist and patron, the satisfaction of the senses and the spirit being central to Gaudí's vision of synthesis. This form of ennobled monism was to be expressed in the park through his creation of a quasi-Doric colonnaded, temple-like market hall; the grand plaza which could act as an open-air stage for the performance of Catalan folk festivals and theatre; and the intention to build a chapel at the park summit. For these and the extravagant tiled forms of the entrance lodges (Colour plate 2) and the serpentine parapet bench, he drew upon an English sense of incorporation of the natural environment, the Catalan tradition of tiling and his own vision of the architect as divine artificer. For him it was not simply a matter of the fusion of ornament and structure, but the fact that design and construction were a single process in which he acted as agent of God, and worked from the 'book of nature'.

Such messianistic zeal and belief inspired his synthesis of an array of brightly coloured floral and reptilian motifs, cross-forms, and abstract organic patterns, an iconography that was to be repeated in his best known domestic buildings – the Casas Batlló (1904–7) and Milà (1905–10).[7] The former incorporates a Gothic cross transformed into a cruciform plant shape and tiled, humped back roof ridge that evokes a sense of St George and the dragon. The Casa Milà (Plate 19), a tenement rather than family home, was given a rippling facade. The references to organic nature on the outside, such as the sand dune and seaweed effect, was continued within. At the same time the labyrinthine plan with two irregular kidney-shaped inner courts was made possible by the inventive use of a steel framework and concrete. In addition, there were allusions to the make-believe giants of local festivals in the primitive guard-like forms of the ventilation ducts on the roof. However, the series of religious dedications and sculptures of the Virgin Mary and armed angels were not mounted as planned. This was because just as the building was about to be completed the *Semana Trágica* (Tragic Week) occurred in Barcelona. The rising wave of anti-clericalism, which identified the church with social inequality, had resulted in the destruction of many churches and monasteries. At the behest of the Regionalist League, to which Gaudí and his patrons belonged, the demonstrations were violently repressed, eighty-three demonstrators being killed and several anarchists and workers executed.

Gaudí's essential and highly original eclecticism was undoubtedly inspired by Domènech. A leader of the Catalan Renaixenca movement, Domènech's work and theories indicated a greater awareness of international developments than Gaudí. In his five-storey Hotel Internacional, built in sixty-three days for the 1888 exhibition he made effective use of prefabricated modular sections. This interest in modern construction methods was repeated in his innovative iron and glass Palau de la Música Catalana (1905–8), the home of the Catalan choral society, though here he clothed the steel framework in an extravagant and appropriately resonant display of Catalan floral decoration – in glazed tiles, stained glass and plaster relief. Here, and in his contemporary masterpiece, the Hospital of Sant Pau (1902–26), he created two civic monuments to the eclectic ideology and experimentalism that was to typify the best of the Modernista movement in Barcelona.

Notes

1 Although in the late 1890s Gual created posters for such events as a cycling festival at the Barcelona Velodrome and the Fourth Exhibition of Fine and Industrial Arts, his main contribution to the development of the Modern Style was in the theatre (see below).

2 M. Demeur, 'A Mural Decorative Artist in Catalonia: Alejandro de Riquer', *The Poster*, January 1899, p.22.

3 The Atheneum (Ateneo Barcelonés) played an active part in the promotion of local applied arts and design.

4 An exception was José Maria Xiró, whose approach was derived from German symbolism, as witnessed in *Nietzschian Fantasy* (1902), with its naked superman, limbs taut and head held back in communion with the swirling, engulfing cosmic forces.

5 A modern designer much in demand, Busquets revealed similar Art Nouveau tendencies to Homar, i.e. an awareness of the curvilinear furniture of Guimard and Majorelle, and the interiors of de Feure. The latter is apparent in his 1903 dining room for the banker Evaristo Arnús.

6 For a detailed analysis of the park, see C. Kent and D. Prindle, *Park Güell*, New York, 1993.

7 Much of the decorative work of Gaudí's projects was created by Josep Maria Jujol, an architect who independently contributed to the later development of Modernismo through such buildings as the Torre de la Creu House (1913–16) and Vistabella Church (1918–24).

5

BRITAIN

Glasgow

Background

The Art Nouveau movement in the Britain of the 1890s and 1900s was vital, widespread and extremely diverse in its fields. As elsewhere in Europe, it was characterised by the 'Free Style', a synthesis as well as estrangement of nationalist and universalist intentions, the historical and the modern. The stylistically varied appearance was created by numerous enterprises and individuals. It included the modern vernacularism of Arts and Crafts designers such as Charles Voysey, Hugh Baillie Scott, and Walter Crane; the eclectic Byzantinism seen in John Bentley's Westminster Cathedral; the medievalism of William Morris's Kelmscott Press; Aubrey Beardsley's erotic, Japonist graphic art; Edward Gordon Craig's theatre of suggestion and emotional response; C. R. Ashbee and the Bromsgove Guild of Applied Art's respective curvilinear metalwork; the universalism of Bing designer Frank Brangwyn, the Académie Julian-trained Beggarstaff brothers (William Nicholson and James Pryde) (Plate 20), and the architect Charles Harrison Townsend.

In addition, the movement was encouraged by new periodicals such as *The Studio* and the *Magazine of Art*; art schools such as the Slade where the modern sculptor George Frampton taught; new 'guild' workshops, exhibiting societies and private galleries like the Grafton Gallery; the promotion of new design by home furnishing shops such as Liberty and Maples; the opening of salons in London by leading French designers and entrepreneurs, among them Gallé and Bing; the marketing of Lalique; and the acquisitions, touring exhibitions and national competitions organised by the South Kensington Museum.

These and the other advocates of the new art saw the beautification of the material environment through means appropriate to the age as central. Appropriateness was relative, dependent on whether the age was to be seen as secular, alienating, immoral and repressive, or liberating, optimistic and enlightened. For some, among them the Dundee painters John Duncan and George Dutch Davidson, and the designer of the Compton Chapel, Mary Seton Watts, it meant Celtic romanticism; for others it meant an embrace of the modern technology, the commercial or the evocation of the underlying forces of nature, as seen in the designs of Christopher Dresser, the posters of John Hassall and Dudley Hardy, and James Salmon's reinforced concrete Lion Chambers in Glasgow (1904–7). Similarly, it could also mean a revitalisation of local traditions, as in the wallpaper designs by Morris or the buildings by Voysey; a new sexual frankness or exploration

of sexual identity, particularly a new assertion of womanhood, as seen in the work of the Macdonald sisters; an expression of gentlemanly reserve, understatement and decadence; or an openness to foreign influence, not least the Japanese stylisation of nature as well as French Rococo and symbolism, as in the silverware of Archibald Knox and the paintings of the equivocal Charles Rennie Mackintosh.

Inevitably, many artists and designers articulated a synthetic response to the age and environment. In the Glasgow Style of the so-called 'Spook School', this involved a mix of Scottish and supranational elements, including borrowings from Scottish baronial architecture, vernacular furniture, and the celtic integration of mankind and nature, as well as musically curvilinear designs, stylised images of androgynous figures, antique symbols and a persistent identification of woman with mother nature and sensuality, if no longer always with beauty.

Glasgow was an obvious fount for Art Nouveau in Britain. A prosperous industrial city with a newly confident and wealthy middle class keen to wallow in comfort, convenience and vainglorious expressions of self, appeared ripe for the promotion of the new design movement. This, however, did not mean that innovations in modern design were to be readily accepted or sponsored. Indeed, the modern movement in Glasgow, while it was to produce some outstanding works of synthetic Art Nouveau, was essentially to remain peripheral and meagrely supported.

In the late nineteenth century, Glasgow experienced a population explosion, as immigrants from the Highlands and Ireland were attracted by the possibility of work in the manufacturing industries.[1] Ideally situated for foreign trade through its access to the Atlantic and for the receipt of local raw materials, Glasgow was to be the base for many engineering, textile and chemical companies. Despite increasing foreign competition, capital was available, the banking system was well developed, and the entrepreneurs were ruthless and self-assured in their drive for profit. Coincident with this the workers were poorly paid and housed in a dense

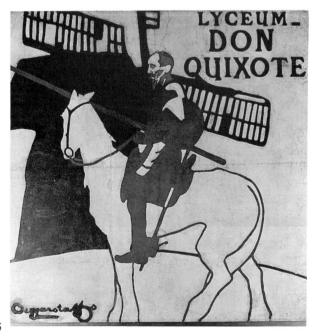

20 Beggarstaff Brothers,
Don Quixote,
design for a poster, 1895

maze of four- or five-storey tenements in the east, while the upper middle classes, benefiting from the railway, moved out south and west to Prestwick or Helensburgh.

By British standards, the Glaswegian civic authorities were remarkably progressive. Services such as water, gas, electricity supply, the tramways, telephones and even working-class housing were municipalised. The Corporation was also very active in its promotion of the city through international exhibitions (1888 and 1901). Such urban development, linked to the liberal politics of the middle class, encouraged intellectual, cultural and recreational life. At Glasgow University Professor William Thomson (Lord Kelvin) advanced his ideas about molecular dynamics and the wave theory of light. Among those who studied under him was James Frazer, whose anthropological investigations into primitive beliefs used broad-based comparative methods and revealed many alternatives to the Christian and scientific worldviews.[2] Art schools were founded, the foremost being the West of Scotland Academy, the forerunner of the Glasgow School of Arts, and the Institute of Fine Arts. Art collections were started by local businessmen, among them the shipping magnate William Burrell. Art dealers emerged, these including Alexander Reid whose gallery, *La Société des Beaux Arts* (established 1889), was to be the venue of an exhibition of posters by Toulouse-Lautrec, Beardsley, Steinlen and the Macdonald sisters in 1895. By the turn of the century there were five theatres, four music halls and two circuses. The premier theatre was the Royal, whose artistes included, in August 1901, the Art Nouveau dancer Loïe Fuller.

Appearance

In the early 1890s most of the artists who established themselves as the creators of the Glasgow Style were students at the School of Art. They included the 'Glasgow Four', the so-called 'Spook School', Frances and Margaret Macdonald, Herbert MacNair and Charles Rennie Mackintosh, who went on to be identified as the style's primary instigators. The director of the school, Francis Newbery, a progressive socialist, played a fundamental role. He encouraged the education of women, promoted a social role for the school in the fostering of public taste, advanced the cause for young artists so that they might develop their personality free from conventional constraints, and, most significantly, focused on design instead of the fine arts. He was also instrumental in the establishment of links with the continent, particularly with Belgium, exhibiting the students' work at 'L'Oeuvre Artistique' in Liège (1895) and attracting the leading Belgian symbolist Jean Delville to head the painting class from 1900.

The early watercolours of the Four contained the seeds of the mature synthetic style. Around 1893–94 a predilection emerged for sexual symbolism, this through the use of highly stylised organic forms, abstract linearity, grotesquely emaciated vegetal-android figures, images of sexual organs thinly disguised in the compositional arrangement, and primal motifs such as roses, swallows, the moon and crosses.[3] Frances Macdonald's *A Pond* (Colour plate 3) was an illustration for the group's *The Magazine*, its inclusion coinciding with a photograph of a young frog in the third issue (1894). The allusion to primary forms of life, here amphibious and derived from a single source, was full of implicit meanings. Rather than rely on visual sources, Macdonald's glorification of life's physical realities employs a flat, symmetrically balanced linear design in pinkish-tan tones. Evoking a sensation

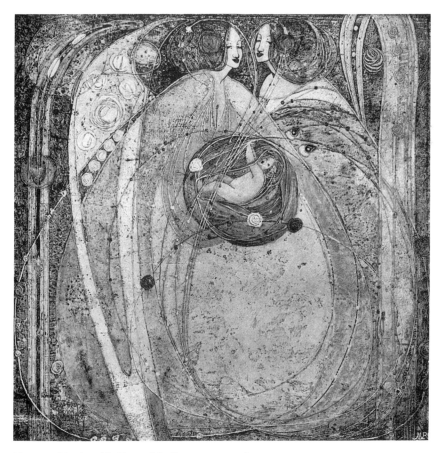

21 Margaret Macdonald, *Heart of the Rose*, gesso panel, 1901

of human tissue and blood vessels this can be read as vaginal imagery, with the androgynous skinny human-dragonfly figures given transparent wings, parted as an opening, as hymen after first intercourse. Above this, closer to the 'water's' surface, are ghoulishly grinning sperm or tadpole forms, potently and ominously grouping as if ready to begin the transformatory processes of life.

The expression of regeneration and metamorphosis, so abundant in European art of the 1890s, was to be frequently repeated in the work of the Glasgow Four. Their visual treatment of man's unity with nature and the potential of the forces underpinning life coincided with several new worldviews then being propagated; not least the social evolutionism of the Dundee biologist Patrick Geddes; the theories of organic transformation of Geddes' colleague at Dundee, the zoologist and classicist D'Arcy Wentworth Thompson; Haeckel's monism with its fundamental exploration of underwater micro-organisms, reproduction systems and larvae[4]; Solvay's productivism with its emphasis on the unison of matter and spirit; and Blavatsky's theosophy, with its overriding of the material by the mystical.

Loose association with such philosophies meant a move away from positivist-inspired materialism and the conventional emphasis on the surface, in favour of new symbolic leitmotifs. These occur in Margaret Macdonald's stained glass design *Summer* (1893). Here the flat, attenuated young woman-plant curves up

59

from her root to be embraced in a kiss by the man-sun. The symbolism is unsubtle. This is the union, in Nietzschian terms, of the Apollonian and Dionysian realms, the wild and the ordered, the complementary opposites, the Yin and Yang, that create life and bring harmony to the world. And this is the union of Margaret Macdonald and her future husband Charles Rennie Mackintosh. Between them is a frieze of swallows in flight, the bringers of summer and symbols for the Egyptian fertility goddess Isis. From the outstretched hand of the woman drop nine thornless white roses. Here as signs for the freeing of sexual impulses, these were also the symbols of Venus, of purity, and, for the Romans, of victory and triumphant love. From this point on the rose was to become a hallmark of the Glasgow Style (Plate 21).

There is much pagan mysticism in the works of the Glasgow Four, but their treatment of the sun as the all-important source of life worthy of worship is ambivalent. For in much of their work it is the moon that provides a halo, while the sun appears as a pernicious harbinger of mortality and death, not just life. Indeed, the watercolours of all four artists of the mid-1890s reveal a predilection for nocturnal mystery, half-darkness, and images of sleep. This coincided with their desire not to recreate images of the seeing eye, but those of the knowing eye – the world of the unconscious, of primal human experience, as in the Macdonalds' copper candle sconce designed for their colleague Talwin Morris *c.* 1896. This simple round plaque, the very form and gleam of which suggests the moon, is fixed astride two vertical strips and features a repoussé peacock dominated by a medley of Egyptian-style eyes. A counterpart to this occurred in Frances' *Sleeping Princess* (1895) with its rectangular watercolour of a Maeterlinckian princess lying, even apparently floating, with eyes closed to the external world. Her dress suggests a peacock plume and Egyptian hieroglyphics. She is encased in a repoussé copper frame of closed eyes covered by cobwebs and the soulful aphorism: 'Love ... if thy tresses be so dark, how dark those hidden eyes must be'.

In 1895 Mackintosh's watercolours for *The Magazine* included *The Tree of Influence, the Tree of Importance and the Sun of Cowardice* and *The Tree of Personal Effort, the Sun of Indifference*. In these virtually abstract works the sun remains omnipotent, but harmful. In the first, a protest against establishment connivance, it circumscribes a splayed torso, hung up, bound and quartered. In the second it wallows behind sturdy, well-established plant forms and encapsulates a chalice in the shape of female sex organs. The sexual imagery, like Pankok's in Munich, is unequivocal. This, conjoined with the stylised image of botanic life, from root to bud, suggests that through sex, through creative effort will come eternal reward. Such form and ideas reveal remarkable coincidence with those of Obrist, himself half-Scottish, and with whom Mackintosh was to show at the 1896 Arts and Crafts Exhibition in London.

Worlds of inner life, cosmic rhythms, enlightenment and darkness, blended with melancholy, hope and innuendoes of release through procreation, were to be continuously revealed in the work of the Four. Persistent also was the iconography of the languorous female beauty and grotesque, the android-plant, the swallow and rose, treated with Japonist stylisation, a Beardsley-like emphasis on opposite counterparts such as solid and void, black and white, together with flattened, elongated distortions, and esoteric symbology. This style was transferred to their poster art, as witnessed in the Macdonalds' and MacNair's design for the Glasgow Institute of Fine Arts (1896) and Mackintosh's for the Scottish Musical Review (1896).

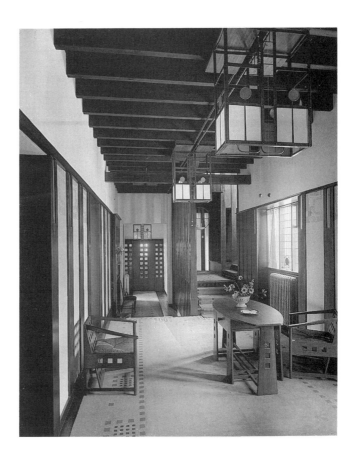

22 Mackintosh, Hill House,
Helensburgh, the hall,
1902–3

MACKINTOSH

As the Glasgow Style developed the dependency on the female figure rescinded. She became increasingly abstract and sometimes wholly or partly replaced by the thornless rose. Crosses, sometimes crucifix-shaped, also emerged as frequent motifs. Multi-level, counterbalancing symbols for the spiritualist Rosicrucian brotherhood, for the Virgin Mary and Christ, the roseheads and crosses were to be accompanied by further abstractions. Mackintosh's furniture and applied art, often lacquered black or white, took on exaggerated vertical format, and used stencilled motifs dominated by the interlaced play of straight and curved slender lines. He also employed half-latent references to pagan mythologies through the use of stylised totemic representations of organic nature, be that a tree, bird, scarab beetle, honey bee, or a budding plant, as on the black painted metal railings, window supports and finials that cloak his Glasgow School of Art building.

Through the late 1890s and early 1900s, as they concentrated more on the integration of the arts and their environment, the Four became increasingly involved in the creation of design temples – installations, interiors and buildings where the whole was co-ordinated according to a unifying order. From the structure to the decoration, the furnishing and the fittings, all aspects were subjected to the order, as witnessed in the Tea Rooms Mackintosh designed for Miss Cranston, the Glasgow section at the eighth exhibition of the Vienna Secession (1900), and the Rose Boudoir at the Turin Exhibition (1902). Major commissions,

such as the Glasgow School of Art (1897–99, 1907–9) and Hill House at Helensburgh (1902–3), were to emphasise the maturity and cohesion of Mackintosh's handling of his synthetic vocabulary. They were also to stand as monuments to his mission to create a new, ennobled, timeless beauty, profoundly relevant to the time and place, and devoid of clichéd paraphrases of historicist styles.[5]

For the School he chose austerity, though not one of self-denial, rather one of confident confirmation. The horizontal elongated rectangle of the north (entrance) facade, with its huge rectangular studio windows under overhanging eaves, typifies this. The windows are plain inserts in the unworked wall, devoid of decorated surrounds. Yet they are grouped in a play of subtle asymmetry around a picturesque central entrance.

The irregularity of the latter, with its protrusions and recessions for the director's room and studio, its extended tower and fortress-like window slit, acts as a counterpoint to the industrial effect of its surroundings. As a bastion of the supranationalist Scottish Free Style, Mackintosh provided a further integral contrast by ringing the facade with the linear network of iron railings and window brackets. Here stylised images of cross-bows and arrows intermingle with the tree of life, a bat, the scarab beetle, honey bee, dove, chalice and thornless roses. These numinous symbols are completed by a stone medallion at the centre of the curved architrave above the entrance, this displaying the roses/chalices combined with the flowing tresses of two idealised female beauties.

The School was conceived as a functional organism, a display of architectural virtuosity, and a physical manifestation of a convoluted cosmogony. Inside Mackintosh made inventive use of space, particularly enabled in this by a construction of steel infilled with concrete. One innovation was the placing of the museum under a glass roof at the heart of the building. It is reached immediately by the stairwell leading from the vestibule, this given an emphasis on slender wooden linear verticality that is overtly Japonist. The museum, which was to display works to be used by the students, was a focal point for the movement within the school, an effective meeting place for its disparate activities. Likewise, the library of the school, the core of the building built during the second stage, also revealed Mackintosh's imaginative feeling for spatial organisation and effect. Again it is Japonist, with plentiful suggestion of nature refined and abstracted – here the straight wooden uprights in the centre and the surrounding gallery create the effect of a grove, while the electric light fittings are simple studies of cubic and quadrangular forms.

Mackintosh paid comprehensive attention to the details of the School, many of his furnishings, fixtures, fittings and their decoration, created from basic, generative, forms such as squares, rectangles, circles, elipses and straight lines and finished in black or white. These, for instance, characterised the circular table in the director's office, the cupboards in the studios, the chairs in the board room and the cage-like balustrading in the west section.[6] Further, almost every door was completed by leaded glass panels, these with patterns of roses, butterflies, swifts, seed pods and embryonic female forms. Through such features he evoked a sensation of primal interpenetration – of solid and void, light and dark – something which he was to repeat in his domestic commissions, and most notably in Hill House (Plate 22).

The mansion was designed twenty-five miles west of Glasgow, along the Clyde and the new railway line, for the publisher Walter W. Blackie. It was to be the familiar retreat from the realities of the city which engendered his wealth for the

successful entrepreneur and his family.[7] Mackintosh received the commission through the recommendation of his friend Talwin Morris, the art director for Blackie & Son from 1893, and himself a leading contributor to the creation of the Glasgow Style.[8] Of his sources Scottish baronial architecture was the most apparent, as witnessed in the massing of the building and the variety of windows. Constructed in red sandstone covered in grey roughcast and with a slate roof, it appears, through its multi-directional joined parts, to have grown organically from the slope on which it is sited. With an irregular L-shaped plan, the two wings being joined in the south-east by a romanticist circular stair tower, the building was designed to suit the particular lifestyle of the Blackies. It was entered on the short south side, to the right of an elongated battered chimney and the left of the slit-shaped windows with unusual stone surrounds of the owner's study.

The internal disposition of space in Hill House was efficiently arranged around the fulcrum of the box-like hall passage. According to convention, the study and dining room were given dark wood linings, imbuing them with a masculine feel. They were also square and rectangular respectively. On the other hand, the drawing room and main bedroom, in keeping with their designation as female domains, were light and of irregular plan. In between came the half-light, half-dark hall, with its ebonised rectilinear framing and angular stencilled motifs of abstract organic forms in blue, pink, purple and green. White predominated in the drawing room, this being given two bays – one for music, the other for summer relaxation, and a corner with fireplace. The projecting window bay, with its opaque curtains and long bands of fenestration, appeared to melt into the transparency of the world beyond. Decoration was sparse, essentially limited to small stencilled designs of roseheads and chequerboard patterns on the walls, patterns of small squares on the carpet, five ovals of coloured glass and a gesso panel by Margaret Macdonald above the fireplace. A similar decorative treatment pertained in the L-shaped main bedroom. Coloured off-white, here the lightness was relieved by two exaggeratedly tall and slender black ladderback chairs whose purpose was less functional than decorative. Stylised roses on a regulated scheme of thin pliant thornless stems, together with apostle-like images of elongated female beauties, were designed to cover the wall around the bedhead, as if testifying to the sanctity of lovers who slept there.

There is a serenity to Hill House that is derived from the subtlety and delicacy of the designer's creation of psychological space. Mackintosh's ability to sensitively infuse atmosphere without mimetic recourse to historical precedents was unique but also in keeping with the modern spirit of the time. It shows appreciation of symbolist tendencies, of Japonism, of national romanticism, and supra-nationalism. As such it was also to show remarkable parallels with developments on the continent, not least in the vast central and east European holdings of the Habsburgs and Romanovs – the lands of imperial Austro-Hungary and Russia.

Notes

1 In 1801 the population was 77,000, by 1851 it was 330,000 and in 1901 760,000.
2 Frazer's highly influential *The Golden Bough*, published in 1890, devoted much attention to magical rituals, totems, taboos and tree worship. Among the notions he analysed was the association of swallows with signs of ill omen. Though this was subsequently shown to be a lopsided interpretation of swallow symbolism by D'Arcy Wentworth Thompson, Frazer's contention, together with his exposure of other animist beliefs, appears to have

had significant impact on the symbolism of the Glasgow Style.

3 Concerning the Macdonalds and Mackintosh's symbolism, see T. Neat, *Part Seen, Part Imagined*, Edinburgh, 1994, and J. Helland, *The Studios of Frances and Margaret Macdonald*, Manchester, 1996.

4 English editions of Haeckel's popular, illustrated studies of evolution began to appear from the 1870s, his *Monism as Connecting Religion and Science* was published in London in 1894. He worked in close collaboration with the Edinburgh naturalist and oceanographer John Murray, particularly through his interpretation of the marine biological discoveries made by the famous scientific voyages of *HMS Challenger* (published throughout the 1880s), and by their joint deep sea investigations in Scottish waters in 1892.

5 For a detailed illustrated analysis, see J. Macaulay, *Charles Rennie Mackintosh: Glasgow School of Art*, London, 1993 and J. Macaulay, *Charles Rennie Mackintosh: Hill House*, London, 1994.

6 For a comprehensive survey of Mackintosh's furniture and fittings, see R. Billcliffe, *Charles Rennie Mackintosh: The Complete Furniture, Furniture Drawings and Interior Designs*, Guildford, 1979.

7 Nearby was Baillie Scott's White House (1899), a large mansion built for H. S. Paul, which, though more conservative, shared many modern features with Hill House. One Helensburgh child was J. G. Frazer, son of a Glasgow chemist.

8 Morris, a furniture, metalware and bookcover designer, was to create a copper repoussé wall sconce for the hall of Hill House. It depicts a mysterious, astral serpent-like form. The other main contributors to the Glasgow Style included the furniture designers George Walton and George Logan, the stained glass designer Oscar Paterson, the embroidery specialists Jessie Newbery and Anne Macbeth, the metalworkers De Courcy Lewthwaite Dewar and J. Gaff Gillespie, E. A. Taylor, designer for Wylie & Lochhead, the home interiors firm, and his wife the versatile Jessie King.

6

AUSTRIA

Vienna

Background

The Art Nouveau movement in Vienna was to be identified with the Secession Style. The name came from the Vienna Secession (*Vereinigung bildender Künstler Oesterreichs*), a society of artists established in 1897 as a new, independent organisation opposed to conservative tastes of the artistic establishment. Its emergence was seen as late, by comparison with developments in Munich, Brussels, Paris, London and Glasgow. However, the unique combination of a state system of crafts schools and a new openness to originality meant that by the time of the 1900 World Exhibition in Paris artistic innovation and quality were already being successfully synthesised:

The Austrian section possesses this great interest – that it represents not only the individual efforts of artists and craftsmen, but also the 'official' decorative art movement of the State schools. Viewed from this last standpoint there is nothing in the entire Exhibition more admirable, more thoroughly commendable, than the display in question. Is it not wonderful indeed that a Government should have entrusted to those, and those alone, capable of acquitting themselves with credit, the task of decorating and arranging its Exhibition? And is it not still more astonishing that, instead of contenting itself, as most other nations have done, with the reconstruction of ancient styles, more or less national in character, a country should have displayed so much independence, so keen an appreciation of freshness and modernity?[1]

In fact the Austrian section was to be dominated by the installations of Josef Hoffmann (Plate 23) and Joseph Olbrich, two architects who belonged to the new Secession group. These interiors were paradigms of modern *gesamtkunstwerk* conceptions. The decorative motifs and forms of the fittings and furniture tended towards simplified, abstract curvilinearity. These combined with an admixture of rectilinearly designed structures, the result having clear echoes of the work by the Glasgow Four, with its effect of underlying energy and life-force.

Austria, with Vienna as its capital, had been ruled over by the Habsburgs since the thirteenth century. Until the beginning of nineteenth century the Habsburg monarchs were elected Holy Roman Emperors and therefore bound to numerous responsibilities before the Catholic church. Although this alliance frequently created political tangles, by the turn of the eighteenth century the leaders felt their empire sufficiently secure and the power of their court sufficiently established to

adopt large-scale investment in the arts and architecture. The Baroque development of Vienna was to be particularly extravagant, as witnessed by the Karlskirche, Schönbrunn Palace and Belvedere chateau.

With this extension in patronage by the church, state and aristocracy, the decorative arts (including painting and sculpture), as well as opera and theatre, also began to flourish. As the political heart of one of Europe's leading powers the city proved to be a unique hub of intellectual and artistic activity, attracting many talents from far and wide. Its cosmopolitan nature, aided by the multinational character of the Habsburg empire and its position in central Europe, created an especially rich cultural web. Italian, Slavic, German and Jewish sources all provided material for the mix. It gained a reputation for its lively spirit, its interweaving of classical and folk traditions, and, in particular, its music. Haydn, Mozart, Beethoven and Schubert all worked there, the latter three becoming sources for the Secession movement. Indeed, among other things, the Secession artists sought a development of the messages of brotherhood and understanding, of victory of light over dark as contained in, for instance, Mozart's opera 'The Magic Flute'; a visual interpretation of Beethoven's advancement of expressive instrumental music with its political and emotional themes; and a response to Schubert's development of the *Lied*, the art song with its union of poetry and music.

Another source for the Secessionists was derived from the so-called Biedermeier age. Following the defeat of Napoleon the Austrian empire entered a new period of stability in which the middle classes prospered and a new sobriety of artistic style emerged that was marked by formal simplicity, an emphasis on comfort, a subtle, Picturesque sense of beauty, and immersion in the wonders of the natural world. Although in many respects a reaction against the staid qualities of the Biedermeier and its association with those opposed to reform, the Austrian variant of Art Nouveau was also to assimilate some fundamental characteristics of this earlier style. Essentially these derived from the Biedermeier's focus on the beautification of the affluent professional classes' home.

Like the Biedermeier period, that which succeeded it, the age of the Ringstrasse development, was to provide both a source and an antithesis for the Secessionists. In the late 1850s and early 1860s, following Franz Josef's instalment on the throne and the Liberal Party's assumption of control of the Vienna municipality, a new era of civic construction began. The city's population was exploding, quadrupling during the period of Franz Josef's reign.[2] Improvements had to be made: to the water supply and sanitation; through the regulation of the Danube; the incorporation of a public health system; and the greater availability of parks for relaxation. In December 1857 Franz Josef decreed that the land of the peripheral fortifications of the inner city should be turned over for suitable urban development. The result was the Ringstrasse, a two-mile long, sixty-metre wide street on which numerous, deliberately impressive, public buildings were built, and the Franz Josef Embankment with its offices and business buildings.

The architecture of the Ring was to be designed on a grand scale in ornate historicist styles, thereby acting as a highly visible reflection of the impressive achievements and imperial venerability of the Habsburgs. Derided by many modernisers for their backward-looking appearance, their dwarfing, anti-humane scale and setting devoid of a heart (i.e. communal squares), in many respects the buildings represented the progressive tendencies of the Viennese authorities since their functions were to answer to local, contemporary needs, be they economic, legal,

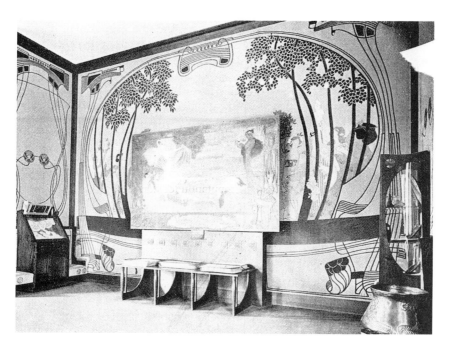

23 Hoffmann, Vienna Applied Arts School installation, Paris exhibition, 1900

political, cultural, social or spiritual, within one cohesive ensemble. Through the rational, state-promoted organisation of the institutions Viennese, and Austrian society generally, had the potential to become fairer, more democratic and more enlightened. Further, the life given to the economy, culture and arts by the project occurred at a time of prolonged recession, that was to be particularly harsh following the markets' crash in 1873.

Within a circulatory flow of space the Ringstrasse buildings included, in anti-clockwise rotation, the Stock Exchange, Museum of Austrian Ethnography, Police Headquarters, Expiatory Charitable Institution, Votive Church, University, Guild-hall and its park, Hofburg Theatre, Volksgarten with Temple of Theseus (Ephesus Museum), Houses of Parliament, Palace of Justice, Natural History and the Art History museums, Ministries of Justice and Railways, Academy of Art, Opera House, City Park with its Kursalon, private mansions, and the Austrian Museum of Art and Industry with its connected Applied Arts School (*Kunstgewerbe Schule*).[3] Whatever its failings, the pomp and circumstance of the Ringstrasse represented the rebirth of the visual arts in the Austrian capital. Its exhibitionism, as well as its emphasis on quality and integration, stimulated their future progress, even if that was to be in reaction against the conservative traditions it invoked. Many artists found training, employment and direction through the project. Further, aspects of its historicist styles, most of all Neo-Classicism, were to infiltrate the art of the modernisers.

After thirty years of the Ringstrasse era the slump began to draw to a close and a younger generation of artists emerged, newly confident in their abilities and critical in their approach. 1897 proved to be the critical year for the new movement. Coincident with the founding of the Vienna Secession, the conservative, histori-cally minded director of the Museum and the Applied Arts School, Professor Storck, retired, to be replaced by ardent modernisers. The museum's energetic

67

new director was Arthur von Scala, an orientalist and English design enthusiast, while Felician Freiherr von Myrbach, a painter and graphic artist, took over at the school. Both appointments signalled a new vibrancy and direction in the crafts, an effect that was immediately manifested through von Scala's publication of a monthly magazine, *Kunst und Kunsthandwerk*, devoted to their critical study, and his organisation of a series of seminal exhibitions.[4] Among the latter were shows of *Fachschule* work and international modern applied art. In late 1898 the latter included much English furniture, glass by Tiffany and Count Harrach's Bohemian glassworks, as well as the Austrian firms Lobmeyr and Bakalowitz, subsequently leading manufacturers of Wiener Werkstätte-designed products.

Von Scala's successes brought a new quality and confidence to Austrian applied art which was followed by new questioning about direction and a certain stand-off between the museum and school. By 1901 the two institutions had separate administrations. Myrbach began to appoint members of the Secession to his teaching staff – among them Hoffmann and Koloman Moser.[5] The young graphic artist Rudolf Larisch and the designer Carl Otto Czeschka were also engaged. Herein, the problems began to surface: Hoffmann and Myrbach backing a more aesthetically-based, modern approach than the ostensibly trade-driven or historical policies of von Scala.[6] However, at heart, despite their differences, both factions ultimately sought commercial, if not popular, success and the establishment of a distinctive identity for modern Austrian applied art that would ensure it.

It was no coincidence that simultaneously with the new attention being paid to the applied arts the Vienna Secession society had been formed in protest against the conservative, hierarchical and insular nature of the all-powerful Artists' House Association (*Kunstlerhausgenossenschaft*) with its 'market hall' exhibition policies, nor that its leader was a Ringstrasse architectural decorator, Gustav Klimt. The group sought to raise the level and influence the direction of Austrian art through contact with modern artists from abroad, exhibitions and the publication of a periodical. As a counterpart to this, the Secession's appearance also served as a reaction against the commercial approach of the Applied Arts Society (*Kunstgewerbeverein*), run from the Museum for Art and Industry since its founding in 1884. The Secession aimed to break the stranglehold of these establishment associations and transform the identity of contemporary Viennese art on all levels and in all fields.[7]

Appearance

VIENNA SECESSION

The Secession's first exhibition was held in March 1898. It attempted to reflect the diversity of modern international art, rather than present stylistic integrity. Thus leading artists from across the continent and America were shown together, whether realist, symbolist or Impressionist painters, Modern Style designers, decorative sculptors or ceramicists.[8] Yet there was an attempt to co-ordinate these contributions, to group works together, to colour-harmonise the decoration, settings and exhibits. This was carried out by the two architects who were to emerge as principal players in the development of the Viennese Secession Style, Hoffmann and Olbrich. In addition, announcing the emergence of the style, Hoffmann designed for the administration a 'Ver Sacrum' (Sacred Spring) room, a refined example of *gesamtkunstwerk* with delicate motifs of abstract dynamism on the walls,

woodwork and carpet, where the emphasis was on harmonised decorative restraint and functionality.

Following the popular and commercial success of its first show, the Secession, keen to define its particular direction, went about the creation of its own premises and exhibiting space. Olbrich was commissioned to make the designs and by autumn 1898 the building, sited just behind the Academy of Arts, was finished (Plate 24). With the Secession's stated aim being to heighten Viennese concern for the arts and to enliven contact with developments abroad, the idea of the building was one of a 'temple of art'. Over the front entrance was placed the group's motto, expressing the need for contemporaneity and liberation: 'To the Age its art, to art its freedom'. The building, while utilising an antique vocabulary, seceded from the fussy decorativeness of the historicist Ringstrasse architecture. It appeared as an embodiment of the Nietzschian description of the eternal struggle between rational (the Apollonian: reductive and controlled) and irrational (the Dionysian: expansive and vivacious) creative impulses. For on the one hand there are simple, cubic forms and flat wall surfaces which surround and create a covered courtyard structure with a glass-roofed exhibition hall in the centre, and on the other, there is an incongruous crowning laurel dome in gilt bronze openwork which emerges from the severe cubic white volumes of the four pylons. This acts as a symbol of art's vitality: its gold colour symbolises light, the laurel immortality, triumph, eternity, Apollo: the god of music, poetry, prophecy and medicine and the symbol of manly youth and beauty. Elsewhere are placed carefully selected symbols representing the counterforces of the irrational and rational, the unconscious and conscious. The first is seen over the entrance in the frieze of gorgons and snakes by Othmar Schimkowitz while the rational is represented by the three owls designed by Moser on the pilasters of the walls. This is Athena or Minerva – the goddess of

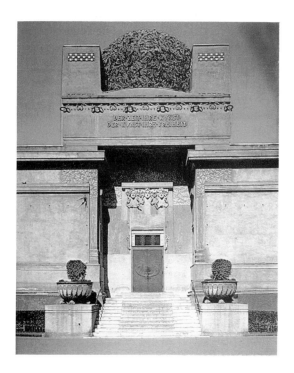

24 Olbrich, Secession Building, Friedrichstrasse 12, Vienna, 1898

wisdom, war and the patroness of the arts and crafts. She was to be further revealed, as an unwavering and determined winged warrior-angel, in Moser's circular stained glass window designed for the vestibule.

The ornamental details of the building are small circles, squares and rectangles, these echoing the shapes of the architectural structure. So the structure itself comprises a mixture of allegorical details and abstract decoration – a fusion that was to characterise the newly born Viennese arts movement around the turn of the century. For at this stage there was no indication that the rectilinear or the functional, the two attributes which are generally considered defining qualities of Viennese Secession style, would gain precedence. The sense of synthesis can be seen from the range of exhibitions organised by the group over the next five years, as well as examples of work in various fields by Secession artists. The exhibitions were disparate. An international cross-section of recent symbolist, realist and Post-Impressionist painting figured prominently, leading artists including Crane, Van Rysselberghe, Khnopff, Munch, Toorop, Gallén, Hodler, Böcklin, Von Stück, van Hofmann, Segantini, Signac, Gauguin, Van Gogh, the Nabis and Toulouse-Lautrec. Modern European graphic art, sculpture and photography was also shown, as was Japanese art and, at the eighth show in 1900, applied art from Meier-Graefe's *Maison Moderne*, Ashbee's Guild of Handicrafts and the Glasgow Four.

Equally important as the bringing to Vienna of the leading European modernists, the Secession also acted as a forum for its own members and their evolving conception of art. Two factions evolved, one, 'the naturalists' supporting 'pure' painting and sculpture, the other, 'the stylists' who preferred closely integrated forms of fine and decorative art. The latter were to show clearest affinity with the Art Nouveau movement. Most were to exhibit mature examples of their work in the climactic fourteenth exhibition, held in the spring of 1902. This was the 'Beethoven' show in which Secession artists created a homogeneous art ensemble around Max Klinger's centrepiece statue of the composer. Hoffmann oversaw the orchestration of the display, creating a basilica-type setting with the statue set as an altar in the empty space of the nave. The sculpture broke with monumental tradition in many ways. The naked Beethoven is seated on a throne, bowed forward with his legs crossed. A plethora of materials is employed: white, red and blue marbles, bronze, alabaster, yellow agate, glass, ivory, pearl, jasper and gold leaf. Numerous symbols allude to his stature as an artist-god, to Prometheus, Zeus, Tantalus, Adam and Eve, and Christ, none directly denotes music.

Overall the Beethoven exhibition presented a unique image of art as a cult, with the artist as priest, in touch with the rhythms of the cosmos and 'administering the life-giving sacraments of beauty and truth'.[9] As a backdrop to the statue, the Secession's then president Alfred Roller, created a mural entitled *Nightfall*.[10] In this repetitive stencilled images of a bowing female beauty, the daughter of Elysium, offer up sacramental moon-like, glowing orbs to the starry night, the outline of their naked bodies visible through drapes covered in 'knowing eye' patterns. The effect of the design, with its interlacing abstract movements and connecting parts is symphonic, a visual accompaniment to Mahler's arrangement for trumpets of Beethoven's final chorus in the Ninth Symphony which was to be played at the opening.

In fact, visual art approaching musical form was a consistent feature of the exhibition. The co-ordination of twenty-one artists' work within one conceptual framework bore witness to this. Here then, the individual was subjugated to the

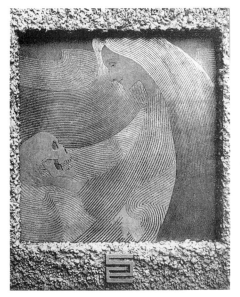

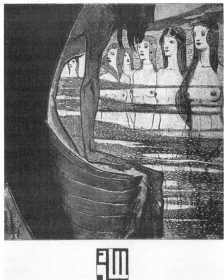

25 Stöhr, plaster cut, Beethoven exhibition, Vienna, 1902
26 *right*] Luksch-Makowsky, *Sadko choosing his bride*, metal inlaid and painted panel,
Beethoven exhibition, Vienna, 1902

celebratory whole, in this case Beethoven's themes of psychological journey, reali-
sation of spiritual freedom, joyous affirmation and familial reconciliation, particu-
larly as expressed in his last symphony with its reworking of Friedrich Schiller's
'Ode to Joy'. The separate parts of the ensemble, which were designed to be viewed

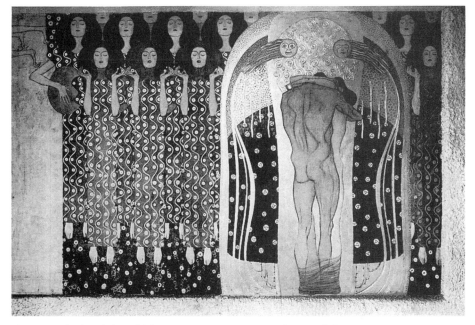

27 Klimt, *Kiss for the whole world*, frieze, casein on stucco, Beethoven exhibition, 1902,
Secession Building, Vienna

in circulatory (clockwise) order with separate circles within the greater circle, alluded to Beethoven's evocation of God-in-nature and universal harmony.[11] They included large wall paintings: Adolf Böhm's *Dawn*, a counterpart to Roller's mural in the central hall, with its stylised images of Eos, the Greek dawn goddess, attending a golden, cosmic fire; Klimt's renowned *Longing for Happiness* friezes in the left aisle; the friezes in the right aisle – Ferdinand Andri's *Manly Courage and Struggle for Joy* and Josef Auchentaller's *Joy, the Beautiful Spark of the Divine*; Friederich König's and Ernst Stöhr's vertically elongated, gilded panels with their ascending groups of maidens, these, in the case of the former, being eight cithara players floating in ether above stylised plants and clad in rose-patterned dresses.[12]

The smaller works, also arranged in sequence and using a variety of media but generally square in format, included Hoffmann's monochrome, abstract-geometrical 'overdoor' reliefs ; Andri's blatant depiction in carved wood of sledge-hammer tyranny; Moser's glass flux mosaic of flying angels; Maximilian Lenz's copper dancing nymphs and fornicating centaur and mermaid; Rudolf Jettmar's fresco visions of bondage and suffering; Leopold Stolba's elegiac cement relief of *Euterpe*, the muse of poetry and music; Stöhr's metallised plaster-cuts (Plate 25) of curvilinear *femme fatale* and tree of life; Emil Orlik's transluscent figure in an intarsia-formed Japonist nightscape; Max Kurzweil's silicate coloured sexual serpent; Elena Luksch-Makowsky's *Sadko Choosing his Bride* (Plate 26) and *The Constancy of the Sun of Love* in metallic intarsia[13]; and König's brooding Prometheus relief.

One of the most remarkable contributions to the exhibition was by Klimt.[14] In his friezes to the left aisle he visualised the following sequence: the longing for happiness; the sufferings of feeble mankind and its appeal to the armoured man; passing the hostile powers – Typhoeus and his three daughters, the gorgons; repose in poetry; the kingdom of the ideal, a choir of heavenly angels, joy – the divine spark, and a kiss for the whole world (Plate 27). The synthetic nature of the friezes, their multi-level symbolism encapsulating the journey to joyous liberation, is full of ambiguities – witness to the enslaving, tormenting world of physical reality and the beatific, dissolving ethereal realm of the spirit. Thus the figurative combines with the abstract, the dominant phallic with the golden harmonic; the light, empty space of the ideal with the dark, turbulent coils and ruptured serpentine twists of the material; the grotesque female forms of earthly suffering – disease, madness, death, debauchery, unchastity, excess and nagging grief – with the perfect female incarnations of poetry, pure joy, happiness and love, and male incarnations of heroic strength. Everything is stylised, made decorative.

The snubbing of convention inherent in Klimt's panels (and the exhibition as a whole), together with the sense of narcissistic fulfilment, overt and implicit sexual imagery, use of antique formulae, metamorphic beings on a journey of growth, and incorporation of nineteenth-century German philosophy (from Kant through Wagner to Nietzsche and Schopenhauer), was to be represented in much of his work. It was seen, for instance, in his controversial, grotesque murals depicting 'philosophy', 'medicine' and 'law' commissioned for the university; his *Danaë* being impregnated by Zeus and his *Judith and Holofernes*. It was also to reappear in another collaborative *gesamtkunstwerk* setting, the creation of the Palais Stoclet near Brussels. Besides this he was also to create works that suggested a monistic conception of reality, not least in his square, mottled or mosaic-like landscapes, his portraits of women and human-aquatic subjects.

The recent focus on Klimt has been to the detriment of other Secessionists.

Yet Moser's art was also to emphatically express the fusion of Apollonian and Dionysian impulses, the development of his approach being vividly displayed in his graphic art, furniture and metalwork.[15] These varied between 'typical' Art Nouveau curvilinear motifs with hybrid figures, in which visual nature, fantasy and scientific theory combined, and rectilinear lattice-work designs. In their different ways both displayed the tendency towards abstraction in order to purvey a feeling of essence, and both to be found in his designs for *Ver Sacrum* (Plate 28), the Secession periodical which began to appear in 1898. One example of the first trend was a visual accompaniment to a 'transformist' poem by Arno Holz where an iris is in the process of metamorphosing into a young woman. This expresses an evolutionist theory of all life-forms deriving, through a process of gradual transformation, from a few simple organisms. Such a process of transmutation is suggested by the lyrics of Holz, the most renowned literary propagator of 'natural rhythms':

Seven billion years before my birth I was an iris
Beneath my shimmering roots revolved another star
On its dark waters swam my blue gigantic bloom.[16]

Having originally been a student of painting at the Vienna Academy, Moser's switch to design, and in particular to the Applied Arts School and the Bohemian glass manufactures where he studied in the mid-1890s, was an indication of his overriding concern to unite the aesthetic with the practical. But he was also concerned, as a genuine Secession member, to truthfully express the spirit of the age:

We are now living in the times of automobiles, electric cars, bicycles and railways; what was good style in stage-coach days is not so now, what may have been practical then is not so now, and as the times are, so must art be.[17]

This meant that he could be diverted from an art which utilised symbolist conventions, being ethereal, musical and figurative, and expressing at once the emotional and immaterial, the untamed and organic – as in his 1897 design for the Vienna City Schubert Centenary Ball, 'Allure for me a will-o'-the-wisp there' with its phosphorescent female synthesised with the musical border, lilies and landscape. Or as in his textile designs, executed by Joh. Backhausen and Sons, with their swirling, dynamic forms of abstract force. The diversion was towards the standardisation of the machine age. This meant the stripping away of extraneous detail and ornamentation for the sake of a new rationalism, a functionalist order, though still imbued with a sense of style, of refinement in simplicity. In *Ver Sacrum* this was to be apparent, for instance, in the illustration 'Early Spring', a rhythmic design based on black, white and orange polka dot patterns. However, such reductive art, where recourse was essentially to opposites, to black and white, solid and void, square and rectangle, was to be most effectively expressed in Moser's household objects – his chairs, cabinets and tableware designed for the Wiener Werkstätte.

WIENER WERKSTÄTTE
The effect of style, the patronage and the choice of expensive materials that characterised much Secession and Werkstätte work belied the social concerns of its artists. This was even to be the case with Hoffmann's and Moser's severe *gesamtkunstwerk*, the earliest Wiener Werkstätte edifice, the Purkersdorf Sanatorium (1904–5), with its radically simple iron and concrete construction, exposed steel ceiling girders, all-pervasive quadrangular design concept (from the plan to

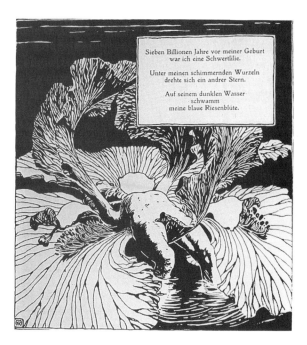

Sieben Billionen Jahre vor meiner Geburt
war ich eine Schwertlilie.

Unter meinen schimmernden Wurzeln
drehte sich ein andrer Stern.

Auf seinem dunklen Wasser
schwamm
meine blaue Riesenblüte.

28 Moser, illustration to Holz,
Ver Sacrum, 1898

the fittings and furniture) and minimalist decoration. This, despite its appearance as a stripped bare, lunatic asylum, was actually a luxurious and fashionable spa retreat, away from the realities of the metropolis, for the moneyed classes of Vienna. It was commissioned by Dr Viktor Zuckerkandl, brother-in-law of a fervent admirer, intimate and early critic of the Secession, Berta Zuckerkandl.

The Werkstätte had been established in 1903 as a combined design, production and commercial enterprise. Financed by another wealthy patron of the Secession, the Jewish textile magnate Fritz Wärndorfer, it was registered as a manufacturing guild of craftsmen. Its creation was recognition of Vienna's leading designers' awareness of the need for a closer integration of all the means of art production. To this end Hoffmann and Moser had, after the success of their exhibit in Paris (and without Olbrich who had departed for the artists' colony in Darmstadt), founded *Kunst im Hause* (Art in the Home) in 1901. This was a group which consisted primarily of their graduates from the Applied Arts School. It specialised in modern interior and household object design but lacked workshops and studios. However, the following year Hoffmann and Myrbach visited the London arts and crafts workshops, notably Ashbee's Guild of Handicraft, after which they returned to Vienna and set up the Werkstätte.[18]

In a way the Werkstätte was utopian and socialist, its ideals being derived from Ruskin and Morris, and hence, ultimately doomed to failure on its own terms. Nevertheless it achieved a remarkable design revolution that was to have repercussions for much twentieth-century design. It set itself high targets – of craftsmanship, material selection, unification of ornament and structural form and an emphasis on function; common aims for Art Nouveau artists – all but the functional aspect even coinciding with Gallé's attempts to overhaul the applied arts in Nancy. The members wanted virtually the whole of contemporary Viennese material culture to be scrutinised and redesigned – preferably by them. Hence they not only

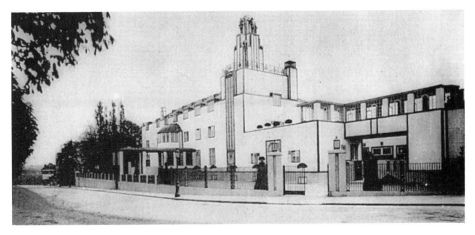

29 Hoffmann, Palais Stoclet, 279–281 Avenue de Tervueren, Woluwé-Saint-Pierre, Brussels, 1905–11

worked on complete buildings and interiors but also created coffee cups, oil and vinegar cruets, egg cups and spoons, umbrella stands, vases, wastepaper baskets, dressing tables, fruit baskets, storm lanterns, samovars, clocks, purses, glasses, trays, fabric patterns, wallpapers, dresses, posters, ceramics, jewellery, bookbindings, lettering, postcards, envelopes, stamps and packaging.

They worked from large premises on Vienna's Neustiftgasse, which housed workshops for jewellery, metalwork, bookbinding and leatherwork, woodwork and lacquerwork. In addition there was an architectural office, headed by Hoffmann. Prior to the opening of this Hoffmann's house designs had revealed an original ability to combine the Austrian rustic and the English vernacular in a display of romanticist modernism. He had built suburban villas and country houses almost exclusively for the upper middle classes, such as the industrialists Karl and Paul Wittgenstein, the doctors Henneberg and Spitzer and the artists Moser and Carl Moll. Now, however, the collaborative effort led by him and Moser at the Werkstätte soon revealed a definitive house style based on square or rectangular screen work in which dark and light, function and ornament, solid and space were combined with a simplicity that was austere if not cheap to come by.[19] In fact it was exactly their cult of refinement that was to be their downfall, getting carried away with it as they did the enormously expensive Palais Stoclet (1905–11) (Plate 29), the symbol of both Austrian and Belgian internationalist patriotism, created for a multi-millionaire Belgian rail and coal magnate. For although they were willing to use inexpensive and common materials and modern techniques, their emphasis on research and experiment, their belief in craftsmanship and the avoidance of corner-cutting in the production process, proved labour intensive, costly and hence primarily available only for the well-off *haute bourgeoisie*. Further, as far as the Stoclet was concerned, though the timeless effect was simple, atectonic and primarily derived from the stark interplay of black, white and gold, it was achieved at great cost – with white Norwegian marble, yellow Italian marble and black Swedish granite as linings, copper roof, onyx and malachite inlays. To this was added the luxurious decorative work by Werkstätte artists – the sculptures including Michael Powolny's Pallas Athena above the entrance, Richard Luksch's

feminine group in the garden and Franz Metzner's Atlases atop the tower; inside designs included Czeschka's chased gold work, embroidery and stained glass, Luksch-Makowsky's ornamental figures, Bertold Löffler's majolica work and Klimt's mosaic mural in the dining room. The latter, with its Byzantinist Tree of Life and richly ornamented, mysterious figures of expectation and fulfilment, extrapolated from the narrative and ancient vocabulary of the Beethoven frieze the celebration of physical and spiritual love, developing its language into a more sensuous abstract-organic style.

The Werkstätte approach meant paying attention to every detail and making the object as functional, convenient and comfortable as possible. Such a design tyranny could be both overbearing and elitest, as had already been intimated by the Beethoven show. However, these aspects were diminished in the approach of the Secession's and Werkstätte's father figure, Otto Wagner. For he consistently emphasised appropriateness to modern life, as expressed in his participation in the urban regularisation plan, in particular the Stadtbahn and Waterway systems (from 1894). Further, he also paid homage to functionalism, industrial materials, the lower levels of society and Austrian nationalism, even in such disparate buildings as his seminal Linke Wienzeile tenements (1898–99), St Leopold's Church at Steinhof (1905–7, another Werkstätte collaborative project), and Post Office Savings Bank (1904–6, 1910–12).[20]

In addition, the elitist aspect was entirely absent in the Vienna *Arbeiterheim* (The Workers' Home) (1902–3), the first work of Wagner's pupil Hubert Gessner. Probably the earliest permanent embodiment of the socialist ideals of the new wave of designers, this multi-functional building encapsulated, like Horta's *Maison du Peuple* in Brussels, the suitability and adaptability of the new design regime to low-cost projects for the poor and underprivileged.[21] A symbol of the new socialist force in Viennese politics, Gessner's *Arbeiterheim* comprised compact workers' apartments, offices, a library, a restaurant, buffet and a large community hall. Decoration was austere, but not absent – wave patterns adorned the walls, metalwork was ornately curvilinear. However, functionalism had the upper hand, with the hall utilising movable partitions for different events, be they recreational or political meetings, or concerts. In addition its curved ceiling was of iron and concrete, with girders left exposed, as were the iron brackets of the gallery and the roof ventilators. In contrast to the Purkersdorf sanatorium, however, the girders were painted red, the same left-political colour of the flags designed, but banned, for the flagposts extending horizontally from the cornice of the street facade.

Notes

1 G. Mourey, 'Round the exhibition. IV. Austrian Decorative Art', *The Studio*, vol. 21, 1901, p. 113.
2 In 1780 the Vienna population was 200,000; by mid 19th century it was over 400,000. In 1870 it was around 800,000 and by 1902 it had reached 1,675,000, making it the fourth largest city in Europe.
3 The applied arts collections of this museum had been established in 1863, shortly after the abolition of the guilds' monopoly over craft production, and by 1905 had become extremely extensive, including examples of metalwork, ceramics, glassware, textiles, furniture, leatherwork and bookbindings both ancient and modern, occidental and oriental. There were also complete rooms designed in a variety of historical styles. Besides its art collections the museum also contained a library and lecture rooms, the latter providing

an important forum for the exploration of new ideas about art as witnessed, for example, through the modern subject of Sigmund Exner's 1882 lecture on 'The physiology of flight and suspension in the visual arts'.

4 Von Scala's exhibitions included: Japanese woodcuts 1899, 1902 and 1905; bookbinding 1903; Austrian folk art 1905; lace 1906 and metalwork 1907. Another important development was that women were encouraged to enrol as students.

5 Alfred Roller, another Secessionist, was already on the staff. Hoffmann, like Adolf Loos, his fellow initiator of the Modern Style in Vienna, was a graduate of the Higher State Crafts School (Gewerbeschule) in Brünn (Brno), Moravia. By the 1880s this had established a reputation as the most advanced architectural school in the Habsburg empire.

6 A sign of the rift was the omission of Wiener Werkstätte objects from Museum exhibitions while von Scala was director (i.e. until 1909) and the refusal of Secession artists to contribute to von Scala's programme for Austrian representation at the Turin international exhibition in 1902. Similar problems were also encountered in the organisation of the Austrian contribution to the St Louis exhibition in 1904, though by this time it was clear that it was internal dissensions among the Secession members, shortly to be made manifest through schism, that led to their failure to exhibit collectively. The situation appeared further confused by the participation at St Louis of the *Fachschulen* and, in particular, the Vienna *Kunstgewerbe Schule*, including Hoffmann's, Moser's and Myrbach's studios. By contrast to von Scala, his counterpart at the Mährisches Gewerbemuseum (Moravian Craft Museum) at Brünn, Julius Leisching, was one of the first to display (and subsequently buy) Werkstätte applied art, when he did so with an exhibition of modern tableware from the Austrian empire in early 1905.

7 Despite its prevailing conservatism, the *Kunstlerhaus*, founded in 1861, did show the work of leading European artists, among them Vereshchagin, Repin, Alma-Tadema, Israels, Puvis de Chavannes, Sisley, Monet, Rodin, Liebermann, Hölzel, von Stuck, Böcklin, Segantini, Fantin-Latour, Klinger. The *Kunstgewerbeverein* also revealed a limited flexibility, showing some modern Viennese designers at its exhibitions. For a fuller description of the Secession's establishment, approach and exhibitions, see, for instance, P. Vergo, *Art in Vienna 1898-1918*, Oxford, 1981; and N. Powell, *The Sacred Spring: The Arts in Vienna 1898-1918*, London, 1974.

8 Foreign exhibitors included Vallgren, Van de Velde, Charpentier, Khnopff, Trubetskoy, Liljefors, Meunier, Frampton, Brangwyn, Besnard, Carrière, Whistler, Aman-Jean, Crane, Rodin, Steinlen, Mucha and Klinger.

9 F. Whitford, *Klimt*, London, 1993, p. 87.

10 Roller was an extremely influential figure in the Secession movement. One of the first editors and illustrators of *Ver Sacrum*, he was also responsible for the arrangement of several exhibitions, was a principal designer for Mahler at the Vienna Opera, worked for the Wiener Werkstätte, and in 1909 succeeded Myrbach as director of the Applied Arts School.

11 In Schiller's hymn the universe is seen as a clockwork mechanism, with joy its spring.

12 Stöhr was a particularly influential figure in the Secession. A painter, graphic artist, poet and musician, he also acted as ideologist for the group, publishing his ideas in exhibition catalogues and *Ver Sacrum*. In 1899 Olbrich built an impressive Modern Style house for him at St Pölten, west of Vienna.

13 Luksch-Makowsky, wife of the Secession sculptor Richard Luksch, was one of two Russian women artists resident in Vienna to exhibit with the Secession (at the seventeenth exhibition, 1903, Teresa Ries, showed the Rodinesque sculpture *The Soul Returns to God*). Luksch-Makowsky's works responded to Russian sources with similar universal, transcendental/enlightenment leitmotifs as the rest of the exhibition: the first a Novgorodian epic poem about the struggles and attainments of a *gusli* player, itself recently interpreted in operatic form by Rimsky-Korsakov (1897), and the second a messianic verse by the philosopher Vladimir Solovyov.

14 There is a wealth of literature on Klimt and his friezes. See, for instance, Whitford, *op. cit.*, C. Nebehay, *Gustav Klimt: From Painting to Drawing*; S. Partsch, *Klimt. Life and Work*, Munich, 1993; G. Frodl, *Klimt*, London, 1990. This attention has tended to obscure the work of the other Secession participants and heighten the sense of artistic individuality

where the emphasis was on collaborative integration and ultimate joy through communional 'brotherhood'.

15 Concerning Moser, see D. Baroni and A. D'Auria, *Kolo Moser. Graphic Artist and Designer*, New York, 1986.

16 *Ver Sacrum*, I, xi, 1898, p. 2. The eleventh issue contained several other illustrations to Holz – by Hoffmann, Alfred Roller, Adolf Böhm and others.

17 Cited from A. Levetus, 'Koloman Moser', *The Studio*, vol. 33, 1905, p. 114.

18 For a comprehensive survey, see W. Schweiger, *Wiener Werkstätte: Design in Vienna 1903–1932*, London, 1984. The Viennese designers also visited Mackintosh in Glasgow in 1902.

19 For Hoffmann, see P. Noever (ed.), *Josef Hoffmann Designs*, Vienna, 1992.

20 Wagner's architecture has been extensively studied. See, for instance, H. F. Mallgrave (ed.), *Otto Wagner. Reflections on the Raiment of Modernity*, Santa Monica, 1993; H. Geretsegger and M. Peintner, *Otto Wagner 1841–1918*, London, 1979.

21 Gessner was to lead the way in the post-war and post-Habsburg social housing programme, designing the massive Metzleinstaler Hof (1919–23), the first tenement block built by the Vienna Municipality under the control of the Social Democrats.

7

CZECH

Prague and beyond

Background

At the heart of Europe, Prague proved to be one of the most vital and important centres for Art Nouveau. Yet the movement for the revitalisation of the arts in late nineteenth-century Prague was far from smooth. Towards the end of the century many critics, artists and intellectuals were openly disparaging and despairing of the state of things. Dismissive of the achievements of recent years, the most radical saw no future for Czech art as long as it clung to historicist models imported from Germany and responded to the tastes of the Habsburg court.

One of the most important catalysts for the development of a modern aesthetic in Czech art and literature was the periodical *Moderní revue*. Founded in 1894, it served as the vehicle of the most decadent and progressive elements in Czech cultural society; was thoroughly internationalist (its early numbers were even published in French and German as well as Czech), being opposed to 'Czechocentricity' and local Germanisation; included disparates of political ideology and artistic approach; included graphic work by leading Czech artists and illustrated articles on artists such as the Pre-Raphaelites, Munch (by Przybyszewski), Rops, Vallotton, Redon, Ensor, Beardsley and Henry de Groux. Essentially, the review was concerned with the search for, and expression of, a new beauty; this in the light of the decay in social, ethical and creative values brought about by the urbanisation and mechanisation of European life in general, and the feeling of Czech degradation and exile in their own Habsburg-controlled lands in particular.

Still, the late nineteenth century was far from being a period of total cultural stagnation in Bohemia. Rather, an historical process of renewal was going on that eventually saw the flowering of Czech Secession Style (*Style Secese*) into an original and distinctive movement marked by its high quality. Events such as the creation of new art establishments, increased access to movements abroad, important exhibitions held in Prague from 1891, and the redevelopment of Prague Old Town and the Josefov district, begun in 1893, helped usher in a new era that was simultaneously one of self-promotion and self-criticism, new confidence and new doubts.

Further, the progress of the arts in Bohemia and Moravia of the 1890s was stimulated by a complex national struggle, begun earlier in the century, that saw the erosion of the cultural supremacy of the large German minority in favour of the Czech majority. This was intensified by the Pan-Slavist movement directed from Russia which fanned the Czech/German national differences. National parties 79

had emerged, first the conservative, propertied Old Czechs, then the more progressive Young Czechs who represented workers and the lower professionals. The national revival was also encouraged by the Bohemian lands being the focus of Austrian industrialisation,[1] which through bringing together the formerly dispersed, agrarian Czech labour force under a German-controlled system inevitably led to its politicisation. The original focus of the national rivalries was language – the Czechs demanding that theirs become the official one. The Czech movement was further stimulated by franchise reforms, first in 1873, then in 1895, which meant that virtually every adult male had the right to vote. These events, and the inherent conflicts they brought with them, impacted on the art and literature of the late nineteenth century by stimulating a medley of styles that could be associated both with different national and political interests, as well as the attempt to transcend them.

A key figure in the emergence of national revivalism in painting was Josef Mánes, who incorporated his mid-century study of the Slavic folk art of Moravia, Slovakia and Silesia into his own artistic expression. His romantic portrayal of local life, traditions and mythology resulted in some formal stylisations and motifs that anticipate those of Art Nouveau. These can be seen, for example, in a flag designed for the Raudnitz Beet Association, in which he entwines the artificially coloured figures of St George and the dragon in a decorative labyrinth of golden arabesques. Other Neo-Czech painters emerged, among them Václav Brozík, with his grandiose depictions of Jan Hus and George of Podebrady (King of Bohemia), František Ženišek and Mikoláš Aleš, the latter two collaborating to produce a vast patriotic decorative cycle on the theme of 'My Country' for the Neo-Renaissance style National Theatre in Prague. Aleš' work was to prove an important stepping stone to Secession Style and it was he who was to be appointed the first chairman of the group which was to subsequently promote it, the Mánes Society. A prolific illustrator of Czech history, in the mid-1890s his graphic designs were transferred to facades of the new monuments to Prague wealth, such as the Zemska (Provincial) Bank, the Wiehl Building and Storch publishing house.

The Zemska Bank building, created on one of Prague's most fashionable streets for one of the richest banks in the kingdom, was to be a brilliant showpiece for the institution. The city's leading architect and artists, most of whom went on to establish the character of Czech Secession Style, were employed on the project. Indeed, despite its predominantly Neo-Renaissance conception, the germs of the later style are evident in separate elements of Osvald Polívka's four-storey building, particularly in its wealth of allegorical and organic mosaic, sculpture, relief and painting decorations. These included: Celda Klouček's and Stanislav Sucharda's figure reliefs of Technology, Agriculture, Industry and Trade on the mezzanine piers; Max Švabinský's richly coloured vestibule wall paintings of St Wenceslas blessing Labour, the source of prosperity; Karel Mašek's and Karel Klusáček's staircase paintings; statues representing the twelve regions of Bohemia in the banking hall; Anna Boudová's tile panels with stylised botanical motifs for the attic storey; and the semi-circular lunette cornice mosaics with stylised figures and golden ground designed according to cartoons depicting industrious heroes of Czech mythology by Aleš.

While the young artists promoted by the Zemska Bank were dismissed, along with their immediate predecessors, for their pseudo-nationalism and historicism by the radicals of *Moderní revue*, just as the German-dominated Art Lovers Association at the Rudolfinium were castigated for their inferior quality and

lack of either contemporary relevance or coherent programme, they nevertheless represented a significant development in the unfolding cycle of modern Czech art. For it was precisely their appearance which brought about a vital eclecticism, created through keen and original selection of decorative elements from historical and national styles which led the way for the modern movement.

In fact the process of artistic regeneration very much involved, and was symbolised by, the establishment of the Rudolfinium in 1872. This project indicated the social changes taking place in Prague society, in that rather than being funded by traditional art patrons, the church or nobility, it was initiated by the business community – in this case the Bohemian Savings Bank. Constructed by the Vienna-trained architects Josef Zítek and Josef Schulz, professors at the Prague Polytechnical Institute, it was planned as a House of Artists, with music conservatoire, art gallery, studio space and a museum of applied arts. It was to be a temple to the arts, created in a medley of historicist styles, these harmonised with functional considerations in a powerful attempt at secular *gesamtkunstwerk*.

Other developments in the arts followed. In the early 1880s the Rudolfinium was to be flanked by the new School of Applied Arts and in the late 1890s by the separate building of the Museum of Applied Arts. This triad of art establishments represented the Prague community's striving for new levels of artistic competence, quality and understanding. According to its founders, the aim of the museum, whose early basis was a collection of objects purchased at the 1878 Paris World Exhibition, was 'to provoke public interest in the applied arts and to refine their taste as well as to encourage new creative work that responded to the more exacting contemporary demands in the fields of arts'. The response was, from 1887, to organise exhibitions, design competitions, lectures and a library for public use. The new building was the result of the growth of the collections and the gradual releasing of funds by the Prague Chamber of Commerce, the Provincial Diet of the Kingdom of Bohemia, the Austrian government and the Municipal Council. The School of Applied Arts opened in 1885. It was run as part of the Austrian Ministry for Education and Culture's programme for the revitalisation of the arts throughout the Habsburg monarchy, with kindred schools in Vienna and Lemberg and a close relationship with the Bohemian *Fachschulen* and the Museum.

With the creation of these new institutions, which broke the divisive monopolies held by the Prague Academy of Fine Arts and the Polytechnical Institute, Czech fine and applied arts underwent a new form of integration. The increased study of historicist styles stimulated their proliferation in the late 1880s and early 1890s, but still their grip was simultaneously beginning to weaken, as artists started to utilise alternative sources, including Austrian, French and Slavic models, and to be more brazen in their use of industrial materials. Further, the curriculum of the schools and their distribution across the Bohemian lands, greatly raised the quality of crafts such as glassmaking, metalwork, ceramics, bookbinding and furniture making – a fact that was recognised internationally through their successes at Paris in 1900 and St. Louis in 1904.

Appearance

In terms of the development of Art Nouveau in Bohemia the installation of the Prague School of Applied Arts at the Paris World Exhibition, while still eclectic,

was an important signpost for the burgeoning movement. Contributions by the staff of the school included a glass display case by Jan Kotera, designed in austere, rectilinear form and indicative of his 'functionalist' training under Wagner at the Vienna Academy. Integrated with a carved wall relief of villagers returning from work by Stanislav Sucharda, this held some fine examples of floriate metalwork from Emanuel Novák's studio and majolica vases, bowls and jugs, similarly adorned with botanic motifs, from the atelier of Celda Klouček. In addition, the installation included the ornate, but highly functional woodwork of Jan Kastner. The latter included an ingenious light three-legged folding chair with rising stretcher joined with the curved back complete with mask and roses (Plate 30). Kastner also showed a modern 'Czech style' domestic altar, adorned by delicately stylised, curvilinear floral motifs which covered its rectangular wooden frame and the altar cloth. This was completed with a brass lamp by Novák and laconic, stylised paintings by Felix Jenewein, another teacher at the school, on the life of Ludmilla, patron saint of Bohemia.[2]

The initiators of the Czech Secession Style, looking in more than one direction at once, turned to Slav revivalism, taking their lead from Mánes and Aleš, as well as to developments in Paris, Vienna and St. Petersburg. This signalled a new permeability to European culture as a whole and an abandonment of any narrow nationalist tendency. A primary indication of the new energy of such exchanges was the distinct combination of inspirations at work in Alfons Mucha's art and Jan Kotěra's architecture. Notwithstanding the idiosyncrasies of much of the Czech mod-

30 Kastner, folding chair, 1900

ern art, there was, in its search of primitive, scientific, organic and spiritual sources, a unifying trend that can be identified as a programme for purification.

The assimilation of developments abroad, and in particular symbolism, was led by the painter Vojtěch Hynais, who lived in Paris from 1878 to 1893, the influential, proto-Art Nouveau sculptor Josef Václav Myslbek and the painter Maximilián Pirner. In the early 1890s Hynais and Myslbek often sought to express the integral relationship of the human soul and physical nature, infusing their work with a rhythmicality that delicately fused the naked female form with its surroundings in a lyrical way, as in Hynais' *The Judgment of Paris* and Myslbek's bronze *Swansong* and *Music*. On the other hand, Pirner, a member of the Vienna Secession, was to create starkly allegorical paintings with grotesque gorgons and muses depicting the tragic relationship of beauty, life and death.

BÍLEK

Greater radicalism was left to Pirner's student, František Bílek, one of Bohemia's leading artists of the new movement, whose work drew inspiration from the spiritual synthetism of both the Czech poet Otakar Březina and Gauguin. During his 1891–92 Paris stay he encountered the evocative religious primitivism of Gauguin's decorative art. Back in Bohemia he designed, with a free interpretation of the vernacular, his own studio-house in the countryside near his native Chýnov, a small town fifty miles south of Prague. Assimilating Gauguin's harmony of the

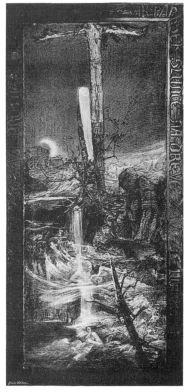

31 Bílek, *Meaning of the Word 'Madonna'*, 1897, wood carving, 153 x 93.5
32 *right*] Bílek, *How the Sunbeam Kills the Wood of Life*, 1899, charcoal on paper

rustic, crude and spiritual in his Bretonist vases and wood reliefs, Bílek began to create graphite-coloured earthenware vases and jugs decorated with floral and human images as well as wood reliefs and sculptures. The primitivist ceramics involved many modernist principles – notably an organic, asymmetrical curvilinearity, dynamism and metamorphism that fused figures and foliage, as well as script, into an integrated, flowing whole.

The wood relief *The Meaning of the Word 'Madonna'* (1897) (Plate 31) has a rough finish and complex interplay of visual and symbolic images. At the centre of the work, which appears like a torn, weathered or burned fragment of paper or bark, is a tattered, open book. Referring to the opening verses of John's gospel, the leaves, which are creased and crumpled, incorporate unevenly written text with illustrations of Christ, the sun and a moonlit sky. Surrounding the book are further images of Christ, hands with stigmata and nails, a broken cross, a Mary-like figure (the *pietà*?) bending over an indefinite horizontal form, a heap of skulls, a face with flowing tresses of hair and a star. Some are carved reliefs, others are grooved lines; some are placed horizontally, others vertically; the hair of the suffering head at the bottom melds into the stooped Mary figure. There is no sense of illusionistic space. Figures are disproportionate to one another, disjointed or fused ambiguously. Behind the head of Christ in the top right corner another bearded head appears, seemingly Bílek's self-portrait, delineated by a few scratches in the surface. Avoiding narrative, all is suggestion.

Bílek's concentration on the fusion of matter and spirit, darkness and light, mankind and nature, was to be a permanent characteristic of his mature work. Sometimes it was expressed more simply, as in the portraits of his mother and father, which incorporate naturalistic images of their faces into untreated wood, in which even the bark is retained, as if the person emanates from the tree. The prevalent union of the human figure and the tree appears a deliberate correlation with Christian symbolism where the tree can represent either life or death. It was also to be found in his *Crucifixion* (1897) which Wittlich has described as 'the first great sculpture executed in a truly Art Nouveau spirit'.[3] The tortured, emaciated figure of Christ appears real, only his limbs are one with the cross and the swirl of his hair one with the sign. Yet the cross itself is roughly hewn and appears to grow organically from the wooden clump that is its plinth. Further, it is set against a flat wooden panel into which are carved stylised attributes of the crucifixion: parts of the crown of thorns, hands and feet with nails, a mournful female face, script, fragments of brick wall.

Bílek's synthetic approach to sculpture corresponded to that expressed in his graphic art. *How the Sunbeam Kills the Wood of Life* (1899) (Plate 32) is dominated by anthropomorphised nature. The trunk of a crucifix-shaped tree splits, revealing a barely discernible female face shrouded in white, she vapourises into the night sky, rocks take on human form, the land and gushing water teem with bevies of minute naked figures in a welter of struggling movement, and the frames are carved with script. This cosmic fantasy, with its questions about the nature of existence, the suffering of man, shows parallels with Rodin's *Gates of Hell* and Wyspiański's pastel *Treasure Hoards*.[4] Organic symbolism and cataclysm are likewise present in Bílek's drawing *The Kiss of Judas*, though here he creates a swathe of partly-revealed human forms caught up in a gigantic wave-like movement around the monumental figure of Christ and fragments of a classical portico. Here Judas is depicted upside down, as if superimposed in a centaur-like pose on the crescendo of the wave.

Another artist who helped engender the Secession Style through his contact with French developments was Karel Mašek. Indeed, like Gallén and Sparre, as well as Mucha with whom he arrived from Munich and helped get established in the French capital, Mašek studied at the Académie Julian in Paris during the late 1880s. There at that time were the fledgling Nabis: Serusier, Bonnard, Vuillard, Denis and Ibels. And as Gallén, Mašek was to show a versatile ability, not only in his approach to painting, which veered between realism, a Von Stück-inspired symbolism and a Neo-Czech style, but also in his work in other fields, such as architecture, decoration and graphic design. In 1898 he was appointed professor of ornamental design at the Prague School of Applied Arts and henceforth it was his instruction in the methods and principles of decorative work that were to be of most significance for the development of stylised natural motifs. Still, in 1901 he built his own villa, in the new, fashionable Prague suburb of Bubeneč. In this he broke away from the classical box through the use of curving walls and window frames, the asymmetrical placing of windows, an interpretation of vernacular forms, such as the hipped, double roof and decorated wooden gable supports, foliate painting and stucco work as well as allegorical sculpture on the exterior. All of which combined into a unity of design that indicates a response to Van de Velde's Bloemenwerf, Gallén's Kalela or, closer to home, to the house of his neighbour, Jan Koula.

Mašek's turn to architecture followed a decade of change in Czech building practices and principles. In 1891 the Jubilee Exhibition of Countries of the Kingdom of Bohemia took place in Prague. One of the major European exhibitions of the late nineteenth century, the aim was to show off the quality and innovation of Czech industry as well as the strength of its economy and culture. Originally envisaged as a universal exhibition for the promotion of art, science, industry and agriculture, the emphasis was localised after the local German sector refused to accept the notion of responsibility-sharing with the Czechs and pulled out. As a result there were 146 pavilions promoting Czech national achievements and business, the pride of them being the 200-metre long central Palace of Industry. Planned by Bedřich Münzberger, its vast steel and glass structure was designed by the engineer František Prasil, who simultaneously constructed a 60-metre high steel ribbed observation tower, reached by a new funicular railway, on top of Prague's Petrin Hill. Built by the Czech and Moravian Engineering Works these projects, together with the city's first electric tram which brought visitors up to the park, symbolised the ushering in of a new aesthetic that looked to functionality and modernity as primary motivations. However, eclecticism was still prevalent: e.g. in the Prague City and Komarov Ironworks pavilions and the glass palace itself, which, for all its luminosity and open space, was completed with Neo-Baroque forms and ornamentation on the four corner pylons, as well as statues of genii and busts of Czech technicians on the side wings.

The Jubilee exhibition was further significant in that it raised Czech morale in economic and cultural spheres and encouraged national awareness through its promotion of industry – from engineering to sugar, paper to agriculture, fisheries to crafts from aristocratic estates; its display of nineteenth-century Czech art; as well as its exhibitions of antiquities and Czech folk art, the latter displayed in a Czech cottage (*chalupa*) designed by Antonín Wiehl. Ultimately, it had two major effects: the stimulation of greater effort in the trades, some of which were criticised

for being backward, and the emphasis of the Czech identity as separate from that of the German Bohemians. The latter was expressed not only through the nature of the exhibits and celebrations, but also the fêting of visitors from Russia, France and America.

The cultural debate and the national divisions opened up by the Jubilee Exhibition were made all the more manifest by an event which it prompted – the Ethnographic Exhibition held in Prague in 1895. There, the material culture of the Bohemian, Moravian, Silesian and Slovakian peoples was represented, not only through the systematic display of applied art but also through the recreation of folk architecture. The focus of the exhibition had been conceived as a circular village with examples of vernacular buildings indicating the stylistic variations within the region as a whole. Some of these were created by the Slovak architect Dušan Jurkovič and they served to spark the wave of Czech Revival architecture that occurred in the succeeding years, led by Jurkovič, along with Koula, Mašek and Wiehl.

So, with the proliferation of folk-based styles and the reaction against its perceived moralistic romanticism, stylistic diversity, controversy and, ultimately, Art Nouveau surfaced. Stimulated by the redevelopment of Prague, which coincided with the slum clearance law of 1893, the argument between ethnographic traditions, modernist aspirations and historical considerations resulted in synthetic work by a number of leading architects, foremost among them Wiehl, Ohmann, Polívka, Jurkovič and Kotěra. The Baroque- and Renaissance-dominated eclecticism of Polívka's Zemska Bank was to be continued in his City Savings Bank (1898–1901), this also incorporating painting, sculpture and mosaic into the interior and exterior design so as to create a rich, almost saturated, emotional sensation of space and surface. However, after 1900, his work became more emphatically modern (see below).

A prime example of Wiehl's work was the Wiehl shop and apartment building (1894–96). Freed from strict adherence to past styles, the most innovative features of his conception of the so-called 'Czech-Renaissance' were expressed in this building: the division of the facade between the functionalist, undecorated ground and first floor (the business and administrative areas); and the ornate, asymmetrical upper floors and roof. Stripped of the excessive stucco work and sculpture that adorned much of Prague architecture, Wiehl confined the building's decoration to picturesque painting on Czech themes. Created by Ludek Novák and František Urban, in accordance with cartoons by Aleš and Josef Fanta, these include ethnographic details, scenes from Bohemian mythology and history, as well as script interlaced with curvilinear floral motifs.

Following Wiehl, Bedřich Ohmann took up the idea of the reflection of local tradition on the facades of the new multistorey houses of the bourgeoisie that he created in Prague. Hence his use of Aleš' painting of St Wenceslas as the protector of Czech lands on Storch's publishing house. In addition to the Czech Revival style he also turned to modern materials and forms. For the Café Corso (1897–98, destroyed) he again utilised facade paintings, this time depicting fashionable men and women in an idealised landscape by Arnošt Hofbauer. In addition, he used iron and glass canopies as the cornice, anticipating Guimard's diaphanous wing marquises for the Paris metro stations, these protecting the *habitués* on the first floor balcony. Ohmann's internationalism, encouraged by his Galician origins, Viennese training and early Ringstrasse practice, was further evidenced by the

stucco decoration of the facade. This included two large angels, festoons of masks and garlands, and putti among foliage as well as the pine cone acroteria. The interior was a modern, cosmopolitan *gesamtkunstwerk*. Using overhead illumination the space was opened up with perimeter galleries; the furniture incorporated curvilinear organic motifs in metal and wood, as well as leather upholstery with embossed motifs; the carving of the panelling, with its gentle serpentines, echoed that of the chairs; the wall hangings, ceiling decorations and ceramic work all used stylised floral motifs; the wall decoration consisted of geometrically faceted, swag and scroll mouldings around which was a huge, Nabi-style mural depicting ladies with fans, men drinking coffee and a flying waitress amid a swirl of transparent drapery and butterflies – the latter, together with the tablecloths, overlapping the polychrome foliate border.

Ohmann's last project in Prague, the Central Hotel (1899–1901) (Plate 33) indicated a restrained mixture of Art Nouveau curvilinearity and Neo-Baroque forms. Completed by his students Alois Dryák and Bedřich Bendelmayer, the white facade with central bay windows was decorated with spreading branches sprouting golden fruit, tendril-like gilded copper work around the light fittings and a female mask entwined with cithara strings and a slender stucco snake. This gentle organic quality, which did not accompany any radically new organisation of space, continued in the interior, through the floral decorations, and the wall painting and sculptures.[5] Dryák's and Bendelmayer's participation was indicative of the eclecticist principles which they further elaborated in the hotels Garni and Archduke Stepan (1903–5). Here again they used a central bow window and flowing floral decorative forms. However, the facades reflected a more complex and asymmetrical play of interior space and exterior form. Colour was heightened through mosaics of stylised pastel green, black, red and white flowers; the gilt metalwork,

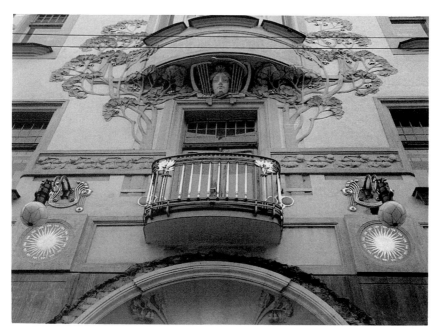

33 Ohmann, Central Hotel, 10 Hybernska, Prague, 1899–1901

with abstract arabesques, spirals, slender verticals, circles and squares, was more overt – in the doorways, railings, and staircase light fixtures; and a mansard roof was added behind the sweeping curves and allegorical figures of the central attic storey.

Recourse to local traditions meant, at least in his early work, an architectural language based on vernacular forms for Dušan Jurkovič. In many ways this appeared a close correlate of Witkiewicz's Zakopane Style just across the Tatra mountain border with his native Slovakia. In fact he also built in the Czech equivalent of the Polish Podhale, the Hungarian Kalotaszeg or the Finnish Karelia – the hilly region of Slovácko, near the Moravian border with Hungarian-ruled Slovakia.[6] This area attracted the new generation of Czech artists seeking inspiration for their modern strivings in the rustic: those who were to be drawn there included several associated with the Secessionist Mánes Society and its journal such as Miloš Jiránek, Vojtěch Preissig, Zdenka Braunerová and Jan Preisler.[7] In addition, in 1895 the tapestry designer Rudolf Schlattauer, after training in Paris and Munich and a study of Scandinavian textile designs, set up a weaving workshop near the town of Walachisch-Meseritsch (Valašské Meziříčí) where he was to produce wallhangings with Modern Style landscapes.

Having produced for the Ethnographic Exhibition a Walachian village and a farmhouse based on the timber building types of the ancient community of Čičmany in Slovácko, Jurkovič concentrated on expressing the common sources and mutualities of Czech and Slovak culture that, still untainted by 'progress', could be found in these border regions. One of his first major projects indicated this – the 'Pustevny' retreat on Radhošt mountain (1897–99), a hermitage and tourist complex on a site associated with the Slav war and fire god, Radegast. Building on sloping ground, he combined stone rubble-faced lower levels and battered chimneys with a picturesque play of forms and space. This was seen in the movement between internal and external space through the use of outside staircases, balconies and galleries, and the incorporation of traditional pyramidal roofs with dormer windows and a variety of mansard roofs.

A similar vocabulary was to be employed by Jurkovič in his grandiose Rezek villa (1900–1) near the north Bohemian spa of Neustadt (Nové Mesto), where he was also to convert the local mill into a tourist base.[8] As Witkiewicz was already doing, the villa modified the vernacular in accordance with the needs of the modern client: the internal space was opened up, the roofs elevated and additional windows inserted where appropriate. It comprised an ornate agglomeration of distinctive wooden units and was completed with rustic-style furnishings, carved decorations and numerous sun motifs. The tourist base employed a combination of half-timbering, rustication, organic decoration and vernacular-style furnishings that showed more relation to the work of Baillie-Scott, an influence which Jurkovič was subsequently to acknowledge.[9]

A similar synthetic style was to be lavishly expressed by Jurkovič in the spa buildings he designed and reconstructed for Count Serényi at Luhačovice in Slovácko (first stage 1901–3). These included the large half-timbered Jan's bathhouse (Plate 34), completed by floral relief work, a refined play of textures and colours, and stylised swan entrance sculptures on the exterior, together with an austere double-storey vestibule with light bentwood furniture which was lit by large rectangular windows. Also, there was the small Inhalatorium with its battered, unadorned walls and display of geometric frame giving it a faceted, almost

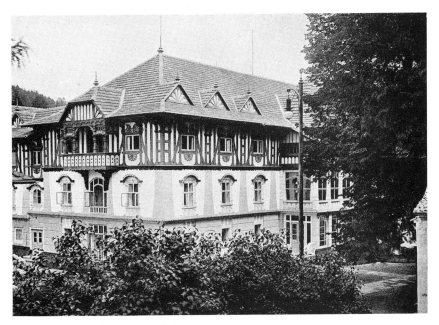

34 Jurkovič, Jan's Bathhouse, Luhačovice, 1901–3

atectonic, Japonist appearance; a 'chalupa' cottage; a restaurant; the Eagles' villa for families; a rustic dairy pavilion; an octagonal music pavilion, finished with a delicately splayed finial; a swimming school; and a hydrotherapy unit.

With buildings such as these by the country's leading architects it became clear that the architectural vocabulary in both Prague and beyond was being stretched towards a modern style, free in its use of historical precedent and freed from earlier limitations of form, material and decoration. These freedoms were to be taken furthest by Polívka, Kotěra and their followers in the years following the turn of the century.

Despite their limitations, the reassessment of values inherent in the early work of Ohmann, Wiehl, Polívka and Jurkovič, together with that of Bilek and Mašek, was to mark the start of a new period of aesthetic enquiry, of questioning the nineteenth-century belief in teleological order and the right of historical styles to represent the order (or lack of it), which appeared to exist. The changes this process of re-evaluation wrought were to be emphatically stressed through the creations of several other artists, designers and architects. Essentially these comprised those associated with the design schools (particularly the Applied Arts School and the Polytechnic), participated with the Mánes Society of Plastic Artists' (*Spolek výtvarných umělcu 'Mánes'*), exhibited at the Topič salon or worked for the leading glassworks. While some artists were active in more than one of these, the distinctive forums they represented can be crudely categorised as the practical, the aesthetic and the commercial.

TOPIČ SALON

The private gallery, the Topič salon was one of the foremost exhibiting venues for contemporary artists in Prague. It was opened in October 1894 by the bookseller and publisher František Topič.[10] His salon, which was housed in the same building

as his publishing house and shop in central Prague, was to be one of the first to promote the younger generation of Czech artists, and most particularly poster and graphic artists. In 1895 exhibitions included the 'First Real Czech Spring Exhibition of Art', with paintings and graphic works by Mašek, Friedrich Wachsmann, Zdenka Braunerová, Viktor Oliva, Jan Koula, Anna Boudová-[Suchardova] and Joža Úprka; and one-man shows of Walter Crane and the symbolist artist Sascha Schneider.

Subsequent shows indicated that the salon was interested in promoting leading contemporary artists of various directions from across Europe without national prejudice: in 1896 there was an exhibition of European graphic art, with works by Gallén, Toulouse-Lautrec, Liebermann, Raffaelli, Tissot, Rops and Vogeler; in 1897 an exhibition of poster designs for the 1898 Architecture and Engineering Exhibition in Prague and a large exhibition of paintings, drawings and posters by Alfons Mucha. Despite leaning towards modern graphic design, the salon was open to diversification, its eighty-plus exhibitions to 1911 including: the first two Mánes Society shows (1898); Marold's posthumous exhibition (1899); Vojtěch Preissig's etchings and Antonín Hudeček's landscapes (1907); French caricaturists (1908); Talashkino applied art (April 1909); Polenov's *Life of Jesus* paintings (1910); and Frank Brangwyn (1911).

This array of exhibitions was important for the development of Czech art, bringing as it did so many leading European artists before a Bohemian audience for the first time and encouraging local artists by providing them with a commercial forum for their work. Thus artists were able to establish a public persona, move into profitable fields like graphic design, and work for Topič themselves – designing posters, book-bindings, exhibition installations and even the firm's premises. The foremost creators of the Topič image were Viktor Oliva, through his book-bindings, illustrations, posters and salon and publishing company emblems; the graphic artist Jaroslav Benda; and Osvald Polívka who redesigned the Topič building (1905–6). The latter included the addition of gilded stucco festoons, swags, masks, eagles and owls to the facade, figure reliefs by Ladislav Šaloun, and polychrome mosaics depicting the firm's logo and Pallas Athena. These superficial changes to the historicist building characterised the company's image, which, whether in its exhibitions or its publications, was more eclectic than radically modern.

Both Oliva's and Benda's graphic art combined experiments in typography with a tendency towards simplification, through laconic composition and limited colour variation. Oliva remained more attached to the visual object, while abstracting it from its natural environment, as in his cover for Čech's *Ballads of a Slave* (1895), depicting a cithara, easel, manacles and drops of blood within a plain ground; and his lithographic poster for the salon's permanent exhibition (1896) which showed a fashionable young lady, more dressed up for a night out than a painting session, dabbling at an easel, against a two-tone ground which included the stretched canvas. This combination of the real and artificial, and the use of sharp colour contrasts, was also expressed in his cover for Neruda's *Cosmic Ballads* (1893), where the surface is dominated by the diagonal flow of the galaxy with planets and stars as they may be seen through a telescope, while three are clearly artificial and linked into a triangle by golden lines. Benda, on the other hand, created more integrated compositions in which he limited his colour to two or three tones and where nature was both more stylised and organic, as in the cover for Topič's twenty-fifth anniversary almanac (1908), the latter including geometricised company initials which echo the Wiener Werkstätte style.

Given the nature of the Topič image described here, it was not surprising that its greatest relevance to the modern movement in Czech art was through some of the outsiders it chose to exhibit, particularly the Mánes Society and Mucha. The Mánes Society, established by art students in 1887 and named after the forefather of Czech revivalism, began to publish a Secession Style magazine, *Volné směry* (*Free trends*), in November 1896, and, within fifteen months, to organise art exhibitions. Indicative of its integrated approach to the arts, in the late 1890s and early 1900s its leaders included painters (Preisler, Slaviček), graphic artists (Hofbauer, Preissig), an architect (Kotěra), sculptors (Sucharda, Šaloun) and critics (Jiranek, Anýž, Šalda) – many of whom worked in more than one field.

One of the first to enunciate the rejection of the traditional approaches and hierarchies in the arts, in favour of an uninhibited modern style, a worldview subsequently advanced by the Mánes Society, was František Xaver Šalda. In 1895 he called to

discard the deceptive liberalism that seeks to make bedfellows of the most disparate ideas ... divest ourselves of what is after all the luxury constituted by unbridled consumption, obsessive collection of antiques, pursuit of period objects, boxes of historical costumes, museums representing every possible cut and fashion – no amount of this will ever give birth to a new style. And this is precisely what is needed: a new style, of a new order altogether, a univocal style that emanates from the soul, engendered from within and projected outward, reflecting its desires and needs: a way of life and a reason for living and dying.[11]

Responding to Šalda's clarion call to action, the Mánes exhibitions concentrated on members' recent work, though with a plentiful admixture of foreign art: for example, a large show of Rodin's sculpture in a specially built pavilion designed by Jan Kotěra and an exhibition of French symbolists and Impressionists (1902); a group of Zagreb modernists, a Josef Mánes retrospective and a Worpswede collective (1903); The World of Art (*Mir iskusstva*), contemporary French graphic artists and Goya's *Los Proverbios* cycle (1904); Munch and Danish art (1905); Nikolai Roerich (1906); the Nabis (1907); British etchers, including Whistler, and Ludwig von Hofmann (1908); Bernard (1909); 'Les Indépendents' and Gallén (1910). They thus showed the range of modern painting, sculpture and graphic art, from Goya's expressionistic etchings to Danish Gröndal porcelain and Braque's proto-Cubist painting.

A Czech artist living in Paris who was supported by Mánes and who exhibited at their shows in the early 1900s was František Kupka. Influenced, like Mucha the compatriate he had followed to the Académie Julien in 1895, by the current ideas relating to the occult and eastern mysticism, Kupka also revealed an interest in the natural sciences and socialism. He participated in the Prague Workers' Exhibition in 1902, showing drawings satirising the motivations and actions of capitalist imperialism and the religious establishment. Around 1900 he began to create synthetic symbolist paintings which purported to the union of the physical and non-physical realms, such as the cycle of aquatints, *The Voices of Silence* (1900–3). Moody, atmospheric and depersonalised compositions they evoked a feeling of mystical energy, a life of the spirit, as in *The Beginning of Life* with its image of lily pads and its flowering lily giving birth to two bubbles containing embryonic forms. Others show shadowy, moonlit rows of identical sphinxes. All is suggestion, an abstract, colour-musical evocation of cosmic forces, of substances transmutating in accordance with the monistic laws of the universe.

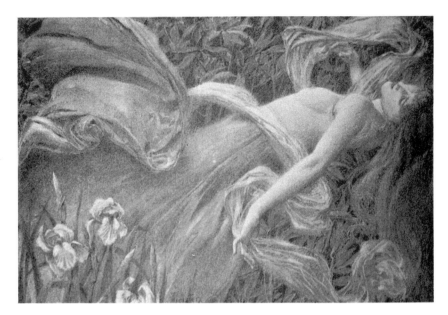

35 Preisler, *The Wind and the Breeze*, 1896, left side of triptych, charcoal on paper, 35 x 54

With regard to Mánes members' work, in keeping with the group's pro-
claimed doctrine of free trends, this proved to be a mixture of realism, national
romanticism, impressionism and symbolism. It was in the late 1890s that the
painters began to show a predilection for the latter, inspired by Pre-Raphaelitism.
Leading members, such as Max Švabinský and Jan Preisler, turned to idealised
romantic images of dreamy feminine figures in stylised landscapes with wind-
swept, fragile trees and flights of swans, e.g. Švabinský's *Communion of Souls*
(1896). Often these expressed the cyclical rhythms of nature as a reflection of psy-
chological reality. This concern with the human condition trapped by overpower-
ing cosmic forces, could also encapsulate Neo-Slavism, as in Preisler's harrowing
illustrations to Julius Zeyer's poem about ancient Rus, 'Brave Young Roman
Vasilich's Song of Sorrow'. In fact it was Preisler who produced the most striking
examples of the new synthetic approach; first, in a charcoal triptych, *The Wind and
the Breeze* (1896) (Plate 35), which served as the cover for the first issue of *Volné
směry*. Here there is an intimate focus on semi-naked, allegorical figures with
translucent swathes of drapery creating broad arabesques as they float through the
all-encompassing lush vegetation. This intimacy, with neither the bodies nor foli-
age fully contained within the picture borders, means the expulsion of illusionistic
space by the interplay of horizontal and vertical organic movement.

Preisler was subsequently to make many decorative works for architectural
commissions, but he also excelled in poster design – a field which particularly lent
itself to his love òf generalised forms and blocks of colours.[12] He designed the
poster for the fifth Mánes exhibition, modern French art, in three tones with a
dominant white peacock motif in 1902; that of the ninth exhibition, the Worps-
wede group (1903), with a flattened weeping willow; and that of the fifteenth,
Edvard Munch (1905), with meditative empty spaces and touches of shimmering
astral highlights conveying the sense of searcher after universal truths. A similar
feel of inspiration in the realm of primal energy flows was revealed in Vladimir

Županský posters, e.g. for the fourth Mánes exhibition – Rodin's sculpture (1902). The common synthesis of symbolist effect and Japonist techniques, was also expressed in Arnošt Hofbauer's designs, this reflecting his training under Henri Rivière in Paris, e.g. the poster for the second Mánes exhibition (1898) with its swirling, Hokusai-inspired wave and drowning man being saved by the Mánes boat.

APPLIED ARTS SCHOOL

The Bohemian craft traditions and the emphasis on local industrialisation by the Habsburg rulers meant that Czech Art Nouveau had many advantages over its counterparts in neighbouring areas. This was manifested in the high-quality work produced at the Prague Applied Arts School, the *Fachschulen* and at the glass manufactures. Though the work created at the *Fachschulen* was not intended to be highly original it did show the assimilation and interpretation of the latest design trends. A prime example can be seen in the works produced at the Turnau school around the turn of the century. They combined exquisite metalwork with felicitous selection of stones and motifs – often feminine and organic – be that in a tortoise-shell comb with gorgon alabaster mask entwined with silver serpents and rosettes, or a dragonfly pendant to a design by the Belgian master Philippe Wolfers executed in gold with smoked quartz, rubies, diamonds and tourmaline.

The new wave of building in Prague around the turn of the century saw the staff and students of the Applied Arts School (as well as the Polytechnical Institute) responsible for the design of new structures, their ornamentation – whether sculptural, stucco relief, mosaic or painted, and their internal decoration and furnishing. Teachers included the architect Kotěra; Klouček, in the decorative modelling class, who was responsible for much of the new stucco relief work; Novák, in the metalwork class, who produced household objects, caskets, paper knives, cigarette cases, vases, pendants, mirrors etc., with increasingly abstract stylisation of natural forms; the bookbinder Hellméssen, designer of Van de Velde style covers with abstract curvilinear motifs; the furniture designer Jan Beneš, who incorporated refined stylisations of plant forms into his functionalist wood-, metal- and mosaic work[13]; the decorative painter Jakub Schikaneder; the embroidery specialist Ida Krauthová; and the textile designer Julius Ambrus. In addition, there was a particularly strong tradition in sculpture – this through the teaching of Josef Myslbek, Sucharda and eventually Ladislav Šaloun, creator of the sprawling, pathos-filled, eloquent Rodinesque monument to the Czech martyr Jan Hus (1903–15).

Their graduates were to include the architects and interior designers Pfeiffer, Novotny and Pelant, all of whom were to reveal the profound influence of Kotěra's functionalist approach in their geometricised, often proto-Cubist designs; Novák's metalworking followers Nováček, Anýž and Němec (Plate 36); Anna Boudová-Suchardová who created simple earthenware and stoneware vases with painted cloisonnist floral designs; and the graphic designer Vojtěch Preissig whose resonant wallpapers were dominated by highly stylised repetitive linear patterns usually based on budding flower motifs.

The attention to delicate objects with organic form was not restricted to those associated with the Applied Arts School or *Fachschulen*. For it also characterised the decorative sculpture applied to objects by Josef Kratina, an artist who spent most of his formative years in Paris. Kratina made numerous fine objects in which he fused the artistic with the functional, his favoured subject being the youthful naked female figure emerging from the material of the utensil – be that a wooden

36 Němec, metalware, 1901

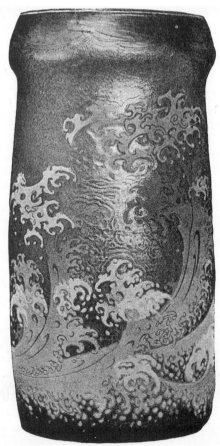

37 Bechert, Johann Loetz witwe vase,
early 1900s

paper knife or a bronze vase. Organic motifs were also to proliferate in ceramicware, particularly Czech-made coffee services. Representing the new popularity of the exotic, stimulating drink among the bourgeoisie, these acquired some of the most refined decorative designs, whether irises, swaying, rotating corn ears or leaves.

Such reliance on visual and human forms was largely absent from the Art Nouveau glassware for which Bohemia became renowned. Here the nature of the material and the recent developments in chemistry and technology allowed all sorts of experiments with form and colour – whether in flashing or external colouring. Glass, more than any other material, leant itself to floral, vegetal and abstract organic forms. As far as Art Nouveau glass was concerned, it was principally produced at a number of factories, foremost among them Pallme König, the Widow of Johann Loetz and Count Harrach's. These benefited from directors and designers, such as Bohdan Kadlec and Marie Kirschnerová, who introduced their companies to the latest European and American developments in art-glass, including the work of Gallé, the Daums and Tiffany.[14] As a result, a wide range of iridescent and opaline glass was produced, the forms and colours of which were infinitely variable – as witnessed by the flowing yellow and mauve forms of a Loetz vase (Plate 37) in laburnum glass (1902); and the floral enamelled and multicoloured iridiscent vases from Harrach.[15]

KOTĚRA

One of the artists who produced innovative designs for Widow of Johann Loetz glassware was Jan Kotěra. And it was he, a teacher of design, a leader of the Mánes Society and editor of *Volné směry*, who was to have a primary impact on the development of the Secession Style in Bohemia. Following studies under Otto Wagner at the Vienna Academy he returned to Prague to teach at the School of Applied Arts in 1897. He worked in all spheres of design, from buildings to furniture, from exhibition installations to electric tram carriages and their fittings, from carpets to criticism. His aesthetic indicated a Wagnerian emphasis on the truthful response of the design to purpose, this determining the form of the decoration.

One of Kotěra's first buildings was the Peterka House (Plate 38), a tenement in central Prague (1899). The facade, though not the more traditional plan,[16] shared certain features with Horta's Hôtel Tassel. Confined to high, narrow sites, both have facades divided into three vertical sections, with the middle section incorporating bow windows with stylised ironwork. Both utilise curvilinear organic motifs for their decoration – a characteristic which continues inside. However, Kotěra's was a property of mixed commercial and residential function, and correspondingly he divided it vertically: between the rusticated sobriety of the lower floors with their large curved windows, behind which were located the transaction hall and offices of the National Bank, and the more atectonic, undulating, lightly plastered and decorated upper storeys. Further, he abandoned ornate window surrounds and restricted the decorative scheme to a few organic and figurative motifs such as stucco roses, complete with thorns and golden petals. The interior was also given light stucco plant motifs and masks, as well as curvilinear botanic forms on landings, doors and iron stair railings. The lyricism of the decorations, with their emphasis on budding plants and waving lines, was to be completed by two symbolic compositions – Josef Pekárek's and Karel Novák's figurative reliefs of pleasure and work on the facade and Preisler's analogous triptych *Spring* (1900) for the

38 Kotěra, Peterka House,
12 Wenceslas Square,
Prague, 1899

interior. Appropriately, these announced the birth of the Art Nouveau movement in Prague, with their synthetic emphasis on burgeoning life, youth, transience, nature's cycles, the union of man and nature, and the dichotomies of joy and sorrow.

Kotěra was to reveal his versatility through a variety of civic and private commissions, including more collaborative and synthetic projects such as exhibition pavilions and installations. The latter included several at Rudolfinium shows; a salon of Biedermeier austerity and geometricism for the Architecture and Engineering exhibition; the Mánes Society pavilion for the Rodin exhibition (1902), with its references to Olbrich's Ernst Ludwig House at Darmstadt; and the Applied Art School's contribution to the 1904 St Louis exhibition, with Emanuel Pelant's spiralling linear motifs of budding nature acting as friezes and vellum ceiling covers.[17]

His early houses for the Czech bourgeoisie revealed his assimilation of the latest trends, particularly the junction of the vernacular and the modern, in residential design. Thus the Mácha villa (1902) in Bechyne (Plate 39), with its half-timbering, battered chimney, overhanging eaves and curvaceous side facade with massive entrance, illustrates a serene reinterpretation of Olbrich and Baillie Scott, for example, the former's Keller House (1900) on the Mathildenhöhe. Further, his 1902 interior for Karel Hoffmeister, the new professor of piano at the Prague conservatory, indicated, through the combination of tensile curves and geometric practicality in the furniture, an affiliation with Hoffmann's early interiors.

In 1903–4 Kotěra realised the first of a series of major public commissions –
the District Building in the east Bohemian town of Hradec Králové (Königgratz).
This clearly articulated structure, with its gently curving gable and swirling organic
mosaic frieze, continued many of the features seen in his Prague buildings – heavy
rustication and large arched windows dominating the ground floor, an asymmetri-
cal plan, and a central oriel window. However, his subsequent civic buildings saw
a new, more radical emphasis on modernity, i.e. the Municipal Society Building in
Prostějov (Prossnitz), Moravia (1905–7), the Hradec Králové City Museum (1906–
12) and the vast semi-circular Education pavilion at the Prague Chamber of Com-
merce and Crafts exhibition (1907–8), the latter designed together with the
Wagnerist Pavel Janák and Josef Gočár, both future pioneers of Cubist architecture
in Bohemia. The Prostějov building comprised a theatre, lecture halls, club rooms,
a restaurant and a coffee room – in other words a unified community centre.
Stripped of all references to architectural orders, the structure was an agglomera-
tion of austere geometrical units – squares, cylinders, triangles and rectangles.
Employing glass ceilings, reinforced concrete and iron vaulted roofs, the only sem-
blance of past styles occurred in the interior with the stucco masks and Preisler's
allegorical wall painting that adorned the vestibule, and the grotesque figure above
the dripping forms of the 'electrolier' in the theatre. A similar rationalism (again
combined with a Preisler decorative panel) characterised the Hradec museum,
which was also designed as a multifunctional building, with exhibition rooms,
lecture hall, workshops, library and reading room. Here, however, he exposed the
brickwork and adorned the structure with a monumental entrance tower com-
prised of receding vertical steps and a dome on a fenestrated drum. For these
buildings Kotěra also designed fittings and furnishings as an integral part of the
architectural ensemble. Such attention to homogeneous detail, as well as the

39 Kotěra, Macha villa, Bechyne, 1902

reductive purism of the works, was to be reiterated in his contemporary Prague domestic architecture – his own house, with its adventurous massing of severe cuboid blocks, and that of the 'Young Czech' publisher Jan Laichter (both 1908–9).

The theoretical cornerstone of Kotěra's approach had been enunciated in 1903 by Šalda:

We are turning away from convoluted imagination and accumulated formal conventions, and going back to essential, simple and functional forms, away from falsehood and pretence and back to honesty and solidity, from cosmetic ornamentation to structure and skeleton and from the secondary to the essential and original. All the arts are gradually coming out of their isolation and breaking out of their material imprisonment. Artists feel with growing intensity that art's vital roots are ornamental and symbolic, and that their purpose is to strive to embellish life, to work on and to serve the whole: style as the highest cultural value, the unity of art and life, becomes the object of our hope ... Only now do we understand the significance and meaning of the word 'style': we understand that it is simply this relationship and this permanent consideration of the whole, wherein nothing lives for itself to the detriment of the other elements and parts, but lives for them and in harmony with them. That style is not limitation and material isolation, but consciousness of spiritual being, consciousness of the rhythmic life of the infinite, obedience to it and union with it.[18]

Such integrated rationalism lent itself to the stripping down of decoration to a symbolic minimum and an increase in the display of constructive planes, masses and voids – these being primary characteristics of the post-1910 edifices with antique modernist references built in central Prague by Kotěra's followers, Bohumil Waigant, Antonin Pfeiffer and Otakar Novotny, Olbrich's pupil Emil Králíček and the builder Matej Blecha, e.g. the Koruna building, the Štenc house, the Adam Pharmacy and the Šupich department store. Despite this, in many respects the swiftness of evolution of Kotěra's modern idiom was too swift for sedate Prague during the first decade of the century – a failing which was recognised by his lack of urban commissions and the civic preference for a more decorative strand of Art Nouveau. Hence the receipt of several major projects by Fanta and Polívka, neither of whom were able to shake off entirely their historicist training.

FANTA

Josef Fanta's most important projects were the Franz Josef railway station (1901–9) and the Hlalol Choral Society Building (1903–6) in Prague. The main facade of the city's main station was dominated by a huge curved window above the five-door central entrance and a large glass canopy supported on massive iron consoles given spiralling, curvilinear form and painted green. It was imbued with an intense play of textures, colours and forms, from the banded rustication of the lower level to the red brick and white plaster above the window vault, the black gable end, and the glass cupolas on stone drums of the twin clock towers. This was integrated with a mix of stucco nudes, masks, birds, foliage, crests and, flanking the entrance, winged wheels representing the railway. A similar juncture of forms and motifs characterised the interior – including the central pavilion with its vast decorated dome and the restaurant with its bold ceramic tile panels by Rako of stylised maidens in nature.

A similar fusion of the monumental and picturesque, the overtly constructive and decorative, was to be found in Fanta's other major edifice, this being built for a Czech nationalist musical association, the 'Resound' (Hlalol) choral society

(Plate 40).[19] Here the curved gable was finished with a brightly coloured, large mosaic frieze with cithara-playing muse and attendant crowd representing music and song. Beneath ran the society's motto: 'With songs for the heart and hearts for the motherland'. Lower down was a plaque of flowing letters announcing 'Hlalol', this surrounded by reliefs of allegorical figures, swathes of drapery, blossoming trees and an infant among reeds with head uplifted and arms raised in archetypal Art Nouveau fashion, as if in response to a second inscription – 'Where there is youth and health, there is Song'. The facade is completed by the highly decorated right entrance. The wooden door is carved with blooming flowers and an arch of musical notation and is finished by metalwork with curvaceous organic forms. This is surmounted by a large mosaic of a phoenix, wings outstretched, rising out of flames to be haloed by the golden sun. Inside, the synthetic approach is continued in the glass-ceilinged concert hall with its floriate chandeliers, allegorical lunette and ceiling paintings, plaster bands and masks.

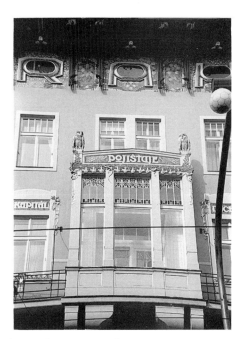

40 Fanta, Hlalol Choral Society Building, 16 Masaryk Embankment, Prague, 1903–6
41 *right*] Polívka, Prague Insurance Company Building, 7 Narodni, Prague, 1903–5

POLÍVKA

Polívka's penchant for orgies of decoration made the Hlalol architect look positively modest. In the prolific years following the turn of the century he was to construct a variety of tenements and commercial premises in central Prague, as well as the city's Municipal Building. The exotic J. Novák department store (1902–3) (Colour plate 4) has a facade covered in a medley of colours, materials, textures and contours, as well as a riotous display of conventional Art Nouveau motifs – irises, lizards, serpents, grotesque frogs, red roses, peacocks, anthropomorphic suns, elves emerging from foliage, flowing drapery. Most of these decorations are in shallow relief. They were complemented by Preisler's mosaic mural of Trade and

Industry. This evoked the local tradition of painted buildings. Its image was one of a rustic celebration of Spring, complete with youthful dancers, Czech seamstress in national costume with naked child, the hawkers and purchasers of her fine cloths, and, above them all, a naked Venus, loosely swathed in iris-like drapery. This vision of the organic purity of Czech business was deemed appropriate for the Novák firm, which was a prime example of the rising capitalist wealth acquired by Czechs in the late nineteenth century. But in addition, the company was not averse to using modern construction methods: Polívka created a two-storey sales hall with arcaded galleries under a roof of glass and iron, that, despite its smaller scale and hints of organic finish, bore much in common with Messel's rationalist Wertheim store in Berlin.

Polívka was to complete two more showpieces of the Czech Modern Style, the Prague Insurance Company Building (1903–5) (Plate 41) and his grandest project, the Municipal Building (1905–12). The first, for another typical sponsor of the new movement, maintained the symmetry, extended cornice canopy with exposed iron and verdant floral motifs, and ornate facade of the Novák store. Here, though, more of the natural details were picked out in gold and Preisler's mural was re-placed with Ladislav Šaloun's highly expressive relief work around the first floor windows. The reliefs, consisting of allegorical female figures and infants fused with nature, appeared in direct response to the tiled inscriptions above the second floor windows – Life, Capital, Pension, Marriage Portion Insurance. A further innovation was the beaded and gilded lettering PRAHA (Prague) around the elliptical windows of the attic storey.

Despite its many modernist references the Municipal Building (Colour plate 5), in contrast to Kotěra's contemporary Prostějov equivalent, was elaborately deco-rated, packed with marginalia and full of references to past styles, as if in an at-tempt to encapsulate the cosmopolitan heritage and condition of Prague at the same time as its Czech identity. It was to be multifunctional – a synthesis of the commercial (shops, restaurants, cafés), social (club and games rooms), cultural (exhibition and concert halls), and municipal (mayor's salon, council rooms). Completed by a squadron of the leading artists, sculptors and craftsmen in Prague, it was the most comprehensive, expensive and extensive Czech Art Nouveau project.[20] Not that this made it entirely cohesive or innovative. Or uncontroversial. On a prime site in central Prague, and making overt references to French Neo-Baroque as opposed to the more covert interpretation of Viennese Secessionism, the Municipal Building was conceived as a primary national statement, and a snub to German domination. Polívka himself took responsibility for designing the ap-pearance of most rooms, from the folk restaurant in the basement, with its huge ceramic mosaic, *The Czech Harvest*, by Jakub Obrovsky, to the austerely geometricised Neo-Classical Gregr Hall and coffee and cake shops, the Moravian Slovak salon with its Biedermeier restraint, the Oriental salon, and the glass-roofed exhibition hall on the second floor. In addition, he also designed many of the fit-tings, including the lift and the metalwork.

On a large rhomboidal site, the Municipal Building was designed around an axis of the main corner entrance. Given a concave aspect and surmounted by a glazed dome, this was adorned with a large semi-circular metal and stained glass marquise-porch, mostly the work of Karel Novák, which was a veritable jamboree of interactive lines and forms. Above the porch in the semi-circular lunette the artist Karel Špillar created the mosaic *Homage to Prague*, the pastoral lyricism of

which he was to repeat in his *Music, Dance, Poetry* and *Drama* wall panels for the centrepiece of the building, the 1,500-seat Smetana concert hall.

Špillar's relatively wan, moody scenes of youthful figures in harmony with nature, with their sensitive line and large monochromatic spaces, were something of a counterpoint to the more vigorous, florid panels of his colleagues, not least Alfons Mucha whose work adorned the circular Mayor's salon. For the municipality's eclectic masterpiece of national romanticism Mucha created a highly ornate room, in many ways the climactic point of the building. He designed the wall, vault and ceiling paintings; the doors; furnishings; the stained glass windows with swirling organic forms; and the door hangings with spiralling floral motifs and paganistic ornaments adorning the tassle-ends of the ties. In these he integrated the national and the universal, the real and the ideal – a synthesis that characterised the building as a whole. A gilded crowned female head, the symbol for Prague adorned the capitals of the pilasters. Bedecked with laurel leaves, these were surmounted by curvilinear stylised inscriptions which announced the civic and moral virtues illustrated by the eight spandrel paintings of Czech heroes above – e.g. 'Mother Wisdom', 'Courage', 'Devotion', 'Relentlessness', 'Sacrifice'. Beneath the soffits with their vegetal motifs Mucha created blue-toned symbolist murals dominated by semi-naked, powerful youthful figures. These are depicted overcoming the frailties of human existence and the cruelties endowed upon the Czech people to gain contact with the divine. The struggle is eventually resolved in the painting of the dome – 'Slav solidarity' which, using Mucha's favourite motif of concentric circles, commences from a ring of root forms, to a ring of rural workers, a ring of fruit trees, and a circular sky with silhouetted eagle. The eagle is haloed and with wings outstretched it symbolises the free flight of the indomitable Czech spirit.

The Municipal Building is really the last monument to the Czech Modern Style's national romanticism: an eclectic *gesamtkunstwerk* that summarised the manifold directions of the movement. Mucha's involvement with it, which marked his post-1900 obsession with Slav themes, revealed the path being trodden by him was the reversal of that of many of his contemporaries – for his earlier work had been truly international and had been created abroad (see Chapter 1). In fact the Mayor's salon was the first major project completed after his return to Prague following his long career in Paris and America.

Notes

1 An example of the industrial policy was the siting of Austria's major ordnance factory, the Škoda works, at Pilsen (Plzeň), west Bohemia from late 1860s.
2 For reproductions of the school's exhibits, see *The Studio*, 1901, vol. 23, pp. 56–63. The Prague Polytechnical Institute was also represented at Paris, with an installation designed by Josef Fanta, noteworthy for its tentatively modern, curvaceous furniture, and its gilded bronze and glass hanging light covered in spiralling flames.
3 P. Wittlich, *Prague. Fin de siècle*, Paris, 1992, p. 56: An extremely useful book.
4 Bílek met Wyspiański during his Paris period.
5 In 1899 Ohmann departed for Vienna. There his balancing of tradition and innovation continued. Appointed professor of architecture at the Academy of Fine Arts and at the same time as an early member of the Secession, he continued to design in both a historicist (the Hofburg) and modern style (the regulation of the River Wien and the Imperial Greenhouse in Burggarten).
6 Jurkovič originated from nearby – the White Carpathian region close to the Slovakian

border with Moravia. In 1889, after studying at the Brno and Vienna Applied Arts Schools, he moved the few miles north to Vsetín in the Slovácko region. The area coincided with that known as Moravian Walachia.

7 Braunerová was to synthesise Slovácko ceramic motifs with Persian ornaments and Pompeii mosaic patterns in her stained glass work created in the 1900s.

8 Jurkovič also converted the Nové Mesto castle into a home for the industrialist Josef von Barton (1908–10), his winter garden appearing very close to Wiener Werkstätte style – with chessboard-patterned ceiling, plain rectilinear, white lacquered chairs and crudely stylised mosaic trees covering the walls.

9 He was also to cite Mackintosh, and the Finns Saarinen and Lindgren as influences. The finials on the roof of the hotel at the tourist base were very close to those used by the Finns on their pavilion at the Paris 1900 exhibition.

10 Topič published modern Czech authors, such as Jan Neruda and Svatopluk Čech, as well as, predominantly, French titles. Books about art and illustrated exhibition catalogues were also published – the most significant being Karel Madl's two-volume study of recent Czech art (1904, 1908).

11 Cited from Wittlich, *Prague*, p. 258. Joined by a heterogenous group of writers and young politicians, later in the year, Šalda signed a manifesto entitled 'Czech modernism' in which his ideas for the new were reemphasised.

12 A huge international exhibition of posters was held in Prague's new museum of Czech commerce in 1900. Participants included Bonnard, De Feure, Cheret, Toulouse-Lautrec, Casas, Bradley, the Beggarstaffs, Klimt, Moser, Olbrich, von Stuck, as well as the Czechs Mucha, Hofbauer, Oliva, Županský.

13 Among his creations was a glazed mosaic floral tableau for the Scottish-owned department store Muir & Mirrielees (1904).

14 Tiffany-inspired designs are to be found in the Harrach pattern books. An exhibition of Tiffany glass was held at the North Bohemian Museum of Applied Arts, Reichenberg (Liberec) in 1897.

15 For a detailed and well-illustrated study of Loetzware, see J. Mergel et al., *Lötz Böhmisches Glas 1880-1940*, Munich, 1989.

16 The plan, actually conceived by the builder Vilém Thierbier, predated Kotěra's involvement with the building.

17 The latter showed a marked similarity to the repoussé metalwork of the light fittings that adorned the contemporary Hotel Stepan in Prague.

18 'The Ethics of the Present Renaissance of the Applied Arts', cited from Wittlich, *Prague*, p. 137–9.

19 The Hlalol society was founded in the early 1860s with the aim of fostering Czech national music. In 1862 Smetana became its conductor and began to compose nationalistic choruses.

20 Besides those mentioned below, the team included the sculptors Šaloun (*Humility and Resurrection of the Nation* groups for the facade and *Slavonic Dances* and *My Motherland* for the Smetana Hall), Josef Pekárek, Bohumil Kafka, Josef Mařatka; the painters Švabinský (*Czech Spring* murals in Rieger Hall), Preisler (the Arcadian *The Golden Age of Humanity* panels in the Palacky salon), Ženíšek (*Love, War and Burial Song*, triptych in the Gregr Hall), Aleš; and the ceramicist Rako (staircase panels of provincial scenes).

8

HUNGARY
Budapest and beyond

Background

In 1900 the Hungarian crown lands were populated by several ethnic groups, the largest of which were Magyars (nine million), Romanians (three million), Germans (two million) and Slovakians (two million). Other large minorities included Croatians, Slovenians, Jews and gypsies. Despite the differences in race, heritage and economy, the development of modern art in late nineteenth-century Hungary showed many parallels with that of its neighbours. And indeed, although urbanisation and industrialisation were proportionally less emphatic than in Bohemia and Vienna, there was nevertheless, encouraged by the 'closed economy' of the Austro-Hungarian empire, a large shift towards the city and a consequent burst of building and artistic activity that radically changed the face of contemporary Hungarian material culture. Encouraged by a remarkable expansion of the railway system from 1846, and with it the development of such industries as banking and food processing, by 1900 the population of Budapest had reached almost 750,000, making it the second-largest city in the central European Habsburg lands and the seventh in Europe.[1] Regularisation of the city's transportation links, not least through a Wagnerian system of multiple *Ringstrassen* and the construction of continental Europe's first underground metropolitan railway, ensued. Most heavy industry was tied to the development of the transport systems. An exception was United Incandescent (*Egyesült Izzó*), an electrical manufacturer also known as Tungsram, originally founded in the 1890s, which was one of the first commercial enterprises to employ an Art Nouveau style for its advertising. By around 1910 this was witnessed by a poster by Géza Faragó promoting the company's light bulbs, in which the flat foreground figures of a young woman and cat stare aloft at, and are illuminated by, a bright nocturnal light, the implied source being a Tungsram wolfram bulb.

Assuredly, with urbanisation and industrialisation came the dual embourgeoisement and proletarianisation of society. These were complemented by the establishment of scientific institutes and new forums for the arts. Among the new research centres was the Hungarian Institute of Geology (1869), which helped advance the modern uniformitarianist theory about planetary formation as opposed to the now outmoded, biblical-inspired catastrophism: a new perception of the earth as being gradually and constantly formed by on-going processes which filtered through to the arts by the turn of the century. Such discoveries, combined

with reaction against the influence of western decadent thought, encouraged artists to take up an east-oriented, aboriginal quest that went beyond their relatively recent (eleventh-century) Christianised traditions.

Developments in the arts included the creation of theatres, such as the People's Theatre in Buda (1861) and the Magyar Theatre (1897),[2] the opera house (1884) and music societies. National motifs began to appear in music, particularly after the failed struggle for independence in mid-century, most notably in the work of Ferenc Erkel, the creator of Hungarian opera, and Ferenc (Franz) Liszt, whose use of folk music was tinged with overtones of tragedy. Literature, likewise, witnessed attempts at national revivalism, not least in the quasi-epic poetry of János Arany who attempted a weak Kalevala-type of writing (see Finland). As elsewhere, this kind of romanticism was to be challenged by those who felt the need to establish more modern, urban traditions, respondent to the new psychology and searching for universals rather than cloying nationalism.[3] The age of Art Nouveau saw writers and artists trying to graft these viewpoints, the new and the old, to one another. In one or two cases, particularly in architecture and design, they did so with considerable success. However, the plastic arts were retarded by the conservativeness of the leading institutions – the Academy of Fine Arts, Polytechnical College and Applied Arts School. This influence was counterbalanced by the new press, one of the products of the social and economic changes, which advanced the debate through its championing of both progressive and conservative trends in the arts as well as in literature and politics.[4]

The wave of public buildings constructed between the 1860s and 1890s included the Academy of Sciences, a Neo-Renaissance structure established for the country's first research institute, which also happened to be the cornerstone of contemporary Hungarian studies; and the luxurious, national romanticist Redoute (Vigadó) municipal entertainment building on the Franz Josef embankment, with its Byzantine, Moorish and Romanesque motifs combined with frescoes illustrating Hungarian heroes, legends and history. Other buildings included the Guild Hall, Opera House, Palace of Justice, *Kunsthalle* (where the Academy of Fine Arts was housed), university, National and People's Theatres, and the vast Neo-Gothic Parliament.

Appearance

Despite the new civic investment in the arts, Hungarian artists were driven abroad by the cultural desert they felt in their own land. Many went to Vienna, others to Munich, and most to Paris – there, as opposed to the 'cemetery of souls' they experienced in their homeland, they encountered a 'holy city' of beauty, love and inspiration.[5] For some the trek west was to eventually enable them subsequently to turn east, and to their own roots, with more assurance. Among these were József Rippl-Rónai, Simon Hollósy, János Vaszary, Károly Ferenczy and Béla Iványi Grünwald, the last four of whom, after spells in Munich and the Académie Julian in Paris returned in 1896 to set up an artists' colony at Nagybánya in Transylvania (now Baia Mare, Romania). As a result it was these artists who were responsible for the birth of the local Art Nouveau, not least through their illustrations for such symbolist poets as József Kiss. The emphasis of the community was on the expression of the Hungarian spirit through meditative images of the people and land in

harmony. The new mood was launched with Hollósy's *Dancing Girls at the Forest Edge* (1895) in which three lithe maidens in swirling transluscent dresses are immersed in a joyful celebration, one holding an archer's bow aloft. This, and the fact that they are watched over by an alert deer, half-hidden in the dark shade of the undefined trees, suggests a visual evocation of Magyar mythology concerning Ildikó, the Hungarian fertility and lunar goddess who rides out at night on a wild deer hunt. Similarly, it could be a response to Arany who had reinvented the Magic Deer legend found in Hungarian chronicles, this identifying the origins of the Huns and Magyars with a deer hunt by two original male members of the tribes which ends in unexpected marriage for them both.

Such themes were to be subsequently taken up by a range of artists, notably those associated with another colony, Gödöllő, as well as Vaszary. Having spent much of the late 1880s in Munich and early 1890s in Paris, Vaszary returned to Hungary to create an œuvre that covered a variety of fields, from painting and graphic art to textile design. Clearly influenced by both von Stück and Puvis de Chavannes, his *Golden Age* (1897–98), acclaimed at the Paris 1900 show, was given an elongated horizontal format, verdant scene with two classical statues and sculpture-like young lovers, and self-made frame whose foliage continues from that in the painting. The young woman holds a symbolic rose above a pot from which a shaft of smoke arises, dissecting the Muse behind it. In the middle distance is a transparent third statue, a ghost-like presence that shields behind it the half-hidden image of a young deer.

The suggestion of an Hungarian theme in an otherwise universal subject was to be less apparent in contemporaneous works by Vaszary, such as his Nabiesque *Woman in a Lilac Dress with Cats* (1900) painted in a narrow vertical format, and the mural, *The News* (1899) for the Otthon Journalists' Club in Budapest (Plate 42). In the latter the stylisations have become more decorative and the scene of primal life in nature is completed by the stucco foliage of the trees. But it was to become a

 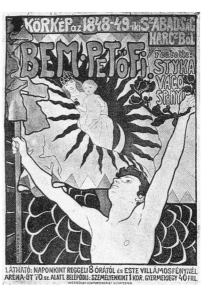

42 Vaszary, *The news*, 1899, mural for Otthon Journalists' Club, Budapest
43 *right*] Vaszary, *Petőfi show*, poster, 1899

more overtly national statement in his Nabi-influenced tapestries depicting Magyar countryfolk and symbols. And it was to be most emphatically stressed in his *Petőfi Show* poster (1899) (Plate 43), designed in commemoration of Sandor Petőfi, the young passionate radical poet who symbolised the Hungarian longing for freedom and who had disappeared fifty years earlier fighting for it in Transylvania. Vaszary depicts him naked, head uplifted with arms outstretched holding a tattered banner and wreath and before a sunburst image of the Hungarian Madonna and child – a pose so typical of the national romanticist trend of the New Style.

RIPPL-RÓNAI

Vaszary's turn to more decorative art forms and occasional national content was mirrored by his colleagues Ferenczy and Iványi Grünwald, both of whom preferred images of man and nature in essential harmony. But it also coincided with the new directions being expressed by József Rippl-Rónai. In 1887, after three years in Munich, he had arrived in Paris to study under his compatriot, Mihály Munkácsy, a leading academic painter and realist.[6] In fact it was largely due to Rippl-Rónai's association with the Nabis in the French capital and the assimilation of many of their techniques, that Hungarian Art Nouveau developed. By 1889 he had encountered the work of the Pont-Aven group and travelled to Pont-Aven, this altering the direction of his art significantly. Initially he went through a 'black period' in which he painted young women against dark or monochromatic backgrounds. Sometimes, as in *Woman with a Bird Cage* (1892), these were Whistlerian evocations of painterly mood, where the figure is only suggested by the black blocks of colour which contrast with the virtual whiteness of the face and hands. Gazing with heavy eyelids at the canary in the cage which she holds rather implausibly aloft, the dreamy, wistful aspect of the girl, her lack of volume and weight, and the barren background in which the shapes of a divan and chair can just be discerned, express melancholy and human transience. The green paint of the cage is the only reminder of nature, all else is enclosed in sombre artificiality, the woman herself apparently reflecting, in Maeterlinckian fashion, on the bars that enclose her life.

Such symbolist painting, with its visual echoes of Baudelaire and Huysmans, was to comprise a consistent trend in Rippl-Rónai's work of the 1890s. But following his contact with the Nabis early in the decade his work assumed new decorative qualities.[7] A transitional work is *The Skittle Players* (1892). Here the figures are delineated by dark contours, detail is abandoned in favour of linearity and a simplified colour scheme of dull browns and greys, and the men, all of whom have their faces turned away from the spectator, are depersonalised as they unite with their surroundings. There is no narrative, no sign of winners or losers, even the skittles are hidden from view. Similar features were characteristic of contemporary works by Vuillard, Bonnard and Denis, as was the concentration on an everyday, communal scene in a provincial setting.

This decorative trend was to continue in subsequent works by Rippl-Rónai. It was evident, for example, in his lithographs for *The Virgins* (*Les Vierges*), a booklet commissioned by Samuel Bing in 1895 (Colour plate 6), and in his contemporary *Village Festival* published in Ambroise Vollard's *L'Album des peintres-graveurs* (1896). In these the human figures in a landscape are reduced to flattened curves and broad swathes of bright colour, the latter restricted to three or four bright

tones. This is synthetist work, derivative perhaps of Gauguin's Breton scenes, in which space is ambiguous, personalities are eliminated, narrative is unclear, and nature is stylised, while a flowing, gentle dynamism fuses the separate elements in a gentle, harmonious whole. Further, for *The Virgins* Rippl-Rónai was working on what was to become an established Art Nouveau theme – of purity, youth, blossoming life – and was to create images in advance of their 'illustration' by texts by the Belgian symbolist Georges Rodenbach, thereby reversing and challenging creative convention. The approach encouraged a new emphasis on an emotional expression of human experience, which was sometimes given ominous undertones through the inclusion of red apples ready for plucking and the immersion of some of the figures in other-worldly contemplation. It was to be summed up by the artist: 'My book is light, youth, the shining sun, golden nature, young girls hesitating on the threshold of adult life, later casting a tranquil glance back at their past, etc. A fleeting dream'.[8]

Bing's patronage, which followed Rippl-Rónai's successful appearance at the Salon du Champs de Mars in 1894, undoubtedly affected his subject matter and approach. Henceforth even greater simplifications occurred, and he turned to the applied arts. However, his subjects remained dominated by the female form, whether in an interior or set outdoors. In 1895 the symbolist periodical *La revue blanche* published his lithograph *Woman Reading* and at the same time he drew *Woman in a Chair*. Both show an affinity with the work of Paul Ranson, another close Nabi acquaintance, although the linearly described nature is less vitalised. The forms are, nevertheless, organic, and in the case of the *Woman in a Chair* almost abstract.[9]

Rippl-Rónai's women are young ladies at leisure, in long gowns, surrounded by flowers or trees, or relaxing in an indefinite interior – as if he is searching for a lyrical beauty that can only, at this stage, be evoked through the female form. And he was, like his friends Ranson and Maillol, to recreate these images in his tapestries. An example is the wall-hanging *Young Woman with Rose*, designed for the dining room of Count Tivadar Andrássy's mansion in Budapest (1898), this with its Pre-Raphaelitic maiden contemplating a plucked rose, the symbol of her love. In fact, Rippl-Rónai was to design the entire dining room, from its furniture and wall decorations to the ceramics and glassware. Not that he was directly involved in the production process, or that this was locally based – for, true to his internationalism, he had the glass manufactured in Wiesbaden, Germany; the wall-hangings were made by his wife, Lazarine Boudrion, at their Neuilly studio; the furniture at the Andreas Thék workshop in Pest; and the ceramics at the Zsolnay works at Pécs. While this detracted from the conception in terms of the unified, co-ordinated treatment of the objects, there was, nevertheless, an exploration of abstract organicism evident in the flowing, brightly coloured forms of the porcelain plates and the floral motifs on the sideboard.

This attempt by a Hungarian painter to raise the applied arts to the level of the fine arts was to signal the revival of applied arts in his homeland. Indeed the Zsolnay factory with which he co-operated was, over the next few years, to become the country's most innovative and internationally acknowledged manufacturer of Modern Style ceramicware – from multicoloured architectural panels and tiles to household utensils.[10] By 1902, the latter, including vases, bowls, pots and jugs in iridescent colours and mostly with abstract botanic motifs and, sometimes, forms, were to be highly acclaimed at the Turin International Exhibition (Plate 44). Such

44 Zsolnay ceramics,
Turin exhibition, 1902

symptoms of the revival owed much to the organisation of the 1896 Millennial celebrations, not least the Budapest exhibition. Following in the wake of Prague's 1891 Jubilee exhibition and 1895 Ethnographic exhibition, the Budapest show included a display of building styles, costumes and carving from across Hungary, combined with performances of folk drama and music. In addition there was plentiful promotion of contemporary achievements in industry, education and the arts – the latter being expressed in a series of historicist pavilions and numerous paintings, murals and sculptures celebrating heroic events of Hungary's past.

LECHNER

The programme of the Millennial celebrations was inevitably compromised by simultaneously proselytising the distinctiveness of Hungarian identity and professing the beneficial effects of the Habsburg association. Nevertheless, it included major new developments outside of the exhibition arena itself, not least the building of the underground railway system and Ödön Lechner's design of the new Museum of Applied Arts. The latter indicated Lechner's arrival as the most modern Hungarian architect. He experimented with materials, using reinforced concrete, clinker, wrought and cast iron in combination with glass and multi-coloured pyrogranite tiles. The building appears eclecticist, with many glimpses of Gothic, for example, in the ogive windows, parapet decorations and medieval castle associations of parts of the courtyard facade, while the overall effect is distinctly eastern. Anglo-Indian in inspiration, this is seminal Indo-Magyar, in other words,

National Romanticist, in practice.[11] The central exhibition hall is spanned by a roof of exposed steel girders and glass, surrounded on two floors by Mogulesque arches which lead to the galleries, and painted white. This fusion of the ancient and the modern was meant to suggest the interiors of the tents of the eastern ancestors of the Hungarians, just as the brick, tile and stone articulation of the street facade evokes the intricate decoration of Hungarian shepherds' woollen coats (*cifraszür*).[12]

Such a novel interpretation of the Gothic, and its combination with non-European styles, attracts comparison with the early work of Gaudí in Barcelona. In fact, Lechner's career shows considerable parallels with that of Gaudí. The son of a local tile manufacturer, after opening a practice in Budapest in 1872 by the 1880s he was designing eclectist buildings such as the Hungarian State Railways Pension Office complex and the Thonet furniture company tenement. The emergence of his national romanticism in the 1890s coincided, as Gaudí's, with a new upsurge in regionalist patriotism in a land governed over by neighbours and, consequently, with a burst of research into folk styles, traditions and beliefs. Of primary importance for Lechner with regard to this, was not his participation in local ethnographic or archaeological circles, but his reading of recent studies of Hungarian decoration by Jozsef Huszka, in which the author sought to establish its Asian origins.[13] At the same time as using orientalism to mark a new national style, Lechner also employed, like Gaudí, new materials, as well as activating a revival of architectural ceramics, a traditional facing material for Hungarian brick buildings. Indeed, his selection of majolica or pyrogranite panels and tiles for clad-ding, which was to be a characteristic feature of his major New Style buildings, was based both on its association with folk tradition (and the lack of suitable stone for construction purposes in the area) as well as functional considerations. With a background closely tied to the ceramics industry, he understood the porous and washable qualities of the materials, their retention of colour, their slenderness and relatively low cost.

Lechner's intention then, rather than the exact copying of vernacular styles, was the creation of a new, expressly Hungarian architecture based loosely on the Magyars' relationship to the Orient. This made its first, strong appearance in the Applied Arts Museum, where, besides the features already noted, he added a large floral motif, created from multicoloured majolica tiles and stucco ribs, to the ceiling of the vestibule. Here, with its arabesques and rosettes, the impression is Hinduesque and yet it can also be related to the stylised foliate decorations of Hungarian embroidery and carving, which, according to Huszka, were themselves associated with Middle-Eastern gold work.

In his works designed and built after the Millennial Exhibition Lechner indi-cates a more confident rebuttal of historicism in favour of a distinctly modern style with recourse to imaginative interpretation of local tradition. Principal among these are the Geological Institute (1896–99) and the Post Office Savings Bank (1898–1901) (Plate 45). In both there was no sign of fussy, sculptured or stucco relief ornamentation, indeed, no laboriously detailed or intricate play of small flat and curved surfaces and space that characterised so many facades of historicist buildings. Rather, there were extensive, unbroken planes and simple masses that emphasised, as Wagner was doing contemporaneously in his Linke Wienziele tenements, the monumentality of the architecture.[14] Where Lechner did allow in-tricacy, was on the roofs and in the flat surface decoration. These were now overtly national, with geometricised linear motifs created through the distribution of the

coloured tiles, and floriate, curvilinear designs that covered both the cornice and various wall, ceiling and floor surfaces on the interior. As far as the Savings Bank was concerned there was an element of functionalism in this as well, for the site was very narrow, restricting the scope for projections. This allows a tectonic functionalism to prevail, an emphasis which is encouraged, like Hoffmann's Palais Stoclet, through the ribboned framing.

Although Lechner uses reinforced concrete and occasionally exposes the steel on the interior, these buildings are also laden with symbolism: a symbolism, articulated in the plan, the roof shapes, and the ornamentation, that speaks of release from Christianised architectural dogma and a striving for a new spirituality based on indigenous and eastern traditions.[15] Thus the ground plan and stylised decoration of the Geological Institute appear derived from north Hungarian building types. Likewise, the golden hens, serpent heads and crowns on the curved, tent-like roofs, and the bull's head above the entrance, of the Savings Bank allude to the recently discovered treasure trove of 'Attila the Hun', which was fast becoming a potent symbol of the Hungarian right to genuine sovereignty. Thus, concurrent with scholarly investigations, there is an evocation of the local animist cults and ritual objects. Further, the primitively stylised plants and vases depicted on the curvaceous parapet of the Savings Bank, and the floral ribbon patterns on some fluted vaults, arches and floors of the Geological Institute, are adapted from painted and carved vernacular furniture, utensils, costumes and embroidery, not least the garlands embroidered on men's sheepskin cloaks (*suba*) in the Kecskemét region.

Lechner conceived his buildings as integrated units of design. As far as the Savings Bank was concerned this incorporated an organic quality, felt in the dynamism of the roof and the raw undulations that described, say, the furniture, fittings and décor of the Council Room, the balustrade and vaults of the staircase, and the wrought iron railings and concrete walls of the courtyard. This organicism was to be further felt in three domestic commissions – the Klein mansion at Szirma (1901, destroyed 1944), the house for his brother, Professor Károly Lechner, at Kolozsvár (Klausenberg, now Cluj-Napoca, Romania) (1901), and the Sipeki-Balázs villa in Budapest (1905–8). The Klein house, designed with his young colleague Béla Lajta, included the same plasticity as the Savings Bank in its curving garden wall and railings that joined with the large horseshoe-shaped porch. Upon entering, the visitor came into a double-storey hall lit by two bud-shaped windows with stained glass rustic depictions of the owners amidst a variety of stylised floral patterns.

Smoothly moulded, curved forms were also present in Lechner's brother's house. However, here, where the asymmetrical exterior reflected the imaginative organisation of internal space, he resorted to the same ribbon framing as the Geological Institute. In addition, he added an Art Nouveau touch to the arrangement of shrubs and flowers in the garden – around a central fountain he arranged the plants into a floral pattern echoing the stylised, curvilinear motifs found on Transylvanian embroidery work. Thus nature was made to resemble art. Also, for the entrance gate he combined similar curvilinear designs, this time taken from local wood carving, the date, and gateposts whose dimpled-star tops and geometrical form were taken from Transylvanian wooden graveposts.

The reassuring plastic forms of the Lechner house and their romantic, harmonious medley of the modern and ancient, were appropriate since they were

designed in the area then being recognised as the soul of Hungary and for a

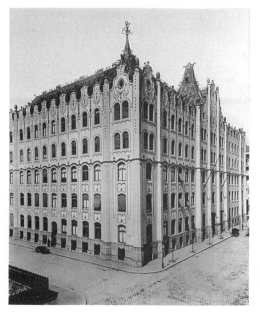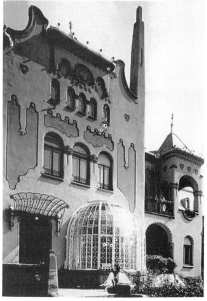

45 Lechner, Post Office Savings Bank, 4 Rozenberg házaspár, Budapest, 1898–1901
46 *right*] Lechner, Sipeki Balázs House, 47 Hermina, Budapest, 1905–8

distinctly modern man: Károly Lechner had been appointed professor of neuro-logical sciences and psychiatry at the new Magyar university in Kolozsvár in 1889. Back in Budapest, Lechner designed his most radical house – this for the similarly middle-class Sipeki-Balázs family (Plate 46). The villa, with its steep roofs, turrets, loggias, galleries, round towers and serenely elongated and slightly curved chim-ney, appeared like some fairy-tale miniature Transylvanian castle, transported to a wealthy Budapest suburb. Faced in ochre and buff it was given a huge semi-circu-lar bay window, whose iron and glass structure, contrasting with the expanse of mass around it, was reiterated by the canopy above the door. While this forceful, asymmetrical play of materials appeared deliberately lacking in cohesion, the same could not be said of the organic interaction of solids and voids, nor of the discrete ornamental figures, or the sensual fusion of tapering, slender shapes and broad surfaces. This synthetic work was completed inside, where, as in the Klein man-sion, the hall opened up into two storeys and the surfaces and spaces were treated with similar sensitivity.

GÖDÖLLŐ

By the time Lechner built the Sipeki-Balázs house his state commissions had dried up and the future for Hungarian national romanticism and the New Style as a whole looked threatened. For in April 1902 the minister of public education an-nounced in the newly opened, Neo-Gothic Parliament 'I dislike Art Nouveau, and, since, often what is called Hungarian Style is in fact Art Nouveau ... I shall do my best to prevent it, I shall not equate it with the real Hungarian style [i.e. Histori-cism].'[16] Yet if the minister's words, enlightening as they are for their identification of Art Nouveau with the National Style, appeared to have signalled the demise of the new movement, this was not to be the case. On the contrary, it was just getting under way, and even with the help of government sponsorship.

As in Austria, the government's policy was to encourage rural handicrafts, in order to stem the flow of peasants from the countryside to the towns by offering them some subsidised form of income. Among the projects it sponsored in 1902, together with the Hungarian Applied Arts Society, was the setting up of an artists' colony in Gödöllő, a village some twenty-five miles east of Budapest. On this occasion the government donated old looms, sequestered from a bankrupt factory, for the weaving workshops. In return a weaving school for forty or so local girls was established, this being attached to the Budapest School of Applied Arts.

The founder of the colony was Aladár Körösfői Kriesch, a fresco painter who had trained under Károly Lotz and Bertalan Székely, two leading Budapest academicians and decorators of the new public buildings and churches. Following a spell at the Académie Julian he turned to weaving, and together with his future Gödöllő colleague Sándor Nagy exhibited carpets at the Paris 1900 exhibition. Absorbed by Hungarian history and mythology, but disillusioned with urban life and searching for an untarnished fount of Magyar culture, Kriesch, who was of Austrian blood, moved to Gödöllő in 1901. The counterculture aims of the colony were akin to those of Abramtsevo and Talashkino in Russia: the survival of rustic traditions; the education of local children in the crafts; the establishment of a new, more healthy, influential relationship with the markets and tastes of the city; and the adoption of a Tolstovtsian fulfilling, simple lifestyle permeated with Ruskinian beauty and happiness that would ultimately lead to the transformation of society.

In their idealistic search for the beautification of life the Gödöllő artists practised all the arts, without dint of hierarchy. Indeed, besides the plastic arts, their holistic approach meant they engaged in the collection of folk art, they used dyes extracted from local plants, published their studies of peasant traditions and their own designs for others to use, held communal workshops for the study of the classics, philosophy and aesthetics, organised poetry and music recitals, engaged in non-competitive healthy sports like skiing and swimming, made fieldtrips together, practised eurythmics and nudism, were vegetarian, and designed their own dress and buildings with folk principles in mind.

Their national romanticism meant they regarded folk art as a primary source for their stylised designs. This was reflected by the persistent occurence of a simplified floral motif, transferred from peasant embroidery, that decorated a variety of designs, not least the integrated interiors of the schools, studios and art-lovers' houses created by Ede Toroczkai-Wigand (Plate 47). From early on Wigand's furniture was notable for its refined structural and decorative simplicity derived mainly from English arts and crafts designs.[17] This was seen in his rectilinear cabinets with strap hinges shown at the 1902 Turin exhibition. However, in the second half of the 1900s he turned to a more sensuous organic style, giving his beds and chairs heavy bulbous forms, and combining these with a limited display of bold abstract floral motifs (as well as squares) in his interiors created for the Budapest and Marosvásárhely bourgeoisie.

Wigand's approach typified the national socialist trend of the Gödöllő community. Often working in collaboration with his fellow artists, he was to design numerous communal buildings for the remoter regions of Transylvania, basing his plans and construction methods on local village traditions. These, he felt, were most appropriate for the expression of a pure synthesis of form, structure, decoration and function. Indeed, his buildings, which were part of a state-sponsored rural development programme, were multifunctional – school-churches, community

centres, studio-houses – and included standardised furniture and fittings. These new buildings incorporated the steep hipped roofs and gables, balconies, cone-shaped spires and carved pillars, traditional to Transylvania.

In particular, the artists turned to the Kalotaszeg area of eastern Transylvania and the styles and myths of its inhabitants, the Székely, an ethnic group that spoke a form of Hungarian and which was regarded as either the true Magyar people or the descendants of Magyarised Turkic peoples who had been settled in the region to guard the frontiers of the Ottoman empire. Thus Kriesch, who took the name Körösfői from the emblematic community of Körösfő in Kalotaszeg, designed tap-estries with stylised depictions of Székely women in national costume, their dress fusing with the geometric ornaments filling the space around them, these derived from local wood-carving motifs.

Elsewhere Kriesch, like Wigand, used the forms of Kalotaszeg wooden grave-posts, which, with their stars, prisms, pyramids and circles, were the closest the ancient settlers came to producing images of their deities and, indeed, sculpture in the round. In his case, however, he flattened them against a simplified landscape created in bold blocks of colour. These posts were to make their appearance in the *Deer* tapestry (*c.* 1910), where they appear in dark silhouette behind two deer stand-ing alert in the moonlit winter night. Still based on visual nature, the work is highly stylised, to the point where the clouds become straight horizontals divided by the verticals of the posts as if in some abstract folk pattern. Nineteenth-century research had suggested that these were the most significant graveposts, having been originally created for heroic warriors–pikemen. Given identical treatment on all four sides, they often appeared together with halberd posts and burial flags,

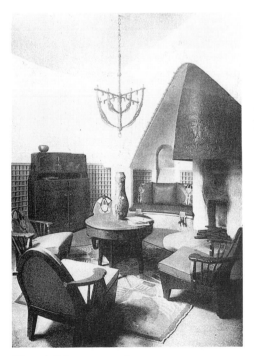 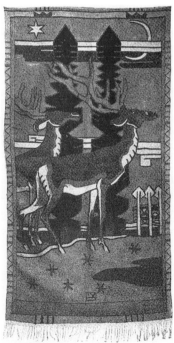

47 Wigand, living room, early 1900s
48 Kriesch, *Deer* tapestry, *c.* 1910, Scherrebek technique

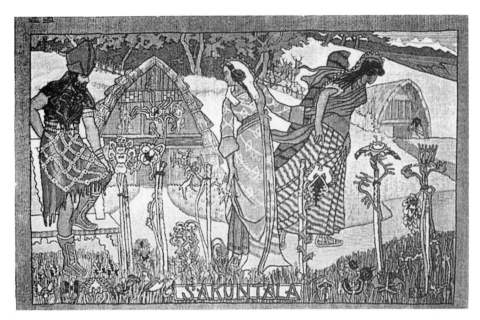

49 Nagy, *Sakuntala* tapestry, 1909

these being placed behind the grave-post proper as depicted on the right side of Kriesch's tapestry (Plate 48). The two deer appear to represent the pride and strength of the deceased guardians of archaic Hungarian civilisation, although they were also Hungarian emblems of the conversion to Christianity, as well as a symbol of the winter sky in folk songs. The dark grave-posts tower behind, assuming the qualities of huge pagan trees of life, which in Magyar myths united the heavens and earth. Is this then a representation of the convergence of Hunnish and Christian cultures that occurred in the region nearly a thousand years earlier?

The problem, albeit a liberating one, for Kriesch and his colleagues, was that very little was known about the cults and mythology of the pagan Magyars. This meant they could freely develop their own visual micro-cosmogonies from the few surviving details of shamanist practice, folk beliefs, magical figures and so forth. It also meant they could explore, without need for historical accuracy or substantive narrative, eastern themes that purported to common sources. Thus Kriesch designed the wall hanging *Eagles Above a Hero's Grave* (1918) in which he combined simplified images of carved grave-posts, a Kalotaszeg church and two eagles, the latter representative of the guardians of the Magyar tree of life; as well as a knotted carpet with an abstract tree of life motif that appeared distinctly related to those found in the Caucasus and Central Asian regions.[18]

Likewise Sándor Nagy frequently resorted to the deer symbol and hunting subjects in his figurative work – this apparently in response to Hollósy's and Vaszary's earlier visual suggestions of the Magic Deer and Ildikó legends. Hence his depictions of the deer hunt in a sgraffito frieze on the entrance facade and in a stained glass window of the Veszprém Theatre (1907–9) by István Medgyaszay. In addition, he designed a tapestry of *Ildikó* (1908) in which the pagan goddess is depicted as a falconer surrounded by highly stylised tree and root forms. Flattened in folk costume with plumed headdress Nagy's Ildikó is a modern visualisation of the Hungarian version of the fertility and moon goddess Hilda, Diana or Artemis

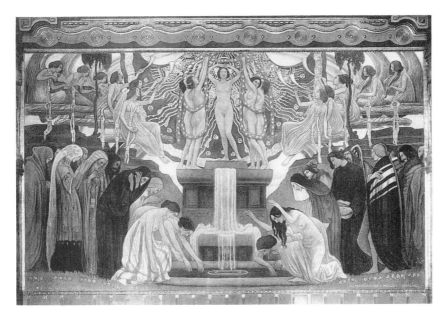

50 Kriesch, *The Fountain of Art*, Academy of Music, Budapest, 1907, fresco

who rides out at night on a wild hunt and to whom, as Mother Deer and the giver and taker of life, deer and bears are sacrificed.

Deer were represented in Nagy's figurative *Sakuntala* petit point tapestry (1909) (Plate 49),[19] a work which emphasised the Hungarian modernists' turn east for their roots and common ties. Again, despite a discernible narrative, the image is still an ambiguous play of the real and the imaginary, figures being heavily outlined, two-dimensional and simplified yet contained within a readable landscape with houses, contorted linear plants, trees and mountains. The subject, Kalidasa's ethereal fifth-century Sanskrit drama 'The Recognition of Sakuntala' was a romantic intepretation of epic legend. It was an appropriate choice given its reliance on the language of gesture and symbols rather than realistic, sequential discourse and action. Indeed, its use of fantasy included the entrance of King Dusyanta on an imaginary chariot and the nymph Sakuntala's plucking of flowers that are not there. But, most significantly for Nagy and the story of the origins of the Huns and Magyars, the play also involved Dusyanta's pursuit of a deer which makes him forget his state affairs. This correlates with his love of Sakuntala, whom he rejects and loses, together with their child, only to be reunited in heaven. Further, the child turns out to be Bharata, the eponymous forefather of the Indian people. In accordance with the New Style's rejection of direct recreation in favour of the expression of essences, Nagy brings together many of the separate components of the romance in his tapestry, the focus being the climactic moment of the couple's parting under a sage's curse.

Wigand, Kriesch and Nagy were designers who advocated collective art, this being expressed in their contributions to the wave of Hungarian pavilions constructed for European exhibitions in the 1900s, as well as a number of other important architectural projects. In 1904 Wigand assisted the designer Pál Horti in the creation of the Hungarian pavilion in the form of a Székely farmhouse at the St Louis Exhibition.[20] In 1906 the three collaborated with the young Budapest Poly-

technic professor Maróti, on the design of the ill-fated Hungarian section at the Milan Exhibition.[21] Maróti's spacious and monumental entrance court, with its play of Romanesque arches and overhead illumination, its concentrated gilded relief work of corn ear motifs, its rose and aquatic decorations, folk style chairs, Zsolnay tiles and glass mosaic of the Virgin and Child, indicated a blend of Neo-Magyar and international New Style features. This was in keeping with Maróti's association and friendship with the Finn Saarinen. Still, Wigand produced a dining room in 'the Hungarian style', Kriesch created a study and reception room for the Minister of Religious and Public Education in a sober functionalist style, and Nagy (furniture), together his wife Laura Kriesch-Nagy (embroidery) and Medgyaszay (installation design), produced several rooms for an 'artist's house'. The last emphasised simplicity but used less expensive materials and replaced the volumetric feel of Kriesch, with a greater sense of vernacularism, lightness and the organic.

A leading craftsman with whom the Gödöllő designers worked was the decorative glass specialist Miksa Róth. For the 1908–9 Venice Biennale his workshop made stained glass windows on the theme of 'Attila's Feast' according to Nagy's designs – these in a figurative style close to that of his tapestries, and incorporating motifs borrowed from Székely carving. In addition he produced Kriesch's two glass mosaic murals for the entrance facade of Maróti's modest Neo-Magyar pavilion – again on themes from Hungarian mythology – 'The God of Iron' and the 'The Siege of Aquileia'. Here, against a sky of undulating two-tone waves, heroic Hungarians receive divine help in their worthy missions – on the one hand to defend themselves with swords and cultivate their land with ploughs, on the other to take the Adriatic city from its Roman occupiers and suppressors of paganism.

Among the permanent architectural projects with which Kriesch, Nagy, Maróti and Róth were involved, the Budapest Academy of Music and the Marosvásárhely Palace of Culture stand out. The former was remarkable for Kriesch's frescos. He created two friezes representing ecclesiastical and secular music with processions of choristers and bridal parties. And for the lobby he painted the huge *Fountain of Art* (1907) (Plate 50). In keeping with fresco tradition he imbues his figures with venerable and serene features, and sets them within artificial space. This is the victory of light over darkness, brought about by the arts, the source of which is a silvery stream of vivifying water. Old and young, men and women, rich and poor, religious and lay alike are drawn to the fountain which has the power to relieve their souls of the sufferings of earthly life. Above them, on either side, an orchestra of heavenly angels announces the solace, salvation and joy represented by the central Olympian group of garlanded naked females atop the fountain. Enveloped by a gilded flowing mantle of radiant lines, buds, streams and winged angels this is the climactic realisation of pure happiness and love through art. In many respects this is Kriesch's, and Hungary's, painterly musical response to Klimt's *Kiss for the Whole World* section of his Beethoven frieze. Yet despite similarities in their decorative techniques they contrast in one fundamental aspect – Kriesch's salvation is unencumbered and complete while Klimt's is ominous, sexual and effected only through the intervention of a male superhero.

The culmination of the artists' co-operative endeavours was the Marosvásárhely Palace of Culture in Transylvania (now Tirgu Mures, Romania). Here Wigand, Nagy, Kriesch and Róth created a monumental modern *gesamtkunstwerk* that drew extensively on both Hungarian mythology and vernacular forms. It has

been described as 'the major accomplishment of the Gödöllő colony,'[22] although it was actually designed by the New Style architectural partnership of Marcell Komor and Dezső Jakab, former assistants of Lechner. The building combined typical national romanticist features with international modern elements. The ground floor was faced with squared rubble; the undulating oriel above the main entrance was decorated with relief work depicting scenes from Hungarian legend and life; the fenestration of the third floor ended with a carved beam end reminiscent of those found in Székely village architecture; and Kriesch's crowning mosaic frieze recreated a moment from Marosvásárhely history. At the same time, the main façade consisted of a play of colours and textures, protrusions and recessions; the elevation ended in a curb roof finished with alternating red and white triangular pyrogranite tiles; and concrete was employed for the oriel.

Inside, the Palace of Culture, with its concert hall, library, art gallery and Hall of Mirrors, was lavishly decorated and supplied with fully co-ordinated furniture. The vestibule, with its series of saucer cupolas and hexagonal chandeliers, was completed with frescoes by Kriesch. The effect was overtly organic – starting from the columns which were faced in deep green 'eosine' ceramic tiles with gold highlights from the Zsolnay works – and ending in the stylised floral motifs, with dominating irises and vines, that Kriesch employed to cover the vaults, soffits, spandrels and ceiling.

The most sumptuous decoration, stained glass windows by Nagy, Wigand and Róth and frescoes by Kriesch, was created in the Hall of Mirrors. Nagy's tripartite windows were based on three folk ballads in which the themes of young love and tragedy are uppermost. In these, as in his painted and tapestry work, he attains emotional effect through the retention of figurative and narrative elements, while at the same time fusing his characters with a rich ground of organic nature created from verdurous colour and emphatic, curvaceous line. Wigand, on the other hand, designed calmer and more optimistic scenes – these dedicated to the cycles of nature and a romantic interpretation of the interior of Attila's 'tent palace'. Meanwhile, Róth depicted an idealised young couple in national costume and the seventeenth-century prince of Transylvania Gábor Bethlen, whose anti-Habsburg campaigns and promotion of local arts and sciences made him a hero for the national romanticists. This glass presentation of the Hungarian spirit was rounded off by Kriesch's romanticised fresco images of the Transylvanian past: *The Folk Song of the Székely* and *Shamans' Circle Dance*.

A predominant motif in the interior decoration of the Palace of Culture was the tulip, stylised according to Hungarian folk art traditions, and transferred to the walls and the furniture. Further, the popularity of this motif in local material culture meant that Komor and Jakab employed it extensively in their other national romanticist masterpiece of integrated design – the Town Hall at Szabadka (now Subotica, Yugoslavia) (1907–10).[23] While the architects were helped in this by Nagy and Róth, another Gödöllő associate, István Medgyaszay, was also exploring the possibilities of fusing national romanticism based on Transylvanian types with modern techniques and materials in his buildings. Of Slovakian origins, Medgyaszay had graduated from the Vienna Applied Arts School in 1903. Upon returning to Hungary he travelled through Székely land making studies of the peasant architecture. His synthetic aims were first expressed in studio-houses for Nagy and Belmonte at Gödöllő (1904–6), the interiors of which provided the basis for his 'artist's house', the sensation of the 1906 Milan exhibition. In brick, with

broad overhanging eaves, large porches and a smattering of 'buttoned' circle motifs reminiscent of those found in Transylvania, the Gödöllő houses represented important early extensions of Lechner's national functionalism. With form following function and a stripping away of extraneous decoration in favour of a severe rectilinearity that comprised an early version of stepped cube construction, the open-plan studios clearly revealed Medgyaszay's Viennese pedigree.

Following studies in the Paris atelier of the prefabricate pioneer François Hennebique in 1907, Medgyaszay began to utilise new construction technology with increasing daring, as in his Veszprém Theatre (1907) and his Church at Rárósmulyad (now Mula, Slovakia) (1908–10). The first combined several Secession Style features, including large unbroken rectangular planes, a battered pylon effect to the elevations, small decorative squares, rosette windows, and cantilevered eaves. To these were added squared rubble facing on the lower floors, Nagy's deer hunt frieze and glass panel, and a novel plan that had the main entrance situated under the stage, a large vestibule directly under the auditorium, a projection room for films. The structure was of reinforced concrete, with arched steel vaults spanning the auditorium, openwork steel consoles supporting the galleries and boxes also in concrete. Medgyaszay also employed a reinforced concrete dome for the Rárósmulyad church, adding to this an elongated quadrangular spire copied from the wooden spire of Körösfő church. The interior decoration of the church was dominated by tulip and heart-shaped openwork.

OTHERS

The synthesis of national romanticism and functionalism seen in Wigand and Medgyaszay's architecture was to be reiterated in the projects of their colleagues Károly Kós and Dénes Györgyi. The latter were leading members of a new group of architects 'The Young Ones' (*Fiatalok*), established around 1907. Taking their lead from Ruskin and Morris, this group promoted a return to medieval traditions, to the Gothic, and an interpretation of the folk spirit through the simple integration of structure and ornament to create a picturesque impression of organic synthesis. In the last their ideas were close to the Arts and Crafts designers active in Hungary, Baillie Scott and Ashbee.

The Young Ones first achieved their aims for a new national architecture in the Roman Catholic Church at Zebegény (1908–10), designed by Kós (together with Bela Janszky). Here he combined the principles of Székely village church building with the lessons of Finnish national romanticism, not least that of Sonck and Saarinen. Thus the Gothic basilica is retained, but is completed with squared rubble, an asymmetrical plan and frescoes, including a Tree of Life, by Kriesch, themselves surrounded by painted floral motifs. Kós was to continue this assimilated national romanticism in numerous other projects, not least his own studio-house at Stana in the Kalotaszeg region (1910), this appearing as a response to Sonck's Suur-Merijoki. The trend also appeared in the designs he made jointly with Györgyi,[24] e.g. the Városmajor School in Budapest, a village school and Budapest zoo, the latter two incorporating high steepled towers with four turrets copied from Körösfő church.

An architect in close contact with The Young Ones, and who indicated parallel aspirations was Béla Lajta. Having been a student of Alfred Messel, the forefather of Berlin modernism, at the time of his construction of the seminal Wertheim Department Store (1897–98), worked in Richard Norman Shaw's practice in

London (1899) and visited the Paris 1900 exhibition, Lajta was one of the most versatile and articulate of Hungarian New Style designers. Around 1900 he began to work with Lechner, collaborating with him on the Klein mansion in Szirma, and following him in his use of Zsolnay tiling and national floriate motifs derived from Huszka: e.g. in the Ferenc Bárd music shop in Budapest (1900) and the Zenta (now Senta, Yugoslavia) fire station (1902). In the late 1900s his blending of German, English and Finnish influences reached maturity in the Budapest Institute for the Blind (1905–8) and the Jewish Home for the Aged Poor (1907–11), both of which are more 'Free Style' rather than national romanticist.[25] The first consisted of two sections – the main building and, perpendicular to it, the gym. Both were surmounted by steeply pitched saddle roofs and pyramidal towers. These together with the rectangular fenestration and massive parabolic portal, were reminiscent of Saarinen's early work, while the high and narrow gable walls with dormer windows were influenced by Shaw. In addition a side entrance was adorned with two narrow steel columns whose menorah-shaped capitals supported an aluminium plated cupola. The construction was fully integrated with ornamental motifs extracted from Hungarian building traditions, such as geometric figures and severely geometricised kissing doves, willows, tulips and hearts, these being applied across a variety of surfaces, including the doors, railings and furniture.

The next phase of Lajta's career witnessed a reduction of decorative features in favour of a more austere rationalism. The Rózsavölgyi House and the Erzsébetváros

51 Töry, Pogány and Györgyi, Hungarian pavilion, Turin exhibition, 1911

Savings Bank (both Budapest, 1911–12) were prime examples, with their cubic plans, flat roofs and rectilinear facades dominated by the stripped horizontals of the upper storeys and the lattice effect of the glazed lower floors. Although both suppressed the use of ornamentation, stylised folk patterns were still to be found, for instance, on the balcony railings and some window borders. Further, the Rózsavölgyi House utilised a facing of white pyrogranite and red, green and brown ceramic bands instead of cornices. Yet the main effect was one of constructive quadrangular blocks, with the attic storeys stepped back, as if in response to Adolf Loos' Michaelerplatz House built a year earlier in Vienna.

1911 marks the watershed of the rationalist New Style in Hungary and yet this did not indicate the waning of national romanticism. Indeed, the latter was at its zenith not least in Budapest, with Aladár Árkay designing a masterful *gesamtkunstwerk* response to Sonck and Wagner: the Calvinist Church (1911–13). This combined a Gothic tower with rusticated and tiled facade, a Byzantine cross plan and an interior bedecked with gold and ochre vegetal ornaments. The fusion of Hungarian, Finnish and Viennese features was also to be present in the Budapest architecture of the Vágó brothers, József and László, created from the latter half of the 1900s. This included the National Salon (1907, destroyed) with its murals and stained glass by Kriesch and Nagy, and play of dark and light geometric forms which were complemented in the vestibule by wicker furniture designed by Josef Hoffmann. The Vágós Árkád-Bazár toy shop (1909) also displayed an eclectic as-similation of sources – from folk art to Wagneresque sheathing of the facade in white majolica tiles with dotted ceramic knobs imitating bolts.[26]

The abiding influence of Lechner, and through him Wagner, was to be felt in many other Hungarian architects' works, including Ferenc Reichl's mansion home in Szabadka (1904) and Géza Markus's *Cifrapalota* (Palace of Many Colours) in Kecskemét (1902) with its rubbery cornice and stringcourse, florid floral decora-tions, amber and green tiled roof and plasticine-type rustication to the ground floor. But while Lechner's legacy and the 'Magyarist' tendency provided scope for an original local interpretation of the New Style, it was supplemented by more conventional Jugendstil structures both in Budapest (e.g. the tenements by Sámuel Révész and József Kollár) and across the country, e.g. Ede Magyar's Reöck family mansion in Szeged (1908) and the numerous tenements in German-domi-nated Brassó (Kronstadt, now Brahov, Romania).

It was the national romanticist trend, however, which proved the more endur-ing. Encouraged by the magnificent 'Attila' Pavilion at the 1911 Turin Exhibition (Plate 51) and Lajos Kozma's establishment of the Budapest Workshop in 1913, which was the belated Hungarian answer to the Wiener Werkstätte, the trend was even to continue throughout the First World War, not least in the War Exhibition pavilions by Medgyaszay (Lemberg 1916; Budapest 1918). Critics at Turin had fore-seen this strength:

The indisputable success ... is unquestionably the Hungarian section, and the palm must be awarded to the architects of the pavilion, and to the various exhibitors from this semi-oriental land ... Hungary (is) so bold in its art, so modern in aesthetic expression and so jealous of its national traditions ... (There must be) a brilliant future for Hungar-ian art, which possesses such exceptional vitality and which takes everything, even exhi-bitions, seriously ... The pavilion is the most striking in the International: austere in its exterior, beautiful and bizarre inside, this building of noble proportions and harmoni-ous colouring, whether it be reminiscent of India or Persia, whether it be a souvenir of

the orient or inspired by antique Hungarian motifs, stands out from the monotonous white buildings.[27]

In fact, the Turin pavilion, designed by Emil Töry, Móric Pogány and Györgyi on the banks of the River Po, combined a romanticised vision of Attila's 'tent' palace with severe modern cuboid blocks punctuated sparingly by unadorned rectangular fenestration. The edifice was completed by two elongated stupa-like towers and three pyramidal cupolas, one capping the 42-metre-high battered tower over the central hall. This was entered through a doorway flanked by Miklós Ligeti's indomitable knights, itself crowned by a parabolic, helmet-shaped copper cupola decorated with vegetal Hungarian lace motifs. A sense of shrine, enhanced by Róth's stained glass windows, pervaded the interior. This Hungarian temple of art was decorated with a series of flat hanging 'mobiles' given the jagged forms of Transylvanian carving motifs and dangling from the ceiling as if totems for a pagan ritual. Elsewhere Kriesch provided frescoes – images of pure youth in naked contact with the spiritual world – and the walls were covered in Zsolnay eosine tiles, some covered with primitive images of flora and fauna.

Notes

1 Half a century earlier the population of the combined towns had been around 100,000, in 1869 it was 270,000 and by 1910 it was 880,000.

2 In 1904 Hungary's first radically modern theatre group appeared – the Thalia company. Staging productions of Ibsen and Hauptmann and directed by Sándor Hevesi, a follower of Gordon Craig, the company lasted until 1908.

3 The opposing poles in the debate were characterised by two periodicals – A Het (The Week) (founded 1890), edited by the intimist Jewish author Jozsef Kiss, and Uj Idok (New Times) (founded 1895), a conservative nationalist response to A Het .

4 Among the new arts periodicals were Müveszi Ipar (Applied Art), Müvészet (Art), Budapesti epiteszeti szemle (Budapest Architectural Review), A Ház (The House), and Magyar Iparmüvészet (Hungarian Applied Arts).

5 Endre Ady, Új versek (New Poems), 1906.

6 Like many Hungarian painters of the period, Munkácsy changed his German surname (Lieb) for a Hungarian one adopted from a place name – in his case Munkács in northeast Hungary (now Ukraine), where he was born.

7 Interestingly he was particularly close to the Scot James Pitcairn Knowles and the Catalan Aristide Maillol, both of whom he knew from around 1889–90, and who shared his house-studio at Neuilly-sur-Seine near Paris from 1892. Indeed, he was responsible for introducing Maillol to the Nabis in 1895, and together with him was drawn to tapestry design early in the decade.

8 Cited from P. Eckert Boyer (ed.), The Nabis and the Parisian Avant-Garde, New Brunswick, 1988, p. 103.

9 For reproductions of his work, see ibid. and G. Ére, Z. Jobbágyi (eds.), A Golden Age. Art and Society in Hungary 1896–1914, Miami, 1990.

10 The factory had been founded in 1853 in the southern town of Pécs. See E. Csenkey, Zsolnay szecessziós kerámiák, Budapest, 1992.

11 Lechner had twice undertaken study trips to England: the second, when he had visited the South Kensington Museum and studied its Indian collection, as recently as 1889. During his stay he could have become acquainted with the designs of Repton, Dance and Nash. He subsequently acknowledged Calcutta Railway Station as a source. His second trip was undertaken with Vilmos Zsolnay, head of the Zsolnay works. For an illustrated analysis of his career, see Lechner Ödön 1845–1914, exhibition catalogue, Hungarian Museum of Architecture, Budapest, 1985. His national romanticism coincided with that

of Ion Mincu and the more progressive Cristofi Cerchez, his Romanian contemporaries active in Bucharest. Further work needs to be done to establish the relationship between these movements, and in particular their common sources and forms.

12 See A. Moravanszky, 'The Aesthetics of the Mask', in H. Mallgrave (ed.), *Otto Wagner: reflections on the raiment of modernity*, 1993, p. 227.

13 E.g. Huszka's *Hungarian Decorative Style (Magyar diszítő styl)* (1885); *The Szekely House (A szekely ház)* (1895) and *Hungarian Ornament (Magyar ornamentika)* (1898).

14 For Wagner, see Austria. Lechner and Wagner were on close terms.

15 This separates Lechner from Gaudí, since the Catalan architect used oriental features, such as Hindu temple forms in the spires of Sagrada Familia, while apparently striving to extend and diversify what was essentially still a Christian architectural vocabulary. Lechner was later to design overtly Brahmanist and Buddhist stupa-inspired buildings; see K. Keserü, 'Vernacularism and its Special Characteristics in Hungarian Art', in N. Gordon Bowe, ed., *Art and the National Dream*, Dublin, 1993, p. 139.

16 Cited from J. Szirmai, 'Odon Lechner and his Followers', in P. Nuttgens, (ed.), *Mackintosh and His Contemporaries*, London, 1988, p. 124.

17 See reproductions in *The Studio*, 1902, vol. 24, p. 206–8. Wigand, like Kriesch, was of Austrian extraction and took a second surname from the Transylvanian village – Torockó. The English influence was important for the Gödöllő artists and the new Hungarian arts movement generally: in 1905 Kriesch published his study of Ruskin and the English Pre-Raphaelites; a large exhibition of Walter Crane's work was held in 1900 and his *Line and Form* appeared in Hungarian in 1910; C. R. Ashbee and Baillie-Scott both designed houses in Hungary in the 1900s; Béla Lajta worked in Norman Shaw's studio in London.

18 For reproductions of such national romanticist work see *The Studio Yearbook of Decorative Art*, 1911,

19 Made by the Paris-trained Swedish craftsman Leo Belmonte who worked at Gödöllő from 1905.

20 Horti was a major Hungarian applied artist. Designer of the pavilion at the 1902 Turin exhibition, he specialised in abstract organic tapestry design. He also produced the 1898 cover for *Magyar Iparművészet*, utilising a typically international floral composition that showed stylised organic growth from root to bud.

21 The Hungarian section, along with the Italian, was destroyed by fire shortly after the opening.

22 J. Szabo, in S. Mansbach (ed.), *Standing in the Tempest: Painters of the Hungarian Avant-Garde 1908–1930*, Santa Barbara, 1991, p. 107.

23 The tulip so characterised Magyar design that one of the national crafts associations organised at the turn of the century was known as *Tulipán* (The Tulip), this specialising in textile design, lacework, basketry and ceramics. Komor and Jakab established their partnership in 1897. Leading Art Nouveau architects, their other projects included the Synagogue, Szabadka, 1901–2; the Trades House, Kecskemét, 1902–3; the Black Eagle (Fekete Sas) Hotel, Nagyvárad (now Oradea, Romania), 1906–9; and the City Hall complex, Marosvásárhely, 1907–18. Many of these employed new construction methods, using iron and concrete, as well as picturesque coloured Zsolnay tiles after Lechner.

24 Györgyi was professor of architecture at Budapest Applied Arts School. His early commissions executed in the national romanticist style included several schools and churches in Slovakian villages, as well as houses and civic buildings in the east Slovakian centre Kosice. He also participated in the design of the Hungarian Pavilion at the 1911 Turin Exhibition.

25 Another important project indicative of his assimilation of Shaw and Baillie Scott, was his Budapest house for Desző Malonyay, the author of *On Hungarian Folk Art (A magyar népmüvészet)* (1907–22), for which the *Fiatalok* architects made numerous studies.

26 Other Vágó works included the Petőfi Museum (*c.* 1910), the 'Stadtwäldchen' Theatre (1908) and the Loos-inspired Schiffer mansion (1910–12).

27 A. Melani, 'Some Notes on the Turin International Exhibition', *The Studio*, vol. 53, 1911, p. 289.

9

POLAND
Cracow and beyond

Background

In considering the development of Art Nouveau across the European continent, that created in Poland stands out through its political division between three neighbouring states – Germany, Austro-Hungary and Russia. But as so often in the history of the movement it was marked by unifying determinants – namely occupation and rivalry. The haemorrhaging of the Polish state in the late eighteenth century – its partition into a nation split across several borders – resulted in a particularly strong sense of loss and a determination to reinforce national identity. One of the most effective ways of advancing the national cause was through art, architecture and design. The mid-nineteenth-century Romantic presentation of this was to be encapsulated in the poetry of Adam Mickiewicz and the painting of Jan Matejko.

As with so many other European peoples deprived of their statehood by the rewriting of the political map, the Poles could only aspire to 'culturehood' as a unifying ideal.[1] Many Polish nationalists turned, therefore, either to a vernacular romanticism or to modern universalism – the latter in the belief that this marked their integration on equal footing with the rest of European and human society. On the other hand, the occupants were also happy to encourage the development of the international trend of the Secession Style since this appeared to contradict and suppress the nationalist inclinations of the population. The result was that Art Nouveau in Poland, as in Catalonia, Scotland and elsewhere, was to be promoted and characterised by a dual set of stimuli – nationalist interest and its suppression. It was the meeting ground for conflicting ideologies, a laboratory where the elements were being mixed, if not united, and convoluted solutions obtained.

The problem faced by Poland was that its division separated its artistic forces and was capable of leading them in different directions. Added to which the country as a whole remained largely underdeveloped and its middle classes often had to spend large parts of their lives in exile. For many this meant emigration to Germany, France, Austria or Russia. And it was in these foreign lands, divorced from their home, that some made their most valuable contributions.[2]

Appearance

Polish contact with west European developments, not least through the large numbers of artists and writers who made a 'tour', studied or lived abroad, was considerable and highly significant for the direction taken by its own art. Around the turn of the century in Warsaw there were exhibitions of Klinger, Toulouse-Lautrec; in Cracow Feliks Jasieński collected Japanese woodcuts and in Lemberg Gabriela Zapolska gathered works by Gauguin and Van Gogh among others. Further, as early as 1887 articles on symbolism had begun to appear in the Cracow press, followed by an influential study of Maeterlinck by the critic Zenon Przesmycki in 1891; and Cracow performances of Maeterlinck, Hauptmann, Wilde and Ibsen in 1893.

In fact, the introduction of literary symbolism to the fertile Polish lands was to germinate a whole new, extremely vital movement that encapsulated all the arts. This, essentially, was the so-called *Moderna* or *Młoda Polska* (Young Poland) movement, a loose association of modernist and national romanticist artists, writers, musicians and architects. In 1897 some of the more nationally inspired among them formed the group *Sztuka* (Art). Periodicals supporting their art and their views began to appear, the foremost being *Życie* (Life) (1897–1900), and *Chimera* (1901–7).

Chimera, a glossy and extensively illustrated review which used new printing techniques such as callotype and photogravure, was founded in Warsaw by Przesmycki and advanced the most integrated conception of the new arts. One of its foremost illustrators was Edward Okuń, whose work showed conventional Art Nouveau leanings. For instance, in the lyrical vignette, *Symbol of Inspiration* (Plate 52), a young violinist is synthesised with her surroundings through the locks of her hair and her instrument body flowing out in sweeping curves to become one with the fields and river behind her. More astral, but similarly stylised and representative of the association of contemplative femininity and cosmic rhythms was his 1903 cover (Colour plate 7). Likewise, an earlier cover depicted on a plinth with goats' heads, swags and the inscription 'Chimera', a diagonally upward striving female beauty, her body dematerialised into ribboned flames.

Życie was poorly funded and irregular in appearance. It was edited in Cracow by the Nietzschian, even Freudian, Stanisław Przybyszewski, with Stanisław Wyspiański as its arts editor. Before taking up the job, Przybyszewski, one of the most influential literary figures for the visual arts both in Poland and, indeed, elsewhere, had lived in Berlin for several years, studying architecture and then psychiatry. During his stay he worked closely with Munch and the dramatist Strindberg, and with them had been associated with the *Pan* circle of decadents. His approach placed art on a pedestal high above all else. It alone was capable of value, the rest was meaningless. It alone could reflect the Absolute – the 'naked soul'. This was a substratum of psychic experience, far deeper than consciousness, where man realises his primal attachment to animal ancestors, instincts and blind forces. Ultimately love was a delusion, a trick created from needs of survival; indeed, the core of man was simply a demon who is nothing other than sexual desire. Far better would it be if the dream of Androgyne, that unity of sexes in one body, could be invoked. Art was not to be in the service of pleasure, patriotism or even the people, as far as Przybyszewski was concerned. It was to be 'the highest religion, and the artist becomes its priest ... He is a cosmic, metaphysical force through which the absolute and eternity express themselves'.[3] It was as if he was verbalising the plastic strivings of Klimt, Munch, Gallé, Fidus or Vrubel.

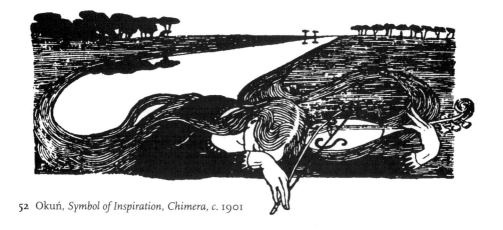

52 Okuń, *Symbol of Inspiration, Chimera, c.* 1901

LEMBERG (LWOW; NOW LVIV, UKRAINE)

It was in the Slav province of Galicia where the new arts movement flourished, and most particularly in the ancient cultural and intellectual urban centres of Lemberg and Cracow. By the turn of the twentieth century Lemberg, with a population of 160,000, was the fifth largest Austro-Hungarian city. Growth was encouraged by its status as an administrative centre, and its being a focal point of the new railway network. By the 1900s the old fortifications had long since been pulled down, boulevards constructed, the waterways regulated, the city divided into several districts, and an electric tramway was in operation. Civic institutions included a university, polytechnic and Applied Arts School, the opera theatre, the art and industry museum, the art gallery and the Ossolineum Institute of Polish Studies. There were also numerous hotels (The George, Grand, Metropole, France and Europe), the Café Vienna, a botanic garden and several picturesque parks.

Most of the new buildings of the late nineteenth century were historicist or eclecticist. Nevertheless Art Nouveau was to be particularly widespread and diverse, encouraged by the city having its own architectural course at the Polytechnical School, this drawing students from a very large region. The most independent experiments with new principles and forms occurred in the architecture of Sadłowski, Lewiński and Luszpiński, all of whom combined Art Nouveau with elements transferred from local wooden building types and decoration. Władisław Sadłowski appeared to initiate the trend with his work on the central railway station and the Philharmonia Hall (1907), which included an ornately carved wooden ceiling. His local borrowings were primarily from two ethnic groups – the Polish and the Huzul (Ruthenian–Ukrainian). Yet it was Lewiński and Luszpiński who were to utilise these most originally.

Jan Lewiński was a leading force in Lemberg design at the turn of the century – having his own architectural practice, a construction materials company and a ceramics workshop. He was also professor of architecture at the Polytechnical School from 1903. Extremely prolific he designed numerous buildings in the Galician Modern Style, among them the Chamber of Commerce, the George Hotel and various sanatoria across the region. An important example of his reinterpretation of the vernacular in a modern idiom was the Dnestr Insurance Company Building (1905), built for Lemberg's first and wealthiest mutual protection company. Not uncoincidentally, the company's founder, Vasyl Nahirny, also happened

to be the chairman of the Society for the Advancement of Ruthenian Art.[4] This society, established in 1898, looked to the Huzul traditions as the fount of its Ukrainian national revivalism, which it displayed in several exhibitions organised from 1899 on. The large, essentially rectilinear, headquarters of the Dnestr building was dressed in rubble on the ground floor, above which the stone work was covered in a mix of decorative stucco work, some derived from Ruthenian folk art, and was capped by a tower and roof whose low pitch and length corresponded to that of Huzul peasant houses. The facade and interior incorporated ceramic friezes and fittings with simple stylised motifs derived from local Slavic folklore.

Such references also characterised Lewiński's Pedagogical Society student residence (1906–8) and Music Institute (1914–16), these, as the Dnestr building, being designed in collaboration with the chief engineer of his construction company, Aleksander Luszpinski.[5] The former included a squat mansard roofed tower over the entrance which was a free interpretation of Carpathian wooden churches. The latter, probably the last building to be constructed in the style in Lemberg, attempted a complete synthesis of architecture and the arts. It was the new home of an essential training ground for Galician musicians – the Mikola Lysenko Higher Institute of Music, founded in 1903 and named after a leading Ukrainian composer and ethnomusicologist. The building combined a classical severity to the facade with a plethora of decoration in the concert and assembly halls. There high-relief portraits of Ukrainian musicians combined with polychromatic murals painted by Modest Sosenko. These transferred motifs from Huzul folk embroidery and combined them with stylised images of ethnic musicians – bandura (mandolin), trembita (horn), fiddle and lyre players.

Lewiński's role in establishing the national romanticist trend in Lemberg's architecture coincided with a similar responsibility in the applied arts. His ceramics workshop was the largest in the city, and the main manufacturer of decorative tiles, crockery, vases and statuettes. His designs were frequently abstractly biomorphic, and in glazes of violet and blue. These he supplemented with traditional local colours (brown, yellow and green) and forms, and stylised depictions of Huzul figures, either in silhouette or set in a rhythmical pattern.

The turn to Huzul tradition was taken further by two graduates of the Vienna Applied Arts School, Olena Kulchytska and Kazimierz Sichulski. Both diversified from painting to the applied arts: Kulchytska practising enamel work, jewellery, tapestry design and graphic art; Sichulski stained glass, graphic design, mosaics and furniture. Kulchytska's use of Huzul types and traditions was represented in a work such as *Folk Art* (1906), a triptych in enamel on copper, which depicted Huzul musicians, children and a craftswoman in folk dress, these in flattened, generalised form. She integrated this with a thick, undecorated frame, the joints and pegs of which formed a modern interpretation of construction techniques found in the arches of Huzul churches.

Sichulski was the pre-eminent Modern Style artist in Lemberg.[6] Associated with the Cracow *Sztuka* (Art) group, he also painted the panels for its meeting place, Michael's Den (see below). In addition, he co-founded and was art editor of the Lemberg Secessionist magazine *Liberum Veto* (1904–5). This satirical journal, close in spirit to the Munich *Simplicissimus*, was highly critical of the rife social injustices and moral failings of the time – not least those perpetrated by the Austrian bureaucracy and army, the church, the aristocracy and the bourgeoisie. These were illustrated primarily by Sichulski's Steinlenesque caricatures – often black

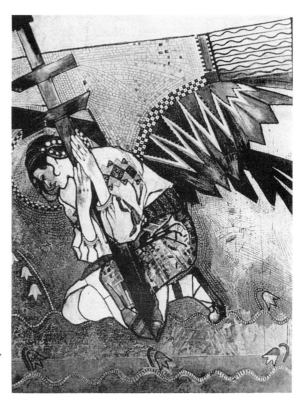

53 Sichulski, *Huzul Madonna*, sketch of right side for a mosaic triptych, 1914, mixed media, 150 x 112

and white, often urban, with expressive linearity conveying a feeling of the grotesque. In 1908 he created stained glass windows for the church in the nearby Stare Selo village. Very close in conception to stained glass designs by the recently deceased *Sztuka* artist Wyspiański, these have young female figures in folk dress depicted in prayer and contemplation. They are entirely enveloped by tall, blossoming flowers, whose colour movement appears tremulous and perpetual. In the larger window he portrayed an angel descended from heaven, her wings lowered, before a praying, haloed young woman. The figures are set in the local landscape.

While these are idealised and full of New Style features, not least the common decorative pulsation of life, Sichulski's sketches for a mosaic triptych of the *Huzul Madonna* (1914) (Plate 53), incorporated more Huzul stylisations. Here the Virgin Mary and her two surrounding angels wear Huzul dress with typical Ruthenian ornamentation and geometrical motifs. Their faces are localised as are the objects they carry. The colours are bold and set against a golden ground, in places delineated as if mosaic. The figures are flattened, set in abstract space which is disturbed only by the zig-zag rays of life entering from the upper corners and the undulating line of the ground with its bluebell pattern.

CRACOW (KRAKAU; KRAKOW)

Such a turn to the Huzuls as the embodiment of a primal national tradition was not to be confined to artists working in Lemberg. Others seeking the spirit of the Polish nation also found it expedient to employ Huzul tradition – most notably Teodor Axentowicz. Early on Axentowicz had worked in a fashionable realist style, even painting Sarah Bernhardt's portrait this way in 1889. In fact he continued to

draw on Parisian developments for much of his career but he divided this interest with his move to pastels of Huzul peasants rendered with a gently flowing Art Nouveau line and delicate tones.

Axentowicz was professor of painting at the Cracow Academy (until 1900 the School of Arts) and it was in this city that the Galician Secession Style was to acquire a most distinctive quality of expression. In 1868 Cracow became one of the first European cities to gain a Museum of Industry, this through the efforts of Doctor Adrjan Baraniecki, who had escaped from Russian Poland after the failed Polish uprising of 1863. In Cracow Baraniecki was able to encourage the formation of a strong, modern Polish cultural identity due to the relative autonomy Galicia enjoyed: Polish was the official language, there was political representation in Vienna, and the Diet in Lemberg had considerable powers over the direction of local development. In keeping with the new Viennese approach to design and rural tradition, the museum held courses for Galician apprentice craftsmen while at the same time collecting and keeping abreast of current European applied art. Thus it served as a focal point for the modernist debate between those who advocated as a primary concern assimilation of European industrial achievements and those who preferred to develop using a more rustic craft approach.

One of those who contributed to, and ultimately resolved, the debate was the architect Tadeusz Stryjeński, who was director of the industrial museum from 1907. He saw expansion as the way forward, and to this end designed a large building for the museum (1909–13), which also incorporated workshops for bookbinding, metalwork, woodwork, printing and photography. He also published the *Crafts Review (Przegląd Rękodzielniczy)*; organised a design standards advisory body; and contributed to various exhibitions. Prior to getting the museum post, Stryjeński had brought significant innovation to Cracow architecture. This was manifested in the reconstruction of the Old Theatre (1903–6), which fused Polish Neo-Renaissance elements with the New Style, using reinforced concrete, stylised railings, a cantilevered gable and a large stucco frieze of wave-like floral forms. The restaurant was also to incorporate wall paintings depicting fashionable, idealised theatre-goers, and furniture by Józef Czajkowski.

The use of vernacular traditions in the new architecture was first advocated by Franciszek Martynowski in the early 1880s, though it was not until the 1890s that his ideas were to be fully realised. This coincided with increased access to, and interest in, the remote mountainous region of Podhale, south of Cracow. Podhale culture was to be the local equivalent of Ruthenia further east, and the Hungarians' Kalotaszeg. Here, instead of the Huzul or Szekely people, were the Górale, a distinct ethnic group who had migrated from the east in the twelfth century. Extremely poor, unindustrialised, and with their own social codes and language, the Górale and their traditions provided virgin soil for the searchers of a new, untarnished, independent Polish spirit. Polish scholars established the Tatra Society in 1873 to promote and improve the Górale way of life. This society collaborated with the Viennese authorities in establishing a *Fachschule* for woodwork in the provincial centre, Zakopane, in 1876.[7] It also encouraged the Polish bourgeoisie and intelligentsia to visit the area by turning Zakopane into a health resort. Needing accommodation, they either built their own villas (often in Swiss chalet-style) or stayed in new sanatoria.[8]

One of those who came was Stanisław Witkiewicz, a realist painter and critic from Cracow. An ardent nationalist and opponent of historicism, following his

first visit in 1886 he became fascinated by the folk traditions of the Górale. He began to proclaim, rather spuriously, that only they had kept alive indigenous art forms which once proliferated across all Poland but had been killed off by alien European styles. Witkiewicz called for the establishment of a new 'Zakopane Style' (*Styl Zakopiański*), which would cover all the fields of art and design and be inspired by vernacular forms, techniques and motifs. The peasant Gorale material culture was thus to become the fount of a Polish national style, which, in Ruskinian fashion, would revive the spirit of the people and bring equality.

With these ends in mind Witkiewicz, together with his architectural and literary colleagues, collected and began to intepret the raw material given up by the region. A complex decorative and architectural language quickly evolved. And so, like so many other painters across Europe in the 1890s, Witkiewicz moved into building. Having studied the long log cabin homes of the Gorale, which had wooden slatted, half-gabled roofs, deep overhanging eaves and simple organic and geometric carved decorations, he introduced these features to the house he designed for Zygmunt Gnatowski (1892–93, Zakopane). Known as the Willa Koliba, this large barn-like home also incorporated modern features: dormer windows informally located; rusticated stonework for the lower level; and an abundance of carving, much of which used the sun motif traditionally confined to the gable ends of Gorale houses.

Other Zakopane villas followed almost annually, culminating in the House under the Firs (1896–97), which Witkiewicz built for the economist and historian Jan Pawlikowski:

This building, displaying an extraordinary virtuosity of craftsmanship in wood inside and out, revealed the style at its greatest distance from traditional roots. Built on a sloping site, the House under the Firs had a plan of concealed complexity with three floors, terracing and projecting gables that held entire rooms. The dominant, steeply-pitched roof was a complex of brick chimneys, deep eaves and dormer windows. These characteristics owed much to the spread of the Free English architectural style across Europe, via Germany and its own vernacular revival, in the 1880s, and an Arts and Crafts-inspired fascination with the commonplace and rustic. But it was the deployment of local building and decorative techniques that was intended to express 'Polishness'.[9]

This then was the Polish 'Red House', 'Bloemenwerf' or 'Hvitträsk'. And as such while borrowing from the vernacular it also was a conscious attempt to exploit rather than imitate peasant culture for the sake of a new art. Thus the carved ornamentation of stylised suns, mountain thistles, edelweiss and other mountain plants, instead of being restricted in its application to door frames, gable ends and the main structural beams, was to be found across all surfaces, including those of furniture and fittings.

In essence the House under the Firs (Plate 54) became a *gesamtkunstwerk* manifesto of wholly integrated structure, design and decoration. Everything, down to the stoves and upholstery, was designed by Witkiewicz or his colleagues, and made by local craftsmen. Carefully selected local techniques were adapted and refined to meet with modern and nationalist requirements, this in turn leading to a revival in the applied arts and the wider dissemination of the Zakopane Style. In fact, Zakopane had become something of an artists' colony, attracting artists, writers and musicians from across partitioned Poland, and especially Cracow. These took back with them something of the approach they had uncovered and synthe-

sised it with the demands of urban architecture and art in the city. Witkiewicz himself designed the railway station at Sylgudyszki (now Lithuania), accordingly, while Slawomir Odrzywolski created the Cracow School of Industry (1912) in this branch of the New Style.

The enthusiasm for national revival in architecture and the applied arts, and the debate it induced, was to provide a catalyst for the foundation of the Polish Applied Arts Society (*Towarzystwo Polska Sztuka Stosowana*) in Cracow in 1901. Founder members included the architects Stryjeński, Czajkowski and Edward Trojanowski, the universalist Wyspiański, and the painters Karol Tichy and Stanisław Goliński. The society published its own journal, *Records of Polish Applied Art* (*Materiały Polskiej Sztuki Stosowanej*) from 1902, established its own collections of folk and modern design, and organised exhibitions of members' work. Uniting many of the *Młoda Polska* artists, although it promoted the vernacularist work of Witkiewicz and his followers, the society by no means limited itself to the advocacy of this trend as the only way forward. On the contrary, members such as Tichy, who by 1904 had become a professor at the new Warsaw School of Fine Art, designed furniture in light, geometrical forms based on squares, rectangles and circles, and using chessboard patterns that were clearly derivative of Hoffmann's and Moser's Secession Style. Similarly, Jan Szczepkowski designed fully modernist table lamps and metalware; and when the greatest national romanticist of them all, Wyspiański, designed the interiors of the Cracow Society of Physicians building (1903–5), the linearity of his light utilitarian chairs was considered by critics as wholly in keeping with the approach being advocated by the Vienna Secession designers.

The Applied Arts Society sought both to protect threatened native culture and to encourage and influence the practice of all the crafts in Poland, from carving to rug-making, embroidery, ceramics, metal and glasswork, bookbinding, illustration, stained glass and lace-making. But like its counterpart in Vienna, the *Wiener Werkstätte*, it frequently had to rely on outside, commercial manufacturers for the production of its designers.[10] Municipal and private commissions attained by the Society included the interior design of the Cracow mayor's apartment, by Czajkowski (1907); the interior of the Cracow Chamber of Commerce, by Mehoffer (1906–7) and the infamous Ludwik Michalowski's Café, the so-called Michael's Den (1911). This was a meeting place for the *Młoda Polska* circle, and home of an irreverent cabaret, The Green Balloon. The salon, designed by Karol Frycz,

was filled with enormous armchairs and sculpted inglenooks replete with symbols deformed in ways connotative of decadent Cracow: owls turning into chair-backs; huge baroque-style scrolls derived from peacock feathers; and jewel-like stained glass windows, punctuating the walls in unexpected places, illustrating spiders and bats. The walls were decorated with strangely organic mouldings, and wall paintings by Kazimierz Sichulski ... caricaturing local artists and writers.[11]

In fact in many respects the salon and cabaret parodied the development of the national revivalist artists, and, in its orgy of florid colour, bulbous, heavy forms and excessive decoration, cocked a snook at the pretensions of austere refinement being advanced by many 'progressive' arts. Unsurprisingly, given the decadent punch of its anti-nationalist and anti-Austrian, its anti-conservative and anti-progressive, visual satire, it was a regular haunt of Przybyszewski and his cohorts.

Michael's Den illustrated the diversity of the Polish Applied Arts Society – a stance which led to the union of distinct, and often competing, ideologies. This

54 Witkiewicz, House under the Firs, Zakopane, 1896–97

openness led some designers to seek a more national romanticist forum for their activities, and hence in 1909 the Society of Podhale Art was founded and in 1910 the Kilim Association, both in Zakopane, and both in pursuance of Witkiewiczian goals. The Kilim Association promoted traditional kilim weaving techniques, using naturally dyed textiles, but with scope for innovative decorative designs. Among those who joined were Czajkowski, the painter Stanisław Goliński and the graphic artist Władysław Skoczylas, the last a wood sculpture teacher at the Zakopane *Fachschule*. Their wall-hangings could be floral or figurative, but in either case they were marked by bold colour generalisations of form and a simplicity of design. Skoczylas, who, like Czajkowski, went on to become professor at the re-established Warsaw Academy of Fine Arts in 1922, was always to favour the southern vernacular in his approach to decoration and technique. Persistently searching for a national style, one of his early tapestries depicted the geometrically stylised celebration of men dressed in local costume around a bonfire, the flames of which create a dramatic diagonal across the composition.

In 1912 the Polish Applied Arts Society organised one of its last and most ambitious ventures, the Cracow exhibition dedicated to the garden city – 'Architecture and Interiors in Garden Settings'. Its initiators included Styjeński, Władysław Ekielski and Czajkowski. A clarion call for a new urban aesthetic, this was also the society's swansong – in 1913 a new organisation, the Cracow Workshops (*Warsztaty Krakowskie*) was established, in which designers and craftsmen worked much more closely, and in 1914 the Applied Arts Society folded. The 1912 exhibition had been preceded by a wave of interest among the Society's members in the town-planning ideas of Ebenezer Howard and Camillo Sitte. Indeed, they had taken part in the competition for the development of Cracow's Salwator region (1908) and had won that for Greater Cracow in 1910. Goliński had even gone so far as to envisage a Howard-like integrated network of the populated regional centres. The 'Architecture and Interiors' show included a main pavilion by Czajkowski and Ludwig Wojtycko in an extravagant 'manor-house' style, as well as more restrained, modest and practi-

cal homes for the bourgeois family and the craftsman's family. The simple rationality of their design, which covered all the elements from structure to furnishings and decoration, was to bear witness to the assimilation in Poland of the modernist approaches of Voysey and Muthesius. At the same time, the use of the Polish manor house as a prototype hinted at the perpetuation of nationalist concerns.

WYSPIAŃSKI

Amongst those visual artists who founded the new movement in Poland, those who studied in Paris included the Pont-Aven member Władysław Ślewiński, an important conduit for the latest developments. Having studied at the Académies Julian and Colarossi from 1888, it was he who introduced Wyspiański to Gauguin and Mucha. The chemistry of the times was powerful:

(their) friendship formed in Paris ... led to a lifelong collaboration between Mucha and Wyspiański, perhaps the most versatile and brilliant of all European modernists ... Mucha and Bílek most resembled Wyspiański in their exploration of mystical, Christian, and early Slavonic subjects and in their mastery of the secese in many art forms[12]

The son of a sculptor, Wyspiański had initially studied art and literature at the Cracow School of Art and the Jagellonian University in the late 1880s. Having been taught painting by the Polish romantic Jan Matejko he was then assigned to assist him with the restoration of the fifteenth-century frescoes in Cracow's Gothic St Mary's Church, a project supervised by Stryjeński. This work, combined with his education and family background were all to be ebulliently moulded into an art of unparalleled scope and originality. The meeting with Stryjeński, one of the most advanced initiators of new ideas in Cracow material culture, encouraged Wyspiański to study in western Europe. In 1890 he toured the Gothic cathedrals of Germany, Bohemia, northern Italy, Switzerland and France, many of which were then being restored, revealing to him the late nineteenth-century idealised notion of medieval craft-society relationships. Then in 1891 he went to study at the Académie Colarossi. After a three-year stay, during which he imbibed the art of Puvis de Chavannes, Gauguin, the Nabis and the symbolist writers, he returned to his native land with a mission to transform its insipid approach to art and design.

In many respects Wyspiański was the complete universalist – a dramatist, stage and costume designer, director, poet, painter, graphic artist, fresco restorer, and stained glass, furniture and interior designer. In all these activities synthesis was uppermost. A synthesis not only of the arts, but of the traditional and modern; the national and universal; the Christian and pagan; the Greek and Galician. His conception of theatre as all image – a unity of sounds, colours and shapes rather than a visual vehicle for an essentially literary art – broke down traditional hierarchies, as did his combination of elements from Greek tragedy, Wagner, village customs, folk festivals and Polish puppet shows. His art was total art, an attempt to reawaken the museum-like city of Cracow and the oppressed and impoverished people of Poland, to vivify and lead them forward with a messianic message that celebrated their inherent qualities.

Upon his return to Cracow Wyspiański restored and painted new frescoes, and designed stained glass windows, in the medieval Franciscan Church (1895–1902). His decorations included:

a richly coloured rhythmic 'garden' of intertwining and stylised floral motifs: lilies, daisies and irises. Around the presbytery the decorative treatment intensified with taut

55 Wyspiański, *Let there be light: God the Father*, stained glass design for Franciscan Church,
Cracow, 1896–1902, pastel, 846 x 390
56 *right*] Mehoffer, *Strange Garden*, 1902–3, oil on canvas 217 x 208

geometric motifs derived from peacock feathers and folk art, and strangely distorted
regal Polish eagles ... Wyspiański's Symbolist imagination came to the fore in the
church's vividly coloured stained-glass windows. In an Ascension scene Christ was
depicted as Dionysius, and God the Father, with raised hand in a gesture of judgement,
sat like Neptune ready to flood the world with brilliant azure waves.[13]

This fusion of alien sources and national codes, all within the *gesamtkunstwerk* of
the church, encapsulated Wyspiański's new language of form. Its realisation,
though not completed by the artist, proved to be one of the most advanced Art
Nouveau creations of its time. The windows of *Let there be Light: God the Father* and
the four elements were designed in an abstract blaze of flowing colour forms,
equal to Van de Velde's early melting wave decorations (Plate 55). Nothing is solid,
everything is in motion and organically linked. God rises above rippling water like
ribboned flames, an appropriate New Style interpretation of Michelangelo's full-
bodied Sistine Chapel Creator. Water is represented by a group of irises, those
most beloved of Art Nouveau flowers, set against a background of undulating lin-
ear rhythm. Life is reduced to underlying force, which, for the most part, is up-
wardly striving – joining the material earth with the immaterial atmosphere. Even
Wyspiański's cartoons for his polychrome figural wall paintings, which included
the *Virgin and Child* and the *Fallen Angels*, enveloped the beautiful, youthful figures
in an elongated decorated swathe of vegetation or gas with which they were united.
The proposed juxtaposition of these with compositions on Polish themes, such the
princess-turned-nun Saint Salomea, the crowned eagles of the monarchy, and the
peacock feathers of the leader of the 1794 uprising, Tadeusz Kosciuszko, com-
prised a theatrical, national romanticist vision.

This was to be developed further by Wyspiański in his dramas where, radically breaking with traditions of theatrical form, he invoked mythopoetic images through the synthesis of elements from Polish rural life, Cracowian history, the Bible and ancient Greece. He decries the nation's present paralysis in phantasmagoric scenes where inanimate art and nature come to life to variously suggest the merits, or lack of them, of the death-in-life circle, of the human desire for atonement and of the triumph of light over darkness. His works are native in inspiration, messianic in goals – ultimate sanctuary will be attained through the revivifying celebration of the national spirit and deeds. This was to be particularly felt in his early, unrealised design for a stained glass window, *Polonia* (1894) (Colour plate 8), which he intended for a cathedral in Lemberg. In this the tragedy and hopes of the Polish nation are drawn together through the unity of the simultaneously expiring and aspiring allegorical figures and flowers.

OTHERS

Wyspiański's syncretism, as well as his cult of ancient Greece, was to be expressed in his illustrations to the *Iliad* (1897) and his suggestion, with the architect Władysław Ekielski, to turn the ancient centre of Cracow, Wawel Hill, into a Polish Acropolis. He drenched himself in the city, in his landscape and portrait pastels, in his plays and in his applied art. And in this, although he was the most outstanding proponent, he was not alone. His path particularly coincided with Józef Mehoffer, who had studied together with him under Matejko, and at the Académie Colarossi from 1891. Mehoffer displayed a decorative talent in his symbolist painting and stained glass designs. His work showed similar daring to Wyspiański's, but lacked his colleague's spontaneity or expressive emotion. He often linked religious motifs with secular themes, historical figures with folk patterns, and he turned his hand to interior decoration, furniture design, and graphic art. The most accomplished stained glass artist of the new generation, Mehoffer's most ambitious project was in Switzerland – twenty-one stained glass windows for the Collegiate Church of St Nicholas in Fribourg (1895–1935) in which he mixed biblical and Polish folk motifs. His depiction of the Virgin and Child was one of the first of the period to attribute Polish peasant features to the Madonna. Similarly the Adoration of the Magi was imbued with a naivety and the form of Polish folk ritual. He also created mosaics for the dome of the Armenian Cathedral in Lemberg (1903–4), these joining the Polish, the Biblical and the Modern Style: one depicted King Jan Sobieski's Mass on the Kahlenberg, the other the Holy Trinity and angels, given coral-like wings.

Among Mehoffer's paintings *Strange Garden* (1902–3) stands out for its Art Nouveau effects (Plate 56). Against a delicate background of a paradisaical garden with sunlight, blossoming trees, flowers and fruit, he distinguishes his wife in black, fashionable dress, a distant nanny in her folk costume, a naked infant with hollyhocks and a dragonfly. The latter, in gold, imposed on the picture surface with wings extended to expose the veins, appears strangely alien and threatening – especially towards the child. The flight and the delicate beauty of the dragonfly, so often a primary subject of New Style artists, here appears ambiguous, at once contributing to the idyll, at once disturbing it.

Natural rhythms, idyllic scenes of sunlit nature and feminine beauty, also characterised part of the œuvre of the painter and graphic artist Wojciech Weiss, e.g. *Radiant Sunset* (1900–2). Weiss's painting was highly sensual, often eulogising the spirit of youth, as in *Dance* (c. 1900), depicting a round dance of naked

young men and women. Similarly, his illustrations in *Zycie* included *Youth* (1900) in which a rural boy was set against the background of a mature naked model with a halo. In this there was also an ominous note, a Przybyszewskian darker side, that was to be further realised in *Terrors* (1905), where, in bright poster-like blocks of form and line, a provincial girl runs away from scarecrows. The influence of Degas and Toulouse-Lautrec is felt in *Demon (In the Café)* (1904), painted after a trip to Paris, notably through the generalised rendition of forms, blocks of black clothes and hidden face of the desperate young woman. To this he adds a ginger-bearded Demon, with remarkable facial likeness to Przybyszewski.

The sense of human weakness and tragedy, combined with specifically Polish themes, was a dominating feature of two members of different generations within the *Sztuka* group – Jacek Malczewski and Witold Wojtkiewicz. Malczewski was responsible for an early form of national romanticism that was overtly patriotic and introspective. In 1893 he painted *In the Dust Cloud* where an allegorical image of *Polonia* as the chained mother who abandons her children to dreadful fate is set against a starkly reduced Polish landscape that is a series of horizontal colour fields. Often, his morbid national and personal allegorism is stressed through the use of fantastic hybrid creatures, angels, androgynes, satyrs and fauns, as in the foreboding *Thanatos I* (1898), *Resurrection* (1900), and *Angel, I'll follow you* (1901). In many cases these paintings are narrative codes for the plight of the Polish nation as well as mankind, though it is the former that usually prevails. The lurid floridity of Malczewski's compositions is always accompanied by figural naturalism, but in a work such as *Angel, I'll follow you*, where the Polish peasant child addresses its prayer to its guardian angel, this is fused with a stylised linearity and simplification of colour-form that suggests association with the decorative tendencies of Art Nouveau.

If there was pessimism in Malczewski, there was also messianism, the hope of which was absent in the paintings of Wojtkiewicz. These are far closer to the decadence proselytised by Przybyszewski, far closer to the literary symbolism of Wilde, Maeterlinck, or the Pole Karol Irzykowski. His is a world of Ensor-like masks, sad clowns, marionettes, children with aged faces and bodies, madmen and dwarves, e.g. the series *Tragi-Comedy Sketches* (1904–5), *Monomanias* (1906), *Circuses* (1905–7) and *Ceremonies* (1908). In the first, which included *Pessimists*, *Lover* and *Mother*, he uses a fiercely tangled Art Nouveau linearity to contort his figures into Toorop-style ogres. Everything is fantasy and illusion, a theatre of distortion, yet this depiction of degeneration and ugliness was the world of Wojtkiewicz's subjective reality – a melancholic realm where the grotesque and the lyrical, the ironic and the serious, combine.

Foremost among the other *Sztuka* artists whose work showed Art Nouveau tendencies, was Kazimierz Stabrowski. A graduate of the St Petersburg Academy and the Académie Julian, from 1904 he worked mainly in Warsaw. Stabrowski was the first director of the Warsaw School of Fine Arts, established on the basis of an earlier school which had been closed down by the Russian authorities forty years earlier. This school, whose curriculum included painting, sculpture and the applied arts, was to be a primal force in the development of Polish modern art.[14] One of its most celebrated students was the Lithuanian symbolist painter-musician Mikalojus Čiurlionis. Stabrowski's artistic leanings were towards symbolism and decorative stained glass work. These he expressed in lyrical landscapes, such as *Country Peace* (1900) and allegorical works with motifs taken from Lithuanian

folklore. He combined them in the painting *Stained Glass Background: A Peacock* (1908), a Klimtian portrait of Zofia Borucińska. Here, against a flattened, rouged background imitating the abstract organic patterns of a heavily leaded stained glass window, Stabrowski depicts his model in a peacock crown and radiant, shimmering blue dress with peacock eyes. Only her half-turned face and the vase of flowers in front of her are represented with any naturalism (Colour plate 9).

Notes

1 See D. Crowley, National Style and Nation-State. Design in Poland from the Vernacular Revival to the International Style, Manchester, 1992. This provides an informative and clear interpretation of the development of the New Style to which this chapter is indebted.
2 E.g. in St Petersburg, the architect Marian Lalewicz, the painter Jan Ciaglinski (Tsionglinsky), and the philologist Jan (Ivan) Baudouin de Courtenay; and in Paris, the romantic poets Juliusz Słowacki and Cyprian Norwid, the physicist Maria Sklodowska (Marie Curie), the painter Olga Boznańska, and the sculptor Wacław Szymanowski.
3 Cited from his manifesto, 'Confiteor', published in the first issue of Zycie in 1899. Translation from C. Milosz, The History of Polish Literature, London, 1969, p. 330.
4 Members included the painter and graphic artist Julian Pankevych and the muralist Oleksa Novakivsky, both of whom combined Art Nouveau stylisations with Huzul themes.
5 Luszpiński, a graduate of the Lemberg Polytechnic, was an ardent advocate of the Huzul style. This he advanced in wooden churches built in several villages, as well as convents and a community centre in larger urban centres, and plans for the revival of villages.
6 Others included the graphic artist Stanisław Dębicki, a member of the Vienna Secession and the Cracow Sztuka group; Kajetan Stefanowicz who adopted a decorative approach not dissimilar to Klimt's in his murals; Oleksa Novakivksy, M. Reisner and the applied artist and interior designer M. Olszewski.
7 The Fachschule 's history proved controversial. Directed between 1886–96 by Franciszek Neuzil, a Czech advocate of picturesque Tyrolean homes, the Polish nationalist camp opposed his alien sympathies and eventually managed to get him replaced by a Polish proponent of a locally based style, Stanisław Barabasz.
8 One such sanatorium, designed by the Cracow architect Henryk Uziembło (1911–12) in the Neo-Classical Secession Style, but with boldly florid stained glass windows made at Stanisław Żeleński's Stained Glass Art Company in Cracow, is reproduced in The Studio Yearbook of Decorative Art (1912), pp. 204 and 217.
9 Crowley, p.20.
10 The workshops included M. Jarry's metalwork factory, the Zelenski stained glass company and the cabinet-makers Andrzej Sydor.
11 Crowley, p. 36.
12 B. Garver, 'Czech Cubism and Fin-de-siècle Prague', Austrian History Yearbook, 1983–84, p. 95.
13 Crowley, p. 42.
14 The staff included Ferdynand Ruszczyc, a landscapist who occasionally used Art Nouveau techniques; the applied artist Karol Tichy; the sculptor Xawery Dunikowski; and briefly Władysław Ślewiński.

10

RUSSIA

St Petersburg, Moscow and beyond

Background

In the late nineteenth century the Russian art schools played a primary role in the training of craftsmen and designers according to the mainstream of European trends. This inevitably meant that while a vital link between art, industry and commerce was established, the general direction was away from rural, folk principles. The revival of the latter was left largely in the hands of artists, many being graduates of the design schools, associated with the crafts colonies at Abramtsevo and Talashkino. The work of these in popularising and modernising vernacular traditions and beliefs,[1] added an alternative dimension to the Russian Art Nouveau of the mass-production manufacturers and the commercial workshops specialising in high quality wares in neo-Russian and international Art Nouveau styles, e.g. the Kuznetsov and Imperial Porcelain factories, the Moscow jewellery artels, the St Petersburg jewellers Carl Fabergé and Alexander Tillander (a Finnish family company), and the St Petersburg stained glass makers M. L. Frank and the mosaic workshops of V. Frolov.

Savva Mamontov was an early sponsor of the Wanderers, the critical realist artists, who had challenged the authoritarian, anachronistic and non-Russian approach of the Academy in the 1870s. Bringing painters like Repin, Polenov, Polenova, Levitan, Vasnetsov and Serov to his Abramtsevo estate thereafter, Mamontov had encouraged new responses to the age and interpretations of Russianness. Indeed, their realisation that the historical and cultural heritage of Russia had much to offer the modern artist and society helped lead the way to the neo-Russian movement and through it to Art Nouveau.

The turn to indigenous culture, its motifs, execution and content, both stimulated attempts to revive peasant arts and crafts, and led to the emergence of Viktor Vasnetsov as a most forceful influence on the leaders of the Modern movement, particularly Elena Polenova and Fyodor Shekhtel. In 1881 Vasnetsov, together with Vasily Polenov, designed the little Abramtsevo Church of the Icon of the Saviour whose simple cuboid form, single dome and belfry were romantically extrapolated from a variety of medieval Russian prototypes, not least churches at the ancient centres of Novgorod, Pskov and Rostov. With Ilya Repin helping to execute the iconostasis, this was a crucial step – 'fine' artists turning their hand to the applied arts and architecture in a first, unified effort to create a total work of art where painting, sculpture, carving etc. were intimately co-ordinated.

The pioneering synthesis of aestheticism and spiritual qualities that was expressed in the church, and indeed generally at Abramtsevo, was to have considerable repercussions in the further experiments by Russian artists. The trawling of Russian folk traditions for modern inspiration was most emphatically stressed by Vasnetsov in his painted subjects, e.g. the legendary epic *Battle of the Russians with the Scythians* (1881) and the medieval knights *The Bogatyrs* (1898). Similar subjects and synthetism were also taken up in the new field of stage design, this shortly after the lifting of the state monopoly on theatre in 1882 and Mamontov's establishment of a private opera company. Vasnetsov's set for a production of Alexander Ostrovsky's fairy-tale play *The Snow Maiden* (1883) was an early example of this. For Act Three, he designed a highly romanticised vision of ancient Rus – Tsar's Berendey's wooden palace is depicted covered in bright, primitive and pagan decorations which combine geometricised carved ornaments with animal, floral, mummer (*skomorokh*) and sky motifs. The furniture is massive, as are the columns; the space is free-flowing and the view from the balcony over the Tsar's domains dotted with exotic towers, fanciful. In fact, such idealised evocation of the national spirit was to be taken up not only in Russia, but also across the empire in Finland and Latvia.

Vasnetsov acts as innovator – previously sets had been created by artisans not painters trained at the Academy – and he helps set in motion a trend that reaches an Art Nouveau climax with the successes of Diaghilev's *Ballet Russe*. The overlap of the arts is extended. Another painter, Mikhail Vrubel, a leading exponent of the New Style, having worked with Vasnetsov on frescoes in Kiev in the 1880s, moves to stage design after arriving in Abramtsevo, and creates images extracted from neo-Russian theatre in ceramics, e.g. Tsar Berendey, Princess Volkhova and Sadko. Further, Vasnetsov continues to diversify, into furniture and graphic design and ultimately, with increasing stylisations and fantasy, his painting becomes a true synthesis of National Romanticism and Art Nouveau. This is witnessed in his *Sirin and Alkonost: the Birds of Joy and Sorrow* (1896), a theme extracted from Byzantine legend, with the anthropomorphic female princess birds perched on branches, their wings unfolding in evocation of eighteenth-century Russian painted furniture, embroidery and woodcuts (*lubki*).[2] Almost always given beautiful young female faces, the birds represented paradisaical spirits who descend to earth to charm people with their song. Sirin is a symbol for beauty, happiness and just rewards and the kingfisher Alkonost represents temptation, sorrow and ultimately death. These heavenly birds, with their power to bring bliss and despair, are frequently represented by Vrubel. They are to be found, for instance, in his *Mikula Selyaninovich and Volga* fireplace (1899) (Plate 57), which won a gold medal at the Paris exhibition.[3] Here they stand regally above the medley of forms, colours, patterns and lines that comprise the *bylina* (epic) subject – a counterpoint to the two stylised serpents below.

The sponsors and artists of the crafts colonies played active roles in the activities of the World of Art group and the Society for the Encouragement of the Arts, both of which were vital for the presentation and interpretation of modern trends in European and Russian art around the turn of the century. This collaboration speaks of a pluralistic approach which is instructive concerning the new interpenetration of the arts envisaged by the leading arbiters of the taste of the artistic community and beyond. In fact, the apparently conflicting national romanticist and internationalist tendencies represented a single, multifarious, reassessment of artistic values. So whether from Slavophile or liberal convictions, both sides desired a reversal of the loss of skills and quality brought about by the march of the industrial age, and the

abolishment of established hierarchies of art in favour of a new order. In this the applied arts, and the creation of a harmonious, integrated material environment as a whole, would reinvest life with a new, hallowed sense of beauty.

It was with these ends in mind that the World of Art, founded in 1898, and the Society for the Encouragement of the Arts, held exhibitions and began to publish the periodicals *The World of Art* (*Mir iskusstva*) (1899–1904) and *Art and Applied Art* (*Iskusstvo i khudozhestvennaya promyshlennost'*) (1899–1902). Both magazines were well illustrated, with reproductions of Iris pottery, Gallén, Vallgren, Denis, Vallotton, Lalique, Galle, Majorelle, Beardsley, Vogeler, Klimt, Mackintosh and Olbrich, as well as work by local artists and designers. The latter varied from national revivalist embroidery and interiors created by Abramtsevo artists to symbolist painting by Borisov-Musatov and functionalist furniture by Fomin.

Many of the illustrations were taken from the exhibitions organised by the societies around the turn of the century. Through exposure to modern European trends and their Russian counterparts, these indicated the many parallels in direction as well as divergences in execution. In this they proved to be the vanguard, together with the new architecture and its associated exhibitions and journals *The Architect* (*Zodchiy*) and *Yearbook of the Society of Architects and Artists* (*Ezhegodnik Obshchestva arkhitektorov-khudozhnikov*). The architectural magazines were to provide unprecedented surveys and criticism of developments across the world, giving special attention not only to local trends, but also to Wagner, Olbrich and the other Viennese modernists, Van de Velde, Voysey, Baillie Scott, Guimard, the Finnish movement and the international exhibitions.[4] Thus the place of Russian art in the creation of the new European material culture was advanced.

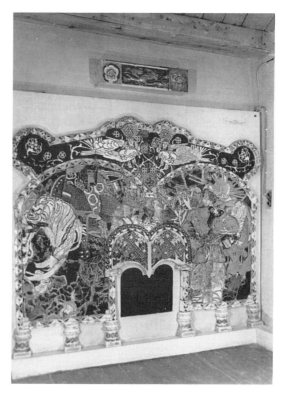

57 Vrubel, *Mikula Selyaninovich,* ceramic fireplace, 1899

Appearance

Besides exhibitions of contemporary Russian art organised by the Society for the Encouragement of the Arts, between 1896 and 1900 it arranged French, Scandinavian, Belgian, British, Austro-Hungarian shows and an international selection of works from the Paris world exhibition. All varieties of modern trends were shown, from realism to decadence.[5] The World of Art exhibitions in Russia, organised by the impresario Sergey Diaghilev, and originally funded by the foremost sponsors of the Russian Romanticist movement Savva Mamontov and Princess Maria Tenisheva, also showed a diversity of modern artists from across the continent. In addition, the group sent Russian selections from their exhibitions around Europe – to the leading salons of Riga, Prague, Vienna, London and Paris. At the first show in January 1899, held in the Stieglitz Museum, besides prominent European painters of the day, glassware by Tiffany and Gallé was shown, together with Abramtsevo pottery and embroidery work by Davydova and Polenova. Later shows were less international, though they continued to display a mixture of the arts, adding carpets and tapestries by the Voronezh weaver E. Chokolova, Vrubel's majolica, Vasnetsov's furniture and Golovin's wall panels, Frolov's glass and Talashkino *objets d'art*.

Other important exhibitions included the Nizhny Novgorod All-Russian Exhibition of Art and Industry (summer 1896); a poster exhibition in the Stroganov Institute (1897); Diaghilev's 'English, Scottish and German watercolourists' (March 1897) and 'Russian and Finnish Artists' (January 1898); the Russian displays at the Paris and Glasgow International Exhibitions (1900 and 1901); the International Poster and Placard exhibition in Kiev (1900); the First International Ceramics Exhibition held in St Petersburg in December 1900,[6] an event noted for spurring on Russian ceramics and glass artists towards the emulation of western standards; the 1902 exhibition at the new 'Contemporary Art' salon, which was followed up in 1903 by shows of Japanese prints, Lalique jewellery, and paintings and designs by Somov and Roerich; a Moscow 'Architecture and Art' show (April 1904) combining work from the Stroganov School workshops with Abramtsevo crafts and designs by Shekhtel; and the vast International Construction and Architecture Exhibition on and around Stone Island, St Petersburg in 1908.

The first and last of these exhibitions serve to indicate the extent of the development of New Style in Russia between 1896 and 1908. Those in between, together with the contemporary architecture, are the best sources for illustration of the steps taken on the way. The All-Russian Art and Industry Exhibition in Nizhny-Novgorod in 1896 was without precedent in its all-encompassing synthetic conception and scale. Coinciding with Tsar Nikolay's coronation, it was sponsored by Witte's Ministry of Finance to show off the wealth and achievements of the Russian empire as well as encourage economic expansion. Located in the central heartland of Russia, where the pulse of the country's economy had long been set by the annual fairs which drew traders from as far afield as India and Britain, Asia Minor and the Arctic coast, the show was to be a multicultural extravaganza. It was served by electric trams and street-lighting, and included a vast iron and glass machinery pavilion, with neo-classical trimmings, designed by Aleksandr Pomerantsev, one of the pioneers of reinforced concrete construction in Russia; Vladimir Shukhov's highly advanced metal-webbed water tower and marquee-like elliptical pavilion;

Ivan Ropet's horticulture pavilion, which fused austere functionalism with a Romanesque entrance and neo-Russian towers; Grigoriev's and Lebedev's Russian Romanticist wooden pavilions; a mosque; Mikhail Preobrazhensky's combined church and school that synthesised folk traditions with modern requirements as Eduard Wigand was later to do in Transylvania; Konstantin Korovin's 'Far North' pavilion and Mamontov's special 'Vrubel' pavilion.

At a sensational show, Korovin's and Vrubel's work was to be particularly significant for the New Style. Mikhail Vrubel was commissioned to create two huge painted panels for the central hall of the arts section: one on 'La princesse lointaine', a play by Edmond Rostand which had just received its première in both Paris and Russia, the other 'Mikula Selyaninovich', from Russian folklore. Eventually rejected by the Academy, Witte and Grand Prince Vladimir for their 'pretentiousness', the themes and the arguments over the merits of his panels epitomised the struggle of ideas inherent in Art Nouveau.

Since 1890 Vrubel had worked in Moscow and Abramtsevo, where he had turned to ceramics, architectural design and the illustration of Lermontov. His most important clients were the industrialist Morozov family and Mamontov. The latter helped him gain the Nizhny Novgorod commission, and when they were refused, built his own pavilion for these and other Vrubel works, which resulted in the artist attaining Courbet-like recognition. Mamontov's support was also instrumental in Vrubel's subsequent recreation of the Princess and Mikula themes in majolica – the first as a frieze on the new Metropole Hotel, the second as the fireplace exhibited at Paris.

The combination of themes, eastern and western, modern and ancient, universal and Russian, was to typify the pan-aestheticism of the moment. Vrubel's dual focus characterised his continual striving to express the struggle of existence, the intangibility of beauty, and the essence of the Russian soul. Both panel subjects were allegorical – one for the eternal artistic dream of the realisation of beauty and love, the other for the strength of the Russian people; both turned to medieval tradition; and both had passionate male heroes who triumph over adversity. In the case of the Princess panel, this is the dying knight Joffroy, who sings of his dream of beauty, accompanying himself on the harp, and with such spirituality that he overcomes his temporal state and at the same time transforms the souls of the pirates who have captured him from evil to good. On the other hand, Mikula the Russian ploughman heroically defends his native land against Volga the foreign invader – who happens to be a Varangian knight and magician. The commonality between the subjects signifies the association of Vrubel's sources with those of his European contemporaries, not least Klimt whose Beethoven friezes emphasised the joyous victory of light over darkness being brought about by the artistic male super-soul.

Such a coincidence also relates to the formal treatment employed by the artists – their abandonment of academic traditions in favour of emotive stylisations and decorative distortions of visual reality. In the ceramic variants of Vrubel's work, strength is imbued to the figures of the fireplace through the bold primitiveness of the finish and their huge, close-up, size. At the same time the imperturbability of the ploughman, rooted to his sunlit native land, is contrasted with the fleeting figure of the knight in armour, who appears alien, dark, oppressive, and weapon-bearing. This resolution itself contrasts with that of the *Princess of Dreams* mosaic frieze for the Metropole Hotel (Colour plate 10). Here the figures are more distant, less powerful, less earthly, evoking a sense of gently laconic spirituality in keeping with the lyrical symbolism of the subject.

Vrubel was assisted on the panels by his friend, the painter Konstantin Korovin, who simultaneously marked his move away from conventional Russian romanticism by his creation of the Pavilion of the Far North at Nizhny Novgorod (Plate 58). While the pavilion was intended, at least partly, to signify the potential for exploitation held by the Russian arctic regions – in terms of trade and its raw materials – Korovin's work expressed a new sympathy with the north and its traditions. This suggested reverence rather than capitalist ravagement. To prepare for the work he travelled through Karelia and the Kola peninsula to the Arctic Ocean archipelago of Novaya Zemlya and Scandinavia. There, the landscape, flora and fauna, architecture and way of life of the indigenous peoples had led him away from the highly ornate, carved and Byzantine forms of the Russian Revivalists. The austere simplicity of the pavilion reflected both architectural forms and the raw nature found in the region. Largely undecorated, the unbroken, geometrical planes of the building were derived from the forms of Arctic coast trading stations. The effect was almost atectonic – a feeling emphasised by the flattened silhouettes of two fish atop the roof ridge, the steep pitch of the glazed roof, the openwork perimeter fence with its carved reindeer motifs and the contrasting white polar bear statue near the entrance. This effect of organic lightness was completed by the white colour of the exterior, suggestive of the snow-laden northern landscapes. Mysterious, rugged communion with severe nature was further reflected in the interior, this decorated with numerous seal pelts, a stuffed polar bear, puffins and penguins, woollen shirts of the White Sea fishermen, their ropes and tackle, white whale skins and whale jaws as well as live examples of the life – a seal nicknamed Vaska from the Barents Sea and a vodka-swilling and live sturgeon-eating representative of the Samoyed people called Vasily. These were complemented by Korovin's atmospheric painted scenes of hunters, reindeer herders and fishermen. The result was not just an early celebration of the north, but an innovative and integral synthesis of architecture, painting, applied art, trade and industry – a *gesamtkunstwerk* that pointed a way forward for the integration of the often exclusive fields of human production.

Korovin's exploration of Nordic life was to be furthered through his contribution to the newly founded World of Art group from 1898 and the Russian pavilion at the 1900 World Exhibition in Paris. He was to contribute highly stylised, elongated panels depicting moose, reindeer, whalers and Arctic coastal scenes to the early World of Art and Paris shows, such as *Shore at Murman* and *The Pier of the Murman Trading Station*. Some of these he turned into vignettes for *Mir iskusstva* (Plate 59). In addition, his cover for the magazine's first issue (November 1898) contained many traits common to his northern works, not least the use of yellow, gold, pale blue, and the expanse of white, the frieze-like format of the landscape, and the simplification of heavily delineated forms. A similar synthesis was to be found in his design of the crafts pavilion for the Russian section at the Paris show, this marking a compromised fusion of neo-Russian teremok forms and the Viking Style, something supported by the publications of the architectural historian Vladimir Suslov on the northern Russian style.

The new Nordic direction was taken up and taken further by several other artists and architects. The inspiration came from St Petersburg and Helsingfors, both modern metropolises on the Gulf of Finland, both in territory that had not long been Russian. And both therefore, with their trading and industrial development, populated by a mixture of nationalities, many of whom were seeking to work out their identity. Shortly after the Nizhny Novgorod show, Diaghilev began to organise

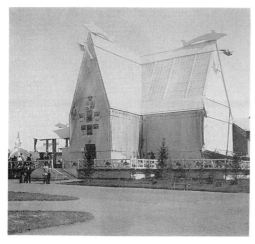

58 Korovin, Pavilion of the Far North, Nizhny Novgorod exhibition, 1896
59 *right*] Korovin, *Mir iskusstva* cover, 1898

northern exhibitions. His first, the Scandinavian show of the Society for the Encouragement of the Arts (October 1897), featured paintings and tapestries with themes taken from the landscape and folklore by Zorn, Larsson, Thaulow, Werenskiold, Liljefors and Munthe. This he followed up with his Russian and Finnish exhibition, which featured recent work by Korovin, Vrubel and Vasnetsov, as well as the Finns Edelfeldt, Jarnefeldt and Axel Gallén. Although this second exhibition still witnessed the Russians' experiments with different kinds of national subject matter, the emergent tendency towards Nordic Romanticism was felt by many Slavophiles as dangerous and a sharp polemical exchange ensued. It was led by the critic Vladimir Stasov, who was subsequently joined by the disgruntled Vasnetsov, both of whom came out in opposition to the liberal trends being expressed by Diaghilev and his World of Art associates.

The trouble was that the Pan-Slav movement and Russian imperial policy had encouraged the Nordic movement, so much so that by the 1900s Viking Revival architecture was being built as far east as Tomsk in Siberia, as witnessed by a log house designed by the Petersburg architect Orzheshko.[7] This encouragement had occurred because by reaching further west and north throughout the eighteenth and nineteenth century the Russians had tried to consolidate their influence through the introduction of Russian and Orthodox traditions, the promotion of research into vernacular, ethnographic culture, the establishment of many institutes of higher learning, and the creation of massive new means of communication, not least the expansion of the railway network.

Through their activities the Russians had encouraged the Finns to turn eastwards – to trace their Finno-Ugric roots back towards the northern Urals from whence they were said to have come. Even the Finnish capital had been moved east – from Abo (Turku) on the Bothnian Gulf, to Helsingfors (Helsinki) much closer to St Petersburg. And so the bonds between the peoples, their historical mixing, became clearer, helped by archaeological and ethnographic exhibitions, and the publication of studies of folklore, folk art and architecture – notably Lonnrot's Kalevala, an anthology of traditional runic folk poems and songs, most of which were from Karelia, in the mid-nineteenth century, Sirelius's study of birchbark and

leather ornament by the Ostyaks and Voguls (from 1901), Blomstedt and Sucksdorff's record of Karelian building types and decorative forms (1901), and Suslov's architectural histories of northern Russia and Scandinavia (1883–89).

As if emphasising the victory of the liberals in Russia, the 1908 exhibition, by way of contrast with that of 1896, was indeed in the modern, 'European' city of St Petersburg and, with displays in eighty-five pavilions by builders from Britain, America, Austria, Germany, Finland, Poland, Latvia as well as Russia, was overtly international. A belated celebration of St Petersburg's two-hundredth anniversary, many of the wooden pavilions were decorated by five leading World of Art artists in a Petrine Baroque style. One, that of the stained glass firm M. L. Frank, designed by the eclectic Polish architect Marian Lalewicz (Lyalevich), was even furnished with a huge glass panel depicting Peter the Great by Valentin Bystrenin, soon to be a leader of the Union of Youth (*Soyuz Molodëzhi*), one of the burgeoning modernist art groups in St Petersburg. In addition, the architect Nikolay Vasilyev announced his knowledge of new construction methods by building a New Style pavilion using ferro-concrete – presaging the subsequent large-scale turn to the material in Russia, and Vasilyev's own effective use of it in the Guards' Economic Society Building and the Liteinyi Avenue Trading Rows in St Petersburg. Other Russian exhibits included the innovatory steelwork of the Petersburg Metal Factory, and the contributions of the Russian branch of the Swedish telephone company Ericsson, the local pneumatic machine factory, the Stieglitz and Stroganov Schools, and the Imperial Porcelain Factory. In addition, there were also ceramics with abstract-organic glazes by Rūdolfs Pelše, the Latvian director of the Mirgorod Applied Arts School in the Ukraine, and jewellery from the Ekaterinburg Applied Arts School, where Teodors Zaļkalns, a Latvian sculptor and ex-Fabergé designer, was in charge of design.

WORLD OF ART

Between 1896 and 1908 the Russian New Style developed along a path littered with remarkable achievements. The architecture in St Petersburg and along the nearby Baltic Sea coast began to assume 'northern' characteristics, fusing its forms with those being developed in Finland according to some loosely defined northern romanticist principles. And the World of Art emerged as a primary force in the development of modern Russian art. Having originated in St Petersburg in the late 1880s, and gone public with its magazine and exhibitions in 1898, the group's aim, like many of the progressive societies in Europe, was to raise the standards of local art in all fields, to acquaint the local public with the international arena, to reflect a deep concern for local culture and history, and to provide an alternative to the hide-bound traditionalism of the establishment. To these ends its exhibitions, publications and commercial ventures represented an opposition to the Academy's preferences of historicism and realism, and to the hierarchical division of the arts. The group's broadening of the artistic base in Russia, their encouragement of criticism, art history, archaeology, preservation, the theatre and the applied arts, meant a new injection of life into the collaboration of artists, industry and public life; a new, original aestheticisation of the material environment which the schools and manufacturers were largely failing to attain. In this transformation they were joined by the leading architects and craftsmen of the day, often working directly with them.[8]

Early members of the World of Art included painters, sculptors, applied artists, critics, stage designers, musicians, historians and many who combined more than one of these professions. Among them were Aleksandr Benois, Dmitry Filosofov,

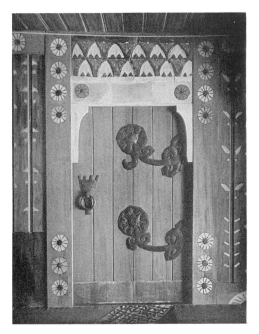
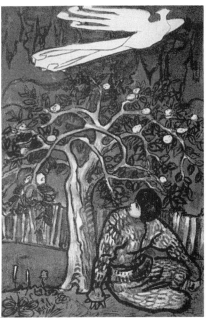

60 Golovin, *Teremok* door, Contemporary Art exhibition, St Petersburg, 1903
61 *right*] Polenova, *Ivanushka-Durachok*, illustration to a folk tale, *c.* 1898

Walter Nuvel, Konstantin Somov, Evgeny Lanceray and Lev Bakst. Unrestricted by the advocacy of one trend over and above another, from the start the group promoted both Nordic Romanticism and the neo-Russian style of Vasnetsov, Malyutin, Polenova and Yakunchikova. In the course of the first period of its existence (to 1903), its artists were to reflect not just a tendency towards native medievalism akin to Scottish Celtic Romanticism or the Catalan Regionalism, but also, among other things, an enthusiasm for Rococo and Baroque. The latter, reflecting the French taste for a new interpretation of eighteenth-century aristocratic styles, was to be expressed effectively in the painting of Benois, Somov and Lancerey. Ultimately, the diversity of approach within the World of Art was symptomatic of the its desire for appropriateness to the complex, modern age and its search for a Russian identity compatible with the leanings of the international artistic community.

A World of Art contributor who collaborated in the exhibition of Russian crafts at Paris and created mosaic friezes alongside Vrubel's for the Metropole Hotel, was the future theatre designer Aleksandr Golovin. Having worked with Polenova on several painted panels depicting the wealth of Russian nature – swans, ferns and mushrooms – for Yakunchikova's dining room in 1898, Golovin turned to furniture, textile and ceramic design. At the second World of Art exhibition (January 1900), he showed a lavatory in wood and majolica, this adorned with elaborate painted peacocks and highly stylised fern and bud motifs, the latter appearing as triangles on the jugs, bowl, stand and cupboard. For the same show he also created an elaborate painted wall panel and door covered with boldly stylised budding plants in a luscious organic curvilinear flow that bore witness to his recent experience of Art Nouveau in Paris and Munich. The rustic simplification and dynamism seen in 1900 was to be repeated by Golovin in his striking *Teremok* (cottage) installation for the opening 145

'Contemporary Art' exhibition in 1903 (Plate 60). Here the crude, organic forms which covered the room from floor to ceiling, as well as the furniture and fittings, comprise a swirling medley of stylised natural motifs in wood, ceramics and metal. The sensation is one of pagan envelopment in virile, monistic, life-giving nature.

Rustic organicism was a characteristic of many artists associated with Abramtsevo, not least Pyotr Vaulin the ceramics specialist who was to be responsible for the majolica tile decoration of many Moscow and St Petersburg New Style buildings around the turn of the century. Others included Golovin's collaborator, Elena Polenova, the head of the estate's woodcarving workshop from 1885, and her successors there and at Princess Tenisheva's Talashkino artists' colony, Natal'ya Davydova, Maria Yakunchikova and Sergey Malyutin. To a large extent it was Polenova who defined the national romanticist branch of the Russian New Style. First, she organised the collection of folk materials from the provinces and its carved interpretation at Abramtsevo. This gave rise, in her own designs, to a wide variety of furniture with both geometrical motifs extracted from distaffs, battledores or other domestic implements, and high relief representational carving taken from folk architectural features such as bargeboards and window casings. Mostly the objects were massive and cuboid, which with the bold simplicity of their carved and painted ornamentation evoked a feeling of the barbaric. Even in frames for hand-mirrors, given horse-head and plant motifs from carved Volga salt-cellars or benches, the forms and execution were deliberately solid and brash.

In most of Polenova's work there was a sense of the naive, the childlike. She could, for instance, decorate a door or a lamp with a family of benign owls and a cat or a letter box with a colourful pomegranate branch. And this love of the innocent was to be translated into her watercolour illustrations of Russian fairy tales and catchphrases which she created during the same period (Plate 61). These displayed a variety of techniques, including cloisonnist line, flat colouring, ambiguous space, as well as sometimes using gentler, warm washes and the inclusion of text. The pictures usually concentrated on conventional creatures of folk fantasy – firebirds, beasts and witches (baba-yagas) – and included ornamental stylisations taken from local woodcarving traditions. Although Polenova attempted to convey the spirituality, beauty and hope offered by the Russian countryside, her watercolours can simultaneously indicate an assimilation of western trends, not least Walter Crane's 'toy books'. This conjunction is felt, for example, in her illustration The Beast with its young maiden and exhausted beast in a fantastic forest-garden, which shows the influence of Crane's 'Beauty and the Beast' illustrations.

On occasion, Polenova's painting was transferred to an architectural setting, for instance an exotic panel with firebird appeared amidst a welter of carved, painted and moulded motifs of stylised trees, birds, plants and animals, in the open-plan teremok dining room of the Firsanova House, designed by Aleksandr Yakimchenko in Moscow (1898–1900s). Such primitivist aestheticisation of every detail of the interior, with its abundant, brightly coloured decoration, was to characterise the work of several of her followers – particularly Sergey Malyutin, and after him Aleksey Zinoviev.[9] Both ran the woodcarving workshops at the Talashkino colony, Malyutin, after their establishment by Maria Tenisheva in 1900 and Zinoviev upon Malyutin's departure in 1903.[10] Essentially, the workshops took over where Abramtsevo left off, the earlier colony going into decline after Mamontov's bankruptcy in 1899. Among those attracted across to the new centre near Smolensk, were Vrubel, Korovin, Roerich, Yakunchikova, Dmitry Stelletsky, Ivan Barshchevsky,

Benois, the sculptor Trubetskoy, and Repin, as well as numerous critics, actors, architects, archaeologists and musicians. The latter included Stravinsky who, appropriately, began to compose his paganist 'Sacred Spring' ballet in Talashkino, and whose Firebird and Petrushka ballets are inspired by the folk traditions reinvented there.[11]

Malyutin, another painter-turned-applied artist and architect, was to be responsible in Talashkino for the design of the picturesque Neo-Russian *terem* cottage-mansion, the theatre, and the Russian Antiquities Museum, which opened in 1905. In addition, he created a plethora of carved and painted objects and furniture, including balalaikas, cupboards, benches, chests, what-nots, tiles, pots and jars. The single-storey cottage was log-built on a high brick basement, and adorned with extravagantly decorated window casings and bargeboards. Its interior, decorated by Malyutin, Roerich and Zinoviev, was alive with the wealth of organic forms that covered it, as the artists explored the natural Russian relationship between material, structure and decoration. This relationship was to be further explored at Talashkino in the co-operative project of the Church of the Holy Spirit (1902–14), with its fusion of Russian romanticism and Buddhist motifs in the mural work by Roerich. In addition, one of the most vivid decorative objects on the estate was Malyutin's painted relief carving of *Sadko – the Rich Guest* (c. 1902), created to adorn the theatre.[12] The whole atmosphere was deliberately magical, like a fairy tale, as the artists attempted to conjure up the spirit of the Russian folk, rather than imitate its styles.

This feeling also predominated in the Pertsov tenement in Moscow, designed by Malyutin together with Nikolay Zhukov (1905–7). Here, faced in red brick and majolica tiles, he combined a medley of structural units derived from the agglomerative *terem* tower and chamber architecture of medieval Rus. Steeply pitched roofs, grotesque corbels, asymmetrical bay windows and balconies were fused with an ebullience of decorative motifs, including smiling suns, forest fruit, snakes, bears, mermaids, sirin birds, shishiga devils, and, in the dining room of the owners' apartment, as if stressing the dualities of the new Russian romanticism, a variant of Roerich's Nordic *Visitors from Over the Sea* (1901).

SHEKHTEL

The strongly decorative, almost theatrical, sense to Malyutin's work was to be rec-reated in a different manner by several other architects working in Russia at the same time. Foremost among these was Moscow-based Fyodor Shekhtel, one of the geniuses of Art Nouveau. Shekhtel's strength has meant that he tends to over-shadow other Russian New Style architects, many of whom made a vital contribu-tion to the richly diverse movement in the country. In fact Art Nouveau architec-ture in Russia spread across the country and included wooden dachas of the intel-ligentsia on the fashionable northern shore of the Gulf of Finland, within easy reach of the capital, but far enough away for total immersion in the raw nature of the forest and sea, as well as mansions, tenements and civic buildings in far-flung cities such as Samara, Kislovodsk, Odessa, Vladikavkaz, and Tomsk. In Vladi-kavkaz it was to take a variety of forms, the most exotic being the fusion of Islamic and regular, curvilinear Art Nouveau motifs in the shop-apartment of an Azeri merchant on the central avenue. Here, geometricised window bands, vaults and painted abstract rectilinear ceiling patterns in the conservatory to the rear, were combined with gilded stucco allegorical ornamentation on the asymmetrical street 147

facade (which also featured a traditional Caucasian balcony), the latter including chimeras, rows of fish, budding roses, shells, winged chalices, female masks, metamorphic sunflowers and zodiac symbols surrounded by golden branches, leaves and fruits appropriate to the season.

Such exotic eclecticism was to be reiterated, together with a variety of other modern styles, in Moscow buildings of the period – not least those commissioned by members of the wealthy Morozov family. Hence the Iberian Romanticist facade and eclecticist interior of Abram Morozov's house (1894–98), and Shekhtel's interior with panels by Vrubel for Aleksey Morozov's mansion (1894), in which a historical survey of great artistic periods commenced from the Egyptian vestibule and progressed to the Gothic study. Both of these indicate the transitional stage reached by modern Russian architecture in the mid-1890s – a stage that was soon to be most emphatically moved forward by Shekhtel.

Shekhtel's first important commission was a Moscow mansion (1893–96) for the head of the Morozov dynasty, Savva Morozov, and his wife Zinaida. Breaking from the neo-classicist tradition for grand town houses, he adopted the Neo-Gothic. This simultaneously marked out the Morozovs as trendsetters, and Shekhtel as an experimentalist. Symmetry is abandoned, forms are carefully balanced and the exterior reflects the organisation of internal space. Ornamentation is stylised – in the main reflecting Gothic trends – crenellated parapet, tracery, lancet windows, grotesque figures, stained glass windows and painted panels on medieval, chivalric themes by Vrubel. A vestibule sculpture, also by Vrubel, of Robert and the Nun shows the two figures from Meyerbeer's popular medievalist grand opera *Robert le Diable* overwhelmed by the drapery that encloses them with forceful, abstract dynamism.

Shekhtel was to show increasing recourse to Russian tradition as well as modern techniques and motifs in his subsequent buildings. Notable among these were the pavilions he designed for the Glasgow International Exhibition of 1901. A state commission, and one which the Russian government hoped would do much to advertise the riches of its country and thereby stimulate new trade with Britain, Shekhtel was to produce a colony of pavilions, large and small. By far and away the most ambitious and extensive foreign contribution to the show, the four main pavilions attracted immense public attention. Everything about them suggested primitive, organic strength, this showing an affinity with the neo-Russian style of Malyutin and Vasnetsov. And like them, and more specifically like Saarinen in his Finnish Pavilion at the 1900 Paris exhibition, Shekhtel freely interprets tradition to create a new architecture through the combination and stylisation of folk and ecclesiastical elements. In his case these include multiple onion domes and octagonal towers from northern Russian (indeed Karelian) churches for the Ceremonial and Mining Pavilions, the horse-shoe porches and gables of peasant houses for the Agricultural Pavilion, and the unhewn log techniques and long low roofs of country barns for the Agricultural and Forestry Pavilions. Contours and proportions are exaggerated, colours and decorative motifs starkly bold. Thus a make-believe, Disney-type world of vernacular distortions emerged, this synthesised with modernist intentions and details (not least the large expanses of fenestration on the cubic Forestry Pavilion), in designs symbolically correlated to the various industries and functions that the pavilions represented.

Back in Russia, Shekhtel embodied this eclectic national romanticism in stone – in the building of the Northern (Yaroslavl) Railway Station in Moscow – this for

the railway funded by Mamontov which ran to the Arctic coast at Archangel. Again

he freely interprets ancient tradition, for instance, in the roof tower with openwork crown and the kremlin-inspired corner towers. This he assimilates with white stucco reliefs of northern fauna (bears, wolves, reindeer)[13], Korovin's waiting hall panels of northern scenes (those first shown at Nizhny Novgorod), and polychrome Abramstevo majolica tiles to his own design, with forest and aquatic motifs (Colour plate 11). Through the sensitive integration of these elements with the grey brick and whitewash facade, the result is a synthetic masterpiece of the national romanticist trend, a permanent application of the principles expressed at Nizhny Novgorod, Paris (in both the Russian and the Finnish pavilions) and Glasgow.

However, in Shekhtel's contemporary domestic buildings his recourse to ancient tradition is more subtly expressed as he moves ostensibly to a more modern idiom. This is the case with the houses he built in Moscow for the offspring of wealthy industrialists, i.e. Stepan Ryabushinsky (1900–3) and Aleksandra Derozhinskaya (1901–2). The clear cubic planes, the cantilevered roof and the asymmetrical arrangement of large and small windows associates the Ryabushinsky House (Colour plate 12) with Voysey's widely publicised Forster House in Bedford Park, London (1891) and Olbrich's Haus Habich at Darmstadt (1900). Yet Shekhtel's formal blocks are more intricate and his roof units more varied as he effects a semblance of medieval Russian *khorom* (mansion) or *terem* architecture, not least in the rising diagonals of the rear staircase windows and the heavy horse-shoe corner porch.[14] The association of these elements with ancient forms is contrasted with the modernity of the rolling wave iron railing that surrounded the house, the floral wooden window mullions and the stylised iris and sky mosaic frieze on the exterior. Such a fusion relates the building most convincingly to Mackintosh's Glasgow School of Art, the first stage of which had been built by the time of Shekhtel's Glasgow commission.

What the massing, the articulation of the roof and the arrangement of the windows have in common with the external decorative details of the Ryabushinsky House is that they evoke a sense of primal, organic force. And this is further expressed inside. Here, the space revolves around a central staircase and hall, the effect of which is one of powerful, aquatic motion. It is that same sense of flow which had described much of Horta's and Guimard's work, and which was to prevail in Gaudí's. All rooms are integrated with this central core where the ripple-pattern on the floor, the waves of the terrazzo balustrade, the dripping forms of the electric lamp, the amorphous forms of the stained glass and the light emanating from above, combine to create an underwater effect.[15]

The Derozhinskaya House also makes use of organic rhythms, though they appear more abstracted from nature – the wrought iron railings become whirling triangles, the metalwork of the heating vents comprise an ardent diagonal force away from the earth's bounds, while the main staircase and the library gallery are made in wood, their curvilinear motifs being stylised plants and trees. This then is the world of above-ground organicism as opposed to the underwater symbolism at the Ryabushinsky House. Even the abundance of wood finishing reflects this, as do the ornamental motifs in the large, double-storey hall – the blossoming trees above the mantelpiece and the carved male and female figures emerging from the material of the fireplace. Whilst incorporating concrete and iron and providing plentiful electric light and a modern heating system, it is still the harmonious integration of decoration, material and structure that appears a primary concern. Thus Shekhtel designs all the details, furnishings and fittings, in the same laconically organic spirit

– from the dynamic patterns on the upholstery of the chairs in the study, the stencilled frieze in the dining rooms, the luxuriantly curvaceous drawing room furniture, the elegantly twisted electric light fittings and the spiral stair railings.

OTHERS

Shekhtel's stylish combination of restrained decoration and function was to be characteristic of his pre-1905 period, as reflected in a number of his Moscow civic buildings – from his redesign of the Moscow Arts Theatre (1902) to the highly austere Stroganov School apartment house (1904).[16] And it was to influence the work of some of his colleagues and students, not least his assistant Ivan Fomin. Fomin really came to the fore with his organisation of the 'Architecture and Applied Art of the New Style' exhibition (winter 1902–3) (Plate 62). At this Moscow show he brought together leading European designers and architects. Mackintosh and Macdonald contributed an installation similar to the Rose Boudoir they had exhibited at Turin earlier in the year; while Olbrich participated with a dining room installation based on that in his 1902 Berlin house for Carl Kuntze.

Fomin and the Russian architectural world had become particularly well acquainted with European developments through the profession's new magazines: detailed surveys of the modern movement began with *The Builder*'s (*Stroitel'*) illustration of work by Wagner, Horta, Olbrich and Guimard in late 1899; continued with *Architectural Motifs'* (*Arkhitekturnye motivy*) panoramic photographic study of Olbrich, Hankar, Kotěra and others in 1901; through the *Architect*'s (*Arkhitekt*) analysis of the latest Viennese, Belgian, French, British and German work, including Darmstadt, in 1901 and 1902; and, prior to Fomin's New Style exhibition, culminated in the *World of Art*'s publication of work by Saarinen, Mackintosh and the prolific Karlsruhe architects Hermann Billing and Robert Oréans. The forms of the simple cubic furniture by the German partners, who added backs of bold diagonals and horizontals to their chairs and cabinets, were to be reinvoked by Fomin's chairs, what-not, cupboard and fireplace. Avoiding frames, Fomin's installation was marked out by an extreme, Mediterranean-type simplicity of design. This effect was enhanced by the unbroken, elongated horizontal planes of its dining table, buffet-sideboard, stove and chandelier, and complemented by the few terracotta vases; the camel and pyramid relief and the symmetrically placed bronze statues of an Egyptian girl on one of the fireplaces. Fomin's work was successfully complemented by a painted frieze depicting a procession of generalised stooping male noblemen, a horseman and stylised trees, created by the decorative painter Vladimir Egorov, a student of Shekhtel and Korovin at the Stroganov Institute.[17]

Following his arrival in Moscow in 1897, Fomin had assisted both Shekhtel and another leading Modern Style architect, Lev Kekushev. Around 1900 Kekushev was to build a number of houses that indicated his versatility and modernity. These ranged from a half-timbered dacha with steeply pitched roof and large round bay-turret to more intricately contoured family homes, including his own (1900–1) and those of E. List (1898–99), V. Nosov (1903) and I. Mindovsky (1903–4). In these he breaks up the planes by using fine brickwork interspersed with massive stonework, roofs of different levels and form, corner galleries, cantilevered gables, curved and rectangular window surrounds, and moulded and glazed decorative details. This disjointed union recalls that of medieval *khoromy* , although, in virtual defiance of this, Kekushev revels in compactness and solidity, and in the later two houses an exuberant plasticity.

The List house was completed by an overdoor mosaic frieze for the entrance, depicting lobsters, fish and undersea plants by the architect William Walcot.[18] This marked the first collaboration of Kekushev and Walcot – a partnership that was to continue in the building of the Metropole Hotel for the Petersburg Insurance Company (1899–1904). The modernity of the huge hotel is expressed in its atectonic interplay of texture, material and structure, this enhanced by a lyrical organic feel to the undulating cornice, mosaic panels by Vrubel and Golovin, stained glass windows and iron balcony railings, and the figurative stucco friezes depicting the four seasons by Nikolay Andreyev. The dominant horizontality of the building and the absence of extraneous casements, architraves, pilasters or capitals complement such a feeling. In addition, Walcot added a vast glass dome over the central court.

The Metropole was Walcot's major work, although he also designed several other buildings in the New Style and was regarded by contemporary critics as a member of the leading trio of Moscow architects. His other projects included the Moscow Trade and Construction Society headquarters (1899), a proposal for a new theatre in the southern town of Novocherkassk, the Gutkheil house (1900–2) and Moscow Housebuilders' Society mansion (1900–3). The functionalist severity of the last, apparently commissioned by the artist Yakunchikova, with its cubic blocks, flat roofs and rectangular expanses of fenestration was particularly advanced for the period.

The Metropole included one of the earliest Russian cinemas, appropriately known as 'The Modern' when it opened in 1907. Around it, much of the interior design was the work of Adolf Erikhson, who also created the Printing House for Sytin, the publishers of the leading Moscow daily *The Russian Word* (*Russkoye Slovo*) (1904–6) – an adventurous combination of commercial and residential premises

62 Fomin, installation,
Architecture & Applied Art
exhibition, Moscow, 1902–3

that used a reinforced concrete frame. Other significant Moscow structures that offered a variety of functions – shops, offices and apartments – included the more restrained Sokol (Falcon) tenement by Ivan Mashkov (1902–3). The plastic treatment of the street facade recalls that of the Metropole, and it included an attic storey mosaic frieze, this time stylised flowers and a seascape with rolling waves and soaring falcon, by the future World of Art artist Nikolay Sapunov.

Whilst the proportions and decoration of these buildings were relatively sober, this was not the case with Georgy Makayev's tenement (1905), with the attenuated form of its curved corner tower, nor with the interior of the Eliseyev delicatessen and vintners store (1901), designed by Gavriil Baranovsky. The latter was an ardent propagandist for the New Style, not least through his editorship of the periodical *Architect*. Although he only designed the internal space of the Moscow shop, he daringly removed the ceiling of the ground floor to create the food and wine halls.[19] These he covered in a glittering, sprawling abundance of Art Nouveau decorative features, from Gallé-like vases and mirrors atop the mahogany counters, to the Neo-Rococo gilded stucco work on the ceiling, whiplash lines in some of the door frames and electric chandeliers in a myriad of twisted, sprouting plant shapes (Colour plate 13).

Most of Baranovsky's work was carried out in St Petersburg – and most of it for the Eliseyev family. Here his love of the Neo-Rococo appeared more in keeping with the modernist trends of the World of Art, although he did make it particularly garish, and he did branch out to create a distinctly Eastern Buddhist temple in 1909. The exuberance of his decorative conception, with its colourful dynamism, was to be fully embodied in his multifunctional Eliseyev Building on Nevsky Prospekt (1901–3). As in Moscow, the ground floor contained a food and wine hall with high ceiling, and a swathe of curvilinear and floral ornamentation that reached a climax in the large, spreading wall-lights given the form of bouquets of lilies. These were augmented by glazed tiles, mirrors (which were even placed in the doors – a functional consideration), and a stained glass frieze. On this occasion, though Baranovsky designed the building from scratch as the Eliseyev Brothers company headquarters, it was to be a holistic conception that united the worlds of commerce, industry, science and art, as symbolised by the mighty statues by the Estonian sculptor Amandus Adamson that adorn the piers of the facades. Thus the interior included the Nevsky Farce theatre and foyer on the second level, as well as a restaurant, a bank, offices and apartments. The theatre was dominated by large stained glass windows with figurative and biomorphic motifs. However, their light curvilinearity and that of the food halls, by no means acted as a leitmotiv for the building as a whole. On the contrary, there is an interplay of these with dark, heavy forms elsewhere. Constructed on a corner site the building's tall, massive bulk was exaggerated by red granite facing, a three-storey arch, massive piers of the Nevsky facade and the mighty allegorical statues. All these features deliberately break up the ensemble effect of the surrounding buildings and thereby serve their eye-catching function.

Such a quality of self-proclamation was to characterise the Singer Sewing Machine Company building, also on Nevsky Prospekt. Built by the Petersburg architect Pavel Syuzor almost contemporaneously with the Eliseyev headquarters (1902–4), there was more stylistic unity to the Singer building, and a more conscious modernism: in the use of ferro-concrete floors and supports which allowed increased expanses of fenestration; the three Otis lifts; and the glass cupola with Singer globe that could be illuminated. Still, details such as the tracery of the window railings and Adamson's emergent winged, indomitable female figureheads

on either side of the three main window shafts, made sure that Art Nouveau decoration was not without its place.

Similar showcases for the breaking international version of the New Style included the eclectic Hotel Europa (1905, Karl Makkenzen) and the Vitebsk railway station (1900–4, Stanisław Brzozowski (Brzhozovsky), Semyon Minash). Like the Singer and the Eliseyev buildings, the function of both these public-commercial buildings, as their names suggested, was to symbolise Russian integration with Europe, and especially its bourgeois capitalist economy. Again it was their interiors, rather than their shells, which were pre-eminently Art Nouveau – in the case of the luxury hotel, the restaurant with stained glass by Kārlis Brencēns, and in the station – the staircases, hall for first and second-class passengers, foyer with stained glass and painted panels by Bystrenin among others, and nearby Tsar's pavilion.

Just as there was much in these buildings that was straightforwardly derivative of recent west European models, there also occurred a plethora of houses and apartment blocks in St Petersburg that were simply given cosmetic Art Nouveau treatment through the addition of facades with stylised decoration. However, the movement was also to produce some much more profound work – not least in the villas for the wealthy and the tenements created by the architects Shmidt, Lidval, Pretro, Vasilyev, Bubyr, Meltser, Lalewicz, Gogen (von Hohen) and Schöne – almost all of whom had foreign blood.

Karl Shmidt was one of the first to realise the potential of the New Style – for example, in his combined luxury house and commercial premises for the shipping merchant P. Forostovsky on Basil's Island (1900–1) and his Fabergé building (1899–1900), which united retail premises with offices and a design studio. While the former employed a functional asymmetry and a generous biomorphic curvilinearity in the metalwork, arched porch and window mullions, the latter observed a more severe, rectilinear symmetry which was crowned by Gothic gables. Both, however, combined primitivist and highly refined features, such as imported yellow brick, rubble and ashlar on the facades, and stained glass.

While Shmidt's exposition of the versatility of red Finnish (Hangö) granite on the Fabergé building was romanticist, it was really only the location of the source that suggested a link with the northern tendency that was to characterise much of Petersburg Art Nouveau. This trend was set in motion by Fyodor Lidval, a Swede born in the Russian capital, who was to design a series of tenements from 1899 indicating his awareness of Scandinavian developments, not least the neo-national styles of Boberg in Stockholm and Saarinen in Helsingfors. Such assimilation of Baltic trends, while only a short-lived feature of Lidval's work, was to embody the 'Northern' New Style in Russia – the movement which Korovin had announced in 1896 at Nizhny Novgorod. It was to be subtly, austerely expressed by Lidval on the facade of his own tenement building on the newly accessible Petersburg Side archipelago (1899–1904), which was given a play of rough textures and windows that are simply incisions in the surface, and in his Meltser tenement (1904–5), which housed the Petersburg branches of Kodak and the Wolseley car company on the lower floors. Exploiting the corner site by adding a corner tower reminiscent of Sonck's borrowings from medieval castles, here Lidval made more emphatic the textural contrasts by moving from smooth grey ashlar to rubble to ochre roughcast within a compact area.

Contact with Finnish developments was manifold. Frequently visiting Russia, and even designing there, Saarinen was a member of the World of Art and the

63 Gimpel, Ilyashev, Rossiya
Insurance Company Building,
Morskaya 35, St Petersburg,
1905–7

Academy; his architecture, together with that of his national romanticist colleagues, was to be extensively reproduced in the *World of Art* and the *Architect*. Andrey Ol, who created an accomplished paraphrase of Hvitträsk in his Raivolo (Roshchino) dacha for the modern dramatist Leonid Andreyev (1907–8), worked in Saarinen's office in 1905; Vasilyev studied the new Finnish architecture first hand; Diaghilev had organised the Finnish and Russian exhibition in 1897; Sparre received commissions for furniture from Countess Shuvalova for her Tsarskoye Selo home around 1900; and the appearance of many Petersburg New Style buildings was attained through the use of Finnish granite, the services of the Finnish Joint Stock Company for stone facing treatment and the Åbo tile factory.

Amongst those who took up the mantle of creating a less restrained version of the Northern Style than Lidval was Ippolit Pretro. Not far from Lidval's first tenement on the Petersburg Side, Pretro constructed the Putilova apartment building (1906–7). The ground floor housed the local shop and offices of Provodnik, the major Riga rubber manufacturer of rubber tyres, linoleum, galoshes and toys. Such a connection with Latvia was to be emphasised through the approach to material and design which, while it was probably more indebted to Finnish developments, had much in common with the nascent national romanticism of Vanags and Pēkšēns: i.e. the rubble-faced ground level with primitive triangular arches, the hipped roofs, monumental corner tower and the overt heaviness of the mass.

The same features were to be found in the architecture of Vasilyev and Aleksey Bubyr, whose practice even extended along the southern Baltic coast as far as Revel (Tallinn) in Estland (Estonia), where the Finns Saarinen, Gesellius and Lindgren were already building in the Northern style.[20] Constructing and designing a number of tenement blocks in St Petersburg in the late 1900s, their collaborative work

announced, as had Shekhtel's before them, a union of national romanticism and modern technology. Again, rather than embellishment with abundant decoration, the elevations of their designs were dominated by the fusion of textures, colours and proportions – rough and smooth, dark and light, elongated and compressed. Where they did apply decorative details, it was rhythmically integrated with the structure and extremely laconic or primitive, being simple geometric patterns or stylised reliefs of fish, birds and trees carved onto the rubble blocks. Both Vasilyev and Bubyr had studied at the Institute of Civil Engineering in St Petersburg and this background may help explain the ease with which they, together with Ernest Virrikh, pioneered large-scale, rationalist ferro-concrete construction in Russia, sometimes retaining 'Northern' elements, as in the gigantic Basseyn Co-Operative Association tenement complex (1912–16).

Vasilyev and Bubyr's northern romanticism coincided with that expressed by the architects Gimpel and Ilyashev in the Rossiya Insurance Company building (1905–7), which used similar rustication, whilst incorporating mosaic panels by Roerich and a majolica frieze made by Pyotr Vaulin on themes from Nordic-Russian folklore (Plate 63). These were complemented in the interior by the stained glass panels of the main staircase, depicting picturesque winter landscapes, birds, griffins and allegorical compositions.

Such demonstrations of northern romanticism in the heart of the city were preceded in domestic architecture by Roman Meltser's villas on the fashionable, and extremely expensive, Stone Island.[21] Due to reforms in land duties brought about in 1895–97, it became advantageous to the island's royal owners to rent out their land and encourage its development. The result was the creation of a remarkable new community for the wealthy, which was characterised by its wholesale advocacy of the New Style. The first house to be constructed was Vasily Schöne's and Vladimir Chagin's Hausvald dacha (1898), which saw an adventurous combination of materials, asymmetrical division of internal space and broad whiplash curves defining the entrance and its wrought ironwork. Other houses followed, including Schöne's own (1902–4) and that which he designed for the Latvian graphic artist Jēkabs Belzēns (1903, demolished). Both indicated an awareness of Olbrich's work of Darmstadt and probably through that owed a debt to the modern English vernacularism of Voysey and Baillie Scott. As 'houses for art lovers', they combined picturesque vernacular qualities such as half-timbering, steeply pitched roofs and a battered chimney with austere ornamentation, open-plan halls and well-illuminated studios.

Meltser's houses included one for himself (1901–4) that in many ways announced the northern romanticist branch of the New Style in St Petersburg. Constructed in wood on a stone and brick base, and with a carved rising sun decoration within the triangle of the entrance porch gable, there are considerable similarities to Saarinen's Paris Pavilion and, most particularly, to his residential complex at Hvitträsk. These are manifested in the rounded log technique, the pitched roofs, the opening up of the interior to the outside through the use of several balconies and large porches, the division of space and levels in the multifunctional drawing room, and the furnishing and fittings of the rooms. The latter included *ryijy* rugs with simple geometric motifs that covered the walls, sofa and floors, simple wooden and padded leather armchairs to Meltser's own design, and a stove covered in blue and green tiles from the Åbo factory. Though on a smaller scale and with increased verticality, these, and the response to a similar location – amidst trees and surrounded by water on three sides – were evocative of Hvitträsk.

In 1904 Meltser received his second Stone Island commission – a house for E. Vollenweider, a fellow Swiss. Using similar principles of verticality, granite rustication of the lower walls, battered chimneys and a free plan that allowed asymmetry in the placement and size of the windows as well as large balconies, the feeling imparted was one of organic relationship with the surrounding landscape. This was enhanced by the bud-shaped roof over the centre of the northern facade and inside by the curving main staircase, the metal balustrade of which was contorted into writhing twisted shapes. Despite the organicism of the house, its form and finish (it was whitewashed and given a dark red tiled roof), rather than belonging to the same northern romanticism of Meltser's home, reflect an affinity with German manor houses and the English free style.

The diversity of Meltser's approach, as well as his mastery, were simultaneously expressed in the Orthopaedic Institute building (1902–5) which was an early example of the rationalist trend. However, the chapel in pressed brick and with staggered flat roofs, incorporated a Vrubelesque majolica panel of the Virgin and Child. This was the design and first major work of Kuzma Petrov-Vodkin, a young discovery of Meltser's who was to be engaged on the decoration of many of his projects. The tiles were executed and installed by specialists from the London branch of the Doulton pottery company, Petrov-Vodkin supervising the early stages of manufacture in Lambeth.

The Orthopaedic Institute was built on Petersburg Side, near to one of the most impressive and earliest studies in neo-classical Modern Style domestic architecture – the mansion of the prima-ballerina and former lover of Tsar Nikolay, Matilda Kshesinskaya (1904–6). This luxurious house was designed by Aleksandr Gogen, an architect who proved himself as versatile as Meltser and even more prolific. Here he broke with his earlier historicist eclecticism and neo-Russian styles to create a building whose rectilinear modernity vies with the contemporary work of Wagner and Hoffmann in Vienna, and Shekhtel in Moscow. Like Wagner on the Steinhof Church, Gogen retains classical swags and garlands, a dome and some semi-circular openings, while having these dominated by a complex cubic geometry, a wealth of materials and an austerity of external decoration. The latter, as in Shekhtel's mansions, belies the eclectic splendour of the interior decor – which served as a place of lavish entertainment for the intelligentsia. Gogen revealed a willingness to break up the facades with a vertical progression from rubble to rusticated granite, to yellow pressed brick and to ceramic tiling and stucco reliefs. He also created a daringly large glass and iron bay for the winter garden.

The union of the classical and the modern represented by Gogen's Kshesinskaya house coincided with a critical moment of new loyalties for the Polish-Russian dancer. For in 1904 she left the troupe of the state-run Mariynsky Theatre to work with Fokine and Diaghilev – an association that saw her touring Europe with the Ballet Russes from 1909. The new freedom of expression she enjoyed and the ability to develop new interpretations of retrospectivist or psychological ballets paralleled the changes already being wrought in the plastic arts by the World of Art.

The primary force in the modernisation of painting and graphic art in St Petersburg, the actual work of the World of Art members and their associates, was marked by an understanding of the metropolis's canon of taste – the Baroque, the Rococo, the Classical, and their mixture with the Russian. Their interpretations of the canon were inherently symbolist, subjective and decorative. They were also highly distinctive: Ivan Bilibin (Plate 64) and Roerich working out their own forms

64 Bilibin, *The Merchant Kalashnikov*, illustration to Lermontov, 1904

of a neo-Russian style; Korovin moving from northern romanticism in his interior and graphic designs to impressionism in his painting; Bakst revelling in classical antiquity and eroticism; Somov exploiting the artifice of the Rococo and the decadence of Beardsley; Benois and Lanceray utilising an eighteenth-century retrospectivism that allowed them to evoke the feeling of an era rather than the events; and Mstislav Dobuzhinsky caricaturing contemporary life. This diversity also encompassed those who exhibited with the group without belonging to its inner circle – such as the landscapists Pereplyotchikov and Purvītis, the symbolists Vrubel, Borisov-Musatov, Kuznetsov and Vasily Milioti, and the sculptors Trubetskoy, Golubkina and the animalier Artemy Aubert (Ober).

The four symbolists, Vrubel, Borisov-Musatov, Kuznetsov and Milioti, all of whom contributed to the 1906 World of Art exhibition, were characterised by the intensity of the metaphysical content with which they imbued their decorative painting. Often this could be decadent, usually it was lyrical and rhythmic, recognising an organic and spiritual relationship between all matter, whether human or inanimate. In Viktor Borisov-Musatov's case this could be a shimmering, idyllic representation of naked youthful optimism in a subject such as *Daphnis and Chloe* (1901), or, and this was more common, a melancholic reflection on the delicate transience of life. For the latter he frequently used wan female figures in eighteenth-century dress set in the generalised landscapes of provincial estates, or omitted figures in favour of atmospheric suggestions of mood through the use of pastel colour of moving nature.

There is a fatalism to Borisov-Musatov's ill-defined forms, as well as a rejection of the barbaric money-based environment of the city in favour of a fantasy world of natural, flowing rhythms in which mankind sits rather uncomfortably, and which he himself likened to the eternal melodies evoked by medieval troubadours, Wagner, Grieg and Turgenev. This pessimism and anti-urbanism was also in

Vrubel, although his mature work is more diverse. In painting he resorted to forceful, complex plays of surface pattern, imparting to this an emotional quality that could either be enchanting or sad. In both cases there was an element of wistful contemplation, as in his *Tsarevna Volkhova* (1898) and *Demon Downcast* (1902). Nietzschian tragedy, and the struggle by the artist to overcome it, abound in Vrubel's art. Landscapes, objects, human beings and mythical creatures are subordinated to powerful, fluid colour relationships. The result is, as with Borisov-Musatov, and Vrubel's followers Kuznetsov and Milioti, the vivification of colour and line, and the distortion of visual nature to evoke an inner world that is at once musical and awesome. Through such synthetic art, these artists evolved Russia's most intense, universalist trend of painterly Art Nouveau.

Notes

1 Which in turn prompted the founding in 1885, under the patronage of Grand Duchess Elizaveta Fyodorovna, of a Moscow Museum of 'Kustar' industries. Concerning the political and social background, see Introduction.

2 The painting was owned by Grand Duke Sergey Aleksandrovich. The birds, very popular in Russian folklore, derived from the Greek Siren and Alcyone. Other Vasnetsov works which show this fusion of ancient and modern are *Gamayun: the Prophetic Bird* (1897), where the girl-bird perches on a slender, serpentine green plant against an empty ground; and frescoes for the Cathedral of St Vladimir, Kiev (1885–96).

3 It was originally shown at the second World of Art exhibition in January 1900.

4 For an informative analysis of the appearance and reception of the Modern Style in Russian architecture and architectural periodicals, see W. Brumfield, *The Origins of Modernism in Russian Architecture*, Berkeley, 1991.

5 The French exhibition (1896) included Monet, Sisley, Renoir, Courbet; concerning the Scandinavian exhibition, see below; the Exhibition of Modern British Art (1898) displayed the work of Holman Hunt, Walter Crane, Swann, Waterhouse, Alma-Tadema and Brangwyn.

6 The selection committee for this exhibition was chaired by Samuel Bing.

7 Orzheshko's use of wooden dragon/sea serpent heads atop the pointed gables of his house's tower, appears very close to that found in the wooden 'Viking' style of the Trondheim architect Karl Norum, not least his Tivoli Restaurant (1904).

8 Lidval, the leading exponent of the Northern Modern Style in architecture, designed the interior for the 1906 World of Art retrospective exhibition

9 Polenova's early death was recognised by Russophiles and liberals alike as a momentous loss to the modern art movement. She was buried the day the first issue of the World of Art magazine was published – 10 November 1898.

10 Zinoviev, a graduate of the Stroganov Institute, took over after working for Fabergé in Moscow.

11 Although Talashkino tends to be identified with Russian national romanticism, Tenisheva was very much an internationalist. She studied and lived in France, where she originally trained as a singer; she supported a wide range of trends and was on close terms with Repin, Benois and Trubetskoy; and she exhibited Talashkino works across Europe – in Prague, Paris and London.

12 Malyutin had been greatly attracted to the Sadko theme since the late 1890s when he created decorations for Rimsky-Korsakov's opera version of the Novgorodian folk tale. Cf. Luksch-Makowsky, Austria.

13 Above the main entrance were stucco reliefs of the emblems of Moscow, Archangel and Yaroslavl – St George the Dragon Slayer, the Archangel Michael and a bear with a poleaxe.

14 The latter was not dissimilar to Olbrich's Villa Friedmann (1898) at Hinterbrühl.

15 The vestibule also included a spiky stick insect or dragonfly lamp, while the salon's door frames effected rippling wave and the stuccoed ceiling included algae and snails.

16 He taught at the Stroganov School from 1898.

17 Egorov was subsequently to become a major stage and early film designer. Fomin's other exhibits included a triangular side table in Karelian birch whose delicate linearity was evocative of Mackintosh and Hoffmann

18 As so many Russian New Style practitioners, Walcot's background was distinctly international. The son of an English father and Russian mother, he was born in Odessa, grew up mainly in France, and returned to Russia to study at the Academy under Leonty Benois in the mid-1890s. He settled permanently in England in 1906.

19 The building was a late eighteenth-century mansion.

20 The Finnish partners constructed the Luther furniture factory club building (1905), while Bubyr and Vasilyev built the owner's mansion in 1910. Lindgren also built the German Theatre in Yuryev (Tartu) in a similar style in 1906–9, having won the design competition in which Bubyr and Vasilyev were placed second.

21 Roman Meltser was the son of Swiss furniture manufacturer in St Petersburg, Friedrich Melzer. He was the court architect of Nikolay II and designed the wrought iron gates to the Tsar's garden on the western facade of the Winter Palace in a biomorphic Modern Style as well as apartments in the Aleksandr Palace at Tsarskoye Selo. Until 1912, when it was given over to the city authorities, Stone Island (Kamennyy ostrov) was owned by members of the royal family – Duke Meklenburg-Strelitsky and Princess Saksen-Altenburgskaya.

II

FINLAND
Helsinki and beyond

Background

In 1899 Juhani Aho, a leading writer and ideologist of *Nuori Suomi* (Young Finland), a nationalist group which was striving for greater expression of Finnishness in all fields of culture, summed up the situation faced by the visual arts in his country in an article published in the April issue of the Russian journal *Art and Applied Art*:

In Finland we do not have an Academy of Arts, or a similar institution, which is responsible for the arts ... Fifty years ago some Finns created a Society whose aim was to have a school of drawing and painting and to create a museum. This Society (the Finnish Arts Association) exists today: it has a drawing school and an art gallery in which are kept works that it gradually acquires; its members give advice to the government on artistic matters; and every Spring they organise exhibitions – for a long time we had to content ourselves with these as the only ones in our region. Five years ago a few of our leading artists took the initiative to organise the autumn 'Exhibitions of Finnish Artists'.

As such our art does not have a past: our artists themselves act as the founders of our arts, which has no national pedigree ... In this exist both the shortcomings and strengths of our art. The shortcomings are that he who does not have his own autonomous tradition generally does not respect tradition: he can easily become superficial, undisciplined and careless, as a consequence of which his work creates the impression of something unfinished, lacking in harmony, immature and poorly defined. The strengths are that leading talents are not oppressed by the weight of tradition or Academy influence; and, unrestricted by the necessity of worshipping old gods, vast fields open up for the expression of individuality.

Yet looking at a collection of our art we realise that it is the absence of a school that is its main shortcoming. For if, on the one hand, it is right that originality and strength can be a substitute for a lightness and harmony of form, that bold imagination can replace deep ideas, and temperament classical severity, then, on the other hand, originality, depth and temperament often appear extremely exaggerated, lacking in measure and difficult to comprehend.

The New Style developed in Finland late in the period of its Russian annexation and during a time, concurrent with the reign of Tsar Nikolay II, of intensified Russification directed from St Petersburg. Stimulated by the suppression of statehood which, around the turn of the century, appeared to threaten the unique status of the country within the Russian empire, the movement was nevertheless symptomatic of both the considerable degree of cultural freedom, and as Aho pointed out, the freedom from the constraints of tradition, that prevailed. It was thus

given the opportunity to blossom into an individual style capable of expressing the new Finnish national consciousness, as well as the surge towards a rationalist modernism. As such there are many parallels, as well as discrepancies, with other centres of the style in the western borderlands of the empire, most notably Livland (Latvia).

The rapid urban development of Helsingfors (Helsinki) during the nineteenth century and the Russian policy that promoted it played a primary role in stimulating the flourishing of Finnish New Style. A new city with considerable new wealth, it had only become the capital of Finland in 1812, taking over from the western port of Åbo (Turku), three years after Russian annexation. By mid-century it had a population of 20,000. There followed a period of development which saw expansion of industry, construction and, inevitably, culture, together with new social deprivation. The Finnish language, rather than Swedish, began to be promoted. A Finnish Literature Society had been established in 1831 and this was followed four years later by Elias Lönnrot's first publication of the Kalevala, his anthology of traditional runic folk poems and songs, most of which depict life in the remote eastern region of Karelia.

A new Finnish movement was advantageous to the Russian authorities in as much as it encouraged an eastern-looking perception in the country. Finnish language newspapers began to appear. New communications were established, one of the most significant being the railway to St Petersburg built in 1870. By the 1890s Helsingfors' population was treble that of forty years earlier (and by 1910 had reached 150,000). This population explosion prepared the way for the creation of Finnish mass culture and the exploration of international trends that that inevitably encouraged. Symptomatic was the new diversity of architectural styles in civic and ecclesiastical building that began to emerge in the 1860s. Foremost were Gothic, Renaissance and Byzantine Revival styles and their eclectic fusion, prime examples being the House of the Nobility, Cathedral of the Dormition and Atenium art museum.

The urbanisation of Finnish society created the conditions for the birth of the national romanticist movement. As elsewhere in Europe, the new urban settlers began to search native traditions in order to establish for themselves a new cultural identity. Following Lönnrot's lead, Finnish literature began to blossom, its early achievements including Aleksis Kivi's writing on rural themes. Research into Finnish artistic, historical and cultural traditions was conducted by the Finno-Ugric Society, established with the aim of undertaking primary ethnographical surveys, and the Finnish Antiquarian Society. From 1871–1902, the latter undertook archaeological expeditions to record ancient art works and buildings. A national theatre and city orchestra were founded.[1] Assisted by Nils Gyldén's creation of a collection of plaster casts from classical sculpture at Helsingfors University the visual arts also took off. In mid-century the Finnish Art Society and its School of Drawing were established. Painters, most educated abroad, began to favour Finnish landscape, genre or literary scenes.

Leading the way Albert Edelfelt, having studied in Antwerp and Paris, gained a distinguished international reputation in the 1880s and 1890s for his refined mixture of Realism and Impressionism. This, however, belies the fact that he also turned to Finnish and Scandinavian subjects and in 1895 illustrated Kung Fjalar, one of the most popular poems of Viking adventures, by Finland's first 'national' poet, Johan Runeberg.[2] One of Edelfelt's illustrations for this is an idealised image, 161

traversed symbolically in the centre by a sword which extends beyond the picture frame, of four blue-eyed young figures in medieval dress. Steadfastly awaiting their opponent from across the sea, each stands as an archetype of Viking tradition, whether through dress and looks or attributes such as sword, harp or bow. The stylised, flat forms fill the extended horizontal of the picture space and are cut off by the frame.

Edelfelt's Viking revivalism coincides with the emergence of Finnish national romanticism and its combination with symbolism and Art Nouveau. Of foremost significance was the Finns' contact with the new decorative approach and spiritual searching of symbolist artists in Paris. For instance, Pekka Halonen and Väinö Blomstedt, the artistic director of the Friends of Finnish Handicrafts from 1900, studied with Gauguin in 1894. They then adopted new flattened, simplified and stylised means of composition – as witnessed by Halonen's panels, *Washing on the Ice* and *Lynx Hunter* for the Finnish pavilion at the 1900 Paris exhibition and Blomstedt's turn to tapestry design for which he used a combination of rich colour zones and pagan Finnish mythology, as in *Sacrifice (Finnish idol worship)* (c. 1901).

With the abolishment of the guild system in 1867, the 1870s marked the emergence of modern applied arts and architecture. A Polytechnic Institute was set up in 1872 which provided Finland with its first school for architectural training. One of its first graduates, Gustaf Nystrom, later to be its director, was appointed as the first building construction teacher in 1879. Largely through his knowledge of modern technologies and techniques involving cast iron, glass and reinforced concrete, new construction methods were introduced to Finnish architecture. Further, in 1871 Carl Gustaf Estlander, professor of aesthetics and modern literature at Helsingfors University, published a seminal essay entitled 'The Development of Finnish Art and Industry. Past and Future'. He called for the reunification of the fine and applied arts, and their principal association with craft-based industry. An ardent advocate of the improvement of quality and taste in all artistic fields, he also proposed a school of applied arts. This soon materialised, and was run by the new Finnish Society of Crafts and Design. The society, largely through Estlander's guidance, was also to be responsible for the organisation of the first industrial exhibitions (from 1876) and the establishment of the Ateneum art museum whose premises it shared from 1887. One other development was the founding of the association called the Friends of Finnish Handicrafts in 1879. This group played an especially important role in the revival of textile art, and in particular that of the Finnish *ryijy* (rug), which was eventually to become a symbol of the vitality of the Finnish Modern Style movement.[3]

The growing awareness of national culture was also to be expressed in the Exhibitions of Finnish Artists mentioned by Aho, and its exploration in published form. Of prime significance for the arts was the crop of new art, architecture and design magazines that began to appear around the turn of the century, foremost among them *Ateneum*, *Kotitaide* (*Home Art*), *Rakentaja* (*The Builder*) and *Arkitekten*. These moved the debate forward from the revival of ethnographic form, disseminated new ideas concerning the style most suited to the present, and, at the same time, served to illustrate and describe the latest developments at home and abroad.

Notwithstanding the internationalism and modernism of these periodicals it was Karelia, with its ancient culture and way of life, that particularly attracted the new generation of Finnish intellectuals, artists and architects, writers and musicians (among them Sibelius[4]), who sought in it the fount of essential Finland. Many

desired to cultivate that fount into a vital expression of modern Finnish national consciousness. Karelian motifs and subjects became persistent themes as the search intensified for a national style. Sources now included not only the Kalevala, whose heroes were supposed to have inhabited the region, and the Karelian countryside itself, but also Karelian building types, embroidery designs and musical instruments (a recurrent symbol exploited by the Helsingfors bourgeoisie was the Karelian zither, the *kantele*).[5]

Appearance

GALLÉN

Those who travelled to Karelia included, in 1890, Axel Gallén and his friend, Count Louis Sparre, a future Modern Style designer of Italian-Swedish blood, who had met while studying at the Académie Julian in Paris in 1886. Stimulated by his membership of Aho's *Nuori Suomi*, the Fennophile group of Helsingfors bohemians, the eastern region provided Gallén with immediate inspiration. His painting became so dominated by Karelian features that he was responsible for the birth of a 'Karelianist' movement. He was commissioned by the Senate of Finland to paint a triptych on the Kalavala tragedy of the young maiden *Aino* (1891). The work indicated a transference of local costume and object designs, combined with a realistic rendering of nature. While the transference was to become freer and the rendition of nature more stylised over the next few years, this painting, which included a frame decorated with carved folk motifs and Kalevala text, was to be a portent of Gallén's subsequent approach. Indeed, by 1894, following increasing inclusion of symbolist and decorative elements he began to branch out from painting.

That year he started to build a studio-home, 'Kalela', by the Ruovesi Lake, forty miles north of Tammerfors (Tampere). This, together with Lars Sonck's family villa (Lasses Villa, 1895) at Finström on the Åland Islands between Sweden and Finland, and Emil Wikström's sculpture studio-home (Visavuori, 1893–94) at Sääsmäki, marked the start of national romantic architecture. Karelian farmhouse design was echoed in Gallén's two-storey structure with its pitched roof, overhanging gable and balcony. The open plan and high studio space also related to vernacular tradition, this incorporating as the house's core a large living/hall space with open fireplace allowing the free arrangement of furniture. Yet the position and size of the windows were determined according to the artist's particular needs rather than observation of any symmetrical model.

While 'Kalela' was being constructed Gallén moved to Berlin to study printmaking. There he became associated with the leaders of the German avant-garde, most notably Edvard Munch and the circle of the arts journal *Pan*. The latter made its first appearance, with Gallén's illustrations, in 1895. These engravings, to Paul Scheerbart's symbolist dialogue 'The King's Song' (*Das Königslied*), depict a naked couple on a celestial throne and in a swirling astral dance (Plate 65). They indicate Gallén's assimilation of the 'beautiful youth in touch with the rhythms of the universe' philosophy of the Symbolist movement, together with a stylisation that closely relates to the most prominent techniques of Art Nouveau: cloisonnist outline, black and white contrasts, fusion of forms into a dynamic unity, flattening of elements on the picture surface – in this case three pairs of hands rising from below the picture frame to hold aloft glasses and apples amidst floating membrane

163

forms. He was to use the same language in the poster he designed for his joint Berlin exhibition with Munch that year.

Upon his return to Kalela in 1895, after a trip to England to study the progress of the Arts and Crafts movement, Gallén's advancement of national romanticism, and its fusion with Art Nouveau, proceeded in earnest. To complement this he Finnised his name, becoming Akseli Gallen-Kallela. With sheets of stained glass brought from London he created works on Finnish and allegorical themes. *Awaken Finland!* (1896) represented the sun as the rose of Finland, rising over the country. National symbols, often combined with abstracted, organic forms began to permeate his work. This was further evidenced in many subjects taken from the Kalevala. He worked in a variety of media, his *Defence of the Sampo* (Colour plate 14) created as a wood relief, a woodcut and in tempera as a wall panel (1896). The stylisations of the tempera can be associated with Art Nouveau idioms: the water's bold, curvilinear patterning and Japonist treatment of the crests of the waves; flattening of the picture space and elevated viewpoint; cloisonnist outlining of figures and objects; large blocks of colour. All of these combine to create a composition of vigorous and complicated dynamism. This is emphasised, for example, by the windswept and exaggeratedly long hair and beard of the hero, Väinämöinen, which harmonises with the undulations of the horizon and green striations of the sea. Further, the depiction of a vessel moving through water and, more importantly, the use of a grotesque, hybrid creature with distorted proportions also correlates with common Art Nouveau subjects. In this case it is Louhi, the toothless witch who governs the north (Pohjola). She has metamorphosed herself into an eagle in a vain attempt to win back the magical Sampo grinder, which has the power to grant happiness and wealth. She anticipates Art Nouveau's persistent attraction to flight, and in particular man achieving heavier-than-air flight. But more than that, she also relates to one of the most striking achievements of French Art Nouveau, Lalique's *Brooch* (c. 1898) in the form of a hybrid female/dragonfly/griffin, with huge outspread wings, and oversized, bared claws and talons. The fact that Gallén's conception was monumental and 'primitivist', while Lalique's was delicate and intricately worked with rare stones and expensive metals, points to the distinctions between the Finnish and French schools of Art Nouveau. Both, however, represented a response to local traditions and the desire to infuse originality into design.

The sense of raw pagan energy and mystery infused by Gallén into *Defence of the Sampo* was to be reiterated in its pair, *Joukahainen's Revenge* (1897) and in the associated Kalevala picture *Lemminkäinen's Mother* (1897) (Colour plate 15). Both use similar decorative techniques to depict the fall of impetuous youth, counterpoised by motherly wisdom and the omnipotent power of nature. The latter can only be harnessed to man's cause by those whose are in organic, intimate tune with its laws. Such themes were not restricted to the *Kalevala*, but were current in much of Finnish folklore and their modern reinterpretration – a fact that was reiterated by Gallén's illustrations for Kivi's most celebrated novel, *The Seven Brothers* (1906–7), about the customs of the countryside, and his painted scenes from Lönnrot's other collection of Finnish poetry, the *Kanteletar*.

Gallén also applied national content to the applied arts. In the late 1890s, his designs for furniture, interiors, metalwork and textiles all incorporated ethnic motifs, subjects or techniques. Doors comprised of vertically running planks, with no attempt to conceal the grain, were finished with elongated strap hinges and other metalwork given stylised pine twig forms; settles, corner cupboards and tables were

designed accordingly. A wall decoration consisted of primitivist, frieze-like rows of conifers, a lake with fish and longboats, tree-covered islands and birds, and irises. Another, which included the massive rustic stone and metal forms of a fireplace, was finished with wainscoting, above which were painted budding flowers and diagonal, shimmering rays akin to those found in *Lemminkäinen's Mother*. The primitive organicism of this design was completed by a frieze of complex arterial forms which evoke primal structures of natural growth, such as roots, sea organisms,

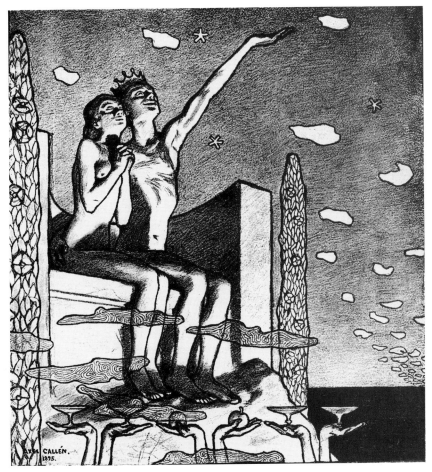

65 Gallén, *The King's Song*, illustration to Scheerbart, *Pan*, 1895

branches, fungi, intestines or veins. Indicative of Gallén's awareness of recent developments in Munich, especially the designs of Obrist and Endell,[6] similar sources are also recognisable in his sketch for a Corner Cupboard (1898). This includes stylised trees, from root to fruit as well as grotesque reptilian heads and scales. These recall Obrist's holistic depictions of growth as in the tapestry *Cyclamen*, as well as Endell's designs of tentacle carvings on shelf panels. In Gallén's case the symbolism is more overt – his trees, one of which is encircled by a snake, representing the 'tree of knowledge of good and evil'.

Gallén's turn to furniture design, as well as his Karelianism, was paralleled by Sparre, who had settled in Finland in 1891. Sparre's enthusiasm for the ethnic building types of Karelia, together with the copious drawings and photographs that he brought back from his 1890 trip, was to provide singular inspiration for the circles of progressive young architects in which he moved in Helsingfors. These included Sonck, Blomstedt and Sucksdorff, who by 1894 had been sufficiently persuaded to make a field study of the Karelian 'timber style' in anticipation of its forming the basis of a new, national architecture. Sparre, therefore, should be acknowledged as one of the prime motivators of the National Romantic movement in Finland.

Sparre's own turn to the applied arts was to have profound effect. As early as 1894 he was awarded second prize for a design of Finnish-style dining room furniture in a Friends of Finnish Handicrafts competition. The success encouraged concentration on design for the next decade, during which he created numerous interiors, textiles, wallpaper and furniture designs as well as bookbindings. This coincided with his planning (together with Gallén) and establishment in 1897 of the Iris Craft Workshops (*Aktiebolaget Iris*) in Borgå (Porvoo), a small, ancient town thirty miles east of Helsingfors. He was artistic director there until the venture closed in 1902. The name Iris, with its manifold meaning, served well to symbolise the company's aesthetic context and aspirations. Not only was it a beautiful flower with upward striving sword-shaped leaves which served as a decorative source for much Art Nouveau art and as a symbol for the sorrow and purity of the Virgin Mary, but it also evoked classical mythology (Iris as the messenger of the gods in the *Iliad* and as the goddess of the rainbow), iridescence and the functioning of the eye. Sparre's adoption of the iris was almost certainly inspired by the flower's evocative form, with its tall, slender stem and petals of delicate patterns. Indeed it was already a potent symbol of the refinement of nature used by Japanese artists, and following them the Pre-Raphaelites, Arts and Crafts designers, Monet, Van Gogh, Gallé and members of the Belgian group *Les XX*.

The company set out to design and manufacture high-quality interior fittings and decoration. Emphasising the integration of aesthetic effect and functionality, Iris designs were marked by a simplicity of form and ornamentation, this involving a certain truth in the treatment and display of the material and its qualities. Such features can be seen primarily in Sparre's furniture and Willy Finch's ceramicware. Surviving examples of Sparre's work indicate his awareness of developments elsewhere in Europe. His first-hand knowledge of these derived largely from a field study he made in 1896 of the new design movement in England, Belgium and France and his visit to the 1897 World Exhibition in Brussels. Indeed the conception of Iris resembles that of Bing's *L'Art Nouveau*, Serrurier-Bovy's enterprises and Van de Velde's ateliers, the latter opening in the Belgian capital simultaneously with Iris in Borga. It also conforms with the ideals of the contemporary Munich United Workshops.[7]

A display cabinet created by Sparre (*c.* 1899) is marked by a constructive sturdiness of design and practicality, as well as restrained decoration and a gentle curvilinearity in the glass panelling, wooden braces and the painted yellow iris. There is no extravagant experimentation with form or ornamentation, although the frames, echoing Morris, are stained green. Such features suggest a combination of British, Belgian and German influence and thereby hint at the internationalism of Iris products. This tendency is further underlined by Sparre's preference for

hardwoods unassociated with Finland (including mahogany, walnut, oak and elm). Indeed, it is internationalism and functionalism, rather than an overt sense of national romanticism, that predominates in Sparre's dining room designs (*c.* 1903) and the majority of his surviving chairs, some of which recall Van de Velde or Riemerschmid, through the curvature of the legs, stretchers and back suggesting organic movement and tension. Sometimes, as in a pine chair for the Otava Publishing House in Helsingfors (1906–7) or an earlier sofa (*c.* 1901), the simple joinery and geometricised forms are combined with horizontal bands of small dark squares, akin to those of Mackintosh or Hoffmann. These references are further evoked in the Otava chair's bevelled cubic form for the seat that slopes at a slight diagonal to the back: the effect of volume and solidity contrasts with the play of empty space and flatness in the ladder and curved back.

FINCH

Sparre's approach to furniture and interior design was akin in many respects to that of Finch whom he invited to Finland to establish and head the ceramics department of Iris after seeing his work at the 1897 exhibition of the *Libre Esthétique* group.[8] Furthermore, Finch, like Sparre and Gallén, came to the applied arts from painting. In his case, however, it was from Neo-Impressionism, and in particular the influence of Seurat. From being part of the group which broke away from the realist art society *L'Essor* (The Flight) to form *Les XX* in 1883, Finch had become one of the foremost figures in progressive Belgian art. First, together with Theo van Rysselberghe, he had been the principal representative of the distinctive Belgian school of Pointillism after 1888. Second, together with Lemmen and Van de Velde, he had belonged to

the first three Belgian artists who broke the shackles of tradition and were the real founders of the modernising movement ... They were the Argonauts ... they should get the credit of having been the first to steer for that virgin territory. The flight of which they set the example took a definite direction when Belgian architects in their turn, joined the ranks of the emancipated and set forth their ideas both in theory and practice.[9]

More than this, Finch was also credited with introducing Van de Velde to the aesthetics of Ruskin and Morris in the early 1890s. And so in bringing him to Borgå, Sparre had attracted a key early player in the development of the international Art Nouveau aesthetic. His arrival in Finland, occurring slightly earlier than Van de Velde's move to Germany, underlines the ease with which their art and approach transgressed national borders and constraints. This cosmopolitanism was further evidenced through the fact that from Finland 'he sends every year ... to the various Continental exhibitions, and the graceful shapes of his specimens vie with their richness of colour'.[10]

In Belgium Finch had begun to experiment with ceramic techniques and form in the early 1890s.[11] His sensibility to materials and colour, already developed in his Pointillist painting, meant that he began to produce glazed earthenware covered with simple, warm engobe decoration. The orientalist tendency in his Belgian work may have derived from Whistler's Japonism, as well as from that of modern French ceramicists, in particular Ernest Chaplet, Jean Carriès, Auguste Delaherche and Gauguin.[12] Thus, although he was always to show a preference for the rustic qualities of form, material and treatment, in Belgium his ornamentation, as well as some of his experiments with technique, appeared distinctly Orient-inspired. Often

66 Finch, Iris ceramics, *c.* 1899

he synthesised the rustic with the refined, his vases, for example, combining delicate fish and lily patterns or wispish curving linear decorations with heavy, simple forms made in terracotta and devoid of extravagant manipulations.

However, once in Borgå, despite continuing his exploration of intricate glazing techniques, Finch favoured the primitive over the oriental. This was evident in the variety of his slipware, which included simple household utensils such as vases, dishes, mugs, bowls, jugs, teapots and tiles decorated with engobe, mixed with metallic oxides, which after firing acquired bold brown, black, green or yellow colours. Still, his ornamental motifs were restrained and organic: they could be stylised flowers or more abstract rotating wave and dot patterns. These features characterise the vessels he sent to Brussels for the *Libre Esthétique* exhibition in 1899 (Plate 66), as well as his contemporary tea services and vases. The biomorphism of his decorative designs sometimes took on a distinctly hybrid combination of forms resembling primitive aquatic life and plant forms but without immediate association with any actual object from nature. A typical example was the cloisonnist cellular and stem/leaf motifs on a deep green four-handled vase.

Finch's ceramicware, with its combination of the crude and refined, abstract and representative, made a highly distinctive contribution to the development of the New Style. Rather than attempting to show off the versatility of clay as a material that could be contorted into the most delicate and intricate forms, he resorted to simple designs, basic organic decoration, sophisticated glazing and bright coloration. In this he expressed Iris's relationship to the craft revival and modernist movements in Europe, thereby highlighting the difficulties in separating the two categorically.

Finch envisaged his ceramics as part of an integrated modern domestic environment. In the first 1901 issue of *Ateneum*, with an aestheticism that appeared

to derive much from that being enunciated by Baillie Scott in *The Studio*, he advanced functionalist concerns:

simplicity ... I do not mean that there should be just bare essentials, but rather that which is necessary to make the room look inviting and cosy, and a simplicity coupled with an equally artistic quality – neatness. Carpets and wallpaper should be subdued in colour, the furniture well designed and of sound construction. Its shape should be rectilinear; this allows no mistake in the proportions. If the lines and surfaces of furniture of this kind blend well one never tires of them: on the contrary, coming home after the day's work or the struggle with one's fellow human beings one experiences a feeling of rest ... Without simplicity, it is not possible to produce any feeling of control and concentration. But the lines of modern furniture are excessively curved, even though these curved lines are a denial of all that is constructive in furniture.

OTHERS

Despite Finch's and Sparre's innovations and the fact that Iris opened a shop in Helsingfors where it sold not only its own products but also high-quality imports, the company was, like the Wiener Werkstätte after it, a commercial failure, this due to the relatively high cost of creating its goods as well as its apparent neglect of a marketing policy.[13] It was driven out of business by its inability to profoundly stimulate the taste of the local bourgeoisie and by more commercially minded operations, some selling cheap imports from England, others selling their own products more effectively than Iris. Among the latter was N. Buman's factory in Åbo, which despite being one hundred miles west of Helsingfors still managed to capture much of the vast St Petersburg market upon which Iris had been over-dependent. Also significant was the Arabia Helsinki factory (founded in 1874 as a subsidiary of the Swedish Rörstrand porcelain works), which, having become independent of its original owner, from 1902 began to successfully mass-produce 'Fennia' ware. Using folk motifs transferred from their traditional medium (textiles or woodcarving), the nationalist content of these vases, pots and dinner services was more marketable than Iris designs. In addition, the Fennia series consisted of plain white earthenware given standardised forms, the painted motifs of which were flat, geometricised patterns (e.g. swastikas) that could be created by a variety of hands simultaneously.

Iris's commercial failure aside, the synthesis of trends evident in the early Finnish expression of Art Nouveau, which was to be most profoundly felt in architecture and interior design, was to reach a high point in two projects to which the company contributed: the Finnish Pavilion at the 1900 Paris Exposition Universalle and the Hvitträsk complex. Both of these witnessed the collaboration of Iris workers with the most progressive artistic and architectural talents in Finland. Furthermore, Finch, together with Lindgren, one of the triad of architects of these projects, was to advance the Iris conception of the Modern Style through his appointment to the staff of the Helsingfors School of Applied Art in 1902. There, the new appointees, who also included the metalworker Eric Ehrström, introduced a new identity to the school's work, through their emphasis on a vital, organic simplicity that was distinctly Finnish. This was to be effectively expressed in the abstract designs by the graduates of different studios, including the dynamic embroidery designs of S. Wickstrom and Keinonen, the carpets of Ilona Jalava (Plate 67), and the pottery of Juselius and Eklund.[14] Several of these utilised rotating cross motifs derived from swastikas, but fused with flowing natural forms, as in Jalava's carpet with its branch motifs.

The Finnish contribution to the Paris exhibition was remarkable on several counts. Apart from their own pavilion, the Finns made a substantial contribution to the Russian fine arts section in the Grand Palais on the Champs-Elysées: twenty-four leading painters and graphic artists and six sculptors taking part, including Blomstedt, Edelfelt, Enckell, Gallén, Halonen, Järnefelt, Simberg, Sparre, Vallgren and Wikström. Their work, the selection of which was overseen by Edelfelt, represented the Finnish assimilation of the variety of modern trends, from realism and impressionism, to synthetism, symbolism, national romanticism and Art Nouveau, without favouring one above the other. Still, irrespective of style, Finnish subjects, in particular the landscape and rural life, dominated the paintings.

The use of an international vocabulary to express national characteristics, a recurring feature of the modern style itself, was also to be found in the Finnish Pavilion (Plate 68). One of the most revealing and perceptive contemporary reviews of the principles at work in the building appeared in *Art et Décoration*:

the Finnish pavilion is one of the most alluring and profoundly interesting structures of the whole Exhibition ... we are in the presence of a genuine national art, and yet it is clearly something new. The architects have not confined themselves to seeking inspiration from local architectural elements ... Denmark and Norway, for example, have attempted to give such an impression in their pavilions. The Finns can recognize themselves in the completed work, but there is an individual stamp in the choice and arrangement of the various parts ... the Finns seek inspiration in everything surrounding them, in their own natural environment, and it is this that gives an extremely vivid quality to what they produce. There is no attempt to use classical formulas, ready-made columns or capitals from which a cast is simply made, but instead a continual and direct return to the animal and vegetable worlds to find original forms of decoration.

... the pavilion has been built by a young architect from Helsingfors, Eliel Saarinen, who has drawn up all the plans, designs and various details of ornamentation, and who has been assisted in the execution of the building work by H. Gesellius and A. Lindgren. The broadly arched doorways, the pointed roof resting on half-turrets, the distinctive form of the rounded bell tower which dominates the whole with its delightfully curving arrises – all this is irresistible, and the pleasure of the eye is in unison with the logical satisfaction of the mind. The lines are simple, felicitous, and new. Even the arrangement of the colours, discreetly employed in the decoration of the roof of the bell tower, adds a very pleasing impression which is enhanced by the beautiful varnished red wood of the doors.

From the main lines and general forms, the eye ventures to consider the details of the decoration. One observes, each time with renewed surprise, the ingenious ornamental inventions: the serpents descending from the roof of the bell tower and the four bears placed at its base, in a simplified, solid style well adapted to the architectural sculpture of stone hewn in simple planes, and asserting their composite character. As we move downwards, the decoration becomes even more attractive. First one notes the turrets which seem to enhance the entire perimeter of the roof and which take the form of fir cones, with the overlapping of the scales soberly and accurately interpreted.

The observation of everyday nature enlivens and enriches the construction; figures of plants and animals inherited from traditional styles could not possibly be introduced here. Around the doorway of the main facade there are bears' heads, again very simply modelled, and arranged in alignment; on the other facade the doorway is surmounted by a delicious frieze of squirrels playing in pine branches. The same can be said of the frogs perched under the wings of the roof, as if they were coming out of their swamp to

67 Jalava, Carpet, 1906
68 *right]* Saarinen, Finnish Pavilion, exterior, Paris Exhibition, 1900

breathe in the air, and below them a light, fan-shaped pattern of water-lily leaves carved in simple relief.[15]

This glowing appraisal accounts for the distinction of the pavilion, the first major work of three architects who had formed a joint practice after graduating from the Helsingfors Polytechnical Institute in 1897, and hints at some of the multiple sources present on its exterior. Of modest proportions, the building was highly picturesque. It had a steeply pitched roof covered in hexagonal shingles and glass. The pitch, the tiles and the crowning finial with its bulbous body ascending in a decreasingly slender line to a point, are all elements found in early Finnish ecclesiastical architecture.

Above the central entrance the tall octagonal tower rose somewhat incongruously, an abrupt later vertical addition to the prevailing horizontality. The gently elliptical curve of the masonry is topped by a crown consisting of slightly cantilevered triangles, the upward-directed space of which is filled with smouldering images of Finland's rising sun. Above this is a conical spire, whose proportions, together with its piercing of a circular spoked hoop near its base, are repeated in miniature around the periphery of the roof. This play of line and void adds to the feeling of ascension from earthly limitations: a sensation which is to be repeated within.

Overall, the pavilion appeared a *gesamtkunstwerk* temple of art, akin to Olbrich's Secession Building. However, rather than echoing the Viennese eclectical use of classical principles and motifs, Saarinen's work makes the same statement about the sanctity of art through the sparing utilisation of elements from Romanesque, Gothic and local architecture. Both buildings also showed careful, restrained use of decorative language appropriate to their individual environments. Thus Saarinen

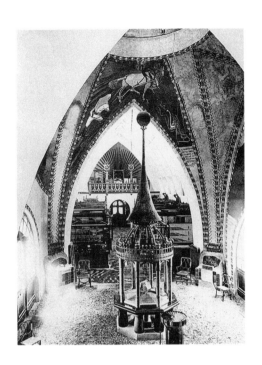

69 Saarinen, Finnish Pavilion, interior,
Paris exhibition, 1900

used pointed Gothic vaulting; large Romanesque entrances; and natural elements symbolic of the Finnish countryside and nation (for instance the fir cones at the base of the corner turrets). Not that all the details were taken from the past or tradition: a glass roof was added and the historicist details combined with a New Style abstract curvilinearity in the exterior metalwork.

The conception set a precedent. In the next few years, other exhibition buildings also incorporated the pinnacled tower and the combination of the ecclesiastical and the modern, notably Shekhtel's mining and ceremonial pavilions at the 1901 Glasgow exhibition and Olbrich's Wedding Tower and Exhibition Palace at Darmstadt (1905–8). Indeed, the integrated, hallowed artistic atmosphere was to be a hallmark of several of the New Style's greatest accomplishments, from Wagner's Steinhof Church to Mackintosh's School of Art.

Inside, the pavilion's association with church architecture was profound (Plate 69). Above the rear entrance and porch was a choir-like balcony where a small display was set up. Under the pointed vaults display cabinets were arranged in rows, like pews. These led to an exotic eight-pillared pulpit-like geological stand in the centre under the tower. Around the vaults of the tower frescoes were painted. But all of these features were conceived in the pagan spirit of National Romanticism or the Modern Style. The display cabinets were topped by stylised wooden squirrels. The choir was given a balustrade of repeated elongated heart shapes and two central balusters that extended to human masks encircled by a play of lines that are straight and curved, thin and thick, horizontal and vertical. These were capped by bud-like forms.

The pavilion was completed by frescoes, friezes and panels, the most striking of which were the four monumental frescoes that Gallén created for the vaults of the tower. These depicted scenes from the Kalevala, including *Ilmarinen Ploughing the Field of Snakes* and *The Forging of the Sampo*. Employing similar decorative stylisations

to *Defence of the Sampo, Joukahainen's Revenge* and *Lemminkäinen's Mother* (shown in the Fine Arts exhibition) he thus completed his depiction of the triad of the mythological heroes – Väinämöinen, Lemminkäinen and Ilmarinen. Such incarnation in this Parisian setting of these pagan representatives of aged wisdom, reckless youth and the heavenly blacksmith renowned for his reliability and competence, was to elevate the primitive culture from which they originated to the level of high culture, on a par with Christianity and as a legitimate component in the hegemony of European civilisation.

The pavilion also contained the 'Iris Room' designed by Gallén and finished by the Iris workshops and the Friends of Finnish Handicraft. Light birchwood dominated – the wall panelling, ceiling, door and furniture. The keynote was simplicity and functionalism, these combining with restrained ornamental evocations of national romanticism and the modern style. The door utilised stylised fir branch strap hinges seen in Gallén's earlier designs. Similar linear motifs were to be found on the upholstery of the chairs and curtains. Finch vases were placed on the shelves and table. A tapestry frieze of primitive grouses and fir branches ran round the centre of the wall above a coarse fabric wainscot. The suggestion of spirallic, upward movement, also found on the exterior of the pavilion, is repeated in Gallén's 'Fire' or 'Flame' *ryijy* (rug) that stretched down from the wall, over a bench, to the floor under the table. Fire, with its free movement away from the earth was an archetypal symbol for Gallén and as such it represents his own conception of the modern style: his own fusion of national romanticism and Art Nouveau. Already seen in his frescoes in the central hall of the pavilion, where it conveys a sense of the forging of the future prosperity and well-being of the Finnish nation,[16] Gallén was to return frequently to flame, or flame-like, motifs for his decorative work. However, here it has an added symbolic function since the *ryijy* tradition which he was interpreting was not just a decorative feature of a rural Finnish home but one established to provide maximum warmth in the cold climate (it even had its origins in fishermen's and sealers' coarse-weaved, heavy blankets).

The design of Gallén's woollen rug indicated a departure from the Friends of Finnish Handicraft's hitherto policy of the continuation of tradition through imitation. It was marked by severe stylisation. The fire is flattened into a repetitive pattern of colour and line. The hottest part is marked by red diamonds with white crosses, these being enveloped by flames of dark and light blue, themselves surrounded by greyish-white smoke patterns. The movement of the flames and smoke is in unison though without rigid symmetry or geometry. Such freedom is consistent with both the nature of fire and Gallén's approach: without being mimetic he expressed the vigour of Karelian textile designs rather than the more strictly geometrical layouts found in the Swedish, western parts of Finland.

HVITTRÄSK

The benefits of the Paris Exhibition were manifold. One impact was that many important works by leading French designers were brought back to Finland, principally by Ernst Nordström, director of the Finnish Society of Crafts and Design. The Society's collection was thus increased by Taxile Doat and Delaherche ceramics; Gallé glassware; Antoinette Vallgren bookbindings; a Colonna drawing room chair, with iris-patterned silk upholstery; and a Gaillard dining chair. Further, following the show, Edelfelt and André Saglio of the Parisian *Grand Palais* collaborated on the organisation of an exhibition of modern French painting and design, held in

Helsingfors in autumn 1901. This brought more pieces from *L'Art Nouveau* to Finland, among them metalwork and ceramics by Georges De Feure (including vases, fans and a candelabrum) and Marcel Bing (cigarette boxes, pendants and brooches).

However, of prime significance with regard to the Paris experience, was the recognition and cash prize awarded to Saarinen, and his colleagues Gesellius and Lindgren. It encouraged several substantial commissions and meant that funds were available to design and construct Hvitträsk (1901–3), an ambitious home and studio complex for themselves. In 1901 the architects bought a site in the conifer forest above Lake Hvitträsk, at Kirkkonummi, eighteen miles south-west of Helsingfors. The project saw each aspect of function and decoration harmonised: every detail, furnishing and fitting designed in accordance with its individual place and use.

The Hvitträsk complex was designed to fuse as organically as possible with the natural environment, the arrangement, levels and form of the buildings and gardens responding to the lie of the land. Two main, irregular masses were grouped around a central garden court. The lower floors were constructed from granite boulders, the facades blending with the granite garden walls. The upper levels were of tarred log construction, resembling that of Karelian farmhouses; the steep-pitched hipped roofs were covered in red pantiles. The exterior was marked by constant changes of direction, becoming a free play of verticals, horizontals and diagonals of different lengths. It was completed by a large square wooden tower breaking the horizontals of Lindgren's villa. This tower, together with the timber construction and free plan was to inspire the 'Northern' style further east, notably Ol's Andreyev dacha on old Finnish land.

The architects radically broke the boundaries between interior and exterior space; this through extensive use of loggias, open-air rooms (where outer walls are replaced by pillars) and corner balconies, allowing further integration between the natural and constructed environment. The quest for organic synthesis was to be further reflected in the interior. Here a zenith of large-scale free planning was achieved as large, open rooms and halls mixed with narrow, closed passages and small nooks; as the varying levels of the floors meant linkage by several steps in many places; and where the size and form of doors, arches, windows were constantly changing, as were the height of the walls and the materials used.

The abandonment of the standard in favour of the unique meant that there was no obligation to adhere to a homogeneous style from space to space. Such freedom allowed the rustic to predominate in some parts, the modern in others, and a combination of the two in most. Thus Saarinen's open-beam timbered hall (Plate 70) incorporated a large circular tiled stove and fireplace surmounted by an imposing, rectilinear hood with slim wrought iron supports; and a bay with rectangular fenestration, the alcove of which was largely taken up by the long window seat and dining table. Elsewhere, stoves were adorned with brightly coloured tiles from the Iris ceramics department, the hood of one being covered with amorphous, serpentine designs by Gallén, who also picked out the lines of the vaults with some bold, organic patterns given primitivist variegation.

The inspiration for this conception of total design, and in particular its application to the interior, may well have derived from Baillie Scott's ideas concerning 'an artist's house'. The coincidence is striking:

'A poor thing, but my own' – that should be the motto of the artist, and the same principle should be carried as far as possible into the construction and decoration of

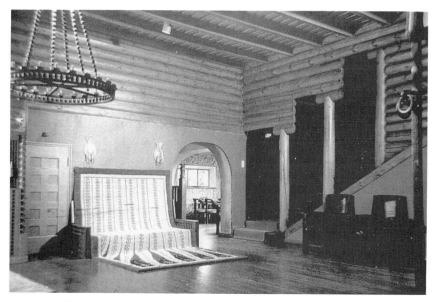

70 Saarinen, hall, Hvitträsk, 1902–5

every detail. The fastenings for the doors and windows, the grates and furniture, all should be specially designed for their special positions and not selected from the pattern-book of the manufacturer.[17]

Baillie Scott, in the Morrisian tradition, called for a combination of individuality, warmth, homeliness, harmony, economy and comfort. He illustrated this with examples of interior designs which he considered effectively achieved it, including inglenooks, dining recesses, open-beam ceilings, tiled fireplaces with projecting settles and copper repoussé hoods. These were unified into decorative schemes that used floral motifs as ornamentation and which cleared the surfaces of extraneous objects. Hvitträsk appears an embodiment of Baillie Scott's principles: to the extent that certain details, such as the recess for the dining area in the hall, the window seats and the foliate motif on the repoussé copper fireplace hood by Eric Ehrström, suggest a direct response. In some instances, this response was given a distinctly Finnish interpretation, as with the textiles produced by Saarinen's wife, Loja, e.g. the large 'Fairy Tale' *ryijy* (1914) with geometricised patterns. Complementing obtusely angled ogive windows and vaults, as well as Gallén's painted stove hood, this adds to the feeling of a modern reinvention of medieval tradition, rather than its ethnological recreation.

OTHER PROJECTS

Reinvention of tradition combined with purely modern elements in varying degrees was apparent in other major country houses designed by the Gesellius, Lindgren and Saarinen partnership after their Parisian triumph. Particularly important was Suur-Merijoki (1901–4, destroyed 1941), near Viipuri (Vyborg), built for a St Petersburg industrialist of German origins, Maximilian Neuscheller. Again the aim was a total work of art, created by a co-operative of architects, painters, sculptors and craftsmen (essentially Blomstedt, Engberg and other employees of the Friends of Finnish Handicraft). As at Hvitträsk, individual architects were responsible for

separate parts of the building, Saarinen creating the central hall, Lindgren the drawing room and Gesellius the bedrooms. They also designed, or at least supervised the making of, all the fittings, furniture and other objects.

More compact than Hvitträsk, and with a plan and execution that were markedly different, Suur-Merijoki showed the same use of rationalised free planning. However, despite having a sunken porte-cochère there was less interplay between exterior and interior space. Similarly, walls were covered in plaster, very few wooden surfaces were left exposed, window shape and disposition were more regular, and vertical movement, created by the pinnacled turret of the massive round tower and other steeply pitched roofs, was more dominant. All this, appropriately for the client's non-Finnish identity, was indicative of a lessening of the national style in favour of international modernism combined with a mixture of ancient traditions – an impression that was further evoked inside.

Saarinen's hall appeared the most original part of the house. Here the medieval, evinced in the Gothic pointed arches and vaults, the short massive pillar, the gallery and the ogive-shaped picture of St George and the dragon between the asymmetrical arches, is balanced by a geometricised style. A lattice effect characterises the settle, the balustrades, the window seat and the candlestand. This grid pattern, and in particular its application to the chessboard panelling of the window arch and the hexagonal metalwork of the candlestand, is reminiscent of post-1903 designs from the Wiener Werkstätte. Similarly, the sideboard and clock-cabinet were decorated with circles and squares, indicative of a stark modernism aligned with that of contemporary Vienna and Glasgow. There were also carved naked figures atop the newel post and the post of the inglenook settle, repoussé hearts and flowers on the chandelier, primitively stylised fir branches on the window soffit, a tree on the wall tapestry, and fern leaf patterning on the ribs of the vaults.

The synthesis of new and old, the local and the international, was given a distinctly Finnish character in the Helsingfors apartment and office buildings created by Gesellius, Lindgren and Saarinen. Most significant were the Pohjola Insurance Company Building (1899–1901) and the 'Doctor's House' (1900–1). In many respects these were the standard bearers for the new 'Northern' style created around the Baltic coast in the cities of Riga, St Petersburg, Viipuri and Revel.

In the Kalevala, *Pohjola* (the Little North), is a prosperous Viking Age farm where the magical Sampo is forged and kept. Hence its appropriateness for a Finnish fire insurance company. The mythical association was remarked upon at the opening of the building:

The style is said to be Finnish-naturalistic ... because the most notable feature in this building is that each material speaks its own natural, characteristic language, and in ornamentation only motifs from the Finnish flora and fauna are used – all this in a way that shows the excellent and vitally powerful talents of the designers ... We people of *Pohjola* ... when we look at the huge stone blocks of the facade our thoughts fly to the high peaks of Koli on the sparkling shores of the great Pielinen Lake, when we step into our 'rustic main room' and see simple pine walls our minds envisage Finnish country homes and sighing pine trees, the iron fastenings we associate with Ilmarinen, the famed smith of old, who with his masterpieces show what moved inside him. We feel in the depth of our hearts that this is Finnish, that only a Finn could create this.[18]

Thus Helsingfors architecture took on the mantle of the National Style. Aided by the insistence that it be faced in fire resistant Finnish stone, the Pohjola building acquired a rusticated granite and soapstone facade. This, together with the detailing

and finish of both exterior and interior, was to convey national traits. Still, the primitivist handling of the facade, which displayed rough hewn surfaces of the stone blocks, also indicated a response to international developments, primarily to the squared rubble technique in Late Victorian Scottish architecture, which had been directly studied by a number of Finnish architects in the late 1890s (Lindgren himself had been in Scotland in 1897), and that employed by Richardson in America.[19]

The exterior included a massive corner tower with pine-cone shaped turret. Like the Paris pavilion it incorporated a rising sun within a pediment. However, the rays are straight, suggestive of regularisation, which is further emphasised through the rectilinear divisions of the facades, most notably that separating the business premises of the lower two floors and the apartments above. The most arresting feature applied to the facades was the sculptural entrance carvings by Hilda Flodin. These included grinning and grimacing trolls, stylised Finnish flora and, again, bears and squirrels (Plate 71).

A prominent feature of the interior was the spiralling staircase with semi-circular landings around which stretched a cast iron railing with rectilinear pine tree motifs. To this were added some curved wooden landing benches and newel posts with carved fern leaves and more crouching trolls. Occasionally these were completed by a leaded glass light fixture which complemented the broad ogive stained glass windows with their fern and owl designs. The sense of medieval was further felt in the rib vaulted vestibule with stone animal reliefs atop the shafts of the pillars and the conical arched metal door with repoussé floral and bird motifs by Ehrström. The main business hall was marked by extensive use of pine – for the wainscoting,

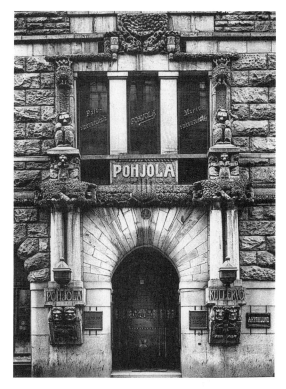

71 Saarinen, Lindgren and Gesellius, Pohjola Insurance Company Building, entrance, Aleksanterinkatu 44, Helsinki, 1899–1901

ceiling and columns. The splayed upper shafts of the columns were fused with primitivist floral strap metalwork and grotesque wood carving of small 'load-bearing' figures that recall the decorative trolls supporting the pillars on either side of the main entrance.

A similar extensive use of wood, together with a sensitive application of decoration and folk-inspired metalwork was evident in the 'Doctor's House'. They were to be seen in the iron stair railings, the dining room's pine panelling, inglenook and pine motifs on its doors, and the stylised snake strap hinges and latches on the stove in the nursery. With a plan less regular than that of the Pohjola, the stress was on making 'homes' and surgeries for well-to-do professionals (mainly doctors) who comprised the housing society which funded the project, rather than speculative apartments. Above the ground floor two large homes were created on each storey. Asymmetry was created by the variety of windows and their placement, flat on the facade, projecting into space as bays or recessed in the upper balcony. Furthermore, the oriels could be curved or obliquely angled, squat or elongated. This rippling, fragmented surface was topped by a roof and gables of differing heights and incline which enhance the feeling of fluidity.

SONCK

Throughout the early 1900s Gesellius, Saarinen and Lindgren gradually advanced their synthetic national/modern style, one of their most important commissions being the design of the National Museum (1901–10) in which again a free interpretation of the medieval ecclesiastic was dominant. A similarly synthetic style was evolved simultaneously by Lars Sonck and his early assistants, Karl Lindahl (a Swede), as well as the Jung brothers Bertel and Valter, and Valter Thomé. In 1894 Sonck won the competition to design the St Michael's Church, Åbo (eventually built 1899–1904), his first major commission.[20] His conception derived from German Neo-Gothic, with red brick facades and grey slate roofs. Building for the Protestant church in conservative south-west, Swedish speaking Finland, Finnish elements were muted. Still, in the final execution the relief work around the windows used 'Finnish' nature as its source – ferns, horse chestnuts and fungi. This was echoed in Max Frelander's painted decorations: from the stylised fern and sun motifs in the main entrance porch, to those of the choir columns and sanctuary reveal arch. These were complemented by a stylised rose decoration on the stair vault and the nine lancet windows of the chancel with stained glass designs of pine trees with green branches straining up towards the blue sky. Elsewhere the effect of upward and outward growth was created by more geometricised or curvilinear decoration, as on the internal soffits and the massive, primitivist soapstone pulpit and altarpiece. Local precedents existed for the botanic decoration, for example the painted motifs of fifteenth-century churches, such as that at Taivassalo.

This late, selective infusion of national elements to St Michael's coincided with Sonck's move to a modern, monumental style for the city. In 1898, responding to increasingly rapid urbanisation, he had set up in practice in Helsingfors and opened an office in Tammerfors (Tampere), 130 miles north. His first commissions thereafter, tenement blocks in both cities, created to suit the new needs of the migrating population, expressed little overt Finnish content, other than the rough hewn granite facing of lower floors. Instead Sonck utilised an eclectic mixture of historicist and Art Nouveau details that was distinctly international in conception. However, on these projects he had collaborated with Onni Törnqvist (Tarjanne).

The partnership led both architects to the championing of a national style through increased use and display of indigenous materials and forms. This was seen, for example, in Törnqvist's Helsingfors National Theatre (1898–1902), with its granite and soapstone facade topped by a rising sun motif and Sonck's St John's Church (later Cathedral) at Tammerfors (1900–7).

Built in an area of new development east of the old town of Tammerfors, St John's was intended as an important symbol for the expanding city (Plate 72). It was to be hailed as one of the masterpieces of National Romanticism and ranked among the most powerful testaments to the New Style in Finland. Sonck entitled his design 'Aeternitas', giving connotations of belonging to the past and future, of perpetual continuance and of the durability of materials, all particularly appropriate for the synthetic *gesamtkunstwerk* that was created.

Influenced by the recent publication of Finnish reports into the use of granite in Aberdeen building, the construction observed a balance between inventiveness and the disciplined reserve required by the working of the stone. Sonck employed an adventurous play of contrasts through the placement of the variegated blocks: large juxtaposed by small, smooth by rough, light by dark; and the granite itself being interspersed by red tiled roofs. He also masked the essentially simple, quadrangular spatial arrangement of the interior behind the picturesque complexity of the exterior. This suggesting an anti-rationalist, Romantic conception that was regularly a feature of the Free Style. Historicist sources are dominated by the Gothic, the main spire being adapted from the tower of the medieval church in Sonck's home parish, Finström. However, he omits details like mouldings, capitals and tracery and instead imposes a stark primitivism through the use of rough surfaces, sharp angles and the natural motifs of the few relief ornaments. Furthermore, the almost square

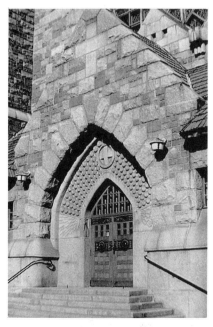

72 Sonck, St John's Church, entrance, Tuomiokirkonpuisto, Tampere, 1901–7
73 *right*] Sonck, Helsingfors Telephone Company Building, Korkeavuorenkatu 35, Helsinki, 1905

179

central space was covered by a sixteen-metre-wide saucer-domed star vault. This, together with the inclined galleries that surround three sides comprise a centralisation that relates the cross-in-square plans of Byzantine churches, and, more directly, to that of neo-classical church planning.

The enclosed, cavern-like impression of St John's, enhanced by the lowness of the galleries supported on stocky piers, is most reminiscent of medieval Finnish churches, an association which is further effected by the addition of frescoes. The revival of wall-painting as an integral part of the creation of psychological space within the built environment was being led in Finland by Gallén.[21] From 1904, his former student, Hugo Simberg, was responsible for most of St John's frescoes, as well as the stained glass designs.[22] Following trips to London, Berlin and Paris in the mid-1890s, Simberg's art had become imbued with a distinctive mystical symbolism. This included the personification of organic nature, the earth's cycles being given grotesque humanoid forms, as in his depictions of autumn and frost. The morbidity that dominated his approach, his obsessive fascination with evil and human tragedy, was to be ambiguously expressed in his church decorations. Against a red background in the central saucer dome he painted a winged serpent coiled up and with an apple in its mouth. This was surrounded by huge feathered wings filling the space of the star vault, allowing the interpretation that the latter represents a host of angels, and therefore implies the conquering of evil by good. These opposites were given further allegorical expression in the curvilinear thorn and rose motifs on the underside of the arches, the same symbols being repeated in the heavy, undulating garland held by twelve naked boys that Simberg painted on the gallery surround. This is the universal symbolism of the garland of life, such use of allegory with the naturalistic rendering of boys' figures in distinct poses against a generalised landscape, recalling that employed from the early 1890s by Hodler.

Simberg produced variations of these good and evil, life and death symbols elsewhere in the church. For the pulpit he designed a decorative relief pattern of thorns and white wings. For the altar cloth he used a motif combining palm leaves and drops of blood. And on the east wall he painted *The Garden of Death* and *The Wounded Angel*. The first had originally belonged to an 1896 series of small mixed media compositions on death. It depicts three black-clothed figures of death tending rows of plants. These human souls in purgatory are neatly sorted according to their distinctive species with individualised forms. Death, black-clothed and skeletal, is shown as caring and sympathetic towards the plants, cherishing them that they may further develop, as have the stronger roots, trunks and branches of the trees behind them. This sense of hope, of potential redemption, is rendered with a child-like naivety: space is flattened, volume denied and objects are primitively stylised and encircled by heavy black outline. The rustic is overtly present in the landscape of *The Wounded Angel*, the first version of which was completed in 1903. Against this two sombre boys carry a stretcher with a blindfolded young white angel holding a bunch of snowdrops. This could be earthliness helping the world of the spirit or, alternatively, trapping it in the material. Certainly it is paradise lost, but whether there is hope through righteous behaviour remains ambivalent. Simberg suggests rather than precisely informs, the message gaining a further twist in the St John's fresco since there he adds to the background some factory chimneys where previously there had been empty hillside.

Simberg's contribution to St John's, his first monumental work, was indicative

of the liberalness of its conception. This, together with the freedom allowed, as well as his questioning, doubting temperament, meant that the decoration suggested that search was preferable to blind faith or dogma. It also meant a denial of stylistic integrity: the works employing a variety of styles from naturalism to cloisonnism, and in the stained glass windows, as the north gallery's Riders of the Apocalpyse, a more convinced decorative interpretation of the New Style.

The modern is further evoked in the north gallery by Simberg's boldly curvilinear vault decoration. Here the wavy colour zones contain sword-like crosses, apparently resembling the back of a cross-spider.[23] Visual representation of Christ is avoided, his presence suggested rather than revealed. This is the case even in the altar fresco of the Resurrection, where a group of naked and clothed men and women rise from the dead and walk towards the light; and Magnus Enckell's cross and thorns chancel window. Further, the sacristy door was carved with images of the devil, completing the suggestion of human vulnerability and the invisibility of Christ.

The eclectic *gesamtkunstwerk* that was St John's Church was less in evidence in Sonck's other buildings. Foremost among these were the Helsingfors Telephone Company Building (1903–5) and Eira Hospital (1904–5). A precedent for these was the Sampo Building (Polytechnic Students' Union, 1901–3). This was the first significant commission for a new partnership formed by Sonck's early associates Valter Thomé and Karl Lindahl. It was also the first Helsingfors project to develop the National Style advanced by the Pohjola Building. The Sampo Building had multifarious functions: there were to be spaces for various students' organisations and social gatherings, a restaurant, a two-storey hall, and shops. The individual treatment and division of these spaces was underscored by the powerful fusion of ancient and modern elements. The result was a play of highly varied shapes. Gothic vaults, lancet windows and rock-piled pillars mixed with log cabin walls and rectangular openings; bright, flowing abstract painted ceiling decoration complemented corbels with woodpecker motifs. The mixture, however, was not random, every decorative feature being accorded an appropriate place. Furthermore, the building was clothed by a facade that appeared a modern interpretation of a medieval group of houses, with a squared rubble round tower; broad, pointed arch lower fenestration and doorways; and a modified Karelian gable.

Sonck's Telephone Company Building (Plate 73) had, like the Sampo, to accommodate various functions: offices, apartments and equipment halls. This gave rise to an asymmetrical plan and a complex organisation of internal space, neither of which were reflected truthfully on the exterior. Again the conception is romantic, the street facade being a picturesque interpretation of medieval architecture combined with an inventive fusion of forms. These included colonnades, a massive tower, a variety of window shapes and a hipped roof. There was also a limited amount of relief ornamentation, comprising stylised ferns and other natural motifs, as well as some geometric designs that appear to refer to the telephone technology on the bay window. Again Sonck utilised the squared rubble technique, this time with a more liberal admixture of bands of light coloured ashlar and rough-hewn coursed masonry. The play of texture and colour is thereby enhanced, the more so by the massive pointed ashlar door surround that protudes from the grey granite.

Like the Telephone Company Building, the Eira Hospital is often claimed as a masterpiece of National Romanticism. However, the hospital stands out as much more homely and intimate than Sonck's other city buildings, this because it was designed as a geriatric convalescent home. In fact, the massing and the light

stuccoed walls on a rough granite boulder podium appear closer to the recently completed Suur-Merijoki, a similarity that was also felt in the vaulting, painted friezes and use of nooks. The play of smooth and rough is the reverse of that seen in the Telephone Company Building, this being reiterated by the ecclesiastical style pointed door surround, here completed in rock-faced squared rubble and set against the plain stucco. This he complements with the granite boulder wall and lych gate that evoke medieval Finnish church architecture. Again the plan is asymmetrical, the organisation of space complicated. A free-standing building on a corner site, Sonck broke up the geometry in the two wings by adding a circular stair tower and rooms with diagonal, curved or othogonal walls. He also used a split-level plan, helped in this by the slope of the site, to provide a more flowing integration of internal space.

The Eira Hospital, together with Saarinen's National Museum, represented the climax of the New Style's national romanticist trend. For the fusion of the archaic and the modern, particularly as represented by the early buildings of Saarinen and Sonck, was already under attack: in 1904 the young architects Gustaf Strengell and Sigurd Frosterus began calling for a more rationalist architecture representative of the technological age. The result was a return to the discipline of neo-classicism, this highly suited to the Finnish laconic sense of decoration and love of natural materials.

Notes

1 Other significant developments included the founding of the Helsingfors University Museum of History and Ethnography; Eliel Aspelin's 1891 survey of the history of Finnish art; a National Museum (first the Historical Museum); an architectural history department at the Polytechnical Institute; and various illustrated studies of Finnish folk ornament (e.g. by Tikkanen and Sirelius).

2 Runeberg published Kung Fjalar in 1844. It was written, like the rest of his work, in Swedish. Like Edelfelt, and Gallén, the leader of Finnish national romanticism, he was of mixed Swedo-Finnish blood.

3 In 1895 the Friends published a handbook of traditional Finnish folk motifs which illustrated many of the designs in their textile collection and which became an important source for the national revival movement.

4 Sibelius began to compose nationally inspired music in 1890s, including the Karelia Suite.

5 In 1894 the Finnish Antiquarian Society sponsored the study trip to Karelia of the young architects Yrjö Blomstedt and Victor Sucksdorff. Their visual record of 'Karelian Buildings and Decorative Forms' was published in 1901.

6 If he had not seen the work firsthand, Gallén would have been aware of it through the publicity it received in such periodicals as Pan. His links with Munich were considerable: he exhibited there in May 1898 as part of the Russian section of the Munich Secession, and his work shown at the fourth Phalanx exhibition in the summer 1902 was highly acclaimed.

7 Sparre, as Boulton Smith suggests (The Golden Age of Finnish Art, Helsinki, 1985, p. 109), almost certainly visited Bing's L'Art Nouveau in the summer 1896, when his wife, Eva Mannerheim-Sparre, exhibited bookbindings there. Finnish connections with the salon had commenced early: Vallgren (see under France) designed the electrical light fittings and contributed a bronze vase to the first exhibition in 1895.

8 The most informative and richly illustrated source on Finch is A. W. Finch 1854–1930, exhibition catalogue, Musées royaux des Beaux-Arts, Brussels, 1992.

9 O. Maus, 'Decorative Art in Belgium', The Magazine of Art, 1901, p. 274.

10 Ibid., p. 276. Finch originally intended only staying in Finland for one year.

11 Finch first worked as a ceramic decorator (1890–93) at the Boch Frères Keramis factory

in La Louvière. He first showed his ceramic work, two panels, in early 1891, at the Salon des Independents, Paris and Les XX (this, together with some wooden reliefs and ceramicware by Gauguin and book designs by Crane, was the first applied arts to be shown by the Belgian group).

12 Finch knew Whistler by 1884 when he persuaded him to exhibit with Les XX. He experimented with Chinese style copper flambé glazes, after Chaplet, in the early 1890s. His concern with glazing technique also encompassed experimentation with Neo-Impressionist colour theories – for instance, he designed plates using Charles Henry's ideas of harmonic proportions.

13 Finch subsequently claimed that Iris was in trouble by May 1899, primarily due to Sparre's indifference to business and that every foreign order had to go through Julius Meier-Graefe, the sole European agent.

14 Some of this work was reproduced to accompany Finch's review of the School's annual exhibition in 1906 in The Studio, vol. 36, 1906, pp. 268–72.

15 Cited from P. Jullian, The Triumph of Art Nouveau. Paris Exhibition 1900, London, 1974, pp. 75–8. The author does not give further details of the reference.

16 Besides the Forging of the Sampo, flames and smoke were a central feature in his Vanitas fresco. Again he distorts visual reality, this time by having the fire divide the picture vertically in two, forming an ambiguous unit with the darkened sky. This union of the elements, juxtaposed with a burnt tree and tree stump in the foreground (cf. Madernieks in Latvia), and three diminutive silhouetted figures mounting a cross on a barren shoreline, suggests the struggle of Christianity with powerful pagan forces in Finland.

17 Baillie Scott, 'An Artist's House', The Studio, vol. 9, 1897, pp. 28–37.

18 S. Gripenberg, December 1901, cited in J. Moorhouse et al, Helsinki Jugendstil Architecture 1895–1915, Helsinki, 1987, p. 108.

19 Concerning this influence, see Moorhouse, p. 42.

20 Concerning Sonck, see P. Kivinen et al., Lars Sonck 1870–1956, Helsinki, 1982; P. Korvenmass, Innovation versus Tradition. The Architect Lars Sonck, Works and Projects 1900–1910, Helsinki, 1991.

21 After his Parisian success Gallén had created a further set of Kalevala frescoes for the Old Students' Building, Helsingfors (1901), and an acclaimed series on 'Paradise' and 'The Cosmos' for the Juselius Mausoleum, Björneborg (Pori) (1901, destroyed).

22 Simberg had studied with Gallén during his early years at Ruovesi (1895–97), following which he had travelled to Italy where he undertook a study of early Renaissance fresco painting.

23 See P. Kivenen et al, Lars Sonck 1870–1956, Helsinki 1982, p. 57, where the author notes that Sibelius had also utilised the cross-spider for a composition in 1898, this later becoming a protest song against Russian oppression.

12

LATVIA

Riga

Background

In July 1903, Richards Zarriņš, one of Latvia's, and, indeed, the Russian empire's, leading graphic artists, wrote to his colleague, the painter Janis Rozentāls, concerning the establishment of a National Style through the collection, interpretation and exhibition of Latvian decorative work by the art group *Rūķis* (The Gnome):

I spent a very happy June in Vecpiebalga. I drew and took photos. And collected old Latvian ornaments – from door keys, keyholes, door plates, from barns and other buildings, pictures from women's old work chests, belts, mittens etc. I was lucky to find in Vestiena a man's old long white cloak and an awful top hat. I also have an old woman's outfit. I've collected drawings from old Latvian wardrobes and chairs. I've found original forms and means of construction in the chairs ... Unfortunately I didn't meet any potters because they live so far away. But I found a lot of their ornaments. If we would all do this then we would soon have the national style – have it in our hands ...

If you are somewhere in the country then try to find old chests. Old women sometimes have them. These chests have naive drawings of flowers and cocks. They should be precisely copied or photographed. Could you help to gather material and speak about it to Jaunkalniņš, Madernieks and Purvitis. You can find a lot if you look. I enclose a couple of door handles. Show these forms to other members. In every district there'll be something different. These are from Vecpiebalga and Vestiena. This is all very important source material – we can do a lot with the metalwork of keyholes on doors and chests. If everybody would get different forms then we'd have loads of material. So go and do the same ...

My wife is embroidering a tablecloth for the exhibition with the ornaments from woollen shawl designs. At Gailītis's in Vecpiebalga there was a crowd of young girls getting confirmed. I told them to gather as many old things and embroidery work as they can – in order to help to cultivate our national art on the basis of the old styles. Here are some flower pot ornaments from Smiltenes. They have white ornamentation on a red ground.[1]

With this call for the establishment of a national style based on observation of ethnographic tradition, Zarriņš announced his conception of the way forward for his country's art. Coincidentally, he furnished evidence of the aims and plans of the first Latvian arts society, *Rūķis*, of which, by this time, he was the main organiser.

In Latvia the New Style was characterised by a practicality. There was little room for dilettantism, little audience for decadent art, no market or Maecenian protection for the self-pretentious. The society was ill-prepared to offer a living to a 'fine artist'

and few sought it. Art was to have a use: it was to be beneficial – whether to the material environment, to a political cause or a social movement. It was rarely free from such chains, almost never indulged in for its own sake, and as a result proved to be a highly professional, versatile and varied phenomenon in which the arts were combined naturally. Unaffected by the artificial distinctions between the fine and decorative arts that the more developed artistic centres had created, art, design and architecture were melded into one. Those who practised painting had frequently started off life as craftsmen and continued to imbue their work with a craft-like approach even if they dropped their former profession.

The nature of the Latvian New Style also derived from the extensive training of its artists, locally, in St Petersburg and western Europe. Given ample opportunity to absorb the developments elsewhere, to reflect on them, and pick up their impetus for change, they tended to favour a rare, somewhat conservative, balance of functional and decorative considerations. This resulted in the broad popularity of the New Style which, with its multifarious and rapidly evolving identity, transformed the face of the local art, streets and interiors between 1896 and 1914. Ultimately, it also comprised one of the most mature regional variations of the style in Europe.

Like Finland, Latvian modern art 'had no past', no school or national pedigree. Indigenous culture had been suppressed by the occupying forces, be they German, Swede or Russian. And it was they who introduced Renaissance, Baroque, Gothic and Classical styles. While these had assimilated features from the local environment their development was fragmentary and late. Further, under Russian rule Latvian lands were divided between the provinces of Livland, Kurland and Vitebsk. However, in the late nineteenth century Tsar Aleksandr III's Russification policies stimulated a new national awakening, this encouraged by the growth of the capitalist economy, the development of industry and, with the abolishment of serfdom and medieval guild privileges, an increase in the size of the Latvian middle class. As a result, artists of Latvian nationality began to emerge from the cloak of German domination of all professional and cultural fields.

The new era was ushered in by the construction of a railway system linking Latvian ports with Russia and Europe, and by the expansion of Riga, following the demolition of its old city walls and fortifications in 1857–63. Latvians rapidly drifted away from their agrarian communities to the new residential areas of the Livland capital, to the extent that they overtook the Germans and Russians as the largest ethnic section of the urban population. The growth of the city was immense: by the start of the twentieth century the population was four times what it had been fifty years earlier; it had become the Russian empire's busiest port; and its factories accounted for nearly 6 per cent of Russia's total manufacturing output though the entire Latvian population only amounted to 1.5 per cent of that of the empire.

The challenges and opportunities that such profound social changes presented to the various ethnic groups had an inevitable effect on the visual arts. The year after the destruction of the city walls, in response to the need for new building and building knowledge, the first Technical Society (*Technische Gesellschaft*) was founded in Riga, half its members being architects. New educational institutions began to spring up, one of the first being the privately financed Polytechnicum in 1862 (from 1896 the Riga Polytechnic Institute), in which was opened an architecture faculty in 1869. Its foundation, sanctioned by Tsar Aleksandr II, was indicative of the new slackening of the hitherto omnipotent state/guild control over the arts. This allowed the establishment of private technical and art schools, societies and exhibitions, 185

which despite close state regulation, were at least outwith the St Petersburg Academy's immediate control. This new relative independence led to a burgeoning of local talent and identity: by 1900 more than half of the fifty or so architects practising in Riga were graduates of the Polytechnic, this in contrast to the fifteen active in the 1870s, almost all of whom had studied in Berlin or St Petersburg. In addition, many Polytechnic graduates left their homeland to practise elsewhere in the Russian empire.

Other institutions included the Crafts School (*Gewerbeschule*) of the Riga Trades Association (*Der Gewerbeverein*), founded in 1872. Providing initial training in drawing and construction techniques for those who sought further education in the arts, from the 1880s its students were to include several who went on to become leading New Style progenitors, e.g. Janis Rozentāls, Bernhard Borchert and Ansis Cīrulis. Among the private studio-schools those of Elise von Jung-Stilling and Jūlijs Madernieks were to prove the most important training grounds for leading progressive talents.

From the 1870s art-related societies were also established, the foremost being the Riga Association of Architects (*Rigaer Architekten-Verein*) and the Art Associatation (*Kunstverein*). The *Kunstverein* (also known as the Riga Society for the Encouragement of the Arts), was one of the first to gain official sanction, its foundation coinciding with that of the Wanderers society of critical realists in St Petersburg. According to its statutes, published in German, the society's aim was the furthering of national art, art education and understanding. To this end, symptomatic of the new wave of local patronage, it founded an art gallery and collection. From 1871 it also organised Riga's first regular art exhibitions. From their inception to the mid-1890s, these were restricted to artists with local connections and Russian groups, such as the Wanderers and St Petersburg Society of Artists. In April 1895, to celebrate its twenty-fifth anniversary, and again in September 1896, the *Kunstverein* organised its first international exhibitions. These were dominated by naturalist tendencies, sentimentalised genre scenes, lyrical landscapes, atmospheric allegories, picturesque still-lifes and salon portraits. Participants included the Germans Feuerbach, Menzel, Lenbach, Thoma, von Uhde; the Glasgow Boys Macaulay Stevenson, Nisbet, Docharty and Brown; and the Swede Liljefors. The appeal was to the conservative bourgeoisie who desired readily intelligible pictures, professionally executed, of idyllic country scenes or beautiful allegories. Yet among the sea of dully refined paintings, there were a few more adventurous works, e.g. impressionist canvases by Liebermann, symbolist paintings from Böcklin, von Hofmann, Klinger and von Stück.

Having essentially been a forum for retrospectives of late nineteenth-century trends in Russia and Germany, in December 1898 the *Kunstverein* opened the Riga Art Salon. It became a crucial venue for the development of new Latvian art. From the outset the salon's programme indicated diversification. Most importantly, exhibitions of applied and graphic art became regular features. Oriental work was shown. An international photographic show was held. The display of recent European trends extended to exhibitions of Finnish (including group shows and a one-man Gallén show in 1902) and Dutch artists. In October 1899 there was also a show of fifty platinotype reproductions of Pre-Raphaelite work. The German/ Russian orientation was up-dated with exhibitions of the Worpswede and World of Art groups, as well as the popular symbolists Sascha Schneider and von Hofmann. Significantly, there was a notable increase in the promotion of the new generation

of local artists, now including those of Latvian blood as well as German. Leading representatives to show there included Madernieks, Lībergs, Valters, Zarriņš, Rozentāls, Škilters, Borchert, Baranowsky and Siecke.

The variety of modern art shown at the Riga Art Salon was further set apart from the earlier *Kunstverein* exhibitions in that it now included work by contemporary French artists. One of the first shows to be held, in March 1899, was a version of Diaghilev's most extensive retrospective of the international scene, the first World of Art exhibition, straight from its closure in St Petersburg. Exhibits included: Menard's lyrically atmospheric *Evening*; Rivière's Japonist Breton landscapes; Aman-Jean's Maeterlinckian landscapes and soulful portraits; and Lagarde's Pointillism. Further, in 1900, there were two exhibitions of French and Belgian goldwork, arranged through the Berlin Jugendstil salon Keller and Reiner, which included work by Alexandre Charpentier and Joseph Chéret. This acquaintance with French trends was complemented by art dealers trading in French and Belgian Art Nouveau posters. In 1899, for example, Eduard Bruhns' art salon displayed posters by Cherét, Mucha, Berthon, Privat-Livemont, Pal and Rivière.

The Riga German press gave impressive coverage of the international scene. For instance, the *Riga Review* (*Rigasche Rundschau*) placed a long interview with Max Klinger and a discussion of his Beethoven statue, the focus of the Vienna Secession's fourteenth exhibition, on its front pages in early 1902. Likewise, the *Duna Gazette* (*Düna Zeitung*) frequently devoted much of its first two pages to art, contributions including appraisals of John Ruskin; a series entitled 'Art and Science', which discussed, among other things, Ernst Haeckel's *Kunstformen der Natur* and the Darmstadt periodical *Deutsche Kunst und Decoration*; the Darmstadt Kunstlercolonie; Nietzschian philosophy, including a translation of Alois Riegl's 'A judgment on Friedrich Nietzsche'; exhibitions of the Berlin, Munich and Viennese Secessions; Maeterlinck; the Pre-Raphaelites; the Paris 1900 exhibition; the Estonian folk epic *Kalevipoeg*; and modern Russian art.

As the capitalist economy developed, so did the Latvians' awareness of their own culture and nationality. Initially this went hand in hand with a new anti-German, pro-Russian orientation, indicating a similar west-to-east pattern of national rediscovery to that occurring simultaneously in Finland. Latvian language newspapers and periodicals began to appear, among them *Austrums* (*The Spirit of the Dawn*) and *Rota* (*Decoration*). A Latvian Society was founded, a national song festival established and plays by Latvians in Latvian began to be performed.

While the first generation of Latvian artists had expressed no specific 'national' qualities or aims, their successors, such as Zarriņš and Rozentāls, were enthusiasts for their native country and its peasant culture. New research into folkloric traditions, such as Ansis Lerhis-Puškaitis's publication of over a thousand Latvian folk tales from 1891 and Jēkabs Lautenbah's study of Liv mythology (1896), encouraged them. For in their search for spiritual independence they turned to folk art which they saw as ageless, as a vital synthesis of naivety and wisdom, and therefore representative of a truthful, inner direction for themselves and their nation. Through naturalism or stylisation, they connected mystical, ancient traditions with the present. The micro-cosmological systems present in Latvian folk decoration and folk songs (the '*dainas*', which consisted of completely independent units, which nevertheless belong to others), provided an ideal for the young artists: those seeking universal analogies, from Madernieks to Matvejs, therefore tended towards formal abstraction and generalisation.

This form of symbolism, rather than literary analogy or narrative, was to characterise the national romantic trend of the Latvian New Style. Literary analogy, which was so strongly expressed in Polish Art Nouveau, was largely avoided due to the lack of a national epic with heroic tales of chivalry. However, there was a literary counterpart to the visual form of national romanticism, which saw the publication by Krišjānis Barons of his collected *dainas* (from 1894), of the poetry and dramas of Jānis Rainis (from 1903) and, in 1888, of Andrejs Pumpurs' (1841–1902), 'national epic' poem *Lāčplēsis* (The Bear Slayer), which made selective use of epic elements from the *dainas*. Thus folk poetry was revived and reinterpreted and in this, in the rustic mystical lyricism of an agricultural people, there was an equivalence with the national movement in fine and applied arts.

A most significant milestone for the development of local modern art was the Latvian Ethnographic Exhibition held in Riga in 1896. Until that time virtually all exhibitions in Riga had been for non-Latvian nationals (German Balts, Russians and west European artists). The ethnographic exhibition witnessed the first group appearance of *Rūķis*, the society most responsible for the advancement of the New Style. In addition, the organisers, the Riga Latvian Society, sent expeditions to gather material from the various Latvian regions. One of the leaders of these was Aleksanders Vanags, then an engineering student at the Polytechnic and part-time assistant of architect Konstantīns Pēkšēns, who went on to become one of Riga's leading national romanticist architects. Vanags and Pēkšēns, with the aid of Miķus Skruzītis who had studied the 1895 Czech Ethnographic Exhibition first hand, designed the pavilions. As in Prague, they utilised the forms of vernacular buildings: there was an old Kur log-constructed farmhouse, a thatched Liv combined house/barn, a traditional bath house and a large modern two-storey house in finished wood and with numerous shuttered windows, fireplaces and a porch. All were marked by a low, spreading horizontality, gently pitched roofs and, but for some primitive carving of the gables of the modern house, a lack of ornamentation.

The exhibition witnessed the first collaboration on a single project by Latvian architects, artists and designers. *Rūķis* members, Rozentāls, Valters and Zaļkalns, assisted in the interior display arrangements and created backdrops for the national costumes that were shown. But most of all it was the accumulation of material related to all aspects of Latvian life and culture (the economy, traditional occupations, building techniques, language, literature, music, art and crafts, religious beliefs and geography) that was to profoundly influence the local artistic consciousness. The *Rūķis* exhibits, which appeared specifically chosen for their 'ethnographic' qualities, bore early witness to this. There were many studies of local 'types', in which the features of peasant men and women, farm buildings, Latvian landscapes and country scenes, were copied from nature. Some were more contrived, such as Rozentāls' realist *Leaving Church*, in which he portrayed a carefully selected cross-section of provincial society from his local community of Saldus. Only Baumanis appears to have resorted to romanticised mythology wholeheartedly, his works including *Zemgale Spirits* and *The Soothsayer's Song*.

This was the first stirring of the search for a modern national art, a *heimatkunst*, that used naturalist and neo-romantic styles for its expression. Subsequent developments indicated the Latvians' ability to go beyond narrow parochial, revivalist goals, to assimilate a wide spectrum of international developments with a vitality that created their own distinctive Latvian New Style, and themselves influence the progress of modern art further afield. Further, within Latvia the growth of Russian

capital, the influx of Russian citizens, and the ease of access to German architectural innovations contributed to the complex art dynamic. As part of this a number of architects arrived from Russia, Germany and Finland to build in the New Style.

Appearance

RŪĶIS

The *Rūķis* (Gnome) arts society had originated in St Petersburg around 1890. Its members included painters, sculptors, graphic and applied artists, as well as musicians, many of whom were students at, or graduates of, the capital's higher arts institutes. Backed by the wealthy Latvian bourgeoisie living there it sought to raise the standard and, for some members, the 'Latvianness' of Latvian art through regular studio meetings, exhibitions, lectures, concerts and the publication of work in Latvian periodicals. Its first leader, the painter Ādams Alksnis, was one of the most patriotic and idealistic members. Helped by his tolerance of new styles, the art of the group developed in several directions simultaneously. Alksnis himself preferred primitivist depictions of rural toil and superstitions. Arturs Baumanis turned to both mythology and low provincial life for his subject matter. Vilhelms Purvītis took up impressionistic landscape, specialising in Latvian snow scenes. Rozentāls, Valters and Madernieks were more versatile, moving through a variety of styles and fields. Richards Zarriņš turned to Latvian folklore.

In many respects, Madernieks was the Gallén of Latvian art. For it was he who became Latvia's leading universalist, practising graphic, embroidery, furniture and interior design as well as painting, teaching and art criticism. Furthermore, the development of his decorative art moved from an early, distinctly international vocabulary to a more Latvian-inspired approach to form. Having studied decorative painting and textile design at the Stieglitz Institute and in Paris in the late 1890s, Madernieks returned to Riga to create interior designs for the Latvian bourgeoisie. These included a suite of rooms for the lawyer F. Alberts (1903). The ladies' room was completed with calligraphy-style frieze designs that, like the display of fans and the carving on the asymmetrical cabinet, were orientalist. But the repeated wave-patterning of the frieze is also reminiscent of Van de Velde's designs for the Salon Bing in Paris, a source Madernieks had almost certainly seen.

Flattened decorative patterning and abstract stylisation of organic nature was to be the consistent characteristic of Madernieks' approach – what was to alter was the extent and type of abstraction, and its source. In 1902 he designed a highly abstract wrapper for an edition of solo songs, *Dziesmas/Lieder*, by fellow *Rūķis* member, Alfreds Kalniņš. This was devised from rectilinear forms in which the angling and repetition of diagonals created a sensation of upward, rhythmical dynamism. The forms can be interpreted as geometricised cornflower petals and pods set against a herring-bone motif that, in turn, could be the fir twig design of Latvian folk ornament said to represent Laima, the goddess of destiny in the *dainas*.

This shift to increasingly geometricised forms, only loosely based on Latvian folk ornament invoked the revivalist Zarriņš' chagrin. His approach demanded a far greater adherence to the conventions of Latvian tradition and less free modernisation. The result was a schism in *Rūķis*. In fact, over the next few years Madernieks' work actually only occasionally relied on folk sources, and this even though he continued to design for the leading Latvian arts magazine *Vērotājs* (*The Observer*), and progressive 189

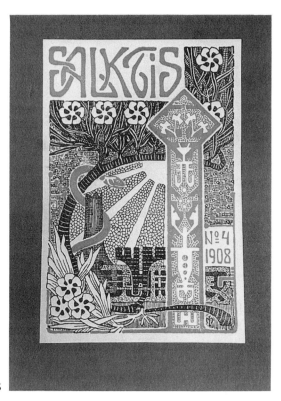

74 Madernieks, *Zalktis* cover, 1908

Latvian writers. His vignettes for *Vērotājs* ranged from curvilinear organic motifs such as flowers, butterflies and wooded landscapes, to abstract rectilinear patterns in which national references are at most oblique.

Still, Madernieks' commissions paid tribute to the new level of Latvian literary and artistic consciousness – a consciousness that was to be shocked with national and social tensions following the violence of the Russian revolution in 1905. The new national current was encouraged by an unprecedented range of Latvian political and art periodicals, newspapers and books that suddenly began to appear. Leading the way were the satirical magazine *Svari* (*Libra*) and the literature and arts journal *Zalktis* (*The Grass-Snake*). Both nationalist and liberal in their ideologies, these gave a vital impulse to art and criticism. One of those who latched on to the impulse was Madernieks. He became one of the nation's most liberal art critics, publishing many articles on local art issues and supporting European-wide modernist developments.

Madernieks' designs for the new Latvian literature, such as Gulbis' poetry anthology *Native Forests* (*Dzimtenes mežos*) and Mikelsons' intimist novels, such as *Wilderness Traveller* (*Tuksneša celotajs*), betrayed little concern with specific national qualities or the direct imitation of peasant traditions. Rather, in accordance with the search for universal truths expressed by the authors, he created forceful decorative images in which natural forms such as flowers, bats, stars, skeletons and pine cones, though highly simplified and distorted, are still readily recognisable.

In contrast, recourse to pagan symbols and national allegory was overt in Madernieks' designs for the magazine *Zalktis* (1908) (Plate 74). One cover contained visually identifiable objects, including a brown snake curled symbolically around a blooming, sinuously curving tree and a thicker, broken tree trunk. In addition,

below the tree uncoloured white space defines the image of the sun, the rays of which are directed to a cluster of stylised flowers in the lower right corner. On the surface plane is a monolithic form reminiscent of a flattened carved memorial stone. This pagan artifact is adorned with a geometric, two-toned pattern. The contours of the stone flow outwards to become a frame for the lower half of the image, this, in turn, extending inward in three series of horizontal lines, some ending in pods, of various length. This surface patterning is set against a ground of intricate web-like forms, these recalling various types of coarse fabric. The dominating decorative play of horizontal and vertical, curvilinear and rectilinear, and dark and light correlates with the decoration found in Latvian embroidery.

Although Zarriņš sympathised with Madernieks' implicit sentiments concerning the dawn and blossoming of new Latvian culture after its break with its recent past, the application of folk motifs, without integrity to ethnographic tradition, created antagonism between the two. Still, the more conservative Zarriņš moved into the applied arts, designing jewellery which made use of traditional Art Nouveau sources, such as dragonflies and dragons, as well as the hybrid figure Sumpurnis (a man-like ogre with a dog's snout) and the 'flowering fern' from Latvian folklore. His graphic art, which paid great attention to naturalistic detail, made frequent redress to medieval literary analogy and narrative: forest mysteries, goblins and elves, enchanted princesses, the happiness- and love-bringing fern that flowers at midsummer, and the exploits of Kurbads, a Latvian hero who fights off the ogre Sumpurnis and beats up a grotesque nine-headed fiend.

ROZENTĀLS

Rūķis' concern with a whole spectrum of arts and themes was further expressed in the output of Janis Rozentāls. Though best known for his painting, he too took up graphic design, applied arts, teaching and art criticism. With regard to the latter, it was Rozentāls who was largely responsible for the establishment of a theoretical basis for modern art in Latvia. Trained at the St Petersburg Academy (1888–96) rather than the Stieglitz, his style appeared more personalised and independent than that of his two colleagues. This gave scope for greater innovation and formal experiment:

The aim of the artist is not the documental depiction of natural objects ... it is not the representation of all chance things and details that occur together with those objects, but rather it is to find in nature and synthesise from it those colours, forms and lines which characterise the essence of being, which themselves are typical and which can serve as a means of expression of the observed or the conveyance of subjective delight ... Thus the artist arrives at new ideas about the inter-relations and conditionality of things ... If it seems that these relations, new essences and more complex questions are impossible to reveal or express with any depth using old technical means then the artist should consider these too. This way the new aims of art also establish new approaches to technique.[2]

In November 1903, with this call for renewed searching for artistic truth and new conceptual stylisations, Rozentāls opened a new era of Latvian art criticism. He chose as his mouthpiece the first issue of *Vērotājs*, whose art section he was to edit until its closure in 1905. Subsequently the magazine was to carry several of his articles on modern art in Latvia, Germany, England, Finland and Russia, as well as some of his best graphic work. In addition, it reproduced works by many of his *Rūķis* colleagues – foremost among them Madernieks, Purvītis, Alksnis and Zarriņš.[3]

Inspired by the original democratic and nationalist ideals of the Wanderers, Rozentāls was a powerful early force in *Rūķis*, and during the late 1890s attempted to live and work in the Latvian provinces. Having sought to reflect the visual nature of this provincial life, following trips to Finland, Sweden and across western Europe, he began to experiment with the conceptualist vocabulary of symbolism and national romanticism. In 1899 his oil *Saga* (Plate 75) was greeted with critical acclaim when it was shown in St Petersburg:

Rozentāls' *Saga* is very poetic. Against a background of a choppy sea, is a slightly styl-ised female figure, one hand gripping a harp, the other plucking its strings. Her hair is uncurled by the wind. Her head is inclined and in her strict, beautiful face there is something severe, almost gloomy. Her gaze, introspective and contemplative, is con-centrated on those images which appear in her soul, the secret words of which com-prise the content of her songs, which is sombre, wild and melancholic like the monoto-nous, bleak music of the sea's breakers. The bent trunks of trees, the foliage expressing the movement of the wind, the ravens around the figure, and the monotonous grey hues in which the whole picture is maintained, make for an integration of mood and the powerfully expressed fantastic and fairy-tale elements.[4]

Identification with a particular saga or Latvian legend is avoided. This could be Aeolus, Greek god of the winds, whose magical music produces remarkable effects in nature; or simply a muse with her lyre, a symbol of creative inspiration. More than a straightforward allegory for the sounds and power of the wind, more even than an emotive image of man's relationship with nature and his means of expressing that relationship, the harpist could be one of a number of Latvian female deities from the *dainas*: e.g. Jūras māte (Mother of the sea), Vēja māte (Mother of the wind), Laima (goddess of destiny), or Saule (the sun), who towards nightfall, prepares for rest by the Sun Tree located in the middle of the world ocean. All are suggested. Sound, movement and mood are given visual form through the limited, wan pastel tones, the lack of definition of the objects and the flattening of the picture space. So while the woman with her ivory necklace and her primitively carved, age-old harp are recognisable, the flat linear rhomboid they create in the centre of the picture is set against a decorative pattern of indistinct shapes and colours that represent the organic flux of nature.

Themes of love, sexuality and mortality, expressed with a new painterly moodiness and musicality, were to be especially prominent in Rozentāls' œuvre after his marriage to a Finnish mezzo-soprano Elli Forsell in 1903. It is no coincidence that similar themes and means of expression were also to dominate Vrubel's work after he married the coloraturo soprano Nadezhda Zabela in 1896. They were to be revealed in paintings such as *Temptation*, with its Biblical *femme fatale*; the folkloric, cloisonnist *Swan Maiden* and, one of his most lyrical works, *Arcadia* (*c.* 1904–10). The latter is a decorative rococo allegory in which the bucolic scene is represented with suitable, sunlit idealisation: beautiful naked, half-naked and dressed nymphs at recreation with nude babies, a row of which tumbles from a tree through the air on to the back of one of the ladies. Again it is woman, water, sky and trees that are chosen to convey the sense of organic unison in nature. But here the scene is bathed in pale blue and is more complex. The brushstroke is freer and more constructive, the colour more mottled, the figures more assimilated into the landscape itself than in the earlier works.

Concurrent with these paintings Rozentāls worked in many different styles, creating portraits, genre scenes, religious paintings and many images of fauns,

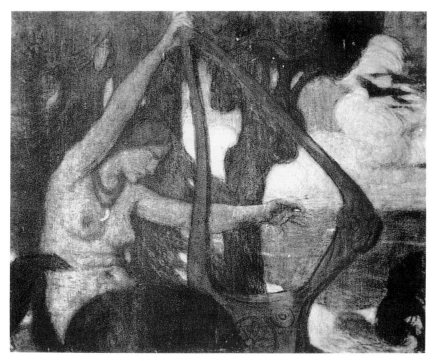

75 Rozentāls, *Saga*, 1899, pastel on card, 68 x 85

satyrs and devils, favourite characters of his *Rūķis* mentor, Alksnis, and of Böcklin. In addition, greatly inspired by Finnish national romanticism, and in particular the work of Gallén, which he saw both in Finland and Riga, he also created some Latvian romanticist works, the most remarkable of which were monumental paintings on the facade of the new Riga Latvian Society building (1910). These consisted of seven friezes, in coloured cement supplemented in places with mosaic: four allegories for the Society's activities (Art, Science, Industry and Agriculture), and three scenes based on Latvian mythology. The forward-facing folkloric scenes act as Rozentāls' response to Gallén's Kalevala panels depicting the heroic trio Väinämöinen, the old sage, Lemminkäinen, the passionate youth and Ilmarinen, the heavenly blacksmith. For now Rozentāls raised his pantheon of pagan Latvian deities to the level of high culture. He settled on the triad of Pērkons, Potrimps and Pikols, the symbols of power, beauty and wisdom respectively, and the primary cosmological symbols of the heavens, earth and the underworld.

　　Pērkons, the Thunderer, an all-important god in the Baltic religions, is set in the middle of the central composition (Colour plate 16). In Latvian mythology, Pērkons was the persecutor of evil and the ensurer of life: he would strike out the devil who hid in trees by his use of lightning, clean the earth of evil spirits with his thunder, and water the land with his rain, thereby bestowing on the world fertility and prosperity. Rozentāls depicts him before the spreading branches of the oak tree, the symbol of his power. In his raised arms he holds a hammer and a swan, symbols of his role as the sky smith and god of fertility. At his feet is a plinth from which rises an eternal flame, a symbol of god. It is decorated with golden Latvian ornaments, including sun and morning star signs and his own swastika, here anti-clockwise.

The last, one of the most widespread motifs of Latvian ornament, signified thunder, fire, light, life, health and wealth. As two crossed lightning bolts it symbolised the most dangerous and immediate source of fire. To the left and right of the central Perkons, are two further embodiments of his main characteristics: one a reclining mighty warrior with spear and shield, the other a muscular thinker with bird of prey and tablet. These figures are surrounded on either side by groups of naked men and women, his devotees making their ritualistic supplications to him, as they did at times of drought, harvest thanksgiving and at the wedding of Ausma (the Dawn), the sun's daughter, when, according to the *dainas*, they give the Sun Tree a golden belt.

Rozentāls' decorative conception of Pērkons, together with his selective interpretation of myth, is reiterated in his Potrimps and Pikols murals. He chose Potrimps as his allegory for beauty, this deriving from descriptions of the god's appearance as a strong, beardless youth who wore a crown of golden cereal ears and his association with fertility, Spring and success in battle. He depicts him astride a three-horse chariot, rising up from the horizonline of an expanse of water. Across the water, of which he is god, a beautiful naked couple greet him, struck by the golden rays that emanate from his crown. This contrasts with wise, old Pikols, the sovereign of the dead, the bearded one, the god of wrath, unhappiness and evil spirits, and a deity of the hills. Surrounded by skulls, he sits hunched, like a primitively carved sculpture, in the top left of the composition, behind a silvered spring from which a youthful couple drink. The mood is darker, more ominous, but equally loose in its sense of narrative and suggestion.

All the friezes are characterised by flattened space, heavy outlining, stylisation of objects and a virtual monochromism that is only broken up by sparse silver and gold highlights. The healthy proportions and emphatic poses of most of their generalised figures indicate an attempt by Rozentāls to classicise Latvian mythology, in keeping with the severe lines and regularised planes and volumes of the Latvian Society Building, the first project in Riga to utilise a Wagneresque neo-classical New Style. Yet the richness of the friezes also contrasts with the otherwise extremely starkly decorated facade, as if they express a time or spiritual belief more commonly associated with the rugged, rustic national romantic style originally intended for the building.

Undoubtedly, Rozentāls' combination of archaic lore and New Style techniques was part of the pan-European attempt to provide an alternative to the perceived anachronism and alienation of the Christian tradition in the industrial age. Indeed his youthful figures in the Potrimps frieze clearly parallel the naked youth with arms raised and sun-like hair designed by the paganist Fidus for the cover of Balmont's *We'll be like the Sun*. However, Rozentāls' recourse to mythological subjects and folk forms was the exception rather than the rule. For it coincided with the call by the revolutionary art critic Jānis Asars for Latvian art to be 'a spiritual expression of its age – ours, with its way of life and technology, has an absolutely new identity, different from the past with its order of serfdom. As long as our art can develop freely, and in response to the needs of the Latvians then it will be genuine art. And as long as this art is genuine then it will naturally be Latvian.'[5]

This call for *zeitgeist* was already in the process of being taken up by Rozentāls' *Rūķis* colleague, the sculptor and graphic artist Gustavs Šķilters. Initially he showed an attraction to the sensual, feminine New Style evocation of universals in both fields. However, the sombre realities of the Latvian present came to the fore in his

caricatures for *Svari*. Published in St Petersburg, *Svari* was founded as part of the vast wave of periodicals dedicated to political and social satire that arose after the bloodshed of the 1905 Russian revolution. The mood was anti-government, anti-military, anti-church, anti-aristocracy, anti-Tsarist, anti-capitalist. In fact anti- all those institutions and individuals regarded as the violent oppressors, or their collaborators, of the workers, justice and rights. The cartoons and illustrations of these magazines were frequently explicit in their stark representation of the agents of government terror – a fact that led to their rapid closure, most conclusively after a censorship crackdown in 1907 (when *Svari* was also closed).

The graphic art of *Svari* reflected not only the influence of the Russian magazines, but also a response to the Munich journal *Simplicissimus*. Among Šķilters' contributions was the lithograph 'Dubrovin in Riga'. This showed the notorious leader of the extreme right wing nationalist party, The Union of Russian People, Dr Alexander Dubrovin, as he arrives in the Latvian capital to be greeted by two German barons conniving appeasement. The epigram reads 'where there is grinding, there the ravens gather'. Dubrovin stares straight ahead, indifferent to his welcome, two blood-stained knives tucked into his belt, more in his pockets. The Germans, dressed for riding and hunting, are stereotyped by their pernicious attributes – spurs, whip, gun and cigar. All are set against a background of blood red – the dominant colour of the new periodicals' illustrations.

This evocation of the dual enemies of the Latvian people was to be particular to *Svari*. It arose not just out of the political and social structures governing the local populace, but also out of the actual, bloody events of the years 1905 and 1906. Then Latvian workers struck and demonstrated, and peasants burned down German manor houses. The result was brutal suppression at the hands of the German and Russian occupants, and, for thousands, exile in Siberia or execution without trial. Hence Šķilters' 'Dubrovin' and the new wave of national romanticism that broke out following 1905. This was made possible by the concessions made by the new Imperial Duma to the Baltic demands for political and cultural rights.

Svari was one of the most radically blunt of the new Latvian publications. Another of Šķilters' works was 'The Deputy's Holiday', the cover of the eighth issue, in which a blinkered and gagged Baltic delegate to the St Petersburg Duma returns home to provincial Latvia for the holiday recess.[6] He is escorted by two Russian sailors, bottles in pockets, who he is in the process of bribing. Although still bathed in red, this reference to the toothlessness of the local participation in the legislative process was mild by comparison to Jānis Roberts Tillbergs' exposé of the recent turn of events. Tillbergs, who became editor of *Svari*, designed the cover of its first issue, 'The Unemployed'. The action is identified as in Latvia by the sign *Stadtamt* (Municipal Office) written in German. There is no doubt who Tillbergs considers the real unemployed – the two well-dressed, cane-swinging and cigar-puffing German factory owners who fill most of the picture space. They amble slowly off to the right, their backs turned on their laid off Latvian workforce who, crammed into the dark-shaded top left corner, await the pronouncement of the top-hatted guardian of the city chambers. This exposure of the injustices of the Latvian times was made more brutal in his cover for the seventh issue, 'Tourists in Riga' (Colour plate 17). Here, with the epigram 'Keeper: "Please excuse the mess, the museum opened too early"', he puts on display the instruments of torture used during the obviously vicious reign of 'Inquisitor Davus (1905–7)', whose portrait hangs over the cudgels, tongs, pincers and rack. Bourgeois German tourists peer with disdainful curiosity

at the grotesque exhibits while the custodian hurries to sweep up the mess from the most recent torture. The woodcut style of broad blocks of two or three colours and flattened space, combined with the blunt political message, is reminiscent of Paul's *Simplicissimus* cartoons.

OTHERS

The polarisation of Latvian society witnessed in the pages of *Svari* affected the arts in other ways. Relations between German Baltic, Russian and Latvian artists altered. New allegiances were established, mainly along nationalist lines. The Germans, now made all too aware of the Latvians as a nation (rather than as a social class), underwent their own national awakening. The result was something of a schism in the art life, with the creation of new groups – the German-dominated *Baltischer Kunstlerverband* (1910) and the Latvian Society of Artists (*Latviešu mākslas veicināšanas biedrība*) (1910). The first adhered to a conventional programme of promotion of 'fine' arts, the second revealed a predilection to the applied arts, not least through the display of national romanticist ceramics by Ansis Cīrulis. In addition, there was a clash over the apparent favouring of the local Germans by the direction of the Riga city art museum which had opened in September 1905, thereby taking over from the Riga Art Salon as the principal exhibiting venue in Latvia. The *Kunstverein* was given its own hall in the new art museum and for its first show in late 1905, selected many of the region's best artists of the middle-younger generation. Predominantly German, these did also include other nationals, not least Rozentals and the Finnish textile artist Jalava.

Despite these signs of divorce, with many of the artists being political liberals as well as artistic internationalists, there was considerable opposition to division on nationalist lines. This was embodied by the new magazine, *Vystavochnyy vestnik* (*Exhibition Herald*), published in Russian in St Petersburg, by the Latvian Voldemārs Matvejs. It gave extensive attention to recent, current and forthcoming exhibitions around the world, its universalist credentials being asserted through the coverage not only of art shows but also trade and industrial exhibitions. Also it included articles discussing the significance and purpose of modern exhibitions, gave the latest news from the art schools, published Van Gogh's letters to Bernard and was illustrated by a variety of young Latvian and Russian artists. The idea of unison was reiterated in the local coverage in the most significant new art and design magazine of the new period, the annual *Bildende Kunst in den Ostseeprovinzen* (*Plastic Art in the East Baltic Provinces*), published by the Riga Association of Architects.

In fact, the new situation saw an increase in the collaboration between nationals that had begun to emerge in Latvian art prior to the 1905 revolution in other respects. What changed was the expressed ideology. One such aspect, the new socialist element, was to find expression as early as June 1907 in the Exhibition of Workers' Apartments and Popular Nutrition. This witnessed the collaboration of the Latvian ceramicists Cīrulis and Jēkabs Dranda with the German designers Max Scherwinsky, Martha Hellmann and Elsa Springer. Indeed, the ceramics of the Latvians, which had just won a silver medal at the Milan international exhibition (1906), were distributed among the interiors of the German designers, as their functional and decorative complements.

In 1901 Riga had celebrated its 700th anniversary. A jubilee Industrial and Craft Exhibition was organised. By 1904 Jānis Asars claimed that the rapid changes in Riga's physical appearance (its buildings, advertising, design and fashions) in the

early 1900s, largely stemmed from the show: 'that taste which has caught on in Riga, particularly after the 1901 Jubilee Exhibition, is indeed something new; and it is acknowledged by a wide public which attaches to it, both purposely and readily, such terms as "the new style", "modern" and "secessionist" etc.' Forty pavilions were erected on Riga's Esplanade. The layout was by Alfred Aschenkampf and Max Scherwinsky, who had just designed one of the earliest New Style buildings in Latvia. Both then were teachers at the Crafts School, Scherwinsky having been its director since 1888. Their design for the site was conceived as freely asymmetrical, with curving paths and grassed areas linking the network of pavilions. Most of these, including the Industry, Construction and the Restaurant and Confectionary Pavilions, were open-plan. Designed by Scherwinsky, they incorporated New Style details such as large curvilinear window and balcony frames.

The interior of the Construction Hall was decorated with a broad curtain, 'Spring Landscape', designed by the Riga decorative painting company Kurau & Passil. Within a curving frame and against a generalised background of cliffs and blue sky, lithe nymphs in flowing dresses danced and played pipes. This augmented the Craft School display, with its range of eclectic New Style furniture, metalwork, stained glass, lighting and decorative painting, and Eduard Walker's frieze of stylised moose strolling through pine trees.

Kurau & Passil were one of three partnerships of decorative artists to receive medals for their work: the others being the sculptors and stucco specialists Otto & Wassil, and Baranowsky & Siecke. In September 1902 the latter held an exhibition at the Riga Art Salon. There they made an assertive, new challenge to the artificial dividing line between decorative and fine art:

One might expect to find here exhibits of predominantly decorative or functional character, yet ... most of the items are paintings which seem to lay claim to artistic autonomy. However, the overtly decorative treatment of even the most weighty subjects can hardly be overlooked. Everything, not necessarily in harmony with the subject, is crudely painted and seems to have originated in sudden impulses and pure painterly enthusiasm. Some of the paintings are strange and disconcerting. Others are obscure and blurred.[7]

Baranowsky's *Songs of a Bygone Age* was a decorative painting, dominated by boldly stylised linearity and loud orange and blue colouring. His sombre, blue and black, *On the Way* revealed the generalised forms of a dark figure holding an hour glass in its hands, walking past an old couple. The creation of colour-mood was the preeminent goal. This visually abstract evocation of feeling was to be found in *Autumn* (1902) (Colour plate 18). An old woman sits mournfully on a chair decorated with a tree ornament. Space and volume are ambiguous. Here, with dark melancholic greens and blues, with flattened forms and heavy cloisonnist delineation, an image is created that is essentially a surface pattern. Visual detailing is avoided. What remains is a feeling of autumn, the season and the last lap of life. In evoking this he expressed his relationship with Rozentā ls, the owner of the painting, who, having started as a house-painter, called for the synthetic balance of the experience of nature and the decorative element.

Baranowsky's tapestries, *Fishwives* and *Waves*, revealed similar conventions: the former including geometricised linear and square motifs that relate both to ethnic tradition and the approach of Secession Style artists in Vienna; and the latter generalising natural form into undetailed abstract colour blocks that can be related to Madernieks' wall-hangings. Such associations between the German Balt 197

Baranowsky's works and that of his Latvian colleagues suggest common purpose, direction and even identity. Indeed, they speak of a lack of internecine conflict in Latvian New Style art at the formal and aesthetic level.

Another local German painter and applied artist was Erich von Campenhausen, a designer of ceramics, furniture, silverware, interiors, and textiles. From around 1905 these tended to be in the rationalist functional spirit of Riemerschmid. Further, some of his plate designs incorporated abstract aerodynamic motion, strongly suggestive of Van de Velde and Behrens. Supranationalism was reflected in his poster for a Kunstverein exhibition. The script was written in German, Russian and Latvian in a new attempt to avoid national discrimination. It employed a fusion of medievalist and New Style idealisations: colour is reduced to four tones, volume is completely flattened, the composition geometrically divided into two unequal halves, and the objects – the knight, his horse and the trees – are represented by the simplest of colour-forms.

Campenhausen's fellow German Balt Bernhard Borchert, one of the most talented of the local painters and a graduate of the St Petersburg Academy, also paid little heed to national divides in his art. Exhibiting in Riga from the mid-1890s, his paintings showed a predominance of symbolist, mythological and fairy-tale concerns. The pastel *Panic-Stricken Terror* was an allegory for the cultural dangers brought by industrial progress, showing a group of centaurs fleeing and falling in terror down a railway embankment, away from the path of an oncoming train. Occasionally he depicted the medieval settlers of Latvia, as in a watercolour of vikings arriving at the Latvian shores, for their passage down the western Dvina river and a depiction of Teutonic knights riding through a local forest. More often he betrayed a love for the fantastic, as in *Fairy Tale* and *Maidens' Circle Dance* with their playful nymphs and mysterious male figures.

Integration was also stressed by the Latvian designers who settled in Russia. Foremost among these was Kārlis Brencēns, who, having studied under Grasset and at the Académie Colarossi in Paris, was to head the stained glass studio at the Stieglitz Institute from 1907 to 1920.[8] Surviving examples of his early stained glass include *Cock in the Snow* (1904), shown at the Salon du Champs de Mars in 1904. In this the brightly coloured figure of the cock is depicted against a simple, two-tone background which is broken up by the falling snowflakes. Back in St Petersburg Brencēns' range of subject matter broadened, his patrons calling for allegorical and historical representations of figures such as St Nicholas, George and the Dragon, and Peter the Great. Of primary significance among his work for New Style buildings was the stained glass panels for the restaurant of the newly renovated Hotel Europa in St Petersburg. These were remarkable for two reasons. First, they included a monumental, figurative picture, in this case Helios astride his chariot riding through the sun-drenched sky above the clouds and the world. This was a great rarity since the vast majority of the local stained glass comprised abstract vegetal subjects or simple landscapes. Second, Brencēns utilised two different techniques, the first of which was seldom practised in the New Style. For the large mushroom-shaped Helios window in the end wall, he, or members of his team, stained the glass themselves with ceramic-based dyes, while for the more abstract, organic ornamentation of the ceiling, overdoor and stage wings he used already coloured glass, cutting and collecting it into a composition through the moulding of the leads, in the more common mosaic fashion.

This fusion of techniques, as well as the synthesis of the abstract organic, the

figurative-representational and allegorical, was to be employed on a smaller scale in the staircase windows for Pēkšēn's Merchant Bank of the Mutual Credit Society in Riga (1912). The bank was designed as an embodiment of wealth and security. It was finished with numerous expensive materials and details, an example of which was Brencēns' windows. The commission provided him with a rare opportunity to turn to themes related to the awakening of Latvian national consciousness. Thus a central focus of his glass work is a circular, realistic portrait of Krišjānis Valdemārs, a prime instigator of the Latvian revival movement. Valdemārs is surrounded by a golden wreath around which are the words, in old Latvian, of a rhyming appeal he once made to the people to enrich themselves for the sake of their country and culture: 'Latvians sailing the seas, save your gold in the dowry chest.' The script is interspersed with an asymmetrical play of vertical golden oblongs and circles, these, in turn, being surrounded by a rich border of highly stylised, interwoven floral motifs in a variety of colours, symbolic of the potential fruitful blossoming of the Latvian nation. The window's script relates to a second panel in which a galleon surrounded by a crowd is blessed by a priest. Other windows depict different sources of Latvian wealth – corn, wisdom (an owl) and the railway industry (a winged wheel rolling over a globe).

Through his Helios window Brencēns revealed formal, compositional and subject similarities to the painted cosmological symphonies of his Russia-settled compatriot Rūdolfs Pērle. The Greek god of the sun and his three-horse chariot dominate the large upper oval of Brencēns' composition, and by so doing subjugate the green countryside, cottages, ancient sailboats and blue rivers in the smaller, rectangular lower section to their life-giving (and life-threatening) power. In comparison, Pērle often depicted cosmic riders charging through the sky, the landscape below them being silently subjected to the changes they wreak and the battles they engage in. Similarly, the sun, and sometimes the moon, was often the focus of his compositions, its rays of light streaming through fantastic mountainscapes.

Indeed, of the other Latvians who settled in Russia it was Pērle, together with Matvejs, who stood out for their primitive-atmospheric evocation of spiritual life. With its sense of eternity and universal harmonies, this indicated mutual concerns with the Russian artists Roerich, Borisov-Musatov, even with Kandinsky, as well as with the painterly-musical compositions of the Lithuanian Mikalojus Čiurlionis. Pērle's paintings showed a preference for fantastic images of supernatural worlds and beings. They were dominated by archaic, mythical scenes of gothically attenuated mountains, some rising from the sea, some dwarfing teams of celestial equestrian figures, boatmen or mystically sparkling precious stones. He melts his objects into a unison of ethereal, ascending and descending forms, be they ruins and ravens or the soaring, organic peaks of aquatic mountains.

Pērle's representation of cosmic forces, with its pagan-mythical inspiration and consequent portrayal of the relative organic impotence of mankind, was common to Matvejs, the leader of the St Petersburg art society, the Union of Youth (*Soyuz molodëzhi*). And like Pērle, Matvejs also chose affectedly naive stylisations as the most effective means for their evocation. Paintings such as *Times Past* and *Seven Princesses* utilise indistinct human figures set within a wan grey-green landscape in which natural elements are integrated through a lack of definition and a unifying, monotonous timbre. Hence the generalised tree forms and the stretch of coast as well as the sense of communion with nature. The result was the evocation of a

medieval, ancient or timeless atmosphere, without statement or narrative. In the case of *Seven Princesses* this was consistent with the suggestive nature of Maeterlinck's drama of the same title.

GERMAN ARCHITECTS

The heavy industrialisation of Riga in the late nineteenth century, combined with its development as a major port, drew new city dwellers from across rural Latvia, as well as beyond. The urban population explosion, from 100,000 in 1868 to 300,000 in 1897 and more than half a million people in 1913 was remarkable, even for Europe. Latvians replaced Germans as the largest ethnic group in the city. With the need for new building never having been greater, there was a significant shift in the demands, aims and nationality of both builders and clients. Expansion meant the creation of a new centre, beyond the ramparts of the old fortress walls of the ancient town. Its tenements, villas, factories, churches, shops, schools and other civic institutions were to be a rich and diverse harvest of New Styles.

The architects were drawn from the Latvian, German and Russian communities. Several from abroad were also commissioned, among them Van de Velde, Behrens, and the Finns Wasastjerna and Lindberg.[9] The earliest Art Nouveau buildings in Riga date from 1899. Still timid in terms of their articulated break with historicism, the most radical was the house built for the Jugendstil publisher Alexander Grosset, not least since it was constructed in the heart of the old city. Designed by Aschenkampff and Scherwinsky, the building functioned as shop, offices and apartments. The plan was asymmetrical, the functions of the floors differentiated on the facades, and the ornamentation flattened atectonic linear images of biomorphic life.

The partnership of Heinrich Scheel and Friedrich Scheffel was to be more prolific. Their buildings, mostly five-storey tenements, sometimes with shops on the ground floor, indicated an assimilation of the international vocabulary of the New Style. This was particularly true with regard to the attention they paid to the elaborate decorative treatment of the facades. Three primary examples are the Dettmann house (1901–2), the Bobrov and Tupikov houses (1902–3) (Plate 76), designed for German and Russian clients.[10] All use classical geometry, and a rich mixture of flat stucco garlands and swags, stucco masks, gorgons, grotesques, angels, as well as figural sculpture. The decorative work was mostly carried out by Otto & Wassil. The buildings incorporated the latest central heating and hot water systems, gas cooking and electric lighting. The finish of the facades was individual – in the case of the Dettmann building, the surface was washed one colour, the commercial ground and first floors were dominated by the huge curved window openings and the vegetal decoration was picked out in black and white. This sprawled around the upper half of the window frames and also characterised the iron forms of the balcony and roof railings.

While the Dettmann house incorporated a massive two-storey bay, the facade of the larger, more atectonic Tupikov building was only broken up by small balconies. These, in rows of two, were given a sense of dynamism by their curving consoles, a decrease in size in accordance with ascending floors and the inverted diagonal of the upper balconies' posts. The surface of the exterior, like that of the Bobrov building, comprised a complex interplay of textures, from the roughcast of the lower floors to smooth and rusticated ashlar above. The staggered corner site of the Tupikov house leant itself to asymmetry. This contrasted with the more regular corner site of the Bobrov building, for which Scheel exploited a narrow chamfered

end with ornate balcony and bay. The eye-catching emphasis complemented its open aspect, in keeping with the retail function of the ground floor.

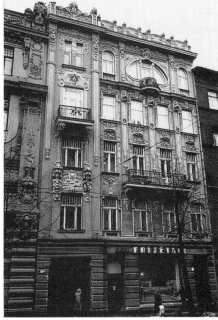

76 Scheel, Scheffel, Bobrov Building, 8 Smilšu, Riga, 1902
77 *right*] Eisenstein, Ilyishev Building, 10a Elizabetes, Riga, 1903

EISENSTEIN

Scheel's buildings are extensively decorated with Art Nouveau motifs, but they appear austere by comparison with those of Russian-born Mikhail Eisenstein. In the early 1900s Eisenstein created a number of tenements in Riga, almost all with highly ornate facades, but none which showed serious concern with the organic synthesis of structure, ornamentation and design. The saturated plastic treatment of the Ilyishev (Plate 77) and Lebedinsky houses on Elizabeth Street borrowed heavily from a recent study of New Style facades published in St Petersburg. The first was asymmetrical, with larger rectangular windows and shafts above the courtyard entrance to the left. The relief decoration fused the curvilinear and rectilinear, the abstract organic with angels, masks and lions heads. Above the central window shaft of the right side was a large elliptical window and balcony opening. The Lebedinsky house used similar motifs but because the building was broader and lower it appeared less light. In addition, it was symmetrical, using a double storeyed bay over the central courtyard entrance, this being crowned by huge androgynous masks and a peacock framing the attic storey. These details, together with the elevation as a whole, were copied from a Leipzig facade. To this, Eisenstein added a novel colour scheme, using blue-glazed bricks and grey plasterwork.

Between 1903 and 1906 Eisenstein built six more tenements on nearby Albert Street – three for the Councillor of State A. Lebedinsky, two for V. Boguslovsky and one for A. Pohl. Again they are most remarkable for the indulgent ornamentation 201

of the facades, the Pohl house using a language replicating that of the Lebedinsky house on Elizabeth Street: blue glazed bricks, central double-storey bay and balcony over the courtyard entrance, grotesques, masks, floral motifs and vertical stripes. To this he added four circular, porthole-like windows at ground level. As a whole the tenements create a distinctively stylised and energised ensemble, yet at the same time each building appears to compete with its neighbours in terms of modern decorative extravagance. The most distinctive facades belonged to the Boguslovsky house at 2a and Lebedinsky house at 4. The first was set apart by the verticality of its six window shafts which include a play of square blue majolica tiles and stripes of red tiling. They culminate high above the eaves in a parapet punctuated by round-arched apertures and fussily decorated by a set of helmeted heads and geometricised motifs. The second was given battered Egyptian-temple style entrance shafts adorned with huge griffins. These ascended towards a broad elliptical window on the second floor, above which a group of three small almost round arched windows and a curved canopy completed the intricate play of shapes. Eisenstein makes abundant use of stringcourses, which with the horizontals of the various balconies arrests the upward movement of the building. His windows, here as elsewhere, are characterised by square bar tracery, usually above a transom, a feature frequently used by Hoffmann in Vienna.

Eisenstein was not the only Riga architect who revelled in riotous facade ornamentation. Wilhelm Bockslaff revealed a similar tendency in the Neuburg House (1903), designed for a master mason turned property speculator. Here, seven shops and twelve flats were hidden behind a picturesque medley of stucco arabesques, grotesque consoles, hermaphrodite masks and rising sun motifs, and plaster 'rubble'. Of the Riga New Style architects it was he who received major commissions most regularly. His buildings almost always featured historicist or vernacular elements. Indeed, often his work shows a preference for Gothic forms in red brick, as in the case of his masterpiece, the Riga Commercial College of the Stock Exchange Society (1902–5),[11] but these are exploited in an innovative way that correlates with the Free Style tendencies in Europe.

In the Commercial College, Bockslaff created a synthetic building, whose asymmetrical, organic plan was wholly rationalised and intimately co-ordinated. Appropriate to the college's function as a temple to trade, the Gothic forms used belonged to the so-called Hanse Style, and as such were sacral symbols for the commercial spirit of the Hanseatic League. In fact, his New Style ecclesiastical buildings indicated an inverse reflection of the spirit of the age – his Dubulti Church (1908–9) and the Church of the Cross at Bikern (1908–9) incorporating a distinctively secular and vernacular vocabulary, as if addressing the new paganism of metropolis. Both churches were constructed beyond the Riga city limits in rural centres, their locations in the green belt appearing particularly suited to the organic, national romanticist features which they displayed. However, while they included tiled roofs, half-timbering, roughcast and, in the case of the Church of the Cross, heavy rubble porches and irregularly disposed window slits on the tower, the restrained geometricised decorative motifs suggested the influence of the Viennese Secession Style. Here then, in Latvia, Hoffmann appeared to have met Sonck. This was illustrated by the interior decoration of the Dubulti Church – under a timber ceiling the whitewashed walls, piers and arches were highlighted by golden border bands comprised of simple, rhythmical geometric figures – zigzags, rectangles, steps, triangles and stripes. These were intercepted by small sets of blue squares, both on

the walls and in the apse windows. Around the exterior ran a similar band of red geometric motifs, only these appeared as stylised leaves transposed from folk embroidery.

PĒKŠĒNS AND LATVIAN ARCHITECTS

The pioneering architect of Latvian nationality whose architecture was to display a similar transcendental use of the ancient and modern, and whose career very much paralleled that of Bockslaff, was Konstantins Pēkšēns. Having given indications of a composite tendency in his Riters tenement (1900) with its subdued Moorish and Gothic detailing, he achieved a purer modernism in the Kamintius House (1901–2) (Plate 78) and the Stamm House (1902). The first was a narrow five-storey tenement faced in red brick and light green plaster. Capped by a black-tiled mansard roof with curved pitch and completed by dark green metalwork for the entrance door and balcony railings, the play of colour contrasts was pre-eminent. This coincided with an organic decorativism which delicately controlled the facade, from the curvaceous forms of the entrance and the plasterwork, to the figurative relief work. The latter was the most remarkable feature of the building. It included stern burghers at either end of the cornice; curious reptiles on the balcony surround; birds, stylised plants, trees and a starling-house; and, greeting the visitors, a monumental fanged grotesque over the entrance. This creature with flaring nostrils and gaping, toothy mouth serves a structural function in that it acts as a support for the oriel windows and balcony above.

In Pēkšēns' *œuvre* only the Stamm House really compared with the Kamintius through its Jugendstil colour combinations and marginalia – in this case more

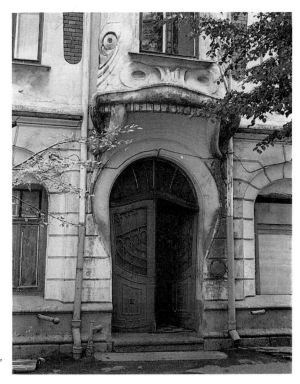

78 Pēkšēns, Kamintius House,
23 Tallinas, Riga, 1901–2

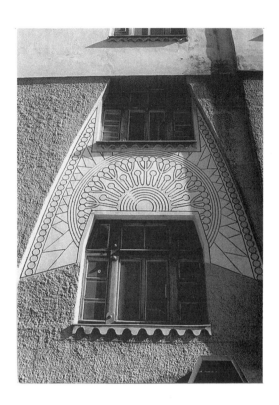

79 Pēkšēns, Laube, Klāviņa House,
26 A. Čaka, Riga, 1905

exuberant peacocks, masks, swirling curvilinear forms, nude male and female figures emerging organically from the wall and a gnarled oak tree visible from its roots to the tips of its manifold leaves. In fact, the Kamintius House's stark colour contrasts, particularly of the red brick and green plaster, together with the combination of decorative restraint and an exaggerated, bulbous organic support above the entrance, were to be most closely interpreted in the Schilensky tenement (1903) by Paul Mandelstamm.

Like Scheel with Scheffel, Pēkšēns was assisted in his early turn to Art Nouveau by a much younger architect. In his case it was Eižens Laube, who in 1903 was still a student at the Polytechnical Institute. And it was in collaboration with Laube that Pēkšēns made his next important step – into national romanticism. Having registered his interest in Latvian vernacular traditions in his designs for the Ethnographic Exhibition, in 1905 Pēkšēns was to create his first permanent buildings in which he exploited those traditions. These were the Klāviņa tenement and the Ķeniņš Secondary School, both for Latvian clients, the latter for the *Zalktis* publisher and symbolist-nationalist writer Atis Ķeniņš. A decisive factor motivating the move into a style more readily identifiable as local was the revolution of 1905, which caused widespread anti-German, and with it anti-Jugendstil, feeling. The urban Latvian population now considerably outnumbered the Germans and Russians together and one of the few ways to assert this new ascendancy was through architecture.[12]

The move into national romanticist building received direct stimulus from architects themselves. In 1904, Vanags and Laube, both of whom were working in Pēkšēns' office, visited the practice of Wasastjerna and Lindberg in Helsingfors, architects who were then building in a national style.[13] Upon their return, both took

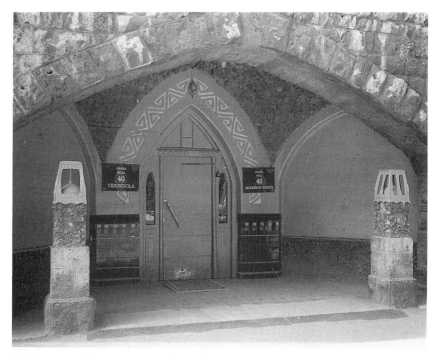

80 Pēkšēns, Laube, Ķeniņš Secondary School, 15–17 Terbatas, Riga, 1905

up national romanticism, Laube in his contribution to Pēkšēns' buildings. The Klāviņa house appears transitionary. In accordance with pan-European New Style conventions, it utilised a light blue wave frieze under the cornice, considerable asymmetry in the play of forms, colours, apertures and textures, and a careful juxtaposition of the few highly stylised, flat decorative details (Plate 79). To these it added a picturesque bud-shaped gable, the same curved roof as the Kamintius, a variety of window shapes, the most common having a tapered upper half evoking the silhouettes of Latvian vernacular building types, and a large sgraffito design of concentric circles and cornflower pods surrounded by a sun (or sunflower) derived from national embroidery motifs. The facade was completed by an inscription, in square format, which pronounced in Latvian 'My home is my castle' – a phrase pregnant with national implications.

Similarly, the facade of the Ķeniņš School was largely stripped of ornamentation, its effect being conveyed by the integration of finishing and structural materials – in this case dark grey limestone rubble, red brick, grey roughcast, pink smooth plaster and green tiles (Plate 80). Again this combined with the distinctive shapes of the apertures – chamfered windows and a main portal that was a broad, cavern-like arch leading in to a large porch. The last was one of the most innovative features of the building: the rubble surround; two free standing stone and metal posts, presumably for lamps; the green tiles interspersed with flower motifs around the base of the door; the extremely coarse, dark pebbledash vault; and the hooked zigzag pattern (abstracted from the folk motifs symbolising the deity Mara, the guardian of life, and the sacred serpent) above the arched door, all combining to create a powerfully organic, paganised feel. This was completed by the projecting brackets, borrowed from Latvian wooden farm buildings, for the mansard roof of the

assembly hall. Situated on the top floor, the hall itself was adorned with features of the vernacular – in this case a village meeting or prayer house – with its diagonal struts and vaults combined with geometricised decoration and images of birds flying around suns.

Throughout the second half of the 1900s Pēkšēns was to combine further use of ethnographic forms and decorative motifs with New Style concepts and the latest technology in numerous buildings he constructed in Riga and its environs. In this he was joined by Vanags, who had set up his own practice in 1905. One of Vanags' first independent commissions was the Jānis Brigaders tenement (1906).[14] Here he used a crossed bargeboard motif, characteristic of Latvian peasant cottages and symbolic of the deities of fertility and prosperity, above the portal. Flattened against the surface it was picked out in the plasterwork above the chamfered entrance in such a way as to suggest the completion of a silhouette of a farm or fisherman's dwelling. The primitive dynamism of the entrance was supplemented by series of striated chevrons on the surround and the thick, opposing diagonals of the metalwork, recalling that of the Pohjola building in Helsingfors. Vanags also exploited the geometric symbols of folk art in the zigzag patterned stone mosaic that acted as a frieze under the cornice. And the national image of the fir tree occurred – in the highly stylised landscape of the stained glass overdoor in the vestibule.

Vanags' friend Eižens Laube set up practice in 1907. National romanticism was given high profile in his 1908 designs, particularly those for the Krastkalns and Virsis tenements. He published his ideas about the expression of national identity in *Zalktis*, calling for the study of folk art as a means of 'plunging into the spirit of our ancestors ... which, through its mighty power of renewal, would grip each and every one of us for all our lives and in all our creative work.'[15] For Laube it was the spirit, rather than the imitation, of national forms of art that was important for the creation of a new, genuine Latvian architecture. Further, he compounded this principle, as Rozentāls was doing simultaneously, by also considering it essential not to neglect foreign impulses, where these could contribute appropriately to the expression of the age.

In his 1908 tenements, the use of local forms, notably in the slate-tiled roofs, was picturesque. For the Krastkalns house he combined steep pitched wallhead gables with mansards and a pointed round corner turret. The two peaked gables differed in their completion – one was timbered as if on a rural building, the other adorned with abstract, curvilinear plaster reliefwork. Similar, freely organic decorative details as well as ethnographically-based geometric motifs were dotted around the facade, as they were on the dark grey face of the Virsis house. All the features, from the apertures to the projections and recesses of the surface were dealt with individually, almost fussily. So were each of the five floors. The result was a dynamic ensemble, given atectonic effect through the lightness of the detailing and its verticality.

Ultimately, whether national romanticist or decorative, Latvian Modern Style architecture, with the exception of Eisenstein's buildings, tended to be characterised by a high degree of functionalism. Further, it expressed the new maturity of local architects, and their awareness of the latest European developments, which they exploited in distinctive ways to create a uniquely Latvian trend. Romanticist tendencies were, however, not limited to ethnic Latvians or the exploitation of Latvian vernacular traditions. This was evident in the buildings of the German architects in Riga, at the forefront of whom was Bockslaff, as well as in those by the

Russians Proskurnin and Yakovlev. In 1906 Nikolay Proskurnin, a Petersburg architect, designed the Rossiya Insurance Company building, using a similar northern romanticism, with parts of the facades faced in rubble and given Gothic forms, to that employed by Gimpel and Ilyashev in their contemporary project for the company's Petersburg office. On the other hand Nikolay Yakovlev's tenement on Romanov Street (c.1910) is more in keeping with the Neo-Russian style through its references to Russian folk art and architecture – the stucco relief Baba Yaga witch, peacocks, stylised trees, and fruit; the curvilinear and triangular gables, and the pear-shaped columns. Such stylistic diversity within one movement does much to signify the political and social status of Latvia, a Baltic country within the Russian empire.

Notes

1 R. Zarriņš, letter to J. Rozenta–ls, Latvian State Archive (LSA), Riga.
2 R. (J. Rozentāls), 'Par Vilhelmu Purvīti un viņa makslu', Vērota–js, 1903, no. 1, p. 111.
3 Rozentāls' articles included discussions of the work of Böcklin, Whistler, Baumanis, Alksnis, Zarriņš, modern Russian art, modern Finnish art and design, and reviews of Latvian exhibitions
4 M. Dal'kevich, Iskusstvo i khudozhestvennaya promyshlennost', 1899, no. 7, p. 596.
5 J. Asars, 'Makslas amatnieciba', Kopoti raksti, 1910.
6 The epigram read 'The speech of silver, the silence of gold'.
7 B.-l. (Alfred Blumenthal), 'Im Salon des Kunstvereins', Düna zeitung, 11 September 1902, p. 5.
8 By so doing, he became one of four Latvians to lead design departments at the Institute in the inter-revolutionary period. The others were fellow Ru–kçis members: Jaunkalninçš (fabric design and flower painting), Belzēns (decorative painting) and Škçilters (decorative sculpture).
9 Van de Velde designed the school and vicarage of St Peter's Church in Riga (1909–12, destroyed 1944) in a rationalist language. Much of the detail given here is indebted to the seminal research of J. Krastiņš: see his Jugendstil in der Rigaer Baukunst, Michelstadt, 1992.
10 Heinrich Dettmann was a local optician and owner of the Union Corporation, a manufacturer of electric generators and engines for electric trams (from 1898 an affiliate of the Berlin Siemens Corporation).
11 Now the Latvian Academy of Arts.
12 In 1906 Kçeninçš was forced into emigration in Finland due to his suport for the Latvian nationalists during the revolution.
13 In 1906 the Finnish partnership were to design a vast Riga tenement in the national romanticist style for the merchant M. Nesterov, this being constructed under the supervision of Vanags.
14 Ja–nis Brigaders was a publisher and bookshop owner, active in the promotion of Latvian symbolist and national romanticist writers.
15 Zalktis, 1908, no. 4, p. 147. Laube's call coincided with the first publication of the ethnographer August Bilenstein's seminal study of Latvian wooden buildings and implements (Die Holzbauten und Holzgeräte der Letten, Riga, 1907) – his analysis of the Latvian barn was published in the same number of Zalktis as Laube's article.

Select bibliography

Some of the best sources are the contemporary periodicals noted in the reference guide.

GENERAL

M. Amaya, *Art Nouveau*, New York, 1985
V. Becker, *Art Nouveau Jewellery*, London, 1985
L. Buffet-Challie, *The Art Nouveau Style*, London, 1982
E. Cumming and W. Kaplan, *The Arts and Crafts Movement*, London, 1991
E. Godoli and M. Rosci (eds.), *Torino 1902. Le Arti Decorative Internazionali del Nuovo Secolo*, Turin, 1994
N. Gordon Bowe, *Art and the National Dream*, Dublin, 1993
M. Haslam, *In the Nouveau Style*, London, 1989
I. Latham (ed.), 'New Free Style', *Architectural Design*, 1/2, 1980
F. Lenning, *The Art Nouveau*, The Hague, 1951
L. Masini, *Art Nouveau*, London, 1984
G. Naylor, *The Arts and Crafts Movement*, London, 1971
P. Nuttgens (ed.), *Mackintosh and his Contemporaries*, London, 1988
N. Pevsner, *The Pioneers of Modern Design*, London, 1972
J. Richards and N. Pevsner (eds.), *The Anti-Rationalists*, London, 1973
F. Russell (ed.), *Art Nouveau Architecture*, London, 1979
R. Schmutzler, *Art Nouveau*, London, 1977
K.-J. Sembach, *Art Nouveau*, Cologne, 1991
M. Speidel *et al.*, *Art Nouveau/Jugendstil Architecture in Europe*, St Augustin, 1988
S. Tschudi Madsen, *The Sources of Art Nouveau*, New York, 1976
S. Wichmann, *Japonisme*, London, 1967

FRANCE

C. Bacri *et al.*, *Daum. Masters of French Decorative Glass*, London, 1993
F. Borsi and E. Godoli, *Paris 1900. Architecture and Design*, New York, 1989
Y. Brunhammer and S. Tise, *French Decorative Art 1900–1942*, Paris, 1992
A. Duncan, *Louis Majorelle: Master of Art Nouveau Design*, London, 1991
P. Eckert Boyer (ed.), *The Nabis and the Parisian Avant-Garde*, New Brunswick, 1988
P. Garner, *Emile Gallé*, London, 1990
T. Mortimer, *Lalique Jewellery and Glassware*, London, 1989
G. Naylor and Y. Brunhammer, *Hector Guimard*, London, 1978
D. Silverman, *Art Nouveau in Fin-de-siècle France*, Berkeley, 1989
R. Thomson *et al.*, *Henri de Toulouse-Lautrec*, London, 1991
G. Weisberg, *Art Nouveau Bing*, New York, 1986

BELGIUM

F. Borsi and P. Portoghesi, *Victor Horta*, London, 1991

Y. Brunhammer *et al.*, *Art Nouveau Belgium France*, Houston, 1976

F. Dierkens-Aubrey and J. Vandenbreeden, *Art Nouveau in Belgium: Architecture and Interior Design*, Paris, 1991

K.-J. Sembach, *Henry Van de Velde*, London, 1989

M. Stevens and R. Hoozee (eds.), *Impressionism to Symbolism: The Belgian Avant-Garde 1880–1900*, London, 1994

J. Watelet, *Serrurier-Bovy*, London, 1987

GERMANY

K. Bloom Hiesinger (ed.), *Art Nouveau in Munich*, Munich, 1988

L. Burckhardt, *The Werkbund: Studies in the History and Ideology of the Deutscher Werkbund 1907–1933*, London, 1980

J. Hermand (ed.), *Jugendstil*, Darmstadt, 1971

M. Makela, *The Munich Secession*, Princeton, 1990

P. Weiss, *Kandinsky in Munich: The Formative Jugendstil Years*, Princeton, 1978

S. Wichmann, *Hermann Obrist: Wegbereiter der Moderne*, Munich, 1968

SPAIN

J. Cervera, *Modernismo: The Catalan Renaissance of the Arts*, 1976

F. Loyer *et al.*, *Art Nouveau en Catalogne, 1888–1929*, Paris, 1991

C. Martinell, *Gaudí: His Life, His Theories, His Work*, Cambridge, MA, 1975

C. and E. Mendoza, *Barcelona Modernista*, Barcelona, 1989

I. Solà-Morales, *Fin-de-siècle Architecture in Barcelona*, Barcelona, 1992

R. Zerbst, *Antoni Gaudí*, Cologne, 1990

BRITAIN

I. Anscombe and C. Gere, *Arts and Crafts in Britain and America*, London, 1978

D. Brett, *Charles Rennie Mackintosh: The Poetics of Workmanship*, London, 1992

W. Buchanan (ed.), *Mackintosh's Masterwork: The Glasgow School of Art*, Glasgow, 1989

J. Burkhauser, *Glasgow Girls: Women in Art and Design 1880–1920*, Edinburgh, 1990

A. Crawford, *Charles Rennie Mackintosh*, London, 1995

L. Gertner Zatlin, *Aubrey Beardsley and Victorian Sexual Politics*, Oxford, 1990

T. Howarth, *Charles Rennie Mackintosh and the Modern Movement*, London, 1977

T. Neat, *Part Seen, Part Imagined: Meaning and Symbolism in the Work of Mackintosh and Macdonald*, London, 1993

AUSTRIA

I. Latham, *Joseph Maria Olbrich*, London, 1978

H. Mallgrave (ed.), *Otto Wagner: Reflections on the Raiment of Modernity*, Santa Monica, 1993

C. Nebehay, *Gustav Klimt: From Drawing to Painting*, London, 1994

C. Schorske, *Fin-de-siècle Vienna: Politics and Culture*, London, 1979

W. Schweiger, *Wiener Werkstaette: Design in Vienna 1903–1932*, London, 1984

P. Vergo, *Art in Vienna 1898–1918*, London, 1975

F. Whitford, *Klimt*, London, 1990

CZECH

D. Kusak, *Mucha*, Prague, 1992

J. Hoole, V. Arwas *et al.*, *Alphonse Mucha*, London, 1993

J. Mergl *et al.*, *Lötz Böhmisches Glas 1880–1940*, I, Munich, 1989

R. Svacha, *The Architecture of New Prague. 1895–1945*, Cambridge, MA, 1995

M. Vitochová *et al. Prague Art Nouveau*, Prague, 1993

V. Vokáčová et al., *Prager Jugendstil*, Heidelberg, 1992

P. Wittlich, *Fin-de-siècle Prague*, Paris, 1992

HUNGARY

T. Bakonyi and M. Kubiszy, *Lechner Ödön*, Budapest, 1981

P. Constantin, *Arta 1900 in Romania*, Bucharest, 1972

E. Csenkey, *Zsolnay szecessziós kerámiák*, Budapest, 1992

G. Éri and Z. Jobbágyi (eds.), *A Golden Age. Art and Society in Hungary 1896–1914*, Miami, 1990

J. Gerle, A. Kovács and I. Makovecz, *A századforduló magyar épitészete*, Budapest, 1990

K. Gellér, K. Keserü, *A Gödöllői művésztelep*, Budapest, 1987

K. Keseru, 'The workshops of Gödöllő', *Design History*, I, 1988, pp. 1–23

S. Kohmoto *et al.* (eds.) *Panorama: Architecture and Applied Arts in Hungary 1896–1916*, Kyoto, 1995

S. Manbach (ed.), *Standing in the Tempest: Painters of the Hungarian Avant-Garde 1908–1930*, Santa Barbara, 1991

J. Szabadi, *Art Nouveau in Hungary*, Budapest, 1989

POLAND

D. Crowley, *National Style and Nation State. Design in Poland*, Manchester, 1992

Z. Kepiński, *Stanisław Wyspiański*, Warsaw, 1984

A. Olszewski, *Nowa forma w architekture polskej 1900–1925*, Warsaw, 1970

M. Wallis, *Secesja*, Warsaw, 1974

T. Terlecki, *Stanisław Wyspiański*, New York, 1983

RUSSIA

E. Borisova and G. Sternin, *Russian Art Nouveau*, New York, 1988

J. Bowlt, *The Silver Age: Russian Art of the Early 20th Century and the World of Art Group*, Newtonville, MA, 1979

W. Brumfield, *The Origins of Modernism in Russian Architecture*, Berkeley, 1991

D. Elliott *et al.*, *The Twilight of the Tsars*, London, 1991

J. Howard, *The Union of Youth*, Manchester, 1992

J. Kennedy, *The Mir iskusstva Group and Russian Art*, New York, 1977

V. Petrov and A. Kamensky, *The World of Art Movement*, Leningrad, 1991

FINLAND

L. Ahtola-Moorhouse et al., *Dreams of a Summer Night: Scandinavian Painting at the Turn of the Century*, London, 1986

J. Boulton Smith, *The Golden Age of Finnish Art: Art Nouveau and the National Spirit*, Helsinki, 1985

D. Derrey-Capon *et al.*, *A. W. Finch 1854–1930*, Brussels, 1992

M. Hausen *et al.*, *Eliel Saarinen. Projects 1896–1923*, Cambridge, MA, 1990

J. Moorhouse *et al.*, *Helsinki Jugendstil Architecture 1895–1915*, Helsinki, 1987

M. Munch and M. Tamminen, *Furniture by Louis Sparre*, Porvoo, 1990

R. Spence, 'Lars Sonck', *Architectural Review*, no. 1020, 1982, pp. 41–9

M. Valkonen, *The Golden Age: Finnish Art 1850–1907*, Helsinki, 1992

LATVIA

J. Krastiņš, *Jugendstil in der Rigaer Baukunst*, Michelstadt, 1992

I. Pujāte, *Janis Rozentāls*, Riga, 1991

J. Siliņš, *Latvijas māksla 1800–1914*, II, Stockholm, 1980

Chronology

1843–60
Ruskin's call for art, and ultimately society, to be a synthesis of nature, beauty and high morality, this possible through revival of medieval handicrafts and collective forms of art production

1846–54
Comte's positivism: theory of phases in human development from the theological to the metaphysical to the positive (that which seeks only regular connections between phenomena)

1851
Kelvin's ideas about molecular dynamics and the wave theory of light

1855–1910
Afanas'yev's and Lang's publication of thousands of fairy- and folk-tales

1857–69
Vasiliev's investigations into Buddhism

1857–71
Baudelaire's and Rimbaud's literary synaesthesism. Stimulates renewed interest in synaesthesia, the mixing of the senses

1858–75
Viollet-le-Duc's theory of rational architecture created as a coherent and direct expression of current materials, technology and functional requirements

1859
Darwin's survival-of-the-fittest evolution theory

1862–96
Spencer's promotion of individualism

1866
Haeckel's evolutionary trees and monistic conception of nature

1867
Marx's acknowledgment of the capitalist bourgeoisie's appropriation of the products of the proletariat's creative energies and the latter's dehumanised status as a commodity

1871
Mendeleyev's periodic table for the elements

1875 Theosophical Society's and *Societa Rosicruciana*'s belief in the existence of a deeper, spiritual reality beyond matter, reached through intuition, meditation and other altered states of consciousness

1875
Eiffel's *Le Bon Marché* department store

1877–78
Edison's first light bulb and phonograph

1880
Solovyov's Godmanhood: man as unique, vital part of nature capable of knowledge and expression of the divine 'absolute unitotality', the single creative source from which the multiplicity of life emerged and with which it reintegrates

1882
Marey's chronophotographic gun records bird flight

1880s–1890s
Popularity of magic lantern shows

1880s–1890s
Solvay's social energetics, gestalt psychology

1883
Fabian Society's promotion of socialism and women's rights

1883–1901
Nietzsche's notions of perspectivism; will to power (life as the instinct for growth and durability – and how the supreme values of man lack this will and are symptomatic of decline, nihilism); and the superman (*Ubermensch*) who could accept the eternal recurrence of every moment

1884
Dirigible flight

1885
Hertz's study of electro-magnetic waves

1885–1909
Kropotkin's anarchist conception of integrated, organic and comfortable human existence within communities based on mutual aid

1887
Charcot's neurological research

1889
Daimler's manufacture of cars

1890
Frazer's revelation of a whole spectrum of polytheisms

1891
Lilienthal's piloted gliding flights

1894
Ostwald's definition of a catalyst and his belief in energy as the explanation for all physical phenomena

Late 1890s
Wave of pornography, prostitution and displays of open sexuality in theatres and cabarets

1895–96
Popov and Marconi's invention of the receiver

1895
Röntgen's discovery of X-rays

1895
Lumière brothers' development of the cinématographe

1897
Tolstoy's demand for a religious art where the viewer is infected with the condition of the artist's soul

1900
Blossfeldt's plant microphotography

Reference guide

1 France: Paris and Nancy

Background: importance of France's loss of 1870–71 Franco-Prussian war, with Germany occupying Alsace and parts of Lorraine. New protectionist, development policies. Expansion of education, industry and cities. Funding for the arts. Immigration to French Lorraine and anti-German expression.

THE ARTS

New state funding for the arts, private patronage of applied arts. Influence of symbolism, and of the sciences (including botany and psychology). Eighteenth-century Rococo traditions revived. From the late 1880s Gauguin and other members of his Pont-Aven school, notably Bernard, use sources such as Japonism and the Celtic Revival, and seek to unify the arts, by working as furniture designers and ceramicists.

PARIS

The Nabis – early Art Nouveau protagonists. Founded around 1889. Leading members: Maurice Denis, Pierre Bonnard, Paul Ranson, Aristide Maillol. Others: James Pitcairn-Knowles, Georges Lacombe, Ker-Xavier Roussel, Felix Vallotton, Edouard Vuillard. Increasingly decorative, painters move to the applied arts. Rejection of photographic naturalism, anecdotal subject matter, belief in superiority of easel painting. Conceptual art.

Henri Toulouse-Lautrec (1864–1901): commercial, momentary art of the popular entertainment poster made into fine art. Stylisation, with naturalist elements.

Alfons (Alphonse) Mucha (1860–1939): 'Style Mucha', particularly in posters, identified with Art Nouveau.

Samuel Bing's *L'Art Nouveau* salon (from 1895): fount of much new design. International appeal, patronage and work. Artists include Nabis, Villé (Viktor) Vallgren, Georges de Feure, René Lalique, Edouard Colonna, Eugene Gaillard, Alexandre Charpentier.

Hector Guimard (1867–1942): 'Style Guimard', emphasis on free line. Castel Béranger (1894–98), Humbert de Romans concert hall (1898–1901; demolished), Paris Métro station entrances (1900–4), Castel Henriette (Sèvres, 1899–1900), Castel d'Orgeval (Villemoisson-sur-Orge, 1904–5).

Other designers and architects: Charles Plumet, Tony Selmersheim, Henri Sauvage, Jules Lavirotte, Frantz Jourdain.

NANCY

Emile Gallé (1846–1904): glassmaker and furniture designer. Patriotic, pantheistic nature symbolism. Artist as visionary. First president of L'école de Nancy, founded

1901: promotion of applied arts. Members: Louis Majorelle, furniture designer; Auguste and Antonin Daum, glassmakers; Victor Prouvé, designer.

Periodicals: *Art et Décoration* (1899–1904); *L'Art Décoratif* (1898–1908).

2 Belgium: Brussels and Liège

Background: Belgium: new kingdom (1831); colonial expansion – Congo Free State; disenfranchisement of population; Fleming/Walloon division; strength of Catholicism; mixture of nationals; speed and nature of urbanisation. Development of rail system, imaginative capitalism, early advancement of metal industries. Ernest Solvay, chemical industrialist – theory of social energetics, productivism, monism. Social unrest, organisation of working class (e.g. *Parti Ouvrier Belge*: Belgian Workers' Party, 1885), development of symbolism – writers Maurice Maeterlinck, Emile Verhaeren.

THE ARTS

BRUSSELS Opposition to bourgeois vulgarity. Symbolist painters: Fernand Khnopff, Jean Delville, James Ensor. New arts groups: *Société des Vingts* (*Les XX*) (1883–93), *La Libre Esthétique* (1894–1914). Promotion by Octave Maus and Edmond Picard, founder of La Maison d'art (1894). Artists include Van de Velde, Georges Lemmen, Gisbert Combaz, Willy Finch, Anna Boch. International attraction, promotion of applied arts/installations. Art as the visualisation of energy forms and flows.
Poster art: Combaz, Adolphe Crespin, Privat Livemont, Fernand Toussaint.
Henri Van de Velde (1863–1957), painter, designer and architect: Bloemenwerf House, Uccle, 1895.
Victor Horta (1861–1947), architect: Hôtel Tassel, 1892–3; Hôtel Solvay, 1894; Hôtel van Eetvelde, 1897–1900; Hôtel Aubecq, 1899–1900; Maison and Atelier Horta, 1898; Maison du Peuple , 1896–99.
Others: architect Paul Hankar; jewellery designer Philippe Wolfers; glass manufacture: Val Saint-Lambert.

LIÈGE Gustave Serrurier-Bovy (1858–1910), furniture and interior designer.

Periodicals: *L'Art Moderne* (1881–1914); *Van Nu en Straks* (1891–1901).

3 Germany: Munich

Background: German Second Reich established 1871. Exclusion of Austria. Advances in technology, heavy industry, particular state emphasis on further education and research. Development of natural sciences, botany, zoology, morphology, organic chemistry, significant: e.g. Ernst Haeckel, Wilhelm Bölshe – monist conception of existence, all beings from single source. Kingdom of Bavaria under Wittelsbach dynasty from 1808. Royal patronage of the arts crucial. Little industry – little alternative patronage. Munich: small, but population explosion, late nineteenth century. Political crisis: opposition to conservative, repressive Roman Catholic Centre Party's increasing power.

THE ARTS
Rejection of historicism, assertion of the modern: widespread appeal and practice of *Jugendstil* across Germany. Increased sensuality, sexuality, anti-bourgeois statements, attention to applied arts, celebration of Aryan, pagan youth and nature. Opposition to establishment practices of *Kunstlergenossenschaft* (Artists' Guild): Munich Secession

(*Verein bildender Kunstler Munchens*) founded 1892. Other groups: United Workshops for Art in the Crafts (*Vereinigte Werkstatten fur Kunst im Handwerk*), founded 1897; Phalanx Society (1901–4).

Influence of Franz von Stück, painter, sculptor, designer and architect, and promoter of Classical eclecticism.

Hermann Obrist (1869–1927), embroidery and furniture designer, sculptor.

August Endell (1871–1925), decorator of the Elvira Photographic Studio, 1896–98, designer and theorist of *Jugendstil*.

Others: Bernhard Pankok, Bruno Paul, Richard Riemerschmid, Otto Eckmann, Peter Behrens, Vasily Kandinsky.

Periodicals: *Jugend* (1899–1933); *Simplicissimus* (1896–1967); *Dekorative Kunst* (1897–1929); *Deutsche Kunst und Dekoration* (1897–1934).

4 Spain: Barcelona

Background: Catalonia under Castilian rule from early eighteenth century, yet close to France and with distinctive culture/traditions. Nineteenth-century growth of Barcelona as major European industrial and trade centre. Spanish de-Catalanisation of the region. Emergence of labour and anarchist movements, Catholic Revival, the embourgeoisement of sectors of urban society, the Catalan Revival (*Renaixença*) movement, originally linguistic but also nationalist, though not seeking independence from Castile. Growth of the economy – new Catalan institutions, publications, groups, e.g. the Regionalist League (*Lliga regionalista*), founded 1901. Catalan romanticist literature.

THE ARTS

Barcelona School of Architecture founded 1869. Historicist building promoted but Regionalist graduates add elements of Moorish *Mudéjar* style, Catalan eclecticism.

Antoni Gaudí (1852–1926), architect: Güell Palace, 1886–89; Church of the Sagrada Familia (Holy Family), 1888–1926; Park Güell, 1900–14; Casa Batlló, 1904–7; Casa Milà, 1905–10; Crypt of the Church at Colonia Güell, 1898–1917.

Luis Domènech i Montaner (1849–1923): Castell dels Tres Dragons restuarant-workshops, 1888; Hospital de Sant Pau, 1902–26; Palau de la Música Catalana, 1905–8.

Circol de Sant Lluch (Saint Luke): Catholic romanticists, founded 1893. Leading graphic artist: Alexandre de Riquer

Els Quatre Gats (Four Cats) café-concert circle of bohemian artists from 1897: Ramón Casas, Miquel Utrillo, Santiago Rusiñol, Pablo Picasso, Isidro Nonell.

Periodicals: *Pèl & Ploma* (1899–1903), *Joventut* (1900–6).

5 Britain: Glasgow

Background: Late nineteenth-century industrial society exposed to increased competition from Europe and America. Scientific and technological developments; march of empiricism, sociology, growth of countercultures: Darwin, Frazer, Spencer, Geddes, mysticism, Ruskin, Marx. Glasgow population explosion. Prosperity for middle classes. Progressive Corporation – sponsorship of Glasgow exhibitions, 1888, 1901. Money to be spent on housing, education and the arts.

THE ARTS

Conservative taste of British establishment, but early funding of design schools and

exhibitions, South Kensington Museum. Art Nouveau affinities in the 1890s work of Beardsley, the Guild of Handicrafts, Century Guild, Bromsgrove Guild of Applied Arts, (e.g. Ashbee, Knox, Voysey, Townsend and others). Exhibiting societies (e.g. Arts and Crafts), galleries (e.g. Grafton Gallery), shops – Liberty, Maple.

Glasgow School of Art: director Fra Newbery from 1885. Encouragement of youth, innovation and a social role for the school – focus on design. Association with Belgium.

The Glasgow Four ('The Spook School'): Frances and Margaret Macdonald, Herbert MacNair, Mackintosh. New paganist symbolism. Use of woman, night, sexual imagery, roses, swallows, hearts, suns and moons. Hybrid figures. Watercolours for *The Magazine* (c. 1894), posters 1895–98, gesso panels, metalwork, textiles.

Charles Rennie Mackintosh (1865–1933), architect: Glasgow School of Art, 1897–1909; installations at Munich Secession, 1898, Vienna Secession, 1900, Turin 1902; Hill House, Helensburgh, 1902–3. Synthetic design, sparse, linear decoration, elements of vernacular.

Periodicals: *The Studio* (1893–), *The Magazine of Art* (1878–1904).

6 Austria: Vienna

Background: Conservative Vienna, excluded from German Reich: centre of declining Habsburg empire. Rule of Emperor Franz Josef from 1848. Late awakening of arts, following Ringstrasse development, post 1857. Expansion of the city, markets crash 1873. Historicist styles: appearance of grandeur – mask for decline and insecurity. Regulation of waterways, establishment of urban communications. Modernisation – desire to keep apace with contemporary progressive European developments. Encouragement of further education, scientific research, the arts. 1900s new era for self-criticism, analysis – Freud.

New state system of applied arts schools and museums (led by Felician Freiherr von Myrbach and Arthur von Scala). Love of, proximity to, classical culture. Enthusiasm for modern British design.

Form of Art Nouveau: *Sezessionstil* or Secession Style. Principally associated with the Applied Arts Schools, the Secession group of artists (*Vereinigung bildender Künstler Oesterreichs*) founded 1897, and the Wiener Werkstätte founded 1903. Development of rectilinear style, 'functionalism'. Motto of the Secessionists: '*Ver sacrum* (Sacred Spring): to the age its art, to art its freedom.' Seminal 14th Secession 'Beethoven' Exhibition. Collaborative installation.

Joseph Maria Olbrich (1867–1908), architect: the Secession Building, 1898.

Gustav Klimt (1862–1918). Painter and graphic artist. Beethoven friezes, 1902; Palais Stoclet dining room friezes, 1905–9.

Koloman (Kolo) Moser (1868–1918). Graphic artist, designer.

Josef Hoffmann (1870–1956), architect and designer: interiors of Secession exhibitions; Hohe Warte villas, 1900–2; Purkersdorf Sanatorium, 1904; Palais Stoclet, Brussels, 1905–11.

Otto Wagner (1841–1918): 38 and 40 Linke Wienziele tenements, 1898–99; Imperial Post Office Savings Bank, 1904–12; St Leopold's Church, Steinhof, 1902–4.

Periodical: *Ver Sacrum* (1898–1903)

7 Czech: Prague and beyond

Background: Kingdom of Bohemia as part of Habsburg empire. Centre: Prague. Complex political and national stuggles following 1848 revolution. Czech renaissance encouraged by politicisation of urban Czech population, decline in German control of administration. Redevelopment of Prague following slum clearance law of 1893.

THE ARTS

Impetus for artistic change from new art institutions: Applied Arts School (founded 1885), Rudolfinium arts centre (1872). Influence of exhibitions: Jubilee, 1891; Ethnographic, 1895; Architecture and Engineering, 1898. Access to European movements. Secession Style promoted by Mánes Society (founded 1887); glassworks: Widow of Johann Loetz (Johan Lötz Witwe), Harrach, Pallme König; Topič salon.

Jan Kotěra (1871–1923). Architect: Peterka House, 1899; Mánes Union Pavilion, 1902; Macha villa, Bechyne, 1902; Prostějov (Moravia) National House, 1905–7.

Osvald Polívka (1859–1931). Architect: Novák department store, 1902–4; Municipal Building, 1904–12.

Other architects: Friedrich (Bedřich) Ohmann, Josef Fanta, Dušan Jurkovič; painters: Jan Preisler, Max Švabinský, Alfons Mucha; sculptors: František Bílek, Stanislav Sucharda.

Periodicals: *Volné směry* (1896–); *Moderní revue* (1894–1925).

8 Hungary: Budapest and beyond

Background: New autonomy within the Habsburg empire, following the *Augsleich* (Compromise) Agreement, 1867. Injection of Austrian capital into economy. Agrarian economy persisted. Budapest established as seat of government, 1873. Emperor Franz Josef as king. Magyars as largest ethnic group, associated with Finno-Ugric peoples originally from Urals. Large expansion of railway network from 1846. Urbanisation, growth of transport industry.

THE ARTS

Search for new vocabulary in architecture in mid-nineteenth century. Move from historicism to eclectic national romanticism. Introduction of Byzantine, Moorish, Mogul elements. Encouraged by Polytechnical Institute. Infleunce of 1896 Millennial Exhibition. Visual artists' preference for training in Paris. Collaboration with Finnish modernisers. Use of Zsolnay ceramics – new techniques. Nagybánya artists' colony, Transylvania. Plumbing of Transylvanian (Székely) traditions, motifs. Expenditure on design exhibitions.

János Vaszary (1867–1939), symbolist painter.

József Rippl-Rónai (1861–1927), member of Parisian Nabis. Painter and designer

Ödön Lechner (1845–1914), architect, inspiration and leader of national romanticism: Museum of Applied Arts, 1891–96; Geological Institute, 1896–99; Post Office Savings Bank, 1898–1901; Sipeki-Balázs villa, 1905–8.

Gödöllő colony: founded 1902. Artists-craftsmen: Aladár Körösfői-Kriesch, 1863–1920; Sándor (Alexander) Nagy, 1869–1950, Ede Toroczkai-Wigand, 1870–1945: collaborative project: Marosvásárhely Palace of Culture (1910–13).

Others: architects Károly Kós, István Medgyaszay (Stefan Benkó), Béla Lajta; glassworker: Miksa Róth.

Periodicals: *Magyar iparművészet* (1897–); *A Ház* (1908–12).

9 Poland: Cracow and beyond

Background: Poland partitioned in eighteenth century between Prussia, Russia and Austria. Abolishment of Polish state, nation split across several borders. Strong sense of loss and determination to reinforce national identity – one of few ways possible – through art. Lemberg (Lviv), seat of local diet, and Cracow, urban centres of Galicia, Slav province on north-eastern edge of Habsburg empire. Lemberg – mixture of Ukrainians (Ruthenians) and Poles.

THE ARTS

Influence of national romanticist and symbolist movements very strong. Nietzschian writings of Stanisław Przybyszewski. Lemberg: Polytechnical School. Cracow Museum of Industry (from 1868) School of Applied Arts. Art Nouveau generally known as Secesja (Secession Style). Largely synonymous with the *Moderna* or Young Poland (*Młoda Polska*) movement. *Sztuka* (Art) Society – modern nationalist artists founded 1897. Polish Applied Arts Society (1901–14). Interest in Podhale culture – Górale (Highlander) people in remote Tatra mountains of south. Centre: Zakopane.

Zakopane Style established by Stanisław Witkiewicz (1851–1915): painter, designer and architect: House under the Firs (1896–97).

Jan Lewiński (1851–1919), Lemberg architect and designer: Dnestr Insurance Co. Building (1905); Pedagogical Society residence (1906–8); Music Institute (1914–16). Use of local (Carpathian/Huzul) motifs.

Kazimierz Sichulski (1879–1942). Painter and stained glass designer.

Stanisław Wyspiański (1869–1907). Universalist and nationalist. Painter, dramatist, stained glass and furniture designer.

Józef Mehoffer (1869–1946). Painter and stained glass designer.

Others: Kazimierz Stabrowski, painter and first director of Warsaw School of Fine Art, Edward Okuń. Painter and graphic artist.

Periodicals: *Chimera* (Warsaw, 1901–7); *Życie* (Cracow, 1897–1900); *Liberum Veto* (Lemberg, 1904–5)

10 Russia: St Petersburg, Moscow and beyond

Background: Russian empire: multinational and vast. Included Finland, parts of Poland, the Baltic countries – present day Estonia, Latvia and Lithuania, Belarus, Ukraine, the Caucasian region, Central Asia, Siberia. Capital on Baltic coast: St Petersburg, founded in 1703. Poor but with vast mineral wealth. Growth of capitalism, urbanisation, industry, integration with rest of Europe – very rapid in late nineteenth century. Many nouveau riche. Rivalry between Moscow and St Petersburg. Flourishing of culture – science, arts, music, ideas. Fount of political extremism.

THE ARTS

Appearance of modern trends in art, architecture and design – dichotomy between National Romanticists and internationalists. Influence of Baron Stieglitz School of Technical Drawing, Academy of Fine Arts, St Petersburg; Stroganov Art and Industrial Institute, Moscow. Patronage of industrialists and aristocracy. National Revival colonies – Abramtsevo, near Moscow, run by Savva Mamontov from 1870s; Talashkino, near Smolensk, run by Princess Maria Tenisheva. Leading Russian romanticist: Viktor Vasnetsov (1848–1926). Spate of art/design exhibitions around 1900. World of Art (*Mir iskusstva*) society, founded 1898 by Sergey Diaghilev.

Mikhail Vrubel (1856–1910), painter and applied artist. Abramtsevo, Talashkino.

Konstantin Korovin (1861–1939), painter, designer.

Fyodor Shekhtel (1859–1926) Moscow architect: Morozov houses, mid-1890s; Russian Pavilions, Glasgow exhibition, 1901; Northern (Yaroslavl) Railway Station, 1902; Stepan Ryabushinsky House, 1900–3; Aleksandra Derozhinskaya House, 1901

Others: architects Lev Kekushev, William Walcot (Valkot), Gavriil Baranovsky, Fyodor Lidval, Roman (Robert) Meltser; artists: Nikolay Roerich (Rerikh), Viktor Borisov-Musatov, Mstislav Dobuzhinsky; Konstantin Somov, Lev Bakst, Aleksandr Benois (Benua), Sergey Malyutin, Aleksandr Golovin, Maria Yakunchikova, Elena Polenova, Ivan Bilibin.

Periodicals: *Mir iskusstva* (1898–1904); *Iskusstvo i khudozhestvennaya promyshlennost'* (1898–1902).

11 Finland: Helsinki and beyond

Background: Finland annexed by Russia 1809. 'Semi-autonomous' but still subject to Russification. Helsinki (Helsingfors) made capital in 1812. New city, near to Russia – development/new wealth opportunities. Urban population explosion – 20,000 in 1850 to 150,000 in 1910. Early Russian encouragement of Finnish culture as opposed to more western Swedish. Finnish movement – language, literature – Elias Lönnrot publishes *The Kalevala* (1831) – anthology of runic folk poems and songs, most depict life in remote eastern region of Karelia.

THE ARTS

New institutions: Finnish Art Society established 1846, School of Drawing, 1848. School of Applied Arts, 1871. Finnish Society of Crafts and Design, 1875. Friends of Finnish Handicrafts 1879. Polytechnic Institute 1872. Unity of the arts advocated by Prof. Carl Estlander. National romanticism – in theatre, music, literature, visual arts. Finnish Antiquarian Society – architects and artists on expeditions to Karelia in 1880s and 1890s. Industrial art exhibitions from 1876. Revival of Finnish *ryijy* – rugs. New contact with pan-European developments. Young Finland (*Nuori Suomi*) group in early 1890s – young bohemians.

Axel Gallén (Akseli Gallen-Kallela) (1865–1931). Painter. Studied in Paris late 1880s. Symbolist/National Romanticist. Textile, furniture, metalwork, interior, house designer. Own home – Kalela, 1893. Kalevala paintings.

Louis Sparre (1863–1964). Furniture designer. Founder of Iris Workshops, Borga (Porvoo), 1897.

Willy Finch (1854–1930). Belgian painter turned Iris ceramicist.

Others artists: Pekka Halonen, Väinö Blomstedt, Hugo Simberg, Villé Vallgren (active in Paris)

Eliel Saarinen (1873–1950), Herman Gesellius (1874–1916), Armas Lindgren (1874–1929). Architects: Finnish Pavilion, Paris 1900 exhibition; Hvitträsk, 1901; Suur-Merijoki, 1901–3. Pohjola Insurance Co. Building, 1899–1901.

Lars Sonck (1870–1956). St Michael's Church, Åbo (Turku), 1894–1904. St John's Church, Tammerfors, 1900–7; Helsingfors Telephone Co. Building, 1903–5; Eira Hospital, 1904–5.

Periodicals: *Ateneum* (1898–1903); *Kotitaide* (1902–10); *Rakentaja* (1901–5).

12 Latvia: Riga

Background: Latvia incorporated into Russian empire in eighteenth century. Previously under German and Swedish control. Society – German dominated. Threatened with Russification. Latvians – agrarian, kept out from urban cultural developments until late nineteenth century. Intensification of industrialisation, brought urban population explosion in the capital Riga – Russian empire's busiest port. Good communications.

THE ARTS

Polytechnic Institute established 1862 – with architectural faculty from 1869. *Kunstverein* – Arts Association established 1870. Riga Art Salon opened 1898 – international exhibitions and promotion of local artists, including German and Latvian. Growing national awareness among Latvians – new Latvian press, literature and visual arts. Publication of old folk motifs and folk songs (*dainas*) with their micro-cosmological systems. Influential 1896 Ethnographic Exhibition, 1901 700th Riga Anniversary Exhibition. National romanticism in architecture after quashing of 1905 revolution.

Rūķis ('The Gnome'), Latvian arts society, founded St Petersburg, *c.* 1890.

Jūlijs Madernieks (1870–1955). Graphic and applied artist. Critic.

Janis Rozentāls (1866–1916). Painter. Critic.

Konstantins Pēkšēns, architect: Kamintius House, 1901–2; Stamm House, 1902; Ķlaviņa House and Ķeniņš School (1905).

Others: architects Heinrich Scheel and Friedrich Scheffel, Mikhail Eisenstein, Aleksanders Vanags, Eižens Laube, Wilhelm Bockslaff; artists Richards Zarriņš, Gustavs Šķilters, Jānis Tillbergs, Voldemārs Matvejs, Bernhard Borchert, Alexander Baranowsky; stained glass designer Kārlis Brencēns.

Periodicals: *Vērotājs* (1903–5); *Zalktis* (1906–10); *Svari* (1906–7); *Bildende Kunst in den Ostseeprovinzen* (1907–13).

Selected collections

FRANCE
Musée d'Orsay, 62 rue de Lille, Paris 40 49 48 14
Musée des Arts Décoratifs, 107 rue de Rivoli, Paris 42 60 32 14
Musée de l'ecole de Nancy, 36 rue du Sergent-Blandan, Nancy

BELGIUM
Musée Horta, 25 rue Americaine, Brussels
Musées Royaux d'Art et d'Histoire, Jubelpark 10, Brussels
Musées d'Archeologie et d'Arts décoratifs, 13 quai de Maastricht, Liège 21-94-04
Centre Serrurier-Bovy, 186 Boulevard d'Avroy, Liège

GERMANY
Stadtmuseum, St-Jakobs-Platz 1, Munich 089 2332370
Neue Pinakothek, Bärenstr. 29, Munich
Villa Stück, Prinzregentenstr. 60, Munich 089 4708074
Museum der Künstler-Kolonie, Europaplatz, Darmstadt
06151 132778
Karl Ernst Osthaus Museum, Hochstr. 73, Hagen 02331 207576

SPAIN
Museu d'Art Modern, Parc de la Ciutadella, Barcelona
Casa-Museu Gaudí, C. Olot, Park Güell, Barcelona
Museu de les Arts de l'Espectacle, Palau Güell, Nou da la Rambla 3-5, Barcelona 93
 3173974
Museu del Cau Ferrat (Cape Ferrat), Calle Fonollar, Sitges, near Barcelona 894 03 64

BRITAIN
Victoria & Albert Museum, Cromwell Road, London 0171 938 8500
Art Gallery and Musuem, Royal Pavilion, Brighton 01273 603005
Hunterian Art Gallery, 82 Hillhead Street, Glasgow 0141 330 5431
Hill House, Upper Colquhoun Street, Helensburgh 01436 673900
School of Art, 167 Renfrew Street, Glasgow 0141 353 4500

AUSTRIA
Secession Building, Friedrichstr. 12, Vienna
Österreichisches Museum für Angewandte Kunst (Applied Art), 1010 Stubenring,
 Vienna 711 36

Museum Moderner Kunst, 9 Fürstengasse, Vienna

Kirche am Steinhof, 1140 Baumgartner Höhe, Vienna

CZECH
Umělecko prumyslové muzeum (Applied Arts), 17 Listopadu 2, Prague 24-81-12-41
Národní galerie (National Gallery), Hradčanské nám. 15, Prague 24-51-07-93
Národní galerie (National Gallery: sculpture), Cistercian Monastery, Zbraslav, near
 Prague
Moravská galerie (Moravian Gallery), Husova 14 Brno 42-32-12-50
Muzeum východních Čech (East Bohemia) Eliščino nábř. 465, Hradec Králové, 234-
 16

HUNGARY
Iparmüvészeti Múzeum (Applied Arts), Üllői útca 33-37, Budapest 2175-222
Magyar Nemzeti Galérie (National), Budavári Palota, Budapest, 1757-533
Ernszt Múzeum, Nagy-mező 8, Budapest
Janus Pannonius Múzeum, Papnóvelde útca 5, Pécs
Modern Magyar Képtár (Modern Hungarian Gallery), Káptalan útca 4, Pécs
Városi Múzeum (Town), 5 Szabadság ter, Gödöllő, (28) 310-163

POLAND/UKRAINE
Muzeum Narodowe (National Museum), Al. 3 Maja 1, Cracow 34-33-77
Wyspiański Muzeum, ul. Kanonicza 9, Cracow 22-83-37
Mazovian Museum, ul. Tumska 2, Płock 244-91
Lvivska kartynna galereia (Picture Gallery), Stefanik 3, Lviv 72-39-48
Lvivskij muzei Ukrains'koho mystetstva (Ukrainian Art), Pr. Svobodi 20, Lviv

RUSSIA
Muzey Gorkovo (Gorky Museum: Ryabushinsky House), Ul. Malaya Nikitskaya
 (Kachalova) 6/2, Moscow 290-05-35
Muzey arkhitekhtury Shchuseva (Shchusev Museum of Architecture), Pr.
 Vozdvizhenka 5, Moscow 291-21-09
Istoricheskiy Muzey (Historical), Red Square 1/2, Moscow 228-84-52
Tretyakov Gallery, Lavrushinsky pereulok 10, Moscow 231-13-62
Russian Museum, Ul. Inzhenernaya 4/2, St Petersburg

FINLAND
Taideteollisuusmuseo (Applied Arts), Korkeavuorenkatu 23, Helsinki 174455
Finnish National Gallery, Kaivokatu 2–4, Helsinki 173361
Suomen rakennustaiteen museo (Finnish Architecture), Kasarmikatu 24, Helsinki
 661918
Hvitträsk Museum, Bobäck, Uusimaa, 2975779
Gallen-Kallela Museum, Gallen-Kallelantie 27, Espoo, Uusimaa 513388
Porvoo Museum, Välikatu 11, Porvoo, Uusimaa 170589

LATVIA
Janis Rozentāls Museum, Albert iela 12-9, 331641
Valsts Mākslas Muzejs (Latvian Art), K. Valdemara iela 10a, 325021
Dekorativi Lietiškas Makslas Muzejs (Applied Art), Skarnu iela 10, 222235

Index

Page references in italics refer to black and white plates; those between square brackets refer to colour plates.